# AN ILLUSTRATED HANDBOOK OF

*Art history*

## FRANK J. ROOS, JR.

COLLEGE OF FINE AND APPLIED ARTS, UNIVERSITY OF ILLINOIS

REVISED EDITION

*New York*

THE MACMILLAN COMPANY

# PREFACE TO REVISED EDITION

In the preface to the first edition we said that "The choice of men and examples constituting the modern section was particularly difficult." When it was determined to enlarge and bring the latter section of the book more nearly up to date, the problem of selection was no less difficult than it was for the first edition. Schools of painting and sculpture have become increasingly numerous in the past fifteen years, to the point where it has sometimes seemed that each artist tended to become a school in his own right.

It has been our purpose in choosing the illustrations to identify the numerous directions in which modern painting and sculpture have gone. Fifteen years from now some of the illustrations in this section will doubtless seem less important or of historic interest only, just as some of the last illustrations in the Modern Painting Section of the first edition no longer seem as important as when they were selected. On the other hand, architecture has had a more consistent and logical development than have painting and sculpture in the decade and a half since the appearance of the first edition.

Since the relative importance of examples in the pre-modern sections of the book have changed little, and the contemporary scene is changing continuously, the earlier sections have been left as they were, except for a few minor details.

Within the last fifteen years more and more works of contemporary art have become known to the public through numerous art publications, such as those of the Museum of Modern Art, through dramatic and well-staged exhibitions in the larger museums, and through the many color reproductions appearing in non-art journals that have a wide circulation. It will be found that the modern section in this revision has a wider variety of examples than did the same section in the previous edition.

We have made little attempt to bring the locations of works of art in the pre-modern sections up to date, as it would be an almost impossible task. Also, it has not been possible in all cases to locate paintings and sculpture in the modern section; they move around even in peacetime, and, like architecture, their location and condition tend to be affected by war.

May I again express my thanks to the numerous colleagues who have helped me with their advice and criticism in the matter of the choice of examples, to the artists, owners of objects of art, photographers, publications, and museum personnel who have been so gracious with their time and permissions. In particular I wish to thank my wife, Beatrice Adams Roos, and Donald C. Neville.

URBANA, ILLINOIS
January, 1954

# PREFACE TO FIRST EDITION

The aim of this Handbook is to put in the hands of students useful illustrations of as many works of art, together with reference charts, as can be encompassed in the covers of a book selling for a comparatively low price. It is the result of a need felt by myself and other teachers of art history, not for another history of art, since several good ones exist, but for a profusely illustrated reference book, which might be used independently or in conjunction with another art book. The Handbook is organized primarily for students of art history and appreciation courses, particularly for the instructor or student who is handicapped by a small budget for illustrative material and who might find in this book enough examples for a short course.

Before the actual work on the volume was begun, a survey was made of the type and content of art history and appreciation courses in a great number of colleges and art schools. From this survey it was found, unfortunately, that Oriental art and the more anthropological phases of art as a whole were seldom considered. In view of the aim of the book, which is the greatest usefulness to the greatest number of students, these phases of art, particularly the former, were reluctantly eliminated.

An attempt was made, also, to determine the examples that would be best known and therefore most useful, to both instructor and student. A master list was made from an examination of the most commonly used histories of art and of its various phases. Examples illustrated in two or more books were automatically placed on the list which formed the basis of the final list. The master list could not be rigidly followed in all instances, although most of it is here present.

Some readers will feel that too much emphasis has been placed on the Italian Renaissance, or the American or Modern sections, or too little on the Baroque. Here again, usefulness, in the light of the survey of existing courses, was the aim. The choice of men and examples constituting the Modern section was particularly difficult. Although there are as many men of great importance left out as are included, the choice of the names to be considered was here guided by the necessity of using men typical of certain trends and by the availability of material. The examples as a whole have been placed in an order easily suited to a comparative study of the history of art.

Enlargements of details have been used frequently to facilitate an understanding of the techniques involved. Attributions and dates, often problematical, may sometimes be considered in error. Every effort, however, has been made to eliminate such errors. Whenever a choice was possible, American-owned examples were used in preference to those in European museums, and often several works of a similar type, by the same artist, were used for emphasis, in preference to the addition of an isolated work by another man.

Such a handbook as this could not have been produced without the aid of a great number of persons. I wish to thank the various scholars who aided in compiling the parts of the master list and who checked over the finished book. I am grateful to the artists, owners of objects of art, authors, publishers and photographers whose works are here included. Whenever possible they are credited in parentheses where their examples appear.

I wish particularly to thank Mr. Jesse Zousmer for his assistance with all phases of the book, and the staff of the Metropolitan Museum of Art, especially the members of the Extension Division. Without the help of each of these persons and organizations, and the continued cooperation and consideration of the publishers, the production of the book could not have been accomplished.

<div align="right">F. J. R., Jr.</div>

Columbus, Ohio
April, 1937

# CONTENTS

# ABBREVIATIONS

*The locations of the following Art Museums are not always given in the captions:*

Acropolis Museum, Athens; Albertinum, Dresden; Art Institute, Chicago; The Bargello, Florence; Bibliothèque Nationale, Paris; Borghese Gallery, Rome; British Museum, London; Candia Museum, Crete; Capitoline Museum, Rome; Cleveland Museum, Cleveland, Ohio; Cluny Museum, Paris; Fogg Museum of Art, Harvard University, Cambridge, Mass.; Church of the Frari, Venice; The Glyptothek, Munich; The Hispanic Society of America, New York City; Kaiser Friedrich Museum, Berlin; Lateran Museum, Rome; The Louvre, Paris; Luxembourg Museum, Paris; Metropolitan Museum of Art, New York City; Museum of Fine Arts, Boston, Mass.; Pennsylvania Academy of Fine Arts, Philadelphia; Pennsylvania Museum of Fine Arts, Philadelphia; Pergamon Museum, Berlin; Phillips Memorial Art Gallery, Washington, D. C.; Pitti Gallery, Florence; Prado Museum, Madrid; Rijksmuseum, Amsterdam; Terme Museum, Rome; Toledo Art Museum, Toledo, Ohio; Uffizi Gallery, Florence; Victoria and Albert Museum, London.

*The credit lines of the following photographic sources are sometimes abbreviated in the captions:*

(Al) Alinari; (And) Anderson; (Arch. Photo.) Les Archives Photographiques d'Art et d'Histoire; (Berlin) Berlin Museum; (Bib. Nat.) Bibliothèque Nationale; (Bruck) Bruckmann; (Cairo) Cairo Museum; (Can) Candia Museum; (Clev. Mus.) Cleveland Museum of Art; (Fogg) Fogg Museum of Art; (Gir) Giraudon; (Hanf) Hanfstaengl; (Lux) Luxembourg Museum; (Man) Mansell; (Met) Metropolitan Museum of Art; (M.F.A.) Museum of Fine Arts; (N.D.) Neurdein; (Nat. Gall.) National Gallery, London; (Nat. Mus.) National Museum, Athens, Naples; (Taft) Taft Museum, Cincinnati; (Vict. Alb.) Victoria and Albert Museum.

## BEFORE 20,000 B.C.

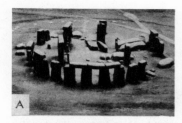

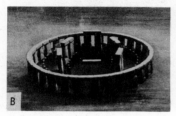

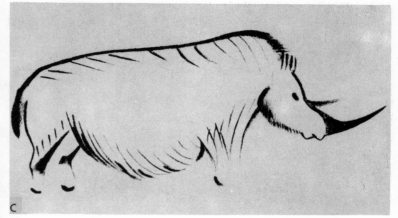

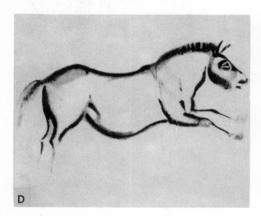

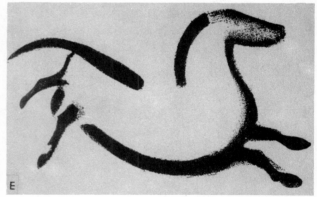

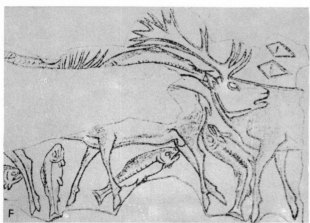

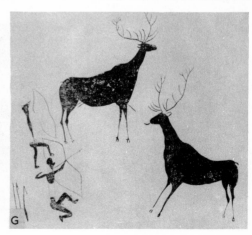

A. Stonehenge Today. Salisbury Plain, England. From a model in the Stonehenge Museum.

B. Stonehenge Restored. From a model in the Stonehenge Museum.

C. Wooly Rhinoceros. Polychrome drawing from Font-de-Gaume cave. Aurignacian. (American Museum of Natural History)

D. Horse. Drawing from Font-de-Gaume cave. Aurignacian. (American Museum of Natural History)

E. Galloping Horse. From a cave at Altamira. (Stoedtner)

F. Reindeer and Salmon. Engraving in Reindeer Horn, from Lorthet, in the Pyrenees. Magdalenian. (American Museum of Natural History)

G. Stag Hunt. From cave at Alpera. (American Museum of Natural History)

2

# PREHISTORIC ART · EGYPTIAN ARCHITECTURE
## OLD KINGDOM · 3400–2475 B.C.

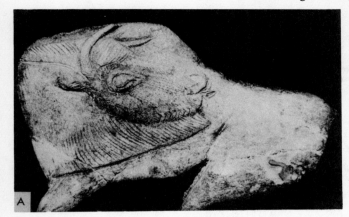

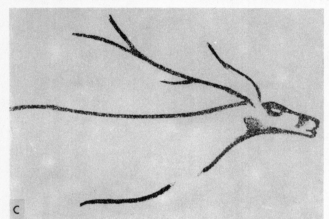

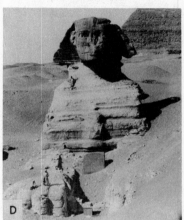

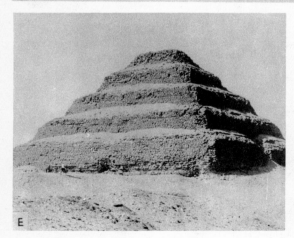

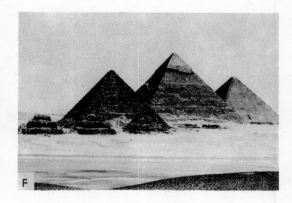

A. Bison with Turned Head. Paleolithic. Reindeer Horn. La Madeleine, Dordogne. Louvre. (Louvre)

B. Egyptian Early Dynastic Jar decorated with Gazelles and Ostriches. Metropolitan Museum. (Met)

C. Prehistoric. Reindeer. Paleolithic. (Stoedtner)

D. The Sphinx. Gizeh. IV Dynasty. (Sebah)

E. Stepped Pyramid at Sakkâra. III Dynasty. (Sebah)

F. Pyramids of Gizeh: Kheops, Khephren, Mykerinos. IV Dynasty. 2900–2750 B.C. (Sebah)

# EGYPTIAN ARCHITECTURE AND SCULPTURE
## OLD KINGDOM · 3400–2475 B.C.

3

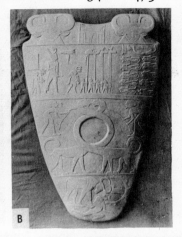

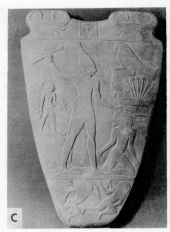

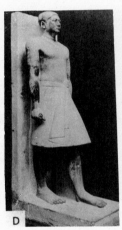

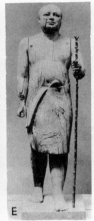

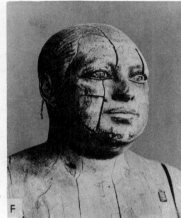

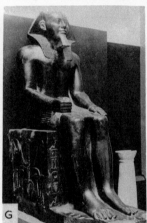

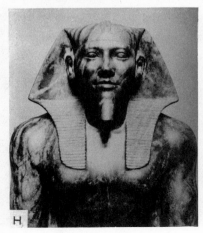

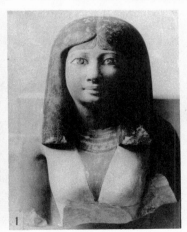

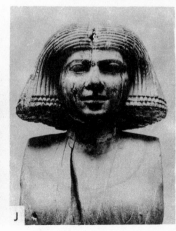

A. Valley Temple of the Pyramid of Khephren. c. 2850 B.C.

B. Palette of Narmer. Museum, Cairo. I Dynasty. (Cairo)

C. Palette of Narmer. King and Prisoner. Museum, Cairo.

D. Ranofer as a Priest of Phtah. V Dynasty, 2750–2625 B.C. Museum, Cairo.

E. "Sheik el-Beled." IV Dynasty, 2900–2750 B. C. Museum, Cairo. (Met)

F. "Sheik el-Beled." Detail of E.

G. Khephren. Museum, Cairo.

H. Khephren. Detail of figure similar to G.

I. Statue of a Lady, probably a princess. IV Dynasty, 2900–2750 B.C. Metropolitan Museum. (Met)

J. Bust of a Woman. Museum, Cairo.

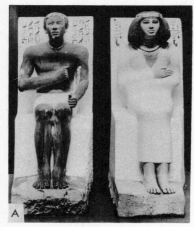

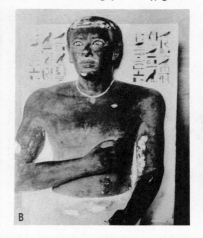

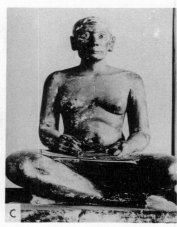

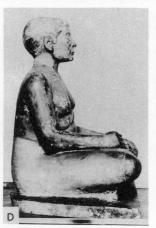

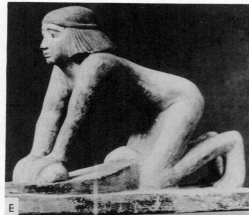

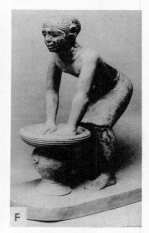

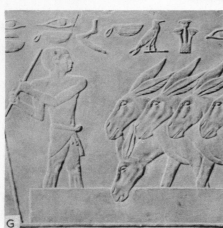

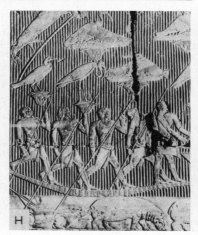

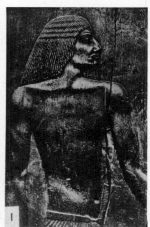

A. Rahotep and Nofret. III Dynasty. From Meidum. (Met)

B. Rahotep. Detail of A.

C. Seated Scribe. V Dynasty, 2750–2625 B.C. Louvre. (Gir)

D. Seated Scribe. Side view of C.

E. Woman Grinding Grain. Archaeological Museum, Florence. (Al)

F. Man Making Beer. Metropolitan Museum. (Met)

G. Cattle Scene. Tomb of Ptahhotep, Sakkâra. V Dynasty, 2750–2625 B.C.

H. Sailing Through Marshes. From Tomb of Mereruka, Sakkâra. V Dynasty.

I. Panel of Hesire. Detail. c. 2800 B.C.

# EGYPTIAN ARCHITECTURE
## MIDDLE KINGDOM · 2160–1788 B.C. AND NEW EMPIRE · 1580–1090 B.C.

5

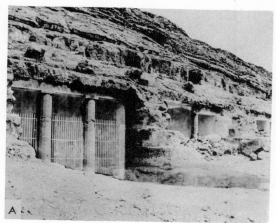

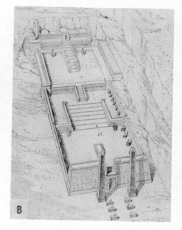

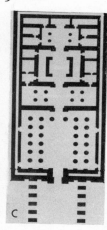

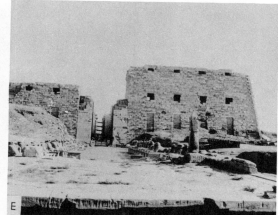

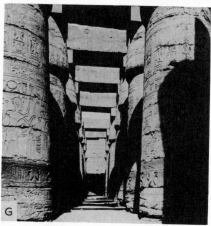

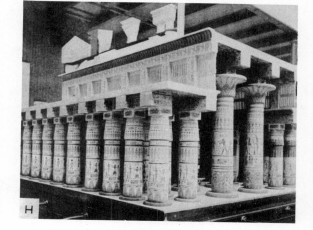

A. Façade of Tomb of Khnûmhotep II at Benihasan. XII Dynasty.

B. Restoration of Temple of Queen Hatshepsut at Deir el-Bahri. XVIII Dynasty, 1580–1350 B.C. (Charles Chipiez)

C. Typical Plan of an Egyptian Temple.

D. Plan of Temple of Amon, Karnak. 1633–323 B.C. (Charles Chipiez)

E. Temple of Amon, Karnak. The Avenue of Sphinxes leading to the Temple. XIX Dynasty, 1350–1205 B.C.

F. Temple of Amon, Karnak. Granite piers bearing the Lily of Upper Egypt and the Papyrus of Lower Egypt.

G. Temple of Amon, Karnak. Side aisle, Hypostyle hall. XIX Dynasty, 1350–1205 B.C.

H. Temple of Amon, Karnak. Hypostyle hall. Restored. Metropolitan Museum. (Met)

# EGYPTIAN ARCHITECTURE
## NEW EMPIRE · 1580–1090 B.C.

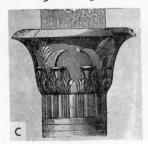

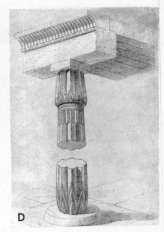

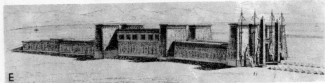

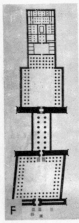

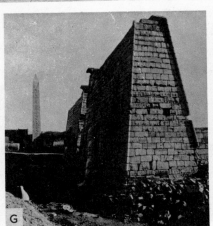

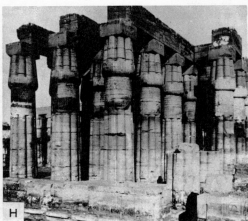

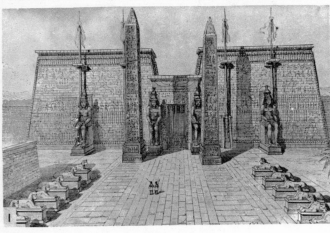

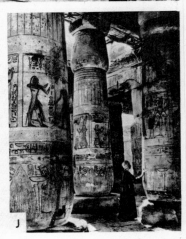

A. Hathor Capital from the Temple at Denderah. Saïte Period. (Rosengarten)

B. Palm Leaf Capital from the Temple at Edfu. Saïte Period. (Rosengarten)

C. Lotus Bell Capital from the Temple at Edfu. Saïte Period. (Rosengarten)

D. Lotus Bud Column of Thotmes III from Ambulatory of Thotmes at Karnak. (Chipiez)

E. Temple of Amon, Luxor. Restored by Charles Chipiez. XVII and XIX Dynasties, 1580–1205 B.C.

F. Plan of Temple of Amon, Luxor. (Perrot and Chipiez)

G. Temple of Amon, Luxor. Pylon with Colossi of Ramses II and Obelisk. XIX Dynasty, 1350–1205 B.C.

H. Temple of Amon, Luxor. Court of Amenophis III. XVIII Dynasty, 1580–1350 B.C.

I. Temple of Amon, Luxor. Principal façade restored by Charles Chipiez. XIX Dynasty, 1580–1350 B.C.

J. Hypostyle hall. Temple of Seti I, Abydos. 1350 B.C.

# EGYPTIAN ARCHITECTURE AND SCULPTURE
## NEW EMPIRE · 1580–1090 B.C.

7

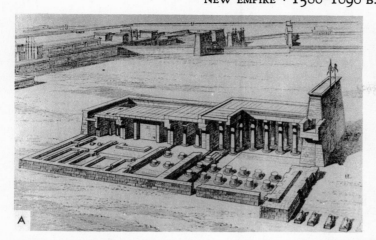

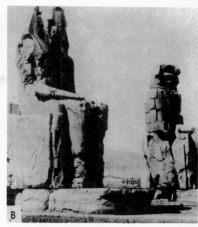

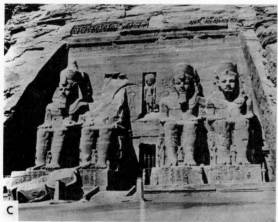

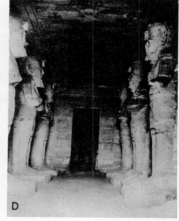

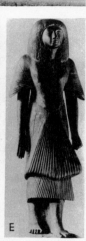

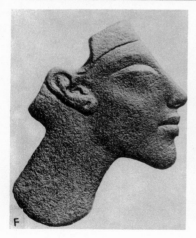

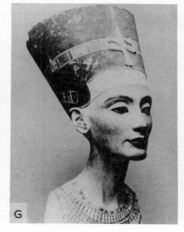

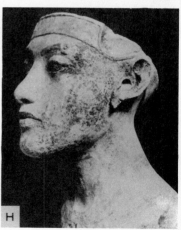

A. Temple of Khons, Karnak. XIX Dynasty, 1350–1205 B.C.

B. Colossi of "Memnon," Thebes. (Langani)

C. Temple of Ramses II, Abu Simbel. 1300 B.C.

D. Temple of Ramses II, Abu Simbel. Entrance hall. 1300 B.C.

E. Guardian Figure. XIX Dynasty. 1350–1205 B.C. Louvre. (Gir)

F. Ikhnaton. c. 1375 B.C. New Museum, Berlin. (Grantz)

G. Queen Nofretete. 1375–1358 B.C. New Museum, Berlin. (Grantz)

H. Ikhnaton. c. 1375 B.C. New Museum, Berlin. (Grantz)

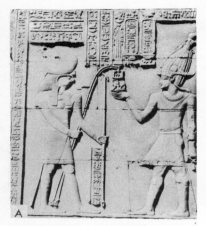

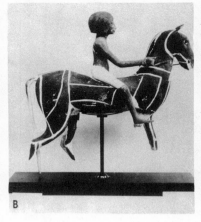

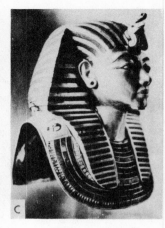

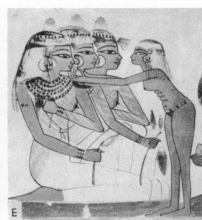

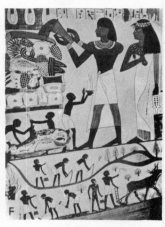

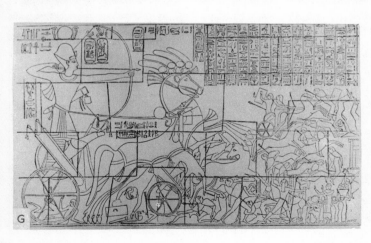

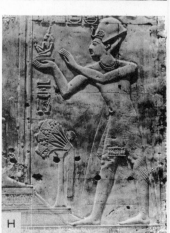

A. Relief from Wall of Temple of Seti I, Abydos. XIX Dynasty, 1350–1205 B.C.

B. Man and Horse. XVII–XVIII Dynasty. Metropolitan Museum. (Met)

C. Gold Portrait Mask of King Tutenkhamon. 1350 B.C. Museum, Cairo. (Cairo)

D. Painted Relief in Tomb of Seti I. XIX Dynasty, 1305–1205 B.C. Archaeological Museum, Florence. (Al)

E. Banquet Scene. Slave Arranging an Ear-ring. Tomb of Nakht, Thebes. XVII Dynasty, 1580–1350 B.C.

F. Wall Painting. Tomb of Nakht, Thebes. XVII Dynasty. (Met).

G. Ramses II in Battle. XIX Dynasty, 1350–1205 B.C. (Champollion)

H. Relief from Second Hypostyle Hall, Temple of Seti I, Abydos. XIX Dynasty, 1350–1205 B.C.

# EGYPTIAN SCULPTURE AND MINOR ARTS
## NEW EMPIRE · 1580 1090 B.C.; SAÏTE PERIOD · 663–525 B.C.

9

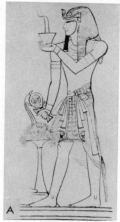

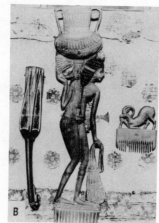

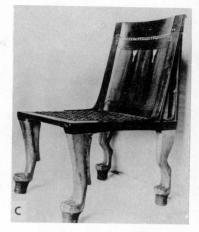

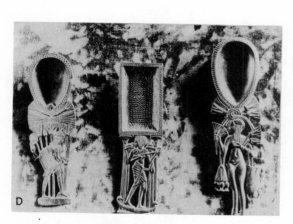

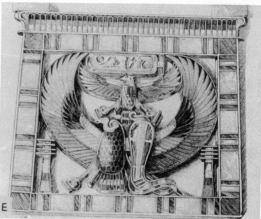

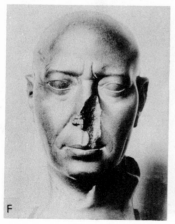

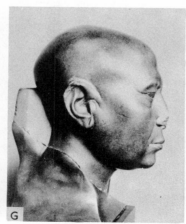

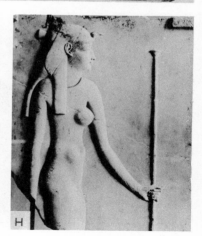

A. Seti I. Necropolis, Thebes. XIX Dynasty, 1350–1205 B.C.

B. Comb and Handle. Louvre. (Gir)

C. Chair. Wood. Louvre. (Gir)

D. Spoons. Louvre. (Gir)

E. Pectoral of Ramses II. XIX Dynasty, 1350–1205 B.C. Louvre. (Gautier)

F. Basalt Head of a Priest. Saïte Period, XXVI Dynasty, 663–525 B.C. New Museum, Berlin. (Grantz)

G. Side View of F.

H. Sculptor's Model of a Goddess. Saïte Period, XXVI Dynasty, 663–525 B.C. Metropolitan Museum. (Met)

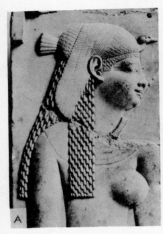

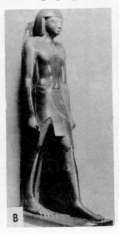

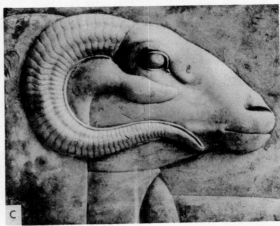

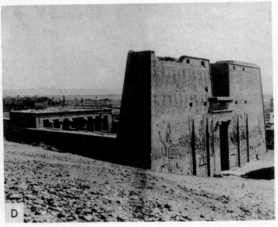

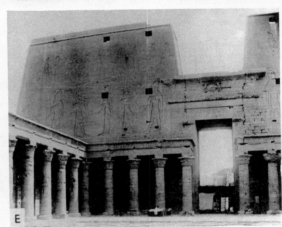

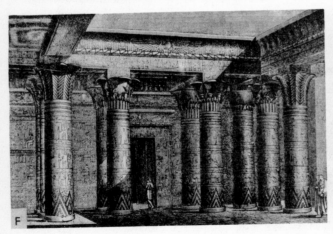

A. Sculptor's Model of Queen or Goddess. Ptolemaic Period. Metropolitan Museum. (Met)

B. Walking Figure. Saïte Period. Vatican Museum. (Al)

C. Sculptor's Model. Ram's Head. Early Ptolemaic Period. Metropolitan Museum. (Met)

D. Temple of Horus, Edfu. 237–212 B.C., in part.

E. Temple of Horus, Edfu. Pylon from the forecourt. 237–212 B.C., in part.

F. Temple of Isis, Philae. Ptolemaic Period. (Rosengarten)

G. Bell Shaped Capitals, Temple at Esneh. c. 280 B.C.

# EARLY BABYLONIAN SCULPTURE · C. 3000–1275 B.C.
## ASSYRIAN SCULPTURE · C. 1650–606 B.C.

11

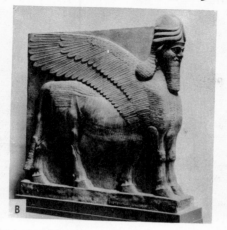

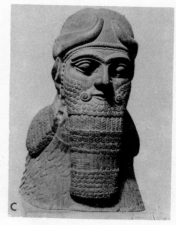

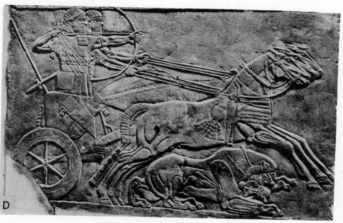

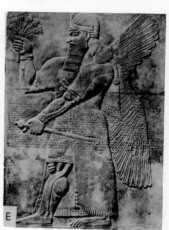

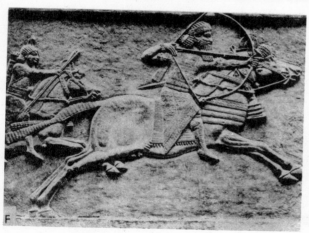

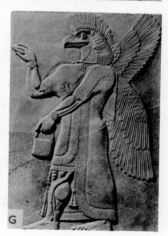

A. Gudea Head. Early Babylonian, c. 2450 B.C. Louvre.

B. Winged Man-Headed Bull. From Palace of Ashurnasirpal
II. IX century B.C. Metropolitan Museum. (Met)

C. Head of a Figure similar to B. British Museum. (Man)

D. Ashurbanipal Hunting. 668–626 B.C. British Museum.
(Man)

E. Winged Being Offering Branch with Pomegranates. From

Palace of Ashurnasirpal II. IX century B.C. Metropolitan
Museum. (Met)

F. Ashurbanipal Hunting. 668–626 B.C. British Museum.
(Man)

G. Eagle-Headed Winged Being Pollenating the Sacred Tree.
From Palace of Ashurnasirpal II. IX century B.C. Metro-
politan Museum. (Met)

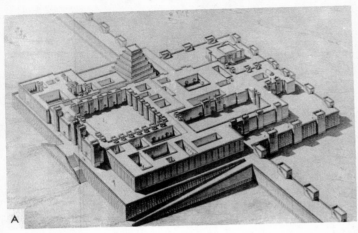

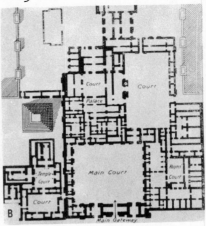

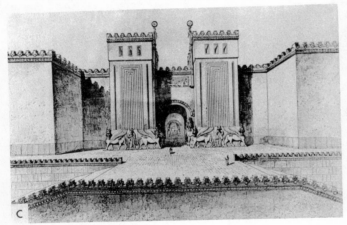

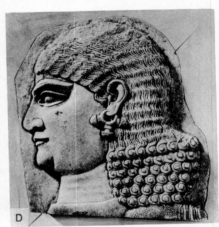

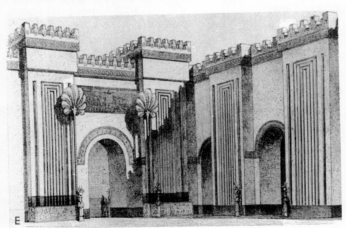

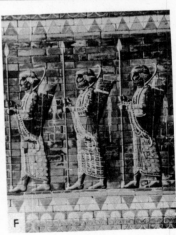

A. Palace of Sargon II, Khorsabad. Restored. 722–705 B.C. (Thomas)

B. Plan of Palace of Sargon II. (Place)

C. Palace of Sargon II. Main Gateway. Restored. (Thomas)

D. Head of Royal Attendant from Palace of Sargon II. VIII century B.C. Metropolitan Museum. (Met)

E. Palace of Sargon II. Harem Court. Restored. (Thomas)

F. Archers of King Darius. Glazed Tile from Palace of Darius at Susa. 521–484 B.C. Louvre. (Gir)

# ASSYRIAN SCULPTURE · 1650–606 B.C.
# PERSIAN ARCHITECTURE AND SCULPTURE · 530–225 B.C.

13

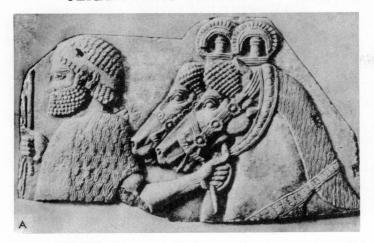

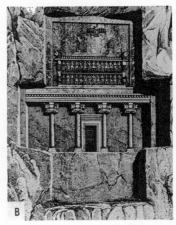

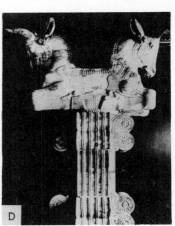

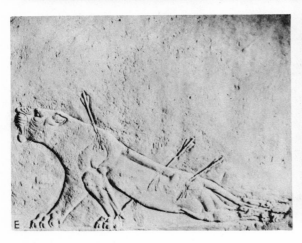

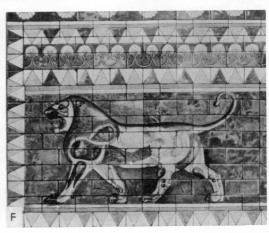

A. A Mede Bringing a Tribute of Horses. From Palace of Sargon II, Khorsabad. 722–705 B.C. Metropolitan Museum. (Met)

B. Tomb of Darius, above the Great Temple at Persepolis. (Texier)

C. Palace of Darius, Persepolis. Reconstruction. c. 521 B.C.

D. Sculptured Capital from interior of Palace of Artaxerxes, Susa. 521–485 B.C. Louvre. (Gir)

E. Wounded Lioness. From Palace at Nineveh. 668–626 B.C. British Museum. (Man)

F. Lion Frieze. From Palace at Susa. Glazed Tile. Louvre. (Louvre)

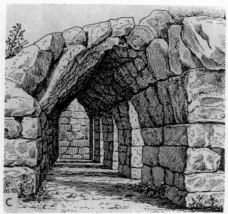

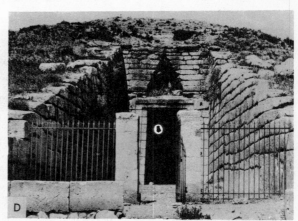

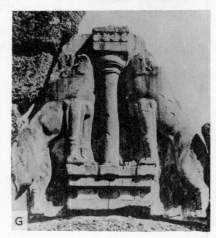

A. Palace of Minos, Knossus. Plan. c. 1500 B.C.

B. Palace of Minos, Knossus. Colonnaded Hall. Restored. c. 1500 B.C. (Maroghiannis)

C. Corbeled Gallery of Citadel, Tiryns. c. 1500 B.C. (Perrot and Chipiez)

D. "Treasury of Atreus," Mycenae. 1185 B.C.

E. "Treasury of Atreus." Mycenae. Reconstruction by Charles Chipiez.

F. Priestess Bearing a Casket. Fresco from Tiryns. c. 1450 B.C. National Museum, Athens. (Met)

G. Lion Gate, Mycenae. Detail. c. 1300 B.C.

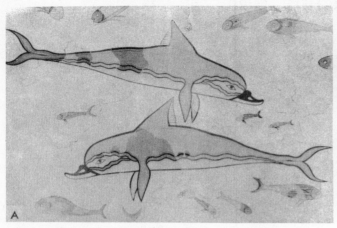

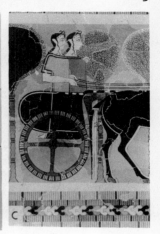

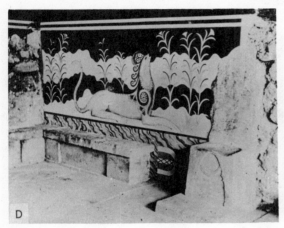
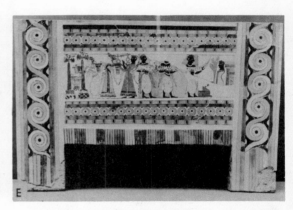

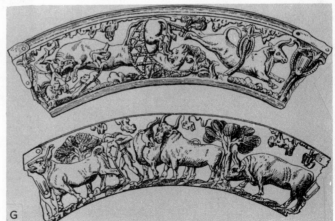

A. Dolphins. Fresco from Palace of Minos, Knossus. c. 1500 B.C. (Met)

B. Cupbearer. Fresco from Palace of Minos, Knossus. c. 1500 B.C. Candia Museum. (Met)

C. Chariot Scene. Fresco from Knossus. c. 1500 B.C. Candia Museum. (Met)

D. Throne Room. Palace of Minos, Knossus. c. 1500 B.C. (Met)

E. Painted Sarcophagus from Hagia Triada. 1400–1200 B.C. Candia Museum. (Met)

F. Gold Cups from Vaphio. 1600–1500 B.C. National Museum, Athens.

G. Detail of F. (Schuchardt)

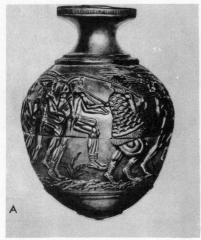

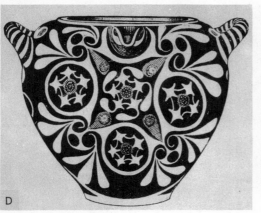

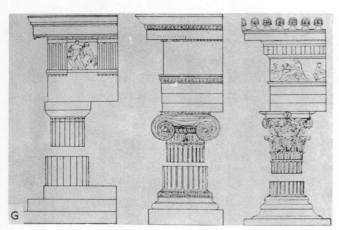

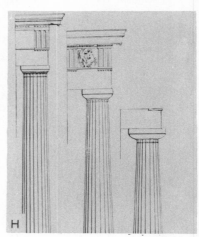

A. Vase from Hagia Triada. Candia Museum. (Can)

B. Amphora of the Palace Style from Knossus. 1500–1350 B.C. (Buschor)

C. Snake Goddess. Detail of E. (M.F.A.)

D. Kamares Style Vase from Knossus. 2000–1800 B.C. (Buschor)

E. Snake Goddess. Gold and Ivory. c. 1500 B.C. Museum of Fine Arts. (M.F.A.)

F. Snake Goddess. Side view of E.

G. Greek Architecture. The Three Orders: Doric, Ionic, Corinthian. (D'Espouy)

H. The Doric Order. R. to L.: Temple of Apollo, Corinth, c. 540 B.C.; Parthenon, 447–432 B.C.; Temple of Delos, c. 373 B.C. (Borrmann)

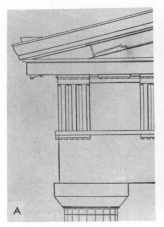

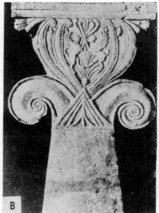

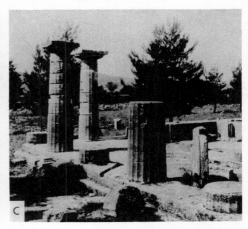

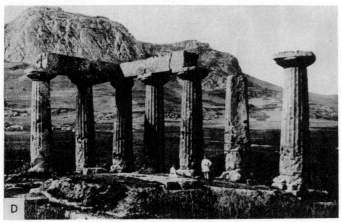

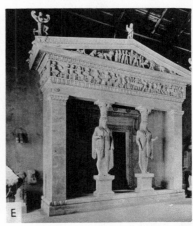

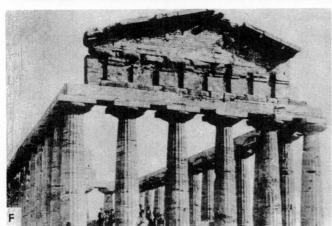

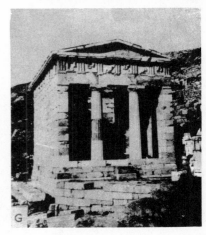

A. Doric Order. Detail. From the Propylaea, Athens. 437–432 B.C.

B. Cypriote Stele. VI century B.C. (Met)

C. The Heraeum, Olympia. c. 700 B.C.

D. Temple of Apollo, Corinth. VII century B.C. (See 16 H.)

E. Treasury of the Siphnians, Delphi. Reconstruction. Delphi Museum. c. 525 B.C. (See 27 B., C.)

F. Temple of Demeter. Paestum. c. 520 B.C.

G. Treasury of the Athenians. Delphi. c. 515 B.C.

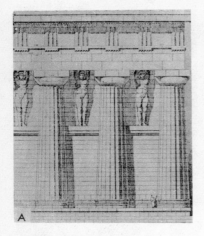

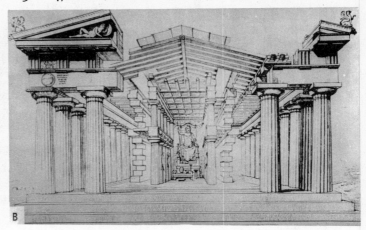

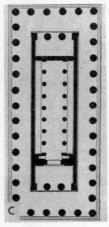

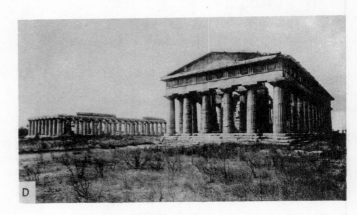

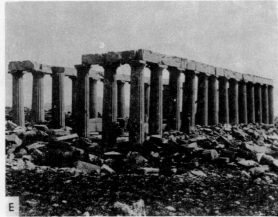

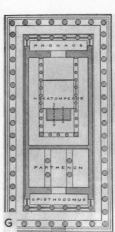

A. Order of the Olympieum, Acragas. Conjectural restoration by Koldewey. 480 B.C.

B. Conjectural restoration of the type of the Temple of Zeus, Olympia. c. 465 B.C.

C. Temple of Poseidon, Paestum. Plan. c. 460 B.C. (Koldewey)

D. Temple of Poseidon, Paestum. c. 460 B.C. Left: The Basilica, 550 B.C. (Al)

E. Temple of Apollo Epicurius, Bassae. c. 450 B.C. Ictinus, architect.

F. Temple of Apollo Epicurius, Bassae. Plan. c. 450 B.C.

G. The Parthenon, Athens. Plan. 447–432 B.C. Ictinus and Callicrates, architects. (Dörpfeld)

# GREEK ARCHITECTURE
## GOLDEN AGE · 470–338 B.C.

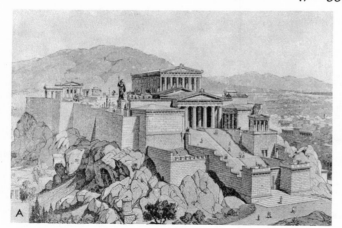

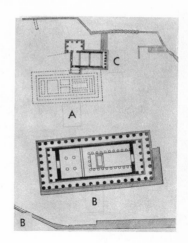

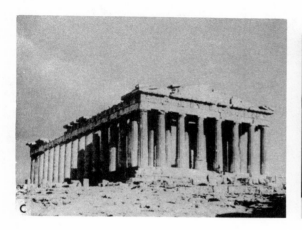

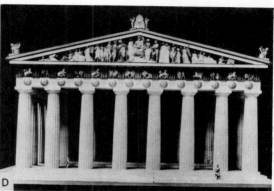

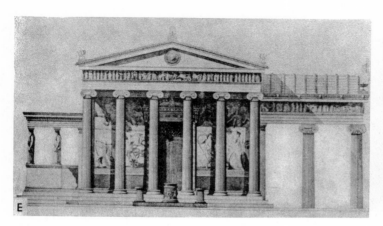

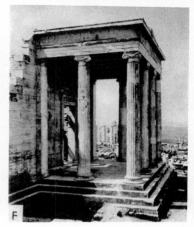

A. The Acropolis, Athens. Restoration. (Bell)

B. The Acropolis, Athens. Detail of plan. (A) The Old Temple of Athena, c. 527 B.C.; (B) The Parthenon, 447–432 B.C.; (C) The Erechtheum, 420 B.C.

C. The Parthenon, Athens, 447–432 B.C. Ictinus and Callicrates, architects. (Fred L. Ball)

D. The Parthenon, Athens. E. façade. Model. Metropolitan Museum. (See pp. 31, 32.) (Met)

E. The Erechtheum, Athens. E. side. Restoration. 420–409 B.C., and later. Mnesicles, architect. (Tetaz)

F. The Erechtheum, Athens. N. porch. (Al)

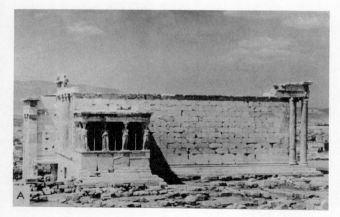

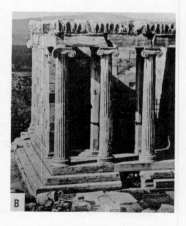

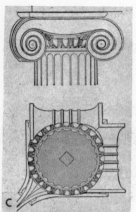

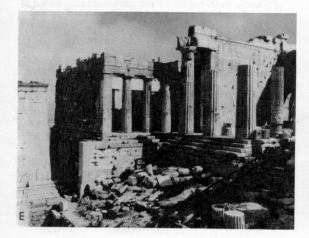

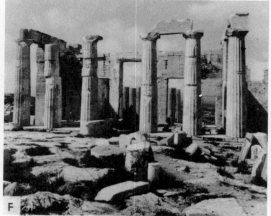

A. The Erechtheum, Athens. S. side. 420–409 B.C., and later. (See 34 C.) (Clarence Kennedy)

B. Temple of Athena Nike, Athens. E. façade. c. 426 B.C.

C. Temple of Athena Nike, Athens. Corner capital.

D. Frieze from the Erechtheum with Honeysuckle, Egg and

Dart, Bead and Reel, Leaf and Dart motifs. Acropolis Museum. (Al)

E. The Propylaea, Athens. W. side. Mnesicles, architect. Begun c. 437 B.C. (Al)

F. The Propylaea, Athens. E. side. (Al)

# GREEK ARCHITECTURE · GOLDEN AGE · 470–338 B.C.
## HELLENISTIC PERIOD · 323–146 B.C.

21

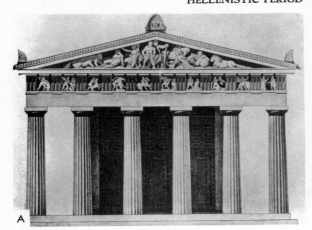

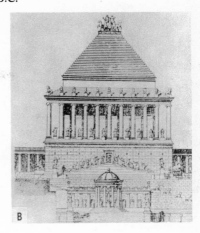

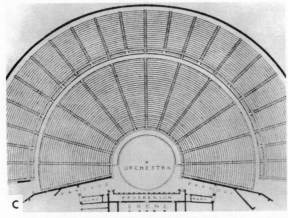

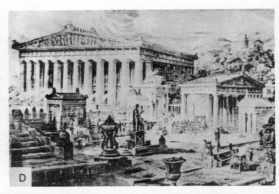

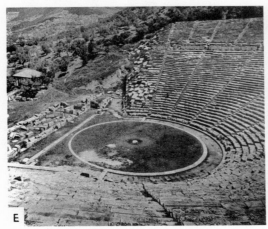

A. The Theseum, Athens. E. façade. Restored. 421 B.C. (André)

B. The Mausoleum, Halicarnassus. Conjectural restoration. 353–340 B.C. (See 37 B.) (Bühlmann)

C. Theatre, Epidaurus. Plan. c. 350 B.C. (Dörpfeld)

D. Precinct of Demeter, Eleusis. Restored. Graeco-Roman. (Gaudy-Deering)

E. Theatre, Epidaurus. From S.W.

F. Corinthian Capital from the Tholos, Epidaurus. c. 350 B.C.

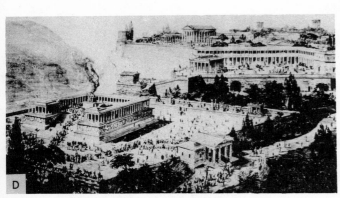

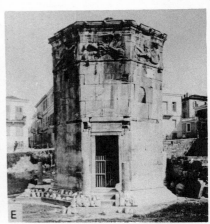

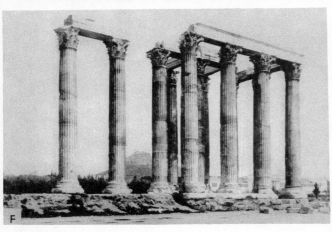

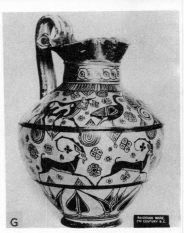

A. Choragic Monument of Lysicrates, Athens. 335–334 B.C.

B. Choragic Monument of Lysicrates, Athens. Restoration by Stuart and Revett.

C. Corinthian Order of the Choragic Monument of Lysicrates. (Stuart and Revett)

D. The Acropolis, Pergamon. Restoration by F. Thiersch, 1882.

A painting in the Pergamon Museum, Berlin. (See 39 A.)

E. Tower of the Winds, Athens. I century B.C.

F. Temple of Jupiter Olympus, Athens. Roman, 174 B.C.–117 A.D. (Al)

G. Oinochoë. Rhodian. VII century B.C. Museum of Fine Arts. (M.F.A.)

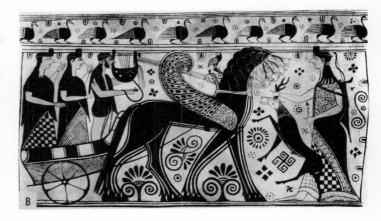

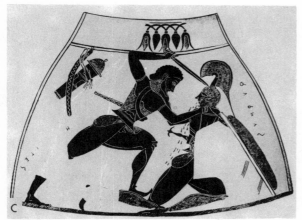

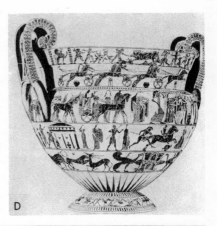

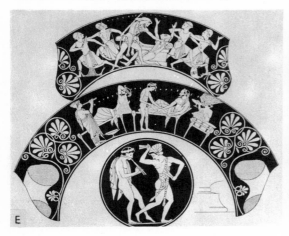

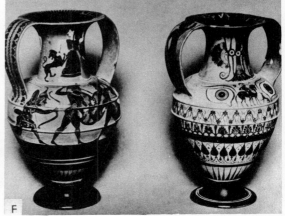

A. Geometric Amphora from the Dipylon Cemetery, Athens. VII century B.C. National Museum, Athens. (Nat. Mus.)

B. Chief Design on an Amphora from Melos. VII century B.C. National Museum, Athens. (Conze)

C. Slaying of Kyknos by Herakles. From a Chalkidian black-figured Amphora. VII century B.C. Munich. (Münch Vasens)

D. Francois Vase. Krater from Chiusi. By Klitias and Ergotimos. VI century B.C. National Museum, Florence. (Furtwängler)

E. Details of a Kylix by Epictetus. VI century B.C. British Museum. (Furtwängler)

F. Amphorae. VI century B.C. Vatican Museum. (Al)

# GREEK VASES
## VI—V CENT. B.C.

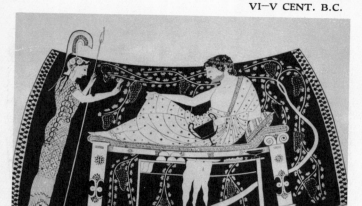

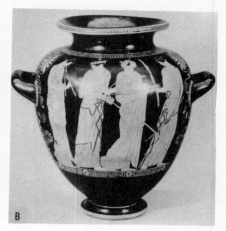

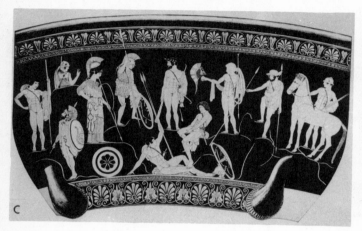

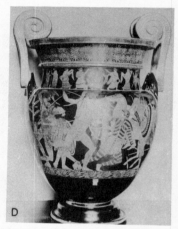

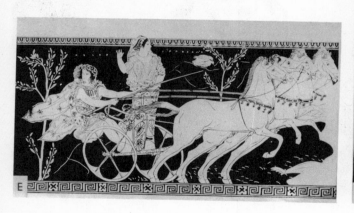

A. Athena and Herakles. From an Amphora in the style of the Andokides painter. VI century B.C. Munich. (Furtwängler)

B. Women Celebrating a Festival of Dionysus. An early Stamnos attributed to the Menelaos painter. Metropolitan Museum. (Met)

C. The Argonauts (?). Detail of a Krater of the Polygnotan Period. V century B.C. Louvre. (Furtwängler)

D. Combat of the Greeks and the Amazons. Volute-Krater. V century B.C. National Museum, Naples. (Al)

E. Pelops and Hippodameia. Detail from a red-figured Amphora. V century B.C. Museum, Arezzo. (Furtwängler)

F. Polyneikes Offers Eriphyle the Necklace. Detail from red-figured Pelike. V century B.C. Lucca. (Furtwängler)

# GREEK VASES · V–IV CENT. B.C.
# GREEK SCULPTURE · ARCHAIC PERIOD · 750–510 B.C.

25

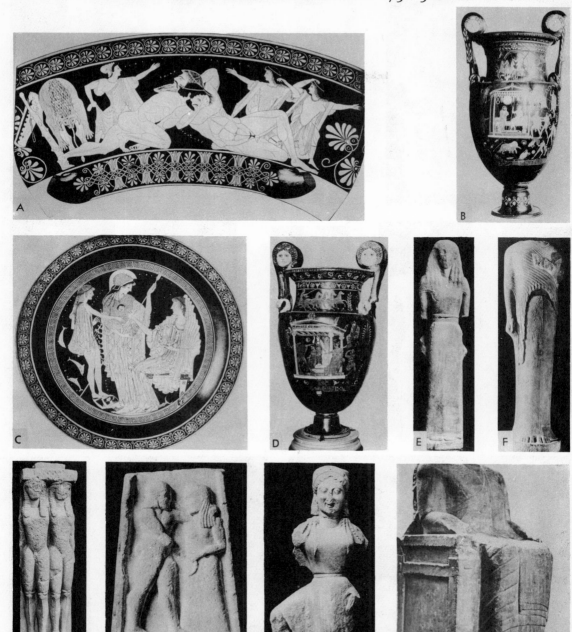

A. Herakles and Antaeus. Detail of a Kylix-Krater by Euphronius. V century B.C. Louvre. (Furtwängler)

B. Apulian Volute-Krater. Achilles and Thersites. IV century B.C. Museum of Fine Arts. (M.F.A.)

C. Theseus, Athena and Amphitrite. Kylix by Euphronius. V century B.C. Louvre. (Furtwängler)

D. Volute-Krater. Shrine of Athena. IV century B.C. National Museum, Naples. (Nat. Mus.)

E. Artemis from Delos. c. 650 B.C. National Museum, Athens. (Al)

F. Hera of Samos. c. 550 B.C. Louvre. (Gir)

G. Kitylos and Dermys. VII century B.C. National Museum, Athens. (Al)

H. Sepulchral Stele from Sparta. Berlin.

I. Winged Figure from Delos. Early VI century B.C. National Museum, Athens. (Al)

J. Seated Figure of Chares from Branchidae. VI century B.C. British Museum. (Br. Mus.)

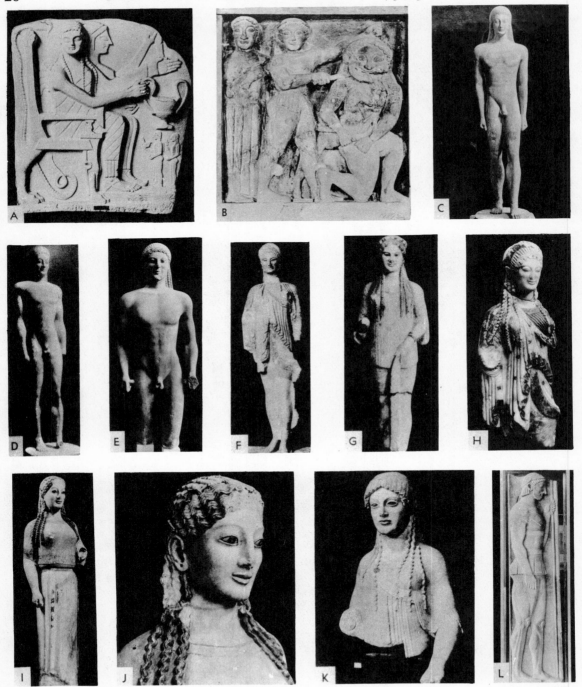

A. Spartan Stele. Mid-VI century B.C. Old Museum, Berlin. (Bruck)

B. Perseus Decapitating the Gorgon. Metope from Selinus. Early Series. Early VI century B.C. Museum, Palermo. (See 28 H.)

C. Apollo from Melos. Early VI century B.C. National Museum, Athens. (Al)

D. Apollo. VI century B.C. National Museum, Athens. (Al)

E. Apollo. Late VI century B.C. National Museum, Athens. (Al)

F. Figure found on the Acropolis. Late VI century B.C. Acropolis Museum. (Al)

G. Figure found on the Acropolis. Late VI century B.C. Acropolis Museum. (Al)

H. Figure found on the Acropolis. Late VI century B.C. Acropolis Museum. (Al)

I. Figure found on the Acropolis. Late VI century B.C. Acropolis Museum. (Al)

J. Detail of I.

K. Figure found on the Acropolis. Early V century B.C. Acropolis Museum. (Al)

L. Stele of Aristion. By Aristocles. Early VI century B.C. National Museum, Athens. (See 27 A) (Al)

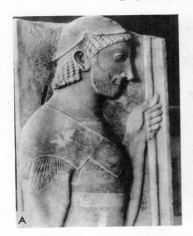

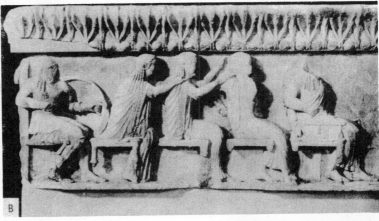

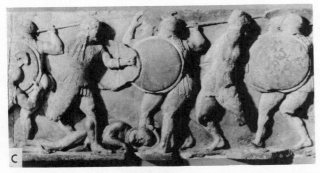

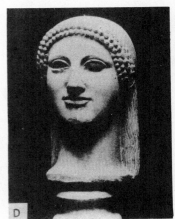

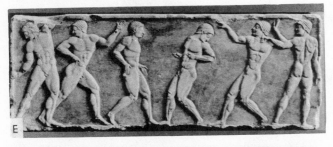

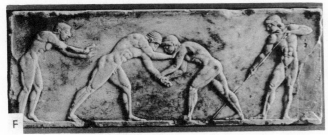

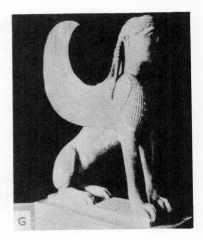

A. Stele of Aristion. (Detail of 26 L.) (Al)

B. Treasury of the Siphnians. Frieze. c. 525 B.C. Delphi Museum. (See 17 E.) (Al)

C. Treasury of the Siphnians. Frieze. Delphi Museum. (Al)

D. Archaic Head. VI century (?) B.C. Terme Museum. (Al)

E. Frieze of Six Youths Playing Ball. c. 510 B.C. National Museum, Athens. (Clarence Kennedy)

F. Palaestra Scene with Jumper, Wrestlers, Spear Thrower. Frieze. c. 510 B.C. National Museum, Athens. (Clarence Kennedy)

G. Naxian Sphinx. c. 550–540 B.C. Delphi Museum. (Al)

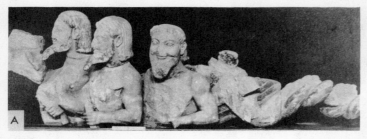

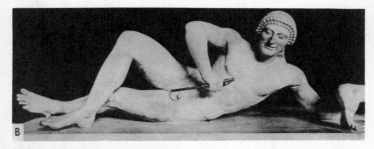

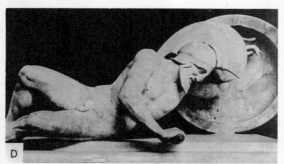

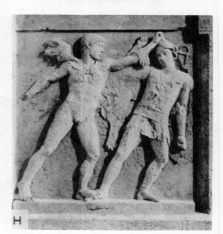

A. Fragment of a Pediment, Athens. The Typhon. Late VI century B.C. Acropolis Museum. (Bruck)

B. Wounded Warrior from W. Pediment of the Temple of Aegina. Late VI century B.C. Glyptothek, Munich. (Bruck)

C. Warrior from E. Pediment of the Temple of Aegina. Late VI century B.C. Glyptothek, Munich. (Bruck)

D. Wounded Warrior from E. Pediment of the Temple of Aegina. Late VI century B.C. Glyptothek, Munich. (Bruck)

E. Archaic Head. School of Aegina (?). VI century B.C. Archaeological Museum, Florence. (Al)

F. The Calf Bearer (Hermes Moscophorus). c. 536 B.C. Acropolis Museum.

G. Head of a Youth. Late VI century B.C. Acropolis Museum. (Al)

H. Hercules and an Amazon. Metope from Selinus. Later Series. (See 26 B.)

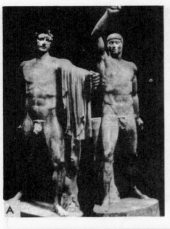

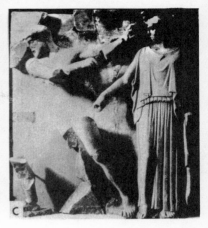

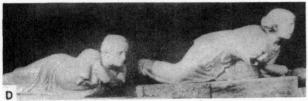

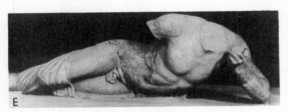
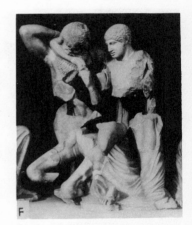

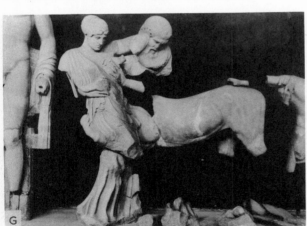
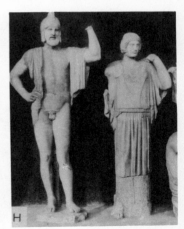

A. Harmodius and Aristogeiton. Probably by Critius and Nesiotes. 477 B.C. Copy. National Museum, Naples. (Al)

B. Harmodius. Detail of A.

C. Augeian Stable Metope. E. side. From Temple of Zeus, Olympia. Olympia Museum. c. 460 B.C. (Al)

D. Detail of W. Pediment, Temple of Zeus, Olympia. Battle of Centaurs and Lapiths. c. 460 B.C. Olympia Museum. (Al)

E. Detail of E. Pediment, Temple of Zeus, Olympia. "Alpheios." c. 460 B.C. Olympia Museum. (Al)

F. Detail of W. Pediment, Temple of Zeus, Olympia. Centaur Biting a Boy. c. 460 B.C. Olympia Museum. (Al)

G. Detail of W. Pediment, Temple of Zeus, Olympia. Centaur and Lapith Woman. c. 460 B.C. Olympia Museum. (Al)

H. Detail of E. Pediment, Temple of Zeus, Olympia. Oinomaos and Sterope. c. 460 B.C. Olympia Museum. (Al)

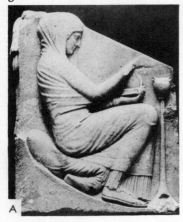

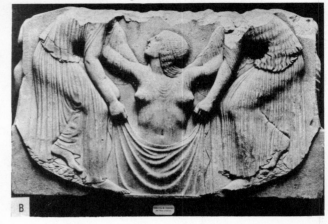

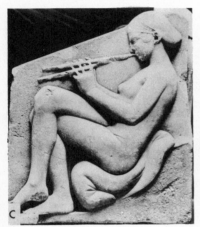

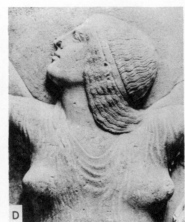

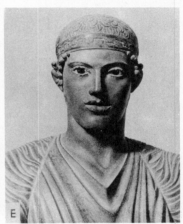

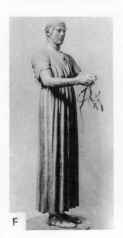

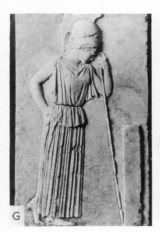

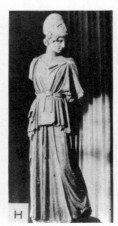

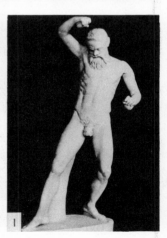

A. "Ludovisi Throne." Relief from R. side. c. 480 B.C. Terme Museum. (Al)

B. "Ludovisi Throne." The back. c. 480 B.C. Terme Museum. (Al)

C. "Ludovisi Throne." Relief from L. side. Terme Museum. (And)

D. "Aphrodite" (?). Detail of B. (Al)

E. Charioteer of Delphi. Detail of F. (Al)

F. Charioteer of Delphi. c. 470 B.C. Delphi Museum. (Al)

G. Mourning Athena. Acropolis Museum. (Al)

H. Myron. Athena, from a Roman Athena and Marsyas group. c. 450 B.C. Gallery, Frankfurt. (Frankfurt Gallery)

I. Myron. Marsyas, from a Roman Athena and Marsyas group. c. 450 B.C. Lateran Museum. (See 31 A.) (Al)

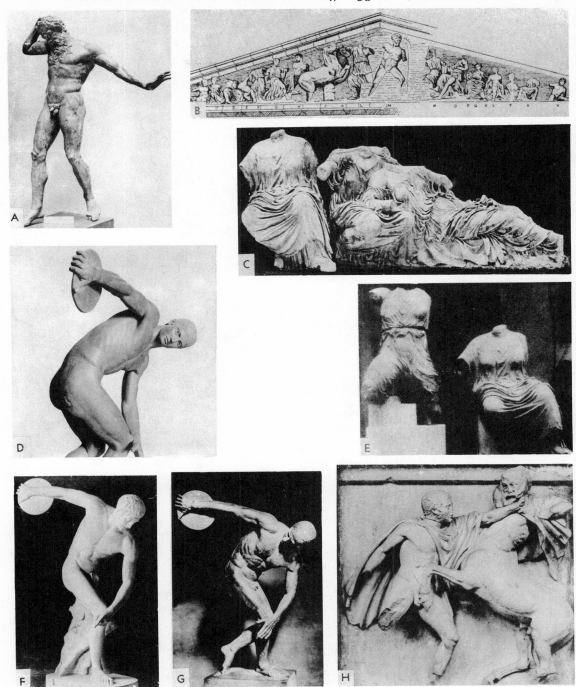

A. Myron. Marsyas. British Museum  (See 30 I.) (Br. Mus.)

B. Phidias (?). W. Pediment. The Parthenon. 447–432 B.C. After a drawing by Jacques Carrey in 1674 in the Bibliothèque Nationale, Paris. (Michaelis)

C. Phidias (?). "The Three Fates." E. Pediment. The Parthenon. 447–432 B.C. British Museum. (See p. 19.) (Br. Mus.)

D. Myron. Discobolus. Reconstruction. Terme Museum.

E. Phidias (?). Nike and a Fate. E. Pediment. The Parthenon.

F. Myron. Discobolus. Vatican Museum. (Al)

G. Myron. Discobolus. Another view of D. Terme Museum.

H. Lapith Conquering a Centaur. S. Metope, The Parthenon. 447–432 B.C. British Museum. (See pp. 19, 32.) (Br. Mus.)

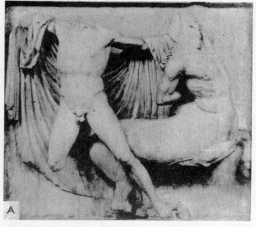

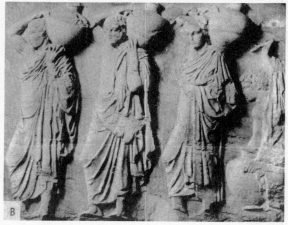

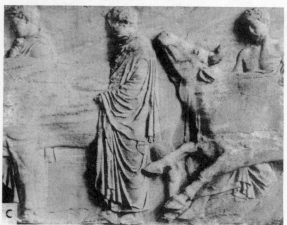

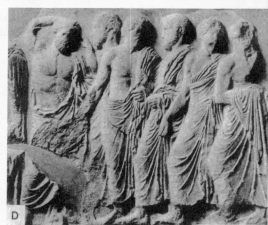

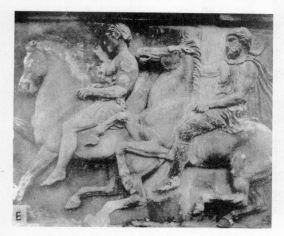

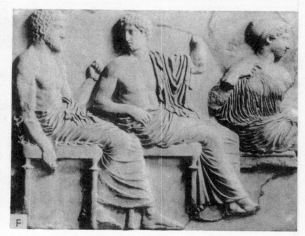

A. Lapith and Centaur. S. Metope, The Parthenon. 447–432 B.C. British Museum. (See 19 D.) (Br. Mus.)

B. Youths Bearing Wine Jars. Parthenon frieze. N. side. Acropolis Museum. (Al)

C. Bulls Being Led to Sacrifice. Parthenon frieze. N. side. Acropolis Museum. (Al)

D. Group of Men. Parthenon frieze. N. side. Acropolis Museum. (Al)

E. Horsemen. Parthenon frieze. W. side. Acropolis Museum. (Al)

F. Poseidon, Dionysus, Demeter (?). Parthenon frieze. E. side. Acropolis Museum. (Al)

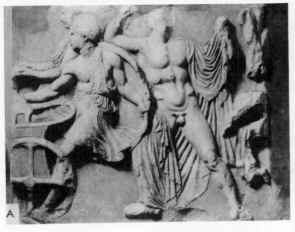

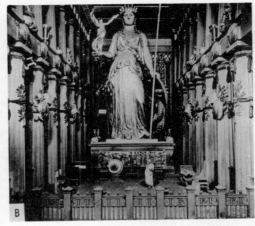

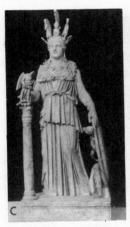

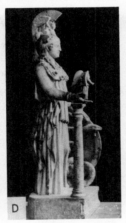

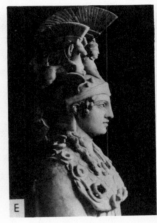

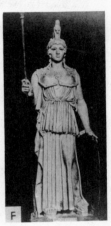

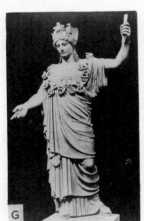

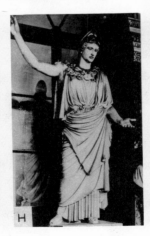

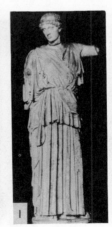

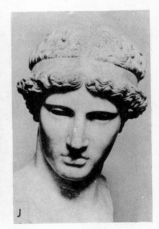

A. Parthenon Frieze. N. side. Acropolis Museum. (Al)

B. Parthenon Naos. Restored. (Met)

C. Phidias' Influence. The Varvakeion Athena. A Roman copy. National Museum, Athens. (Al)

D. Phidias' Influence. Side view of C.

E. Phidias' Influence. Detail of D.

F. Phidias' Influence. Roman copy of Athena Parthenos. Prado.

G. Phidias' Influence. Athena Farnese. National Museum, Naples. (Brogi)

H. Phidias' Influence. The Velletri Athena. Roman copy. Louvre. (Louvre)

I. Phidias (?) Athena Lemnia. Albertinum.

J. Phidias (?) Athena Lemnia Head. Civic Museum, Bologna. (Clarence Kennedy)

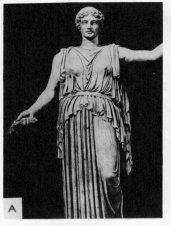

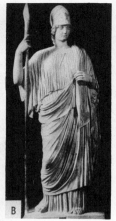

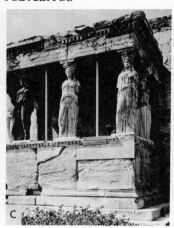

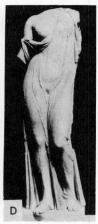

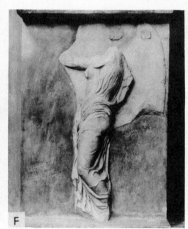

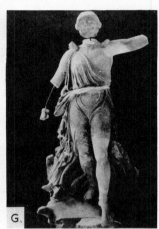

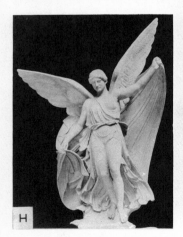

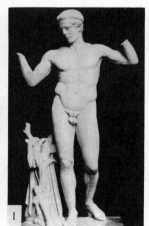

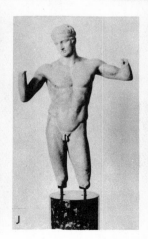

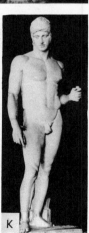

A. Demeter. Vatican Museum. (Bruck)

B. Athena. Capitoline Museum, Rome. Late V century B.C.

C. Caryatid Porch. Erechtheum, Athens. 420–409 B.C. (See 20 A.)

D. Venus Genetrix. Probably after Arkesilaos. Terme Museum. (Al)

E. Nike Fastening Her Sandal. From the balustrade of the Temple of Athena Nike. 421–415 B.C. Acropolis Museum.

F. Figure from the balustrade of the Temple of Athena Nike. 421–415 B.C. Acropolis Museum. (Al)

G. Paionius. Nike. Olympia Museum. (Bruck)

H. Paionius. Nike. Restored. Olympia Museum. (Olympia Mus.)

I. Polyclitus. Diadoumenos. Roman copy. National Museum (Al)

J. Polyclitus. Diadoumenos. Copy. Metropolitan Museum. (Met)

K. Polyclitus. Copy of Spearbearer (Borghese Mars). Louvre. (Louvre)

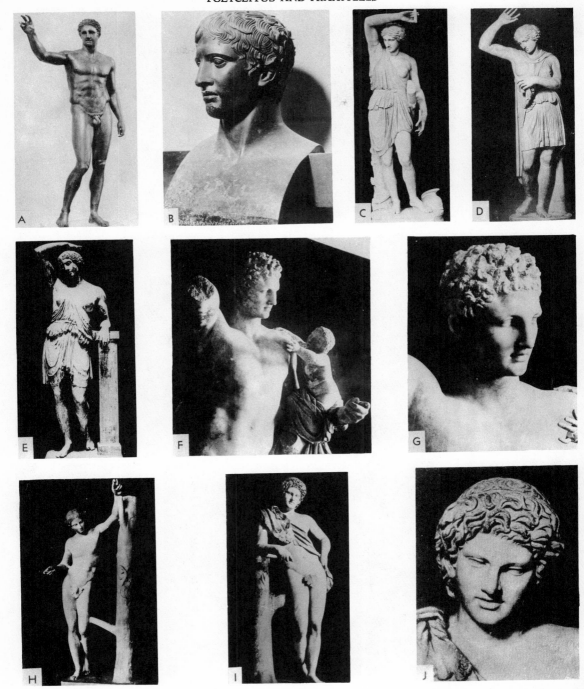

A. Polyclitus, School of. Youth. National Museum. Athens. (Al)

B. Polyclitus, School of. Doryphorus Bust. National Museum, Naples.

C. Polyclitus, School of. Amazon, Mattei type. Vatican Museum. (Al)

D. Polyclitus, School of. Amazon, Capitoline type. Capitoline Museum. (Bruck)

E. Polyclitus, School of. Amazon. Berlin Museum.

F. Praxiteles. Hermes with the Infant Dionysus. c. 350 B.C. Olympia Museum.

G. Praxiteles. Hermes. Detail of F. (Olympia Museum)

H. Praxiteles. Copy. "Apollo" Sauroctonos. 370–340 B.C. Vatican Museum. (Traldi)

I. Praxiteles. Copy. Satyr (Marble Faun). Capitoline Museum. (Traldi)

J. Praxiteles. Copy. Satyr. Detail of I.

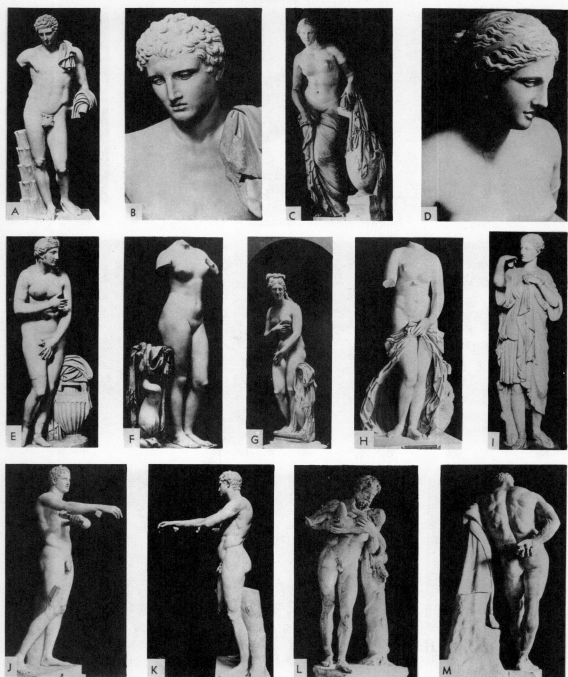

A. Praxiteles' Influence. Hermes of Andros. Vatican Museum. (Al)

B. Hermes of Andros. Detail of A.

C. Praxiteles. Copy. Venus of Cnidos. Vatican Museum.

D. Venus of Cnidos. Detail of C. (Al)

E. Praxiteles' Influence. Aphrodite Anadyomene. National Museum, Naples. (Al)

F. Praxiteles' Influence. Aphrodite of Cyrene. I century B.C. Copy. Terme Museum. (Al)

G. Praxiteles' Influence. Capitoline Venus. Capitoline Museum.

H. Aphrodite of Syracuse. Syracuse Museum. (Al)

I. Praxiteles' Influence. Artemis of Gabii. Louvre. (Louvre)

J. Lysippus. Copy. Apoxyomenos. Vatican. (Al)

K. Lysippus. Copy. Apoxvomenos. Other side of J.

L. Lysippus' Influence. Silenus and Bacchus. Louvre. (Louvre)

M. Glycon, after Lysippus. Farnese Hercules. I century B.C. National Museum, Naples (Al)

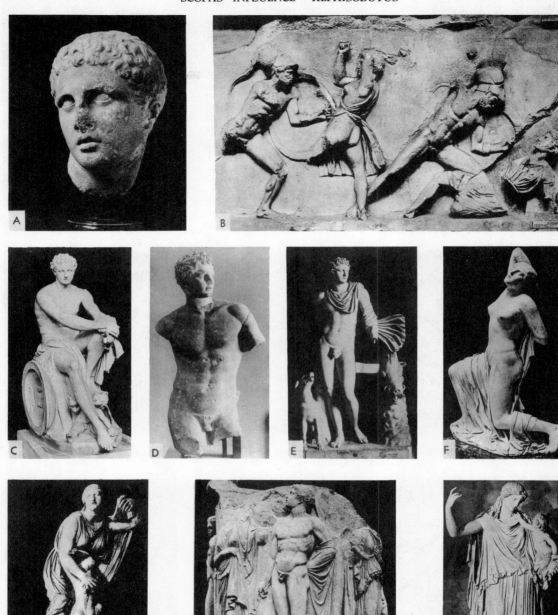

A. **Head of a Youth.** Scopas' Influence. Museum of Fine Arts. (M.F.A.)

B. **Battle of the Greeks and the Amazons.** Frieze of the Mausoleum, Halicarnassus. c. 350 B.C. British Museum. (See 21 B.) (Br. Mus.)

C. **Ares Ludovisi.** Scopas' Influence. Terme Museum. (Grafia)

D. **Meleager.** Scopas' Influence. Fogg Museum. (Fogg)

E. **Meleager.** Vatican Museum. (Traldi)

F. **Niobid.** Terme Museum. (Grafia)

G. **Niobe and Her Youngest Daughter.** Uffizi.

H. **Drum from Ephesus.** British Museum. (Br. Mus.)

I. **Kephisodotus.** Eirene and Ploutos. Copy. Glyptothek. (Bruck)

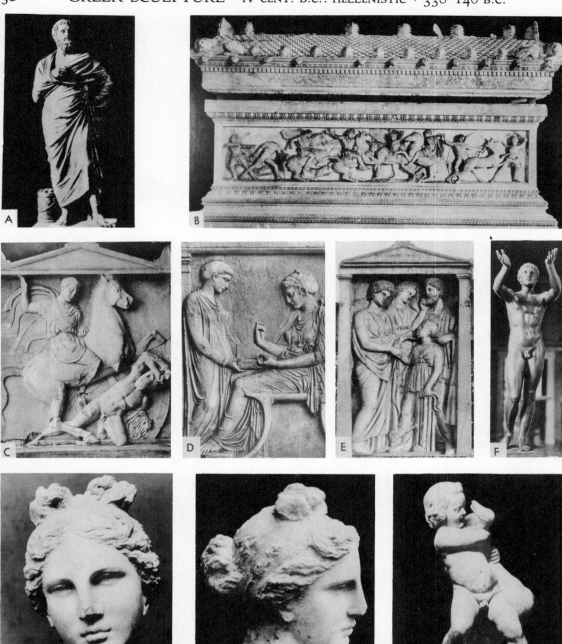

A. Sophocles. IV century B.C. Lateran Museum. (Traldi)

B. "Alexander Sarcophagus." IV century B.C. Museum, Constantinople. (Constant. Mus.)

C. Grave Relief of Dexileos. Ceramicus, Athens. (Bruck)

D. Grave Relief of Hegeso. Detail. Ceramicus, Athens. (Bruck)

E. Grave Relief of Protonoe. Ceramicus, Athens. (Al)

F. Praying Boy. Influence of Lysippus (?). Old Museum, Berlin. (Berlin)

G. Head of Aphrodite. IV century B.C. Francis Bartlett Collection, Museum of Fine Arts. (M.F.A.)

H. Head of Aphrodite. Side view of G.

I. Boy With a Goose. Bœthos. Capitoline Museum.

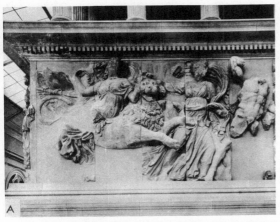

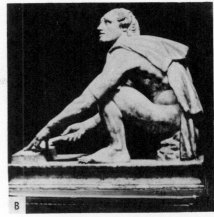

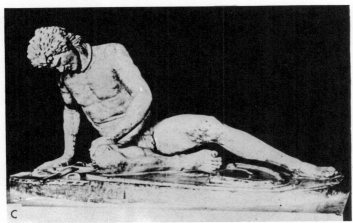

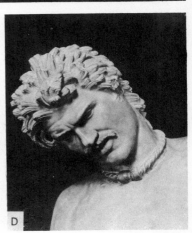

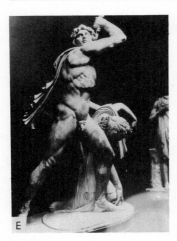

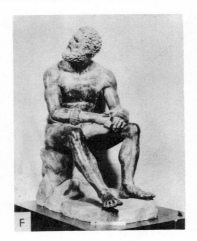

A. Frieze from the Altar of Zeus, Pergamon. c. 175 B.C. Pergamon Museum, Berlin. (See 22 D.)

B. Slave Sharpening Knife. Pergamon School. Uffizi. (Al)

C. Dying Gaul. Pergamon School. Capitoline Museum.

D. Dying Gaul. Detail of C.

E. Gaul and His Wife. Pergamon School. Terme Museum. (Al)

F. Boxer. By Apollonius. I century B.C. Terme Museum.

G. Muse Leaning Against a Rock. Berlin. (Bruck)

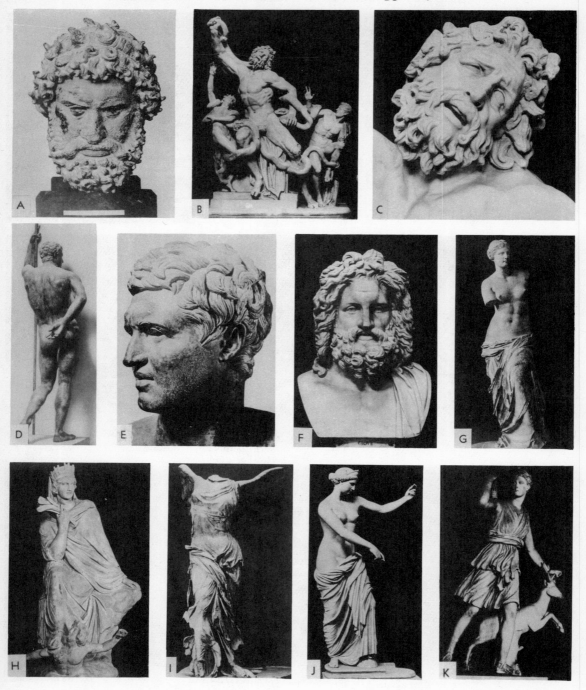

A. Pugilist. National Museum, Athens. (Bruck)

B. Laocoön. School of Rhodes. Vatican Museum.

C. Laocoön. Detail of B. (And)

D. "The Hellenistic Ruler." National Museum, Rome. (Al)

E. "The Hellenistic Ruler." Detail of D.

F. Zeus Otricoli. II century B.C. Vatican Museum. (Grafia)

G. Aphrodite of Melos. II century B.C. Louvre. (Louvre)

H. Tyche of Antiocheia. Vatican Museum.

I. Nike of Samothrace. After 306 B.C. Louvre. (Louvre)

J. Aphrodite of Capua. National Museum, Naples. (Al)

K. Artemis of Versailles. Louvre. (Louvre)

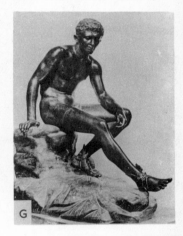

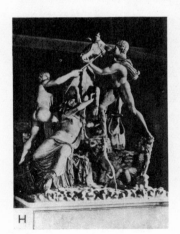
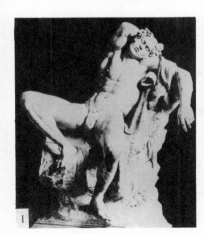
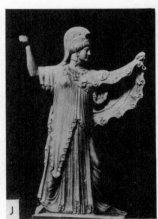

A. Apollo Belvedere. Vatican Museum. (Grafia)

B. Old Fisherman. Capitoline Museum.

C. Tanagra Figurine. IV century B.C. Museum of Fine Arts. (M.F.A.)

D. Old Market Woman. II century B.C. Metropolitan Museum. (Met)

E. Orestes and Electra. Pasiteles' Influence. I century B.C. National Museum, Naples.

F. Demosthenes. Vatican Museum. (And)

G. Hermes (Mercury) in Repose. National Museum, Naples. (Al)

H. Farnese Bull. School of Tralles. I century B.C. National Museum, Naples. (Al)

I. Sleeping Satyr (Barberini Faun). Glyptothek. (Bruck)

J. Archaistic Athena. National Museum, Naples. (Al)

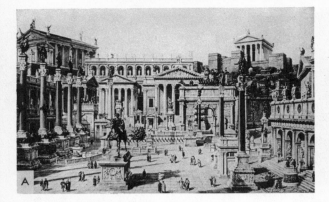

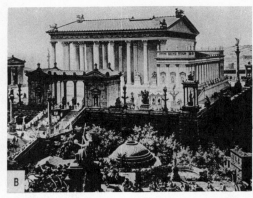

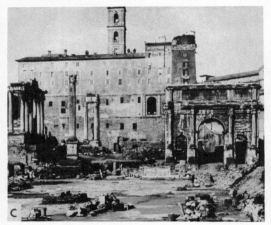

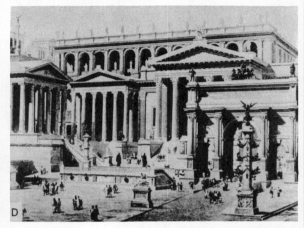

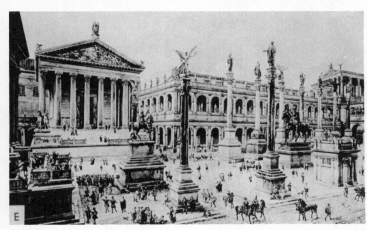

**A. Forum Romanum during the Imperial Period. Restored.**
From S.E. (L. to R.) Basilica Julia, 51 B.C. (behind columns);
Temple of Jupiter Capitolinus, begun 509 B.C. (above); Temple
of Saturn, 284 A.D. (facing R.); Temple of Vespasian, 94 A.D.;
Temple of Concord, 27 B.C.–14 A.D.; Tabularium, 78 B.C.
(with arch order); Arch of Septimius Severus, 204 A.D.;
Temple of Juno Moneta, 146 B.C. (above R.); Basilica Aemilia,
54 B.C. (Tognetti)

**B. Temple of Jupiter Capitolinus during the Imperial Period.**
Restored. (Tognetti)

**C. Forum Romanum.** From S.E. (L. to R.) Temple of Vespasian; Temple of Concord; Tabularium (above); Arch of
Septimius Severus. (Al)

**D. Forum Romanum during the Imperial Period. Restored.**
Detail of A. (Tognetti)

**E. Forum Romanum during the Imperial Period. Restored.**
From E. (L. to R.) Temple of Divus Julius, 42–29 B.C.;
Temple of Castor and Pollux, 6 A.D.; Basilica Julia; Temple
of Jupiter Capitolinus (above R.). (Tognetti)

**F. Temple of Vespasian. Forum Romanum. Fragment of cornice. 94 A.D.**

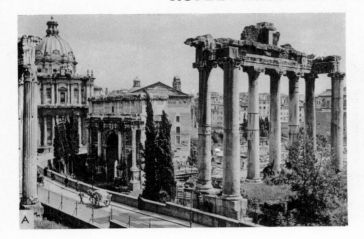

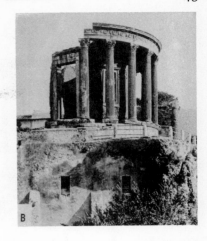

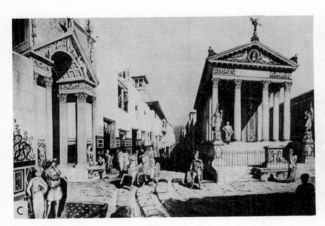

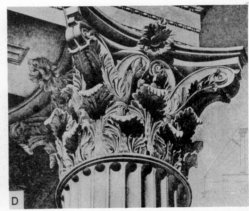

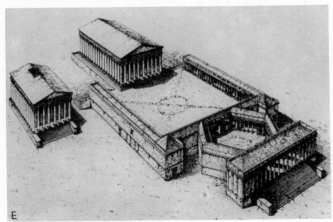

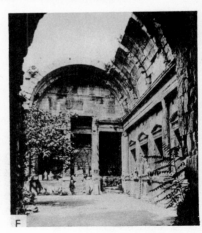

A. Forum Romanum. From W. (L. to R.) Temple of Vespasian; Arch of Septimius Severus; Temple of Saturn.

B. Temple of the Sibyl, Tivoli. 27 B.C.-14 A.D. (And)

C. Temple of Fortuna Augusta, Pompeii. Restored. I century A.D. (Tognetti)

D. Temple of Mars Ultor, Rome. Restoration of Corinthian capital. (D'Espouy)

E. Baalbek. Reconstruction. R., Temple of the Sun, 131–161 A.D.; Temple of Jupiter, 273 A.D.

F. Baths (Temple) of Diana, Nimes. 25 B.C.

# ROMAN ARCHITECTURE
## TEMPLES · BATHS

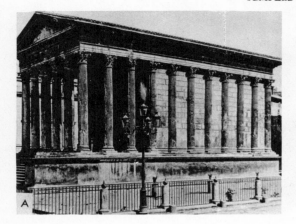

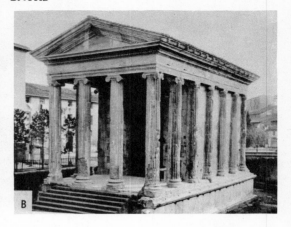

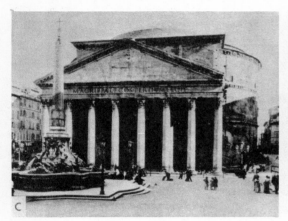

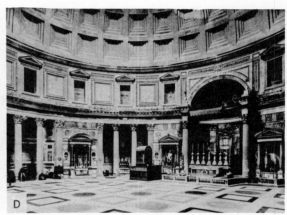

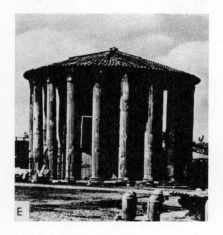

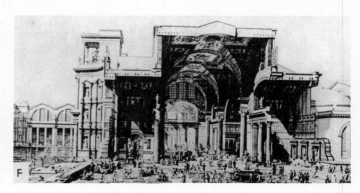

A. Maison Carrée, Nîmes. I or II century A.D. (N.D.)

B. Temple of Fortuna Virilis, Rome. I century B.C. (Al)

C. The Pantheon, Rome. 120–124 A.D. Portico, 27 B.C.–14 A.D. (Al)

D. The Pantheon, Rome. Interior. (Brogi)

E. Round Temple Near the Tiber, Rome. I century A.D.

F. Baths of Diocletian, Rome. Restored. 302 A.D. (Paulin)

### BASILICAS · CIRCUSES · HOUSES · AMPHITHEATRES

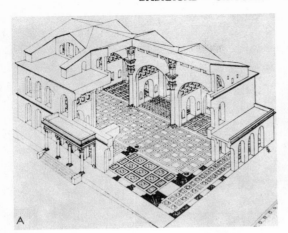

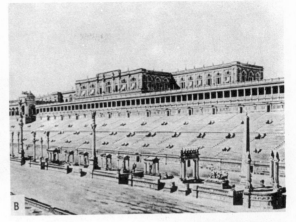

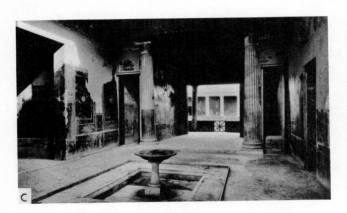

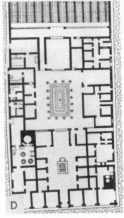

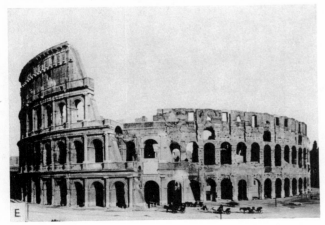

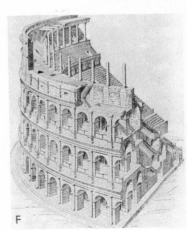

A. Basilica of Maxentius (Constantine), Rome. 306–12 A.D.

B. Circus Maximus during the Imperial Period, Rome. I century B.C.

C. House of Menandro, Pompeii. The Atrium. I century A.D.

D. House of Pansa, Pompeii. Plan. I century B.C.

E. The Colosseum (Flavian Amphitheatre), Rome. 70–82 A.D.

F. The Colosseum. Isometric section.

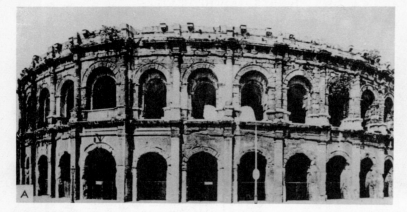

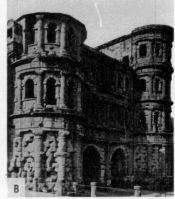

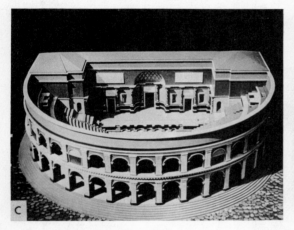

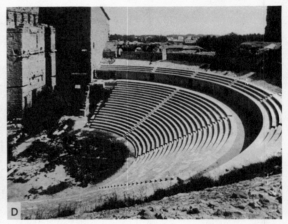

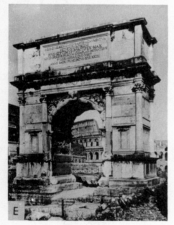

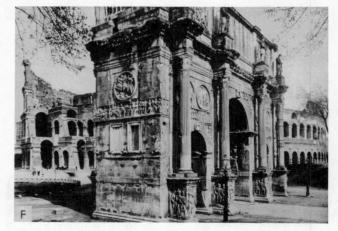

A. Amphitheatre, Nîmes. I–II century A.D. (L.N.)

B. Porta Nigra, Trèves. 275 A.D.

C. The Little Theatre, Herculaneum. Restored. I century A.D.

D. The Theatre, Orange. (N.D.)

E. Arch of Titus, Rome. 81 A.D. (See 48 G, 49 B.) (Grafia)

F. Arch of Constantine, Rome. Re-erected, 312 A.D. (See 49 F.) (And)

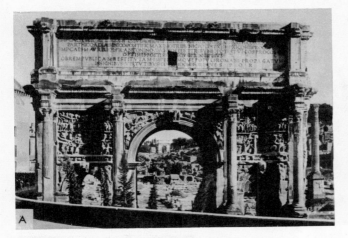

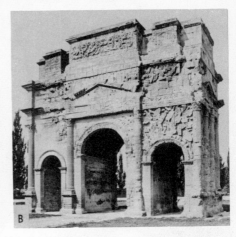

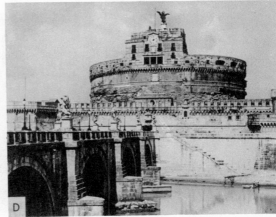

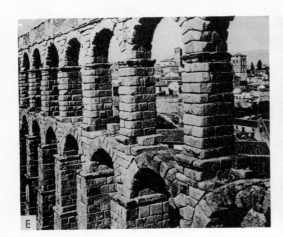

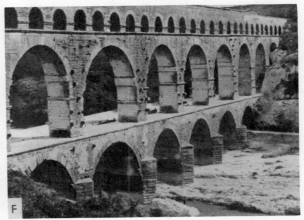

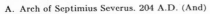

A. Arch of Septimius Severus. 204 A.D. (And)

B. Arch at Orange. 27 B.C.–14 A.D. (N.D.)

C. Columbaria. The Appian Way, Rome. (Al)

D. Tomb of Hadrian (Castel S. Angelo), Rome. 135 A.D. (Grafia)

E. Aqueduct, Segovia. I–II century A.D.

F. Pont du Gard, Nîmes. 27 B.C.–14 A.D.

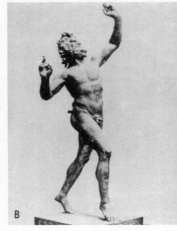

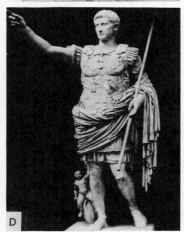

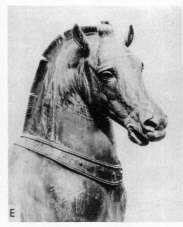

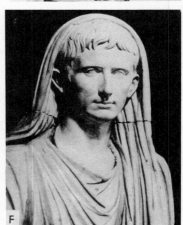

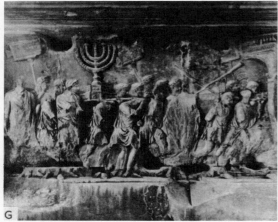

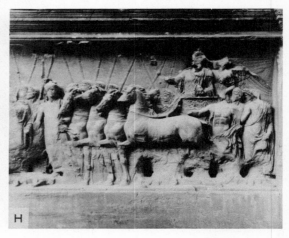

A. Apollo. Found at Pompeii. National Museum, Naples. (Al)

B. Dancing Faun from the House of the Faun, Pompeii. I century B.C. (?). National Museum, Naples.

C. Boy With a Dolphin. Found at Pompeii. National Museum, Naples. (Al)

D. Caesar Augustus. From the Prima Porta. 27 B.C.—14 A.D. Vatican Museum. (Al)

E. Horse of St. Mark's, Venice. Detail of head. (c. 480 B.C. (?).) Once on Arch of Nero, Rome. (See 56 E.)

F. Augustus from the Via Labicana. 27 B.C.—14 A.D. Terme Museum. (Al)

G. Spoils of Jerusalem. Arch of Titus, Rome. 81 A.D. (See 46 E, 49 B.)

H. Triumphal Procession. Arch of Titus, Rome. 81 A.D.

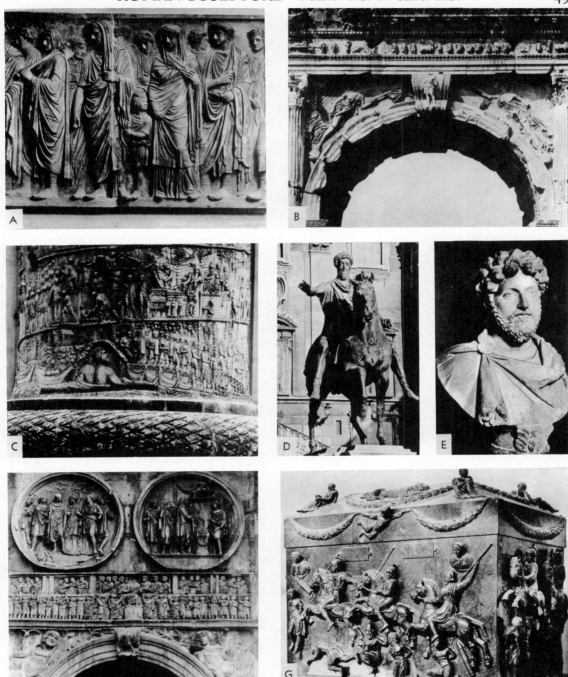

A. Ara Pacis. Procession. 13 B.C. Uffizi. (See 50 D.) (Al)

B. Arch of Titus, Rome. Spandrels. 81 A.D. (See 46 E, 48 G.)

C. Column of Trajan, Rome. Detail of lower drums. 113 A.D.

D. Equestrian Statue of Marcus Aurelius (161–180 A.D.). Campidoglio, Rome. (See 103 A.)

E. Marcus Aurelius. British Museum. (Br. Mus.)

F. Medallions. N. side, Arch of Constantine, Rome. Rededicated 312 A.D. (See 46 F.) (Al)

G. Sarcophagus of St. Helena. IV century A.D. Vatican Museum. (Grafia)

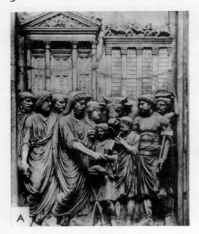

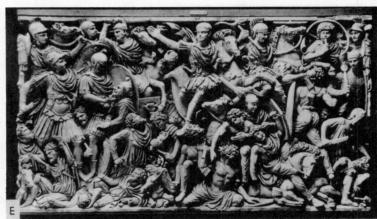

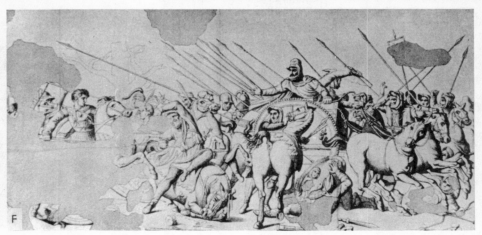

A. Sacrifice of Marcus Aurelius (161–180 A.D.). Capitoline Museum. (Al)

B. Caracalla. 211–17 A.D. Berlin. (Berlin Museum)

C. The Portland Vase. Probably I century A.D. British Museum. (Br. Mus.)

D. Ara Pacis. Detail of decoration. 13 B.C. Uffizi. (See 49 A.) (Al)

E. Battle Between Romans and Barbarians. Sarcophagus. IV century A.D. Terme Museum.

F. The Battle of Issus, Between Darius and Alexander. c. 100 B.C. From a IV century B.C. original. Mosaic from House of the Faun, Pompeii. National Museum, Naples. (See 51 A.)

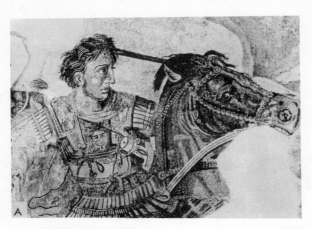

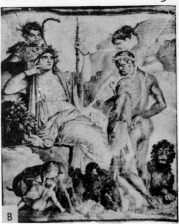

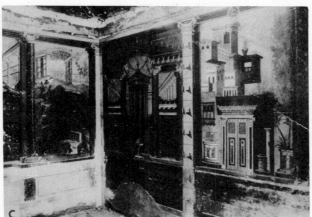

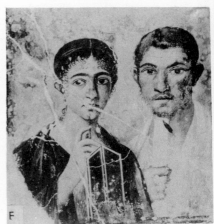

A. Battle of Issus. Detail of Alexander. Mosaic. (See 50 F.)

B. Hercules Discovers His Son Telephos. Painting. From Pompeii. National Museum, Naples.

C. Wall Paintings from Boscoreale. (Met)

D. Putto (Cupid) Riding a Crab. Painting from the House of the Vetii, Pompeii. National Museum, Naples.

E. Pirithous Rescuing Ippotamia from the Centaur. Painting on marble from Herculaneum. V century B.C. type. National Museum, Naples.

F. Portrait of Paquius Proculus and Wife. National Museum, Naples. (See 52 A.) (Al)

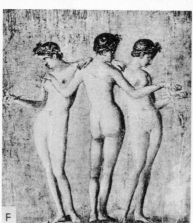

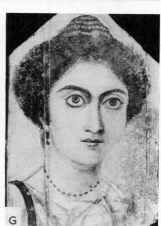

A. Wife of Paquius Proculus. Detail of 51 F.

B. The Aldobrandini Marriage. Painting. I century A.D. Detail. Vatican Museum. (Al)

C. The Aldobrandini Marriage. Detail of B.

D. Doves. Mosaic. From the Villa of Hadrian. II century A.D. Capitoline Museum.

E. Hercules with the Serpents. Painting. House of the Vetii, Pompeii. I century A.D.

F. Three Graces. Painting from Pompeii. National Museum, Naples. (Al)

G. Portrait of a Young Woman. Egyptian painting. III century A.D. Archaeological Museum, Florence. (Al)

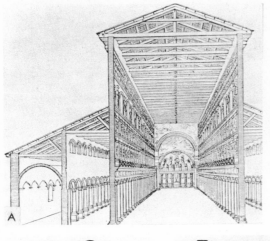

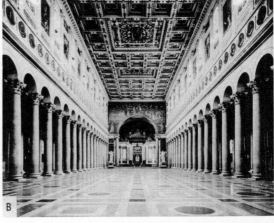

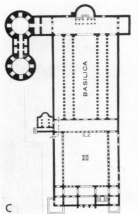

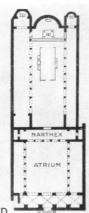

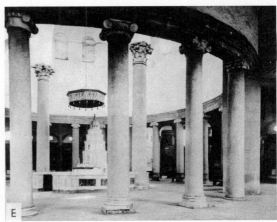

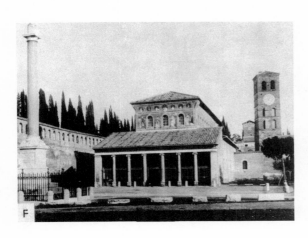

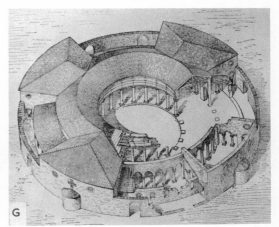

A. Section of the Old Basilica of St. Peter, Rome. Consecrated 326 A.D. Destroyed XV century. (See 139 C for façade.) (Fontana)

B. St. Paul's Outside the Walls, Rome. Founded 386 A.D. Rebuilt 1823. (See 64 C.) (And)

C. Old St. Peter's, Rome. Plan. 326 A.D. (See A.)

D. Basilica of San Clemente, Rome. Plan. 385 A.D. Rebuilt 1108.

E. S. Stefano Rotondo, Rome. Interior. 470 A.D. (See G.) (Al)

F. Basilica of San Lorenzo Outside the Walls, Rome. Façade. Rebuilt 578 A.D. Remodeled 1216–1227. (Al)

G. S. Stefano Rotondo, Rome. Restoration. 468–483 A.D.

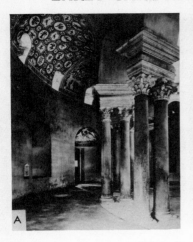

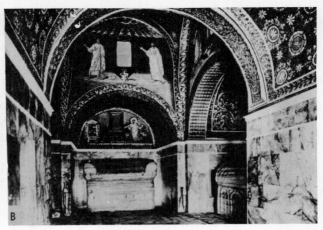

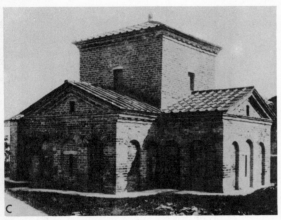

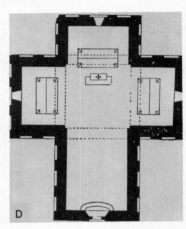

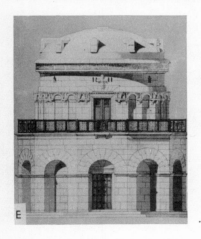

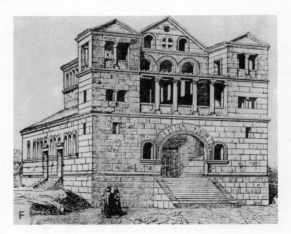

**A.** Santa Costanza, Rome. Interior. 323–37. Rebuilt 1256. (See 60 B.) (Al)

**B.** Tomb of Galla Placidia, Ravenna. Interior. c. 450 A.D. (Al)

**C.** Tomb of Galla Placidia, Ravenna. Exterior. c. 450 A.D.

**D.** Tomb of Galla Placidia, Ravenna. Plan. c. 450 A.D.

**E.** Tomb of Theodoric, Ravenna. Restored. 526 A.D. (Haupt-Hannover)

**F.** Basilica of Tourmanin, Syria. Restored. VI century A.D. (De Vogüe)

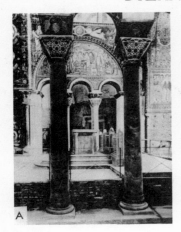

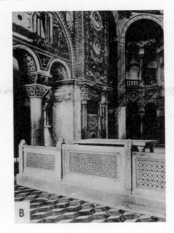

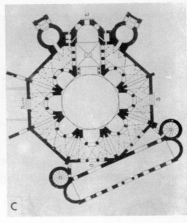

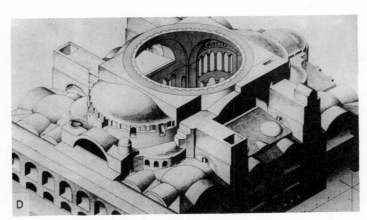

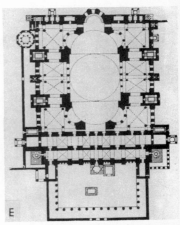

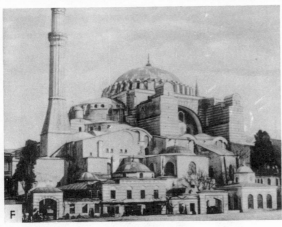

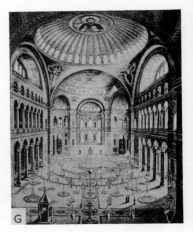

A. San Vitale, Ravenna. Interior. 526 A.D. (See 57 B, 60 E.) (Al)

B. San Vitale, Ravenna. Interior. 526 A.D. (Al)

C. San Vitale, Ravenna. Plan. (Dehio)

D. Santa Sophia, Istanbul. 532–537 A.D. Section without dome. (Choisy)

E. Santa Sophia, Istanbul. Plan.

F. Santa Sophia, Istanbul. Exterior.

G. Santa Sophia, Istanbul. Interior.

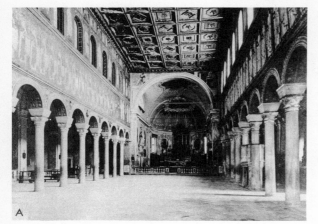

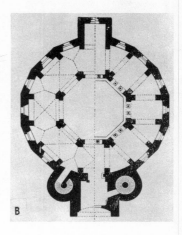

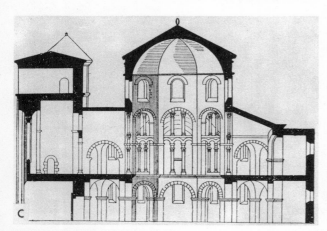

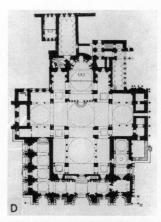

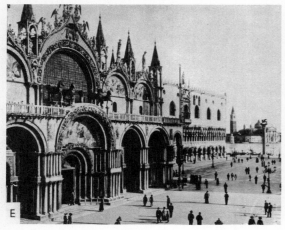

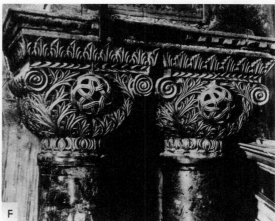

A. Sant' Apollinare Nuovo, Ravenna. The Nave. 549 A.D. (See 61 A.) (Al)

B. Chapel, Aix-la-Chapelle (Aachen). Plan. 796–804 A.D.

C. Chapel, Aix-la-Chapelle. Elevation. (See 89 A.)

D. St. Mark's, Venice. Plan. 1042–1071.

E. St. Mark's, Venice. Façade. (And)

F. St. Mark's, Venice. Capitals. (And)

# BYZANTINE ARCHITECTURE · XI CENT.
## EARLY CHRISTIAN AND BYZANTINE SCULPTURE · IV–VI CENT.

57

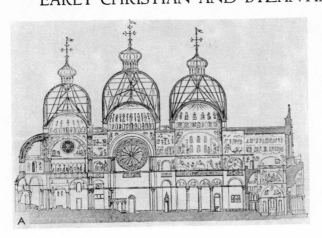

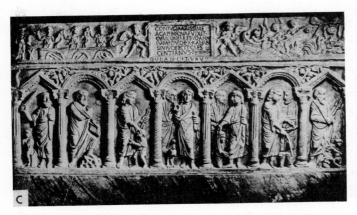

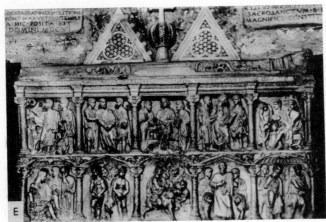

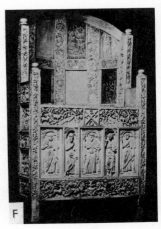

A. St. Mark's, Venice. Section. 1042–1071. (See p. 56.)

B. San Vitale. Byzantine capital. 526 A.D. (Al)

C. The Miracles of Christ. Early Christian Sarcophagus. IV century A.D. Lateran Museum.

D. The Good Shepherd. III century A.D. Lateran Museum.

E. Junius Bassus Sarcophagus. 350 A.D. St. Peter's, Rome.

F. "The Throne of Maximian." c. 550 A.D. Ravenna, Archiepiscopal Palace. (See 58 A.)

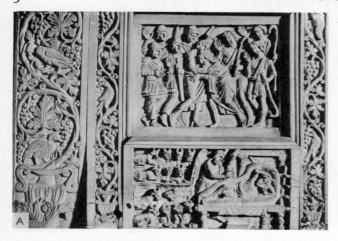

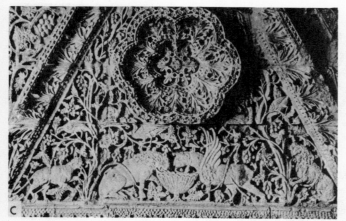

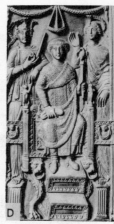

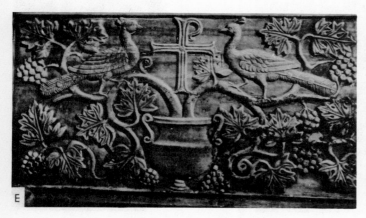

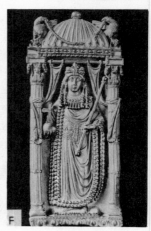

A "Throne of Maximian." Detail. c. 550 A.D. Ravenna, Archiepiscopal Palace. (See 57 F.)

B. Diptych of Consul Anastasius. 517 A.D. Bibliotheque Nationale. (Gir)

C. Mshatta Façade from Syria. IV–VI century A.D. Pergamon Museum.

D. Diptych Leaf. The Consul Magnus Seated with Symbolic Figures of Rome and Constantinople. 518 A.D. Bibliothèque Nationale. (Gir)

E. Sarcophagus Relief. Sant' Apollinare Nuovo, Ravenna. VII century A.D. (Al)

F. Empress Eudosia. VI century A.D. Bargello. (See 60 C.)

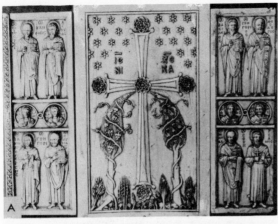

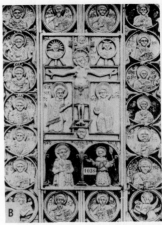

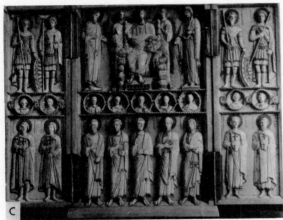

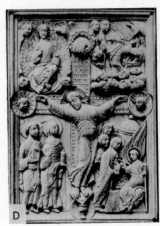

A. The Harbaville Triptych. X century A.D. Louvre.

B. Byzantine Ivory Book Cover. X century A.D. Cluny Museum. (Cluny Museum)

C. Ivory Triptych. X century A.D. Bargello.

D. French Ivory Book Cover. IX or X century A.D. Cluny Museum. (Cluny Museum)

E. Ivory. Late XI or early XII century A.D. The Visitation and the Magi Before Herod. Salerno Cathedral. (Gir)

F. Byzantine Ivory Coffer. X century A.D. The Nativity and the Presentation in the Temple. Louvre. (Louvre)

G. Virgin and Child. Byzantine Ivory. Late X century or early XI century A.D. Metropolitan Museum. (Met)

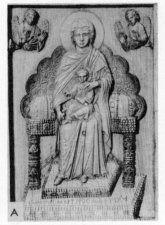

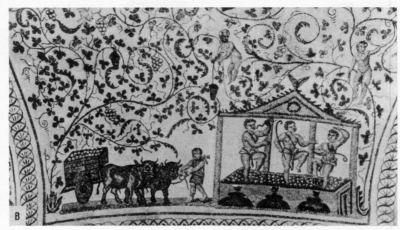

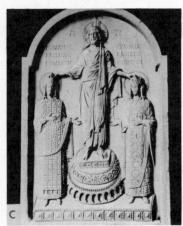

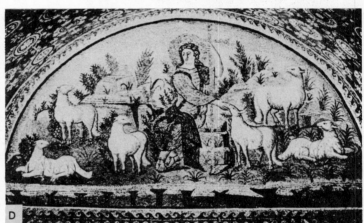

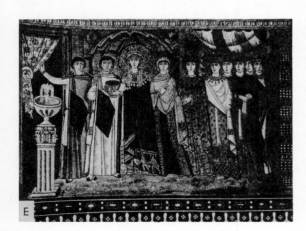

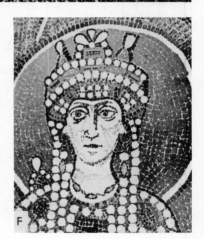

A. The Stroganoff Ivory. XI century. Cleveland Museum.
(Cleveland Mus.)

B. Making Wine. Early Christian Mosaic. IV century A.D.
Santa Costanza, Rome. (See 54 A.)

C. Christ Blessing Romanus IV, Emperor of Constantinople
and His Wife Eudosia. 1068–71 A.D. Bibliothèque Nationale.
(See 58 F.) (Gir)

D. The Good Shepherd. 440 A.D. Mausoleum of Galla Placidia,
Ravenna. (See 54 B.) (Al)

E. The Empress Theodora and Her Attendants. Mosaic, San
Vitale, Ravenna. (See 55 A, B.) (Al)

F. The Empress Theodora. Detail of E. (Al)

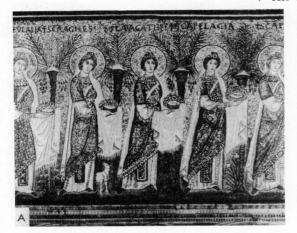

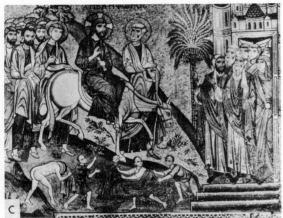

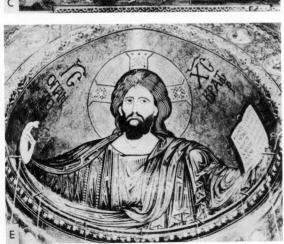

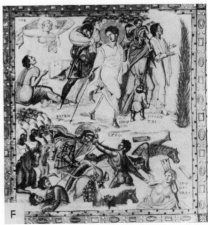

A. Sant' Apollinare Nuovo, Ravenna. Mosaic. Virgins Bearing Their Crowns as Offerings to the Virgin. VI century A.D. (See 56 A.) (Al)

B. St. Castrensis Freeing the Possessed from a Devil and Saving a Ship in Distress. Mosaic. XII century A.D. Monreale Cathedral. (Al)

C. Christ Entering Jerusalem. Mosaic. XII century A.D. Royal Chapel, Palermo. (Al)

D. Angels Appearing to Joshua Before the Walls of Jericho. Manuscript. V–VI century A.D. Vatican. (Muñoz)

E. Apse Mosaic. Monreale Cathedral. XII century A.D. (See 64 D.) (Al)

F. Crossing the Red Sea. Manuscript. X century A.D. Bibliothèque Nationale. (Gir)

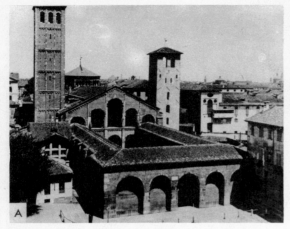

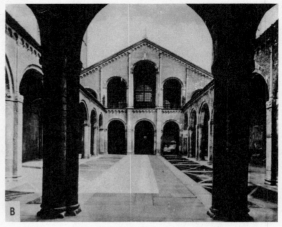

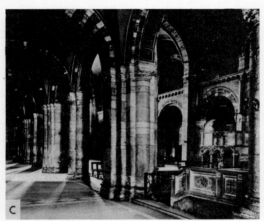

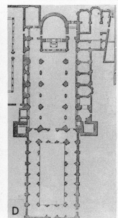

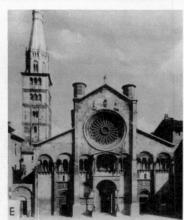

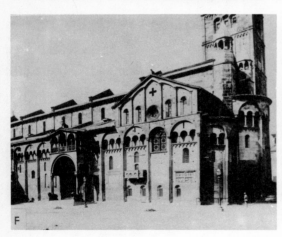

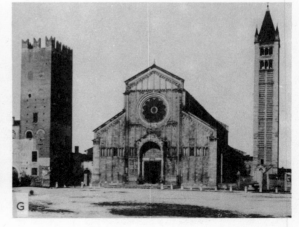

A. Sant' Ambrogio, Milan. XII century. (Al)

B. Sant' Ambrogio, Milan. The Atrium and Façade. XII century. (Al)

C. Sant' Ambrogio, Milan. Interior. XII century. (Al)

D. Sant' Ambrogio, Milan. Plan. XII century. (Ferrario)

E. Modena Cathedral. 1099–1184. (Al)

F. Modena Cathedral. 1099–1184. (Al)

G. S. Zeno Maggiore, Verona. Façade. Begun 1138.

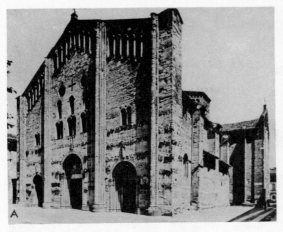

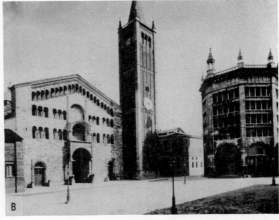

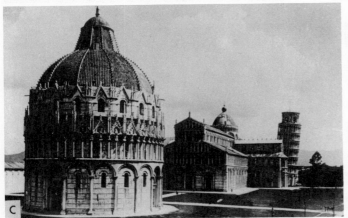

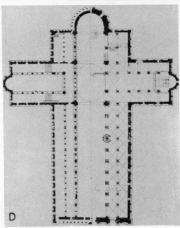

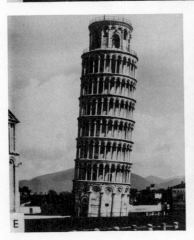

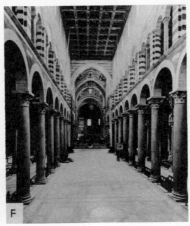

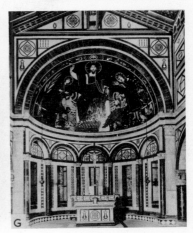

A. San Michele, Pavia. XII–XIII centuries. (And)

B. Cathedral and Baptistry, Parma. XII–XIII centuries. Baptistry, 1196. (Al)

C. Cathedral Group, Pisa. Cathedral, begun 1063; Baptistry, 1153–1278; Campanile, begun 1174.

D. Cathedral, Pisa. Plan. Begun 1063.

E. Campanile, Pisa. Begun 1174.

F. Cathedral, Pisa. Nave. Looking E. (Brogi)

G. San Miniato, Florence. Begun 1013. (See 64 A.) (Al)

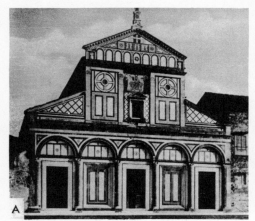

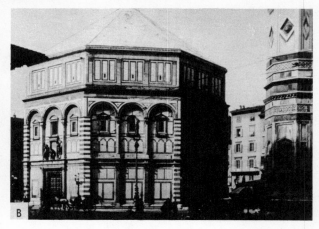

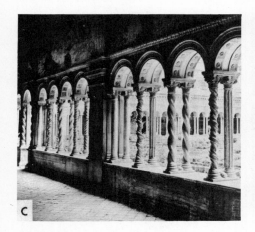

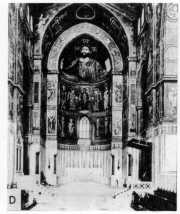

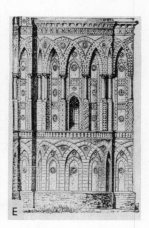

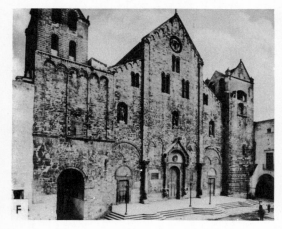

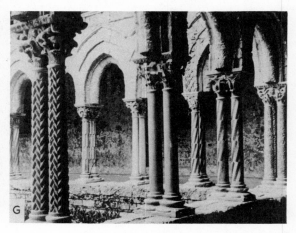

A. San Miniato, Florence. Begun 1013. (See 63 G.) (Al)

B. Baptistry, Florence. Remodeled c. 1200.

C. St. Paul's Outside the Walls, Rome. Cloister. 1220–1241. (See 53 B.) (And)

D. Monreale Cathedral. 1174–89. (See 61 E.) (Al)

E. Monreale Cathedral. Exterior of apse. 1174–89.

F. San Niccolo, Bari. 1197. (Al)

G. Monreale. Cloister of the Benedictine Monastery. (Al)

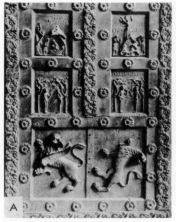

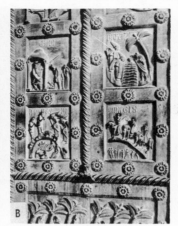

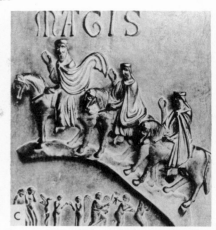

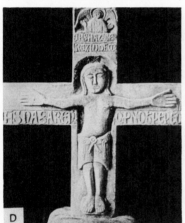

A. Bonannus of Pisa. Bronze Doors, Monreale. Detail. 1186.

B. Bonannus of Pisa. Bronze Doors, Pisa. Detail. 1180.

C. Bonannus of Pisa. Bronze Doors, Pisa. Detail of B. The Magi.

D. Christ on the Cross. Museum, Arezzo.

E. Marble Pavement. Baptistry, Florence. c. 1200. (Al)

F. Pulpit. San Miniato, Florence. XI century. (Al)

G. Pontifical Throne. San Lorenzo Fuori le Mura, Rome. XII century. (Al)

H. Pulpit. Cathedral, Ravello. XIII century. (Al)

# FRENCH ROMANESQUE ARCHITECTURE
## XI–XII CENT.

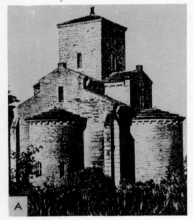

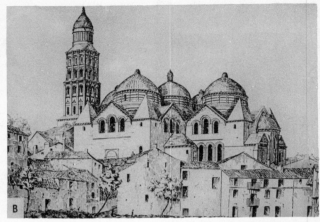

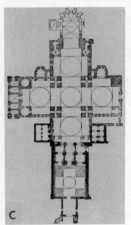

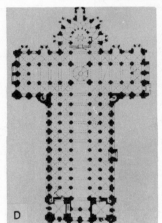

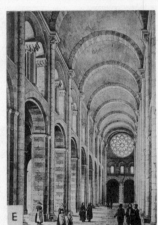

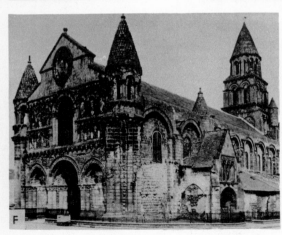

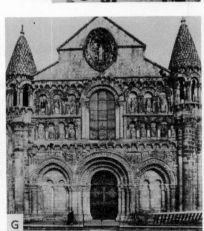

A. Germiny-les-Prés. 801–806.

B. St. Front. Périgueux. c. 1120. (Aquitaine)

C. St. Front, Périgueux. Plan.

D. St. Sernin, Toulouse. Plan. Begun 1080, continued XII–XIII centuries. (Languedoc)

E. St. Sernin, Toulouse. Restoration.

F. Notre Dame la Grande, Poitiers. XI century. (Aquitaine)

G. Notre Dame la Grande, Poitiers. Facade. XI century. (Gir)

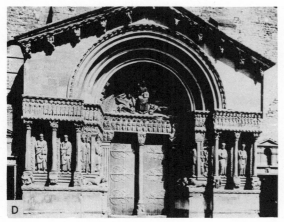

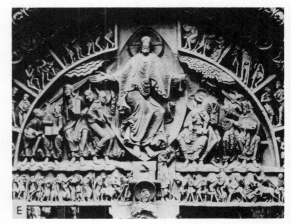

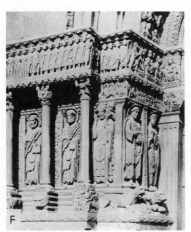

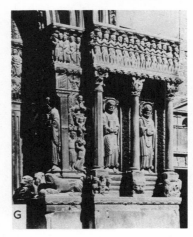

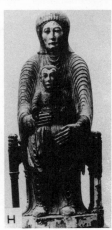

A. Angoulême Cathedral. Plan. 1105–1128. (Aquitaine)

B. Angoulême Cathedral. Façade. 1105–1128. (N.D.)

C. St. Gilles. Portico detail. Late XII century. (Provence)

D. St. Trophîme, Arles. Façade. Second half XII century. (Provence) (N.D.)

E. Abbey Church, Vézelay. Tympanum of Narthex Portal. 1132–40. (Burgundy) (See 68 B.) (Gir)

F. St. Trophîme, Arles. Detail of D. Second half XII century. (Provence) (N.D.)

G. St. Trophîme, Arles. Detail of D. Second half XII century. (N.D.)

H. French Romanesque Madonna. Metropolitan Museum. (Met)

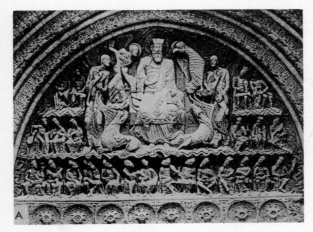

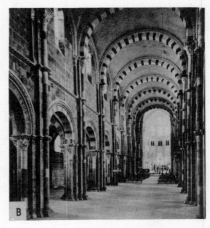

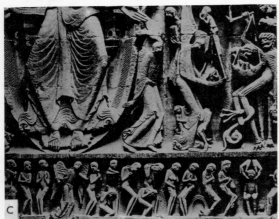

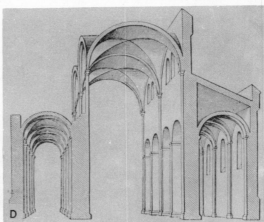

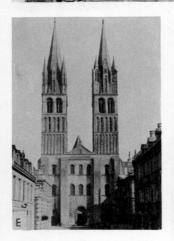

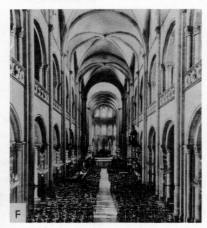

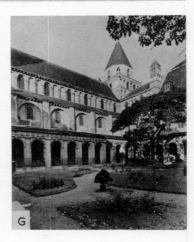

A. Moissac. Tympanum from S. Portal. c. 1100. (Languedoc)

B. Abbey Church, Vézelay. Interior. Rebuilt 1132. (Burgundy)
(See 67 E.) (Gir)

C. Autun Cathedral. Detail of Tympanum. XII century. (Burgundy)

D. Romanesque System of Vaulting.

E. St. Etienne, Caen. Façade. Begun 1064. (Normandy) (Clarence Ward)

F. St. Etienne, Caen. Interior. Vaulting, c. 1135. (See 69 A.)

G. St. Etienne, Caen. Exterior. Begun 1064. (Clarence Ward)

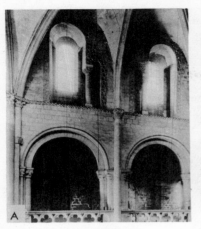
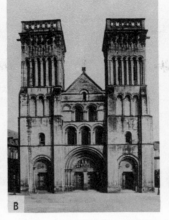
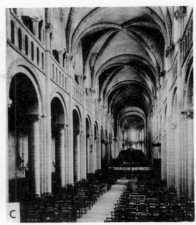

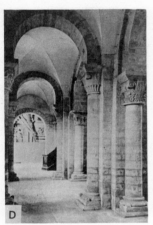
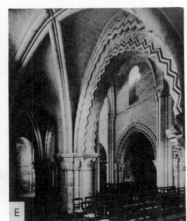
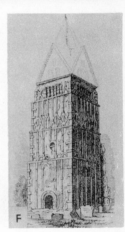

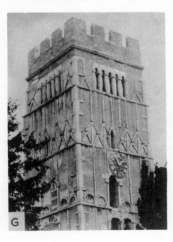
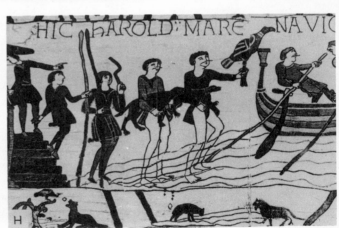

A. St. Etienne, Caen. The Gallery. c. 1135. (See 68 F.)

B. La Trinité, Caen. Begun 1062. Remodeled c. 1140. (N.D.)

C. La Trinité, Caen. Interior. Remodeled c. 1140. (N.D.)

D. Morienval. North aisle. c. 1080. (Ile de France)

E. Bury. XII century. (Clarence Ward)

F. Earl's Barton. Anglo-Saxon. Early XI century (?).

G. Earl's Barton. XI century. (Britton)

H. The Bayeux "Tapestry." Embroidery of Queen Matilda.
XI century. Bayeux Library.

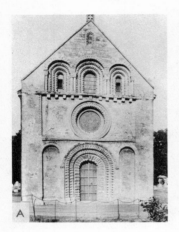

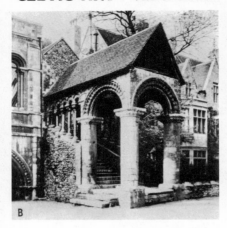

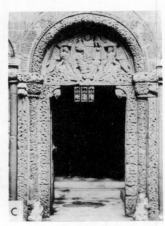

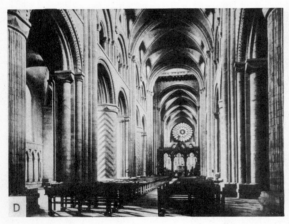

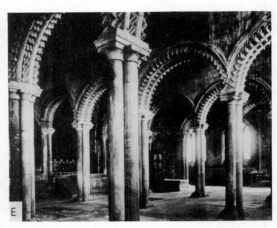

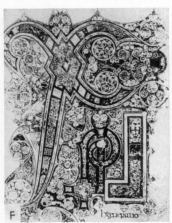

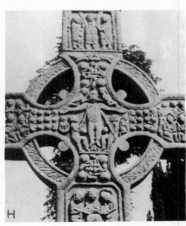

A. Iffley. Late XII century.

B. Canterbury. Exterior Stairway. XII century. (Man.)

C. Prior's Door, Ely. XII century. (Clayton)

D. Durham Cathedral, Nave. 1096–1133. (See 85 F.)

E. The Galilee, Durham Cathedral. 1096–1133.

F. Monogram Page from the Book of Kells. c. 700. Celtic. Trinity College Library, Dublin.

G. Quoniam Page from the Book of Lindisfarne. c. 700. British Museum. (Br. Mus.)

H. Muirdach's Cross. Celtic. X century. Monsterboice, Co. Louth, Irish Free State. (Ralph Fanning)

# ENGLISH MEDIEVAL MANUSCRIPTS · XI–XII CENT.
## SPANISH ROMANESQUE PAINTING · SCULPTURE · XII CENT.

71

A. Pages from the Liber Vitae. XI century. British Museum. (Br. Mus.)

B. Page from the Huntingfield Psalter. Tower of Babel and Abraham Avenging Lot. XII century. Pierpont Morgan Library, N. Y. (Morgan Library)

C. Huntingfield Psalter. Detail of B. (Morgan Library)

D. Portico de la Gloria, Santiago Cathedral. XII century.

E. Portico de la Gloria, Santiago Cathedral. Detail of D.

F. Catalonian Fresco from S. Maria de Mura. XII century. Museum of Fine Arts. (M.F.A.)

G. Apse Fresco from S. Clement de Tahull. XII century. Barcelona Museum.

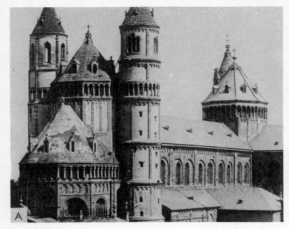

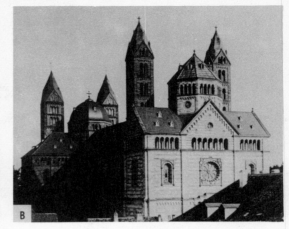

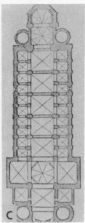

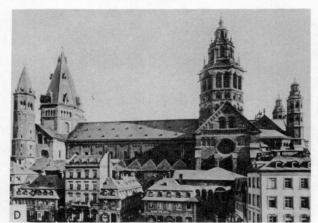

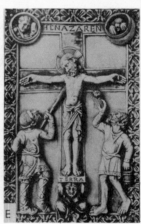

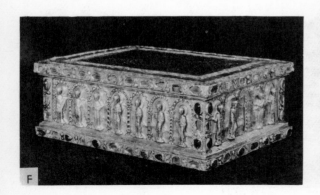

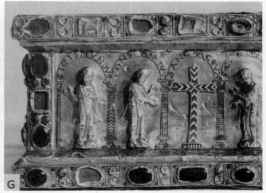

A. Worms Cathedral. XII century.

B. Speyer Cathedral. Founded 1030. Remodeled XII century.

C. Worms Cathedral. Plan. XII century. (Geier and Görz)

D. Mainz Cathedral. Largely XIII century.

E. Echternach Codex. The Ivory Cover. XI century. Library, Gotha.

F. Gertrudis Portable Altar. Brunswick. Middle XI century. Cleveland Museum. (Clev. Mus.)

G. Gertrudis Portable Altar. Detail of F. (Clev. Mus.)

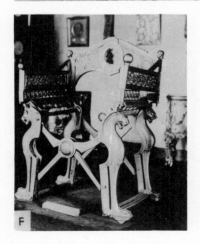

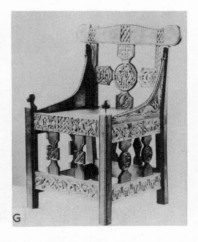

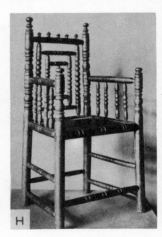

A. Cloisonné Medallion of Christ. Frankish, VII century. Cleveland Museum. (Clev. Mus.)

B. The Second Gertrudis Cross. Brunswick, c. 1040. Cleveland Museum. (Clev. Mus.)

C. The Bronze Doors, Hildesheim Cathedral. XI century (?).

D. The Magi. Detail of C.

E. Page from Codex Egberti. Adoration of the Magi. 977–993. Trier Library. (Trier Library)

F. Throne of Dagobert. Merovingian. VII century. Louvre.

G. Copy of a Norwegian Chair of IX or X century. University of Christiana.

H. German Chair. XIII century or later. (Schmitz)

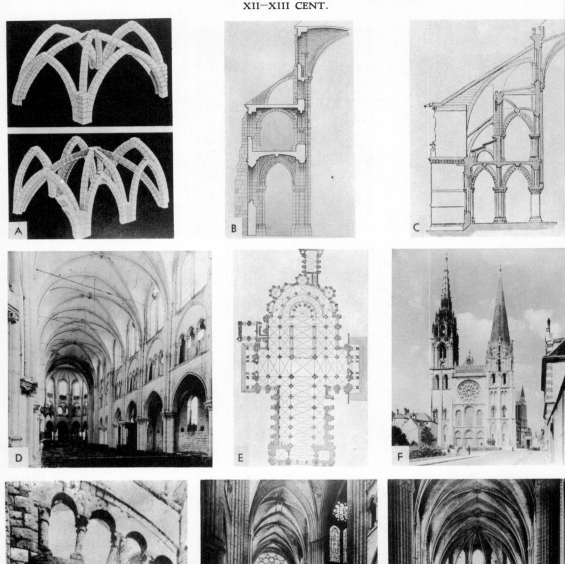

A. Gothic Vaulting Scheme. (Colas)

B. Gothic System. Section. St. Germer. 1130–60. (Dehio)

C. Cathedral of Notre Dame, Paris. Section.

D. St. Leu d Esserant. XII century. (Clarence Ward)

E. Chartres Cathedral. Plan. XII–XIII centuries. (Chapu)

F. Chartres Cathedral. Façade. Chiefly 1194–1260. Earlier spire c. 1250. Later spire 1507–14. Royal portal 1145. (Clarence Ward)

G. Chartres Cathedral. Buttress. XIII century. (Clarence Ward)

H. Chartres Cathedral. Transept. XIII century. (N.D.)

I. Chartres Cathedral. Choir. c. 1220. (See 75 A.)

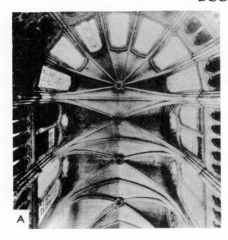

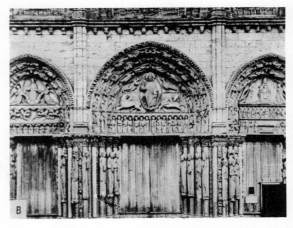

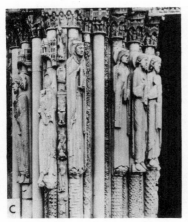

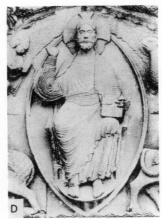

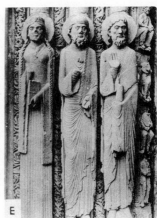

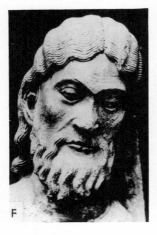

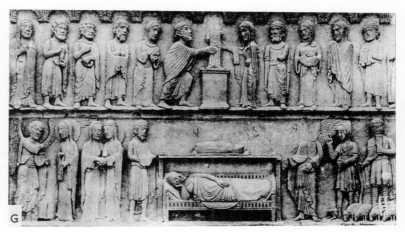

A. Chartres Cathedral. Vaulting of the Choir. c. 1220. (Clarence Ward)

B. Chartres Cathedral. Royal (West) Portal. c. 1145. (N.D.)

C. Chartres Cathedral. Royal Portal detail. Kings, Queens and Saints. (N.D.)

D. Chartres Cathedral. Royal Portal detail. Christ of the Apocalypse. (Laillet)

E. Chartres Cathedral. Royal Portal detail. Saints. Detail of C.

F. Chartres Cathedral. Royal Portal detail. Head of a figure. (N.D.)

G. Chartres Cathedral. Royal Portal detail. Life of the Virgin. (Houvet)

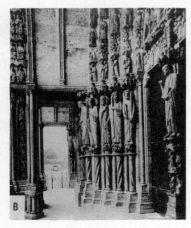

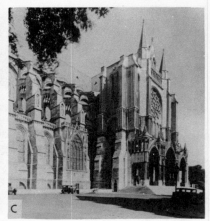

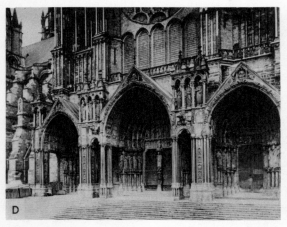

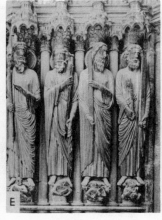

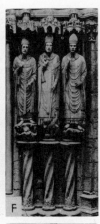

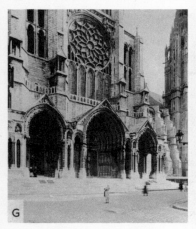

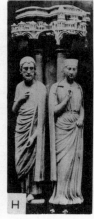

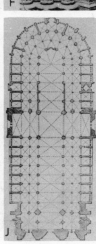

A. Chartres Cathedral. Royal Portal detail. Pythagoras. 1145. (Houvet)

B. Chartres Cathedral. S. Porch. Late XII, early XIII century. (Clarence Ward)

C. Chartres Cathedral. S. Porch. (N.D.)

D. Chartres Cathedral. S. Porch. (N.D.)

E. Chartres Cathedral. S. Porch. Detail of saints. (N.D.)

F. Chartres Cathedral. S. Porch. Detail of saints. (N.D.)

G. Chartres Cathedral. N. Porch. c. 1205–70. (Clarence Ward)

H. Chartres Cathedral. N. Porch detail. c. 1205–70.

I. Chartres Cathedral. N. Porch detail. (Houvet)

J. Paris Cathedral. Plan. 1163–1235. (Chapu)

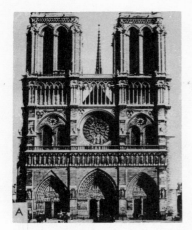

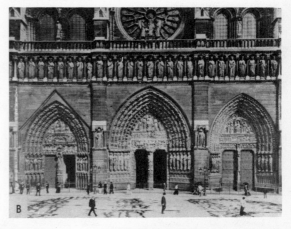

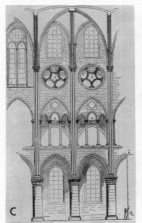

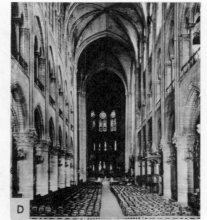

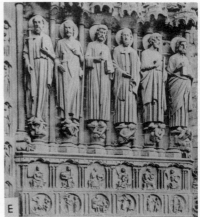

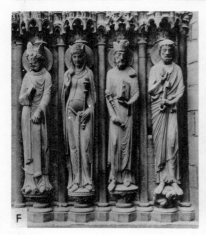

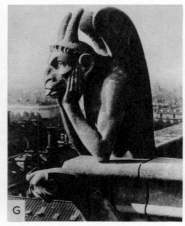

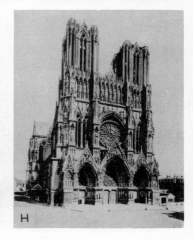

A. Paris Cathedral. Façade. 1163–1235.

B. Paris Cathedral. Façade detail. (Al)

C. Paris Cathedral. The Nave System. (Viollet-le-Duc)

D. Paris Cathedral. Nave. (Al)

E. Paris Cathedral. Façade detail. c. 1235. (Colas)

F. Paris Cathedral. Façade detail. c. 1235. (Al)

G. Paris Cathedral. Grotesque. (Al)

H. Reims Cathedral. W. front 1380. W. towers 1420. (Colas)

# FRENCH GOTHIC ARCHITECTURE
## SCULPTURE XIII–XIV CENT.

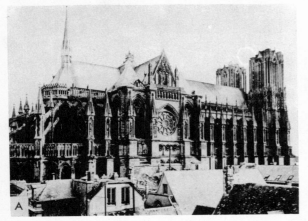

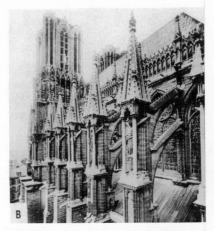

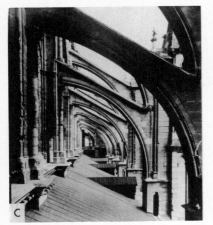

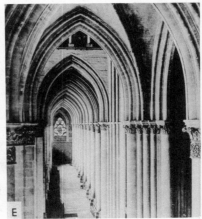

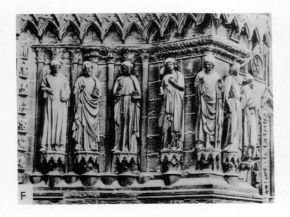

A. Reims Cathedral. XIII–XIV centuries.

B. Reims Cathedral. S. side. (Arch. Photo.)

C. Reims Cathedral. Flying buttresses. (Clarence Ward)

D. Reims Cathedral. Apsidal chapel. 1211–90. (Viollet-le-Duc)

E. Reims Cathedral. Side aisle. 1211–90. (Arch. Photo.)

F. Reims Cathedral. W. façade. Saints. XIV century. (Arch. Photo.)

G. Reims Cathedral. Capital of a clustered pier. XIII century. (Colas)

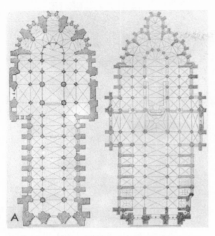

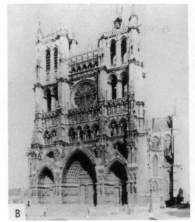

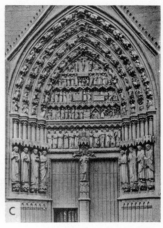

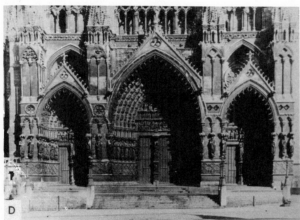

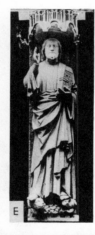

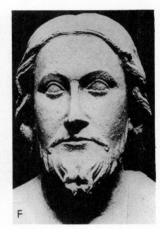

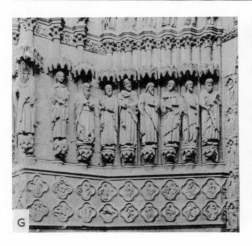

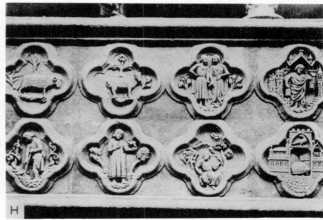

A. Plans. Left, Reims; right, Amiens. (Chapu)

B. Amiens Cathedral. 1220–1288. (Clarence Ward)

C. Amiens Cathedral. Portal of Vierge Dorée. Second half XIII century. (Colas)

D. Amiens Cathedral. W. front. 1220–1248. (Clarence Ward)

E. Amiens Cathedral. Christ (Le Beau Dieu). Detail of D.

F. Amiens Cathedral. Head of Christ. Detail of E.

G. Amiens Cathedral. Detail of W. portal. Detail of D.

H. Amiens Cathedral. The Months. Detail of G.

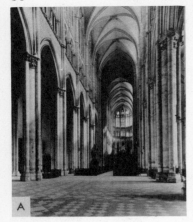

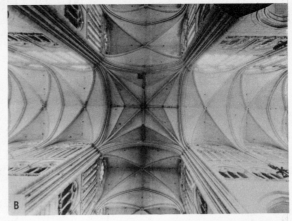

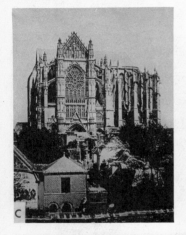

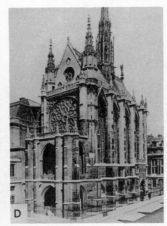

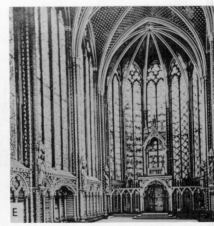

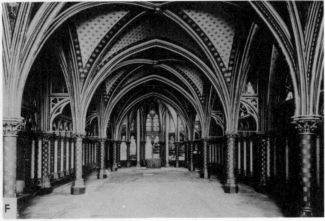

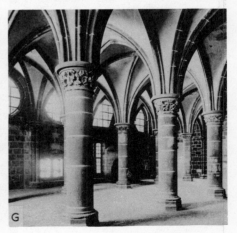

A. Amiens Cathedral. Nave. 1220–1248. (Clarence Ward)

B. Amiens Cathedral. Vaulting at the crossing. (Clarence Ward)

C. Beauvais Cathedral. 1225–1548.

D. La Sainte Chapelle, Paris. 1242–47. (Arch. Photo.)

E. La Sainte Chapelle, Paris. Interior. (Arch. Photo.)

F. La Sainte Chapelle, Paris. The Crypt.

G. Mont St. Michel. Hall of the Chevaliers. XIII century (N.D.)

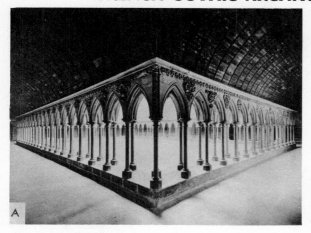

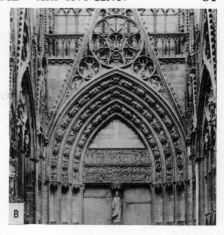

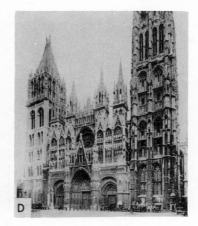

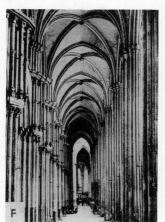

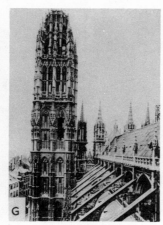

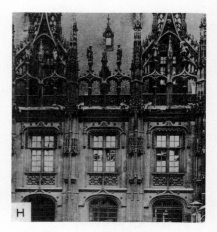

A. Mont St. Michel. The Cloister. 1225–28. (N.D.)

B. Rouen Cathedral. N. Porch detail. Begun 1280. (Arch. Photo.)

C. Rouen Cathedral. N. Porch detail with St. Michael. Begun 1280.

D. Rouen Cathedral. Façade. XIV–XVI centuries. Central section, 1507. (Arch. Photo.)

E. Rouen Cathedral. Detail of D. XVI century.

F. Rouen Cathedral. S. aisle.

G. Rouen Cathedral. Butter Tower. 1497–1509. (N.D.)

H. Palais de Justice, Rouen. 1499–1508. (Arch. Photo.)

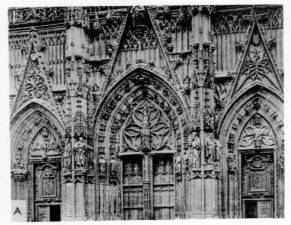

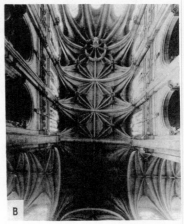

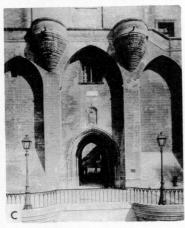

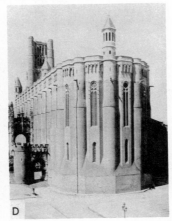

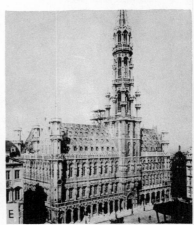

A.  St. Vulfrand, Abbeville. 1488–1539. (Arch. Photo.)

B.  St. Eustache, Paris. Vaulting. XVI century. (Clarence Ward)

C.  Papal Palace, Avignon. XIV century. (N.D.)

D.  Albi Cathedral. 1282–1512. (N.D.)

E.  Hôtel de Ville, Brussels. 1377.

F.  Hôtel de Cluny, Paris. 1490. (See 83 A.) (Al)

G.  House of Jacques Coeur, Bourges. Late XV century.

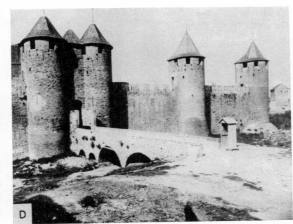

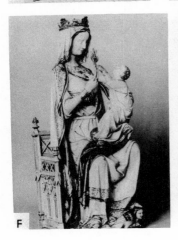

A. Hôtel de Cluny, Paris. 1490  (See 82 F.) (Gir)

B. Medieval Town House. Romanesque. (Viollet-le-Duc)

C. House at Compiègne. (Pagolnet)

D. The Château, Carcassonne. Late XII century. (N.D.)

E. Ivory Madonna. XIV century. Metropolitan Museum. (Met)

F. Ivory Madonna and Child. End of XIII century. Metropolitan Museum. (Met)

G. Claus Sluter and Claus de Werve. Moses Well. Burgundian School. Carthusian Monastery near Dijon. c. 1389.

H. Claus Sluter and Claus de Werve. Mourners from Tomb of Philip the Bold. 1384–1411. Museum, Dijon. (Gir)

A. Reliquary. Limoges Enamel. XIII century. Metropolitan Museum. (Met)

B. Ivory Diptych. XIV century. Louvre. (Louvre)

C. Ivory Casket. XIV century. Metropolitan Museum. (Met)

D. Stained Glass, Chartres Cathedral. Tree of Jesse. XII century.

E. Festival of Roses. Tapestry. 1435–40. Metropolitan Museum. (Met)

F. Story of Alexander. Flemish Tapestry, School of Tournai. XV century. Palazzo Doria, Rome.

G. St. Matthew. Middle XIII century. Louvre. (Louvre)

# FRENCH GOTHIC MINOR ARTS · XII–XV CENT.
# ENGLISH GOTHIC ARCHITECTURE · XII–XIII CENT.

85

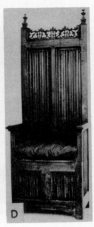

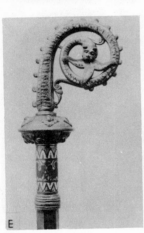

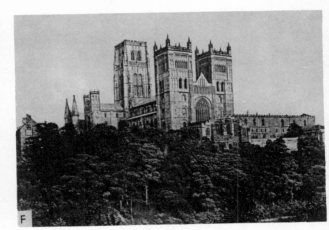

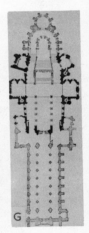

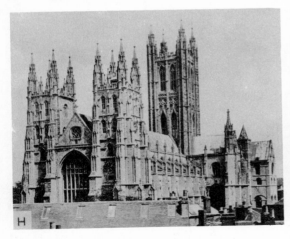

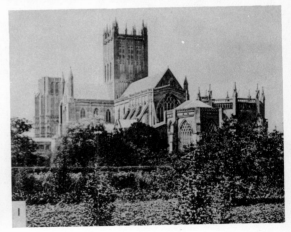

A. Pol de Limbourg and Brothers. February Page from the "Très Riches Heures" of the Duc de Berri. 1412–16. Musée Condé, Chantilly. (Gir)

B. Church Bench. XV century. (Schmitz)

C. Credence. XV century. (Met)

D. Chair. XV century. (Met)

E. Crozier. Limoges Enamel. Second half of XIII century. Metropolitan Museum. (Met)

F. Durham Cathedral. XI–XIV centuries. (See 70 D.)

G. Canterbury Cathedral. Plan. 1175–1503.

H. Canterbury Cathedral. Begun 1175. Central tower 1495–1503. (See 86 B.)

I. Wells Cathedral. From E. 1190–1239. (See 86 A.)

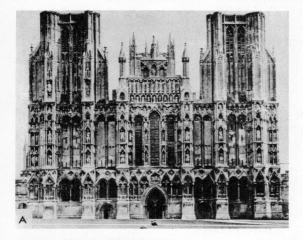

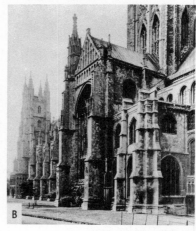

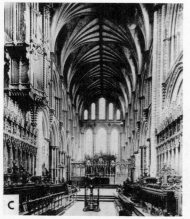

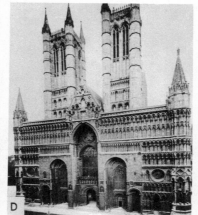

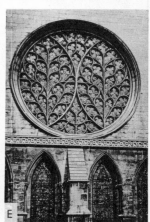

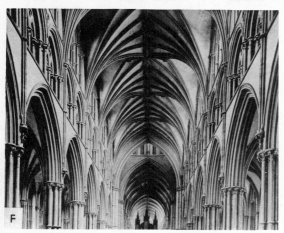

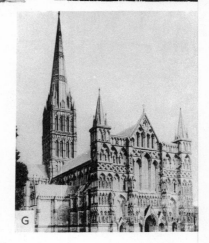

A. Wells Cathedral. Façade. 1220–39. (See 85 I.) (Man)

B. Canterbury Cathedral. S. side. 1175–84. (See 85 G, H.) (Man)

C. Ely Cathedral. Choir looking E. 1229–54. (Bolas)

D. Lincoln Cathedral. Façade. Rebuilt 1192–1200. (Bolas)

E. Lincoln Cathedral. Rose Window. S. Transept. Early XIII century.

F. Lincoln Cathedral. Nave looking E. c. 1250. (Bolas)

G. Salisbury Cathedral. 1220–60. Tower. XVI century. (See 87 A.) (Man)

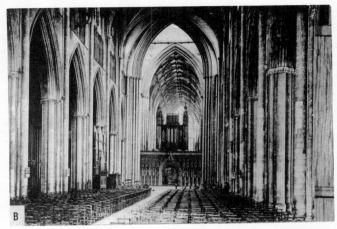

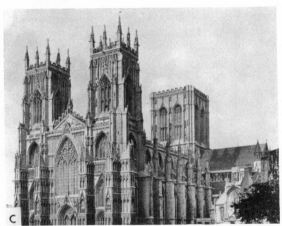

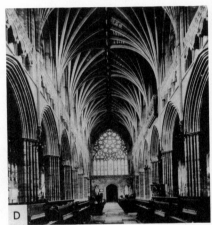

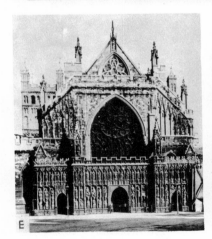

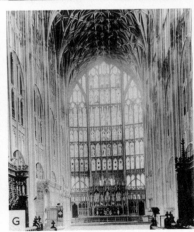

A. Salisbury Cathedral. Plan. XIII–XVI centuries. (See 86 G.)

B. York Minster. Nave looking E. 1291–1394.

C. York Minster. Façade. 1241–1423.

D. Exeter Cathedral. Nave looking W. 1331–50.

E. Exeter Cathedral. Façade. 1328–94.

F. Exeter Cathedral. Flying buttresses and transept tower. XIII–XIV centuries. (Bolas)

G. Gloucester Cathedral. Choir looking E. Rebuilt 1331–37. (See 88 A.) (Bolas)

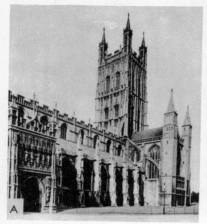

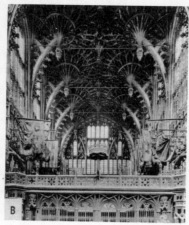

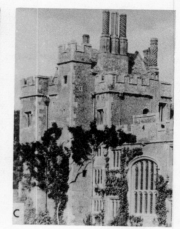

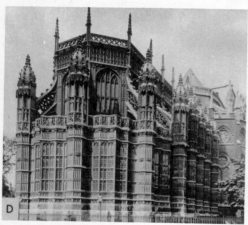

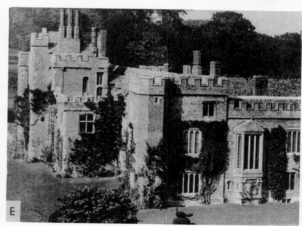

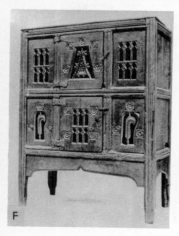

A. Gloucester Cathedral. S. side. XII–XIV centuries. (See 87 G.) (Bolas)

B. Chapel of Henry VII, Westminster Abbey. Fan vaulting. 1503–20. (Bolas)

C. Compton Wynyates, Warwickshire. S. wing. Detail of E. 1520. (Call)

D. Chapel of Henry VII, Westminster Abbey. Exterior. 1503–20. (Bolas)

E. Compton Wynyates. S. wing. 1520. (Call)

F. Standing Cupboard. Middle XVI century. Victoria and Albert Museum. (Vict. Alb.)

G. Oak Cupboard. 1475–1500. Metropolitan Museum. (Met)

H. Madonna Enthroned. The Arundel Psalter. Early XIV century. British Museum. (Br. Mus.)

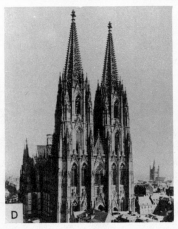

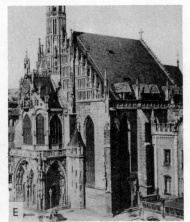

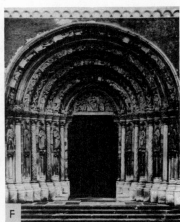

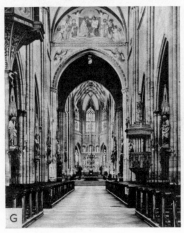

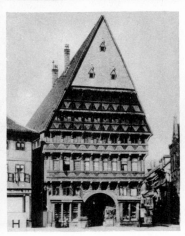

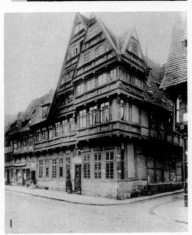

A. Aix-la-Chapelle (Aachen) Cathedral. Chapel, IX century. (See 56 B, C.) Cathedral, XIV–XV centuries. (von Stengel)

B. Church of St. Elizabeth, Marburg. 1233–83.

C. Cologne Cathedral. Plan. Mostly 1248–1322.

D. Cologne Cathedral. 1248–1322. Completed XIX century. (Hertel)

E. Frauenkirche, Nuremberg. 1354–61.

F. The Golden Door, Freiberg Cathedral. XIII century.

G. Freiberg Cathedral. Interior. Nave, 1260. Choir, 1354. (Rölicke)

H. Knochenhaueramthaus, Hildesheim. XVI century.

I. House, Hildesheim. XVI century.

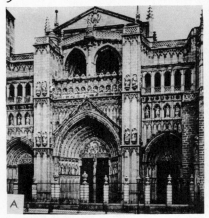

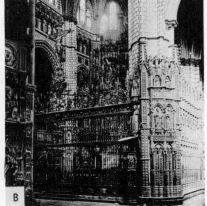

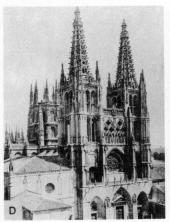

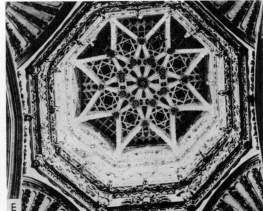

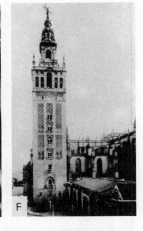

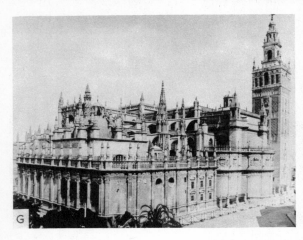

A. Toledo Cathedral. 1227–1493.

B. Toledo Cathedral. Interior. 1227–1493.

C. Toledo Cathedral. Plan.

D. Burgos Cathedral. Spires begun 1442.

E. Burgos Cathedral. Vaulting. 1497–1512. (L.L.F.)

F. Giralda, Seville. Lower stages, 1194–96. Top, 1568. (Al)

G. Seville Cathedral. 1401–1506. (And)

H. The University, Salamanca. XV century. (See 170 E.) (Laurent)

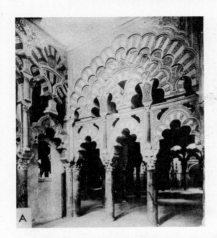

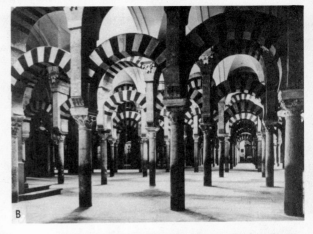

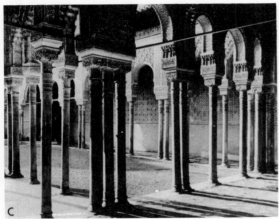

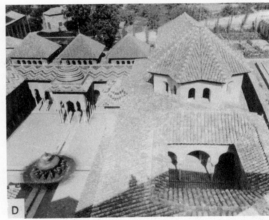

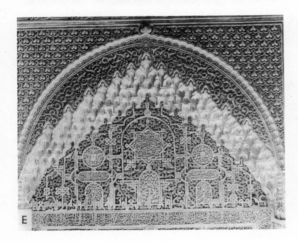

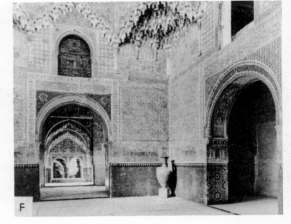

A. Mosque, Córdova. Approach to the Mihrab. Begun VIII century. (Gonzalez)

B. Mosque, Córdova. Interior. Begun VIII century. (And)

C. Alhambra, Granada. Court of the Lions. 1354. (And)

D. Alhambra, Granada. Court of the Lions at L. 1354. (Mas)

E. Alhambra, Granada. Stucco detail. (Al)

F. Alhambra, Granada. Hall of the Two Sisters. Begun 1230. (And)

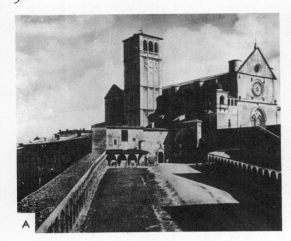

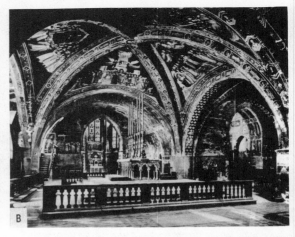

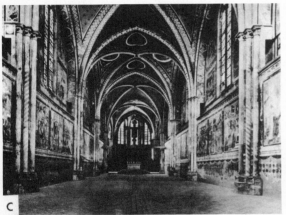

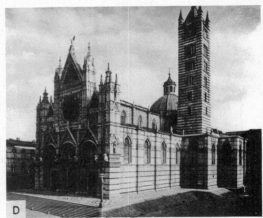

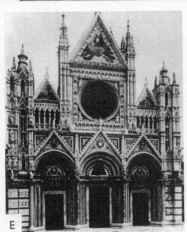

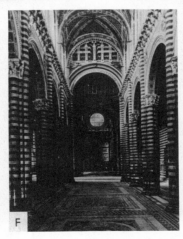

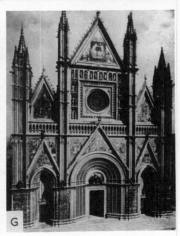

A. San Francesco, Assisi. 1228–53.

B. San Francesco, Assisi. Lower Church. (And)

C. San Francesco, Assisi. Upper Church. (See 120 B, C.) (And)

D. Siena Cathedral. c. 1245–1380. (Al)

E. Siena Cathedral. Façade. Detail of D. c. 1245–1380.

F. Siena Cathedral. Interior. (Al)

G. Orvieto Cathedral. Façade. Arnolfo di Cambio and Lorenzo
Maitani. 1290–1310. (See 93 A, 97 H.) (Al)

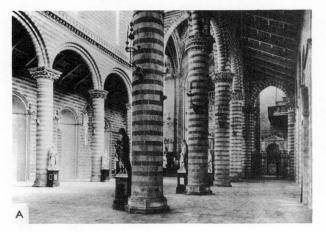

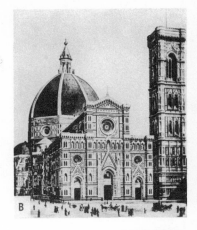

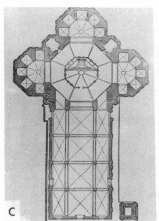

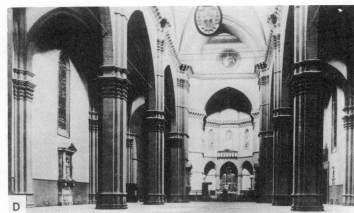

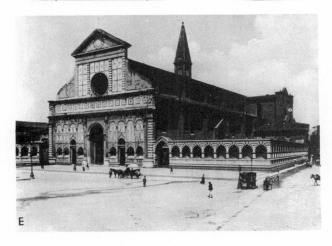

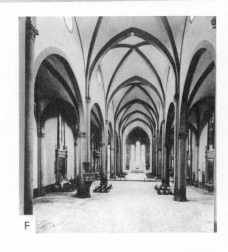

A. Orvieto Cathedral. Interior. 1290–1310. (See 92 G.) (Al)

B. Florence Cathedral and Campanile. Arnolfo di Cambio, Brunelleschi, architects. 1296–1462. Campanile: 1334–87, Giotto and Andrea Pisano. Façade, 1875–87. (See 97 D, E.)

C. Florence Cathedral. Plan. (Isabelle)

D. Florence Cathedral. Interior. Arnolfo di Cambio, architect.

E. Santa Maria Novella, Florence. 1278–1350. Renaissance detail of façade by Alberti, 1470. (See 100 F.) (Brogi)

F. Santa Maria Novella, Florence. Interior. (Brogi)

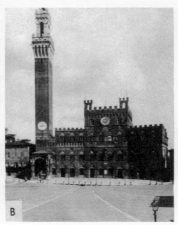

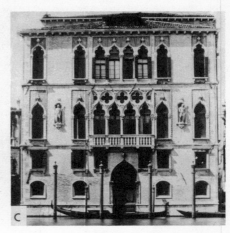

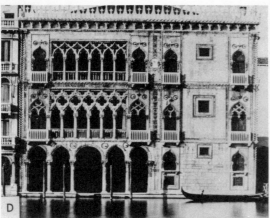

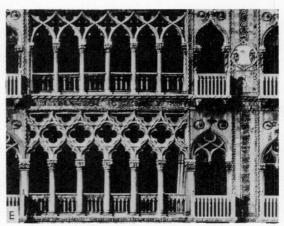

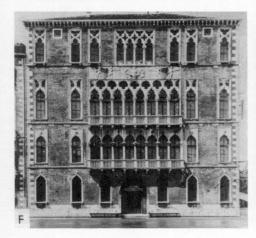

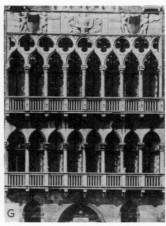

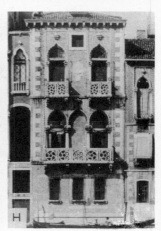

A. Palazzo Vecchio, Florence. Arnolfo di Cambio, architect.
1298. R. and L., the Uffizi, Vasari, architect. 1560–74. (Al)

B. Palazzo Pubblico, Siena. 1289–1305. (See 118 A–D.) (Al)

C. Palazzo Loredan, Venice. XV century. (And)

D. Palazzo Cà d'Oro, Venice. XIV century. (And)

E. Palazzo Cà d'Oro  Venice. Detail of D. (And)

F.  Palazzo Foscari, Venice. XV century. (And)

G.  Palazzo Foscari, Venice. Detail of F. (And)

H.  Palazzo Contarini Fasan, Venice. XIV century. (And)

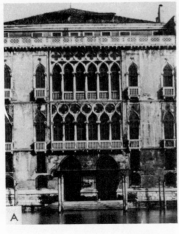

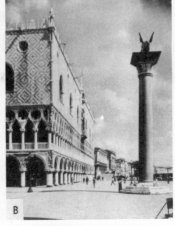

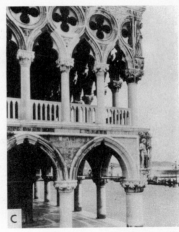

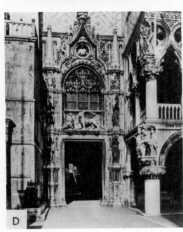

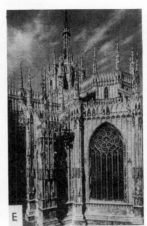

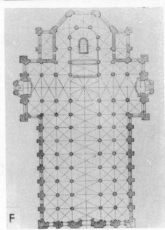

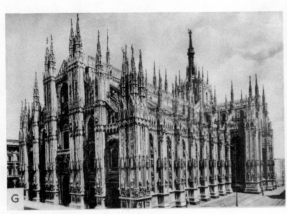

A. Palazzo Pisani, Venice. XIV century. (And)

B. Ducal Palace, Venice. XIV–XVI century. (And)

C. Ducal Palace, Venice. Detail of B. (Al)

D. Porta della Carta, Ducal Palace, Venice. 1438–43. (And)

E. Milan Cathedral. The Apse. XV century and later.

F. Milan Cathedral. Plan. Mainly 1385–1485.

G. Milan Cathedral. 1385–1485. Completed XIX century.

H. Gothic Wood Carving. Church of the Frari, Venice.

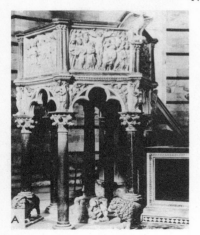

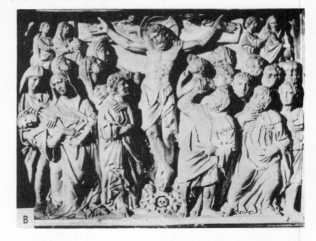

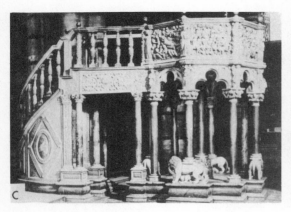

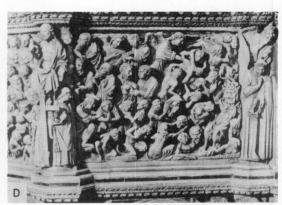

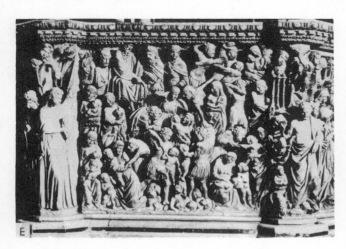

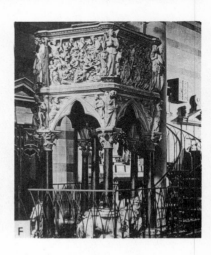

A.  Niccolo Pisano (d'Apulia) Pulpit, Pisa Baptistry. 1260. (Al)

B.  Niccolo Pisano. Crucifixion. Detail of A. (Al)

C.  Niccolo Pisano  Pulpit, Siena Cathedral. 1265–68. (Al)

D.  Niccolo Pisano. Inferno. Detail of C. (Al)

E.  Niccolo Pisano. Massacre of the Innocents. Detail of C. (Al)

F.  Giovanni Pisano. Pulpit. Sant' Andrea, Pistoia. 1298–1302.

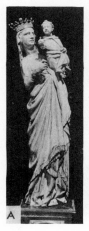

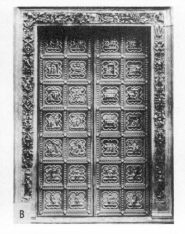

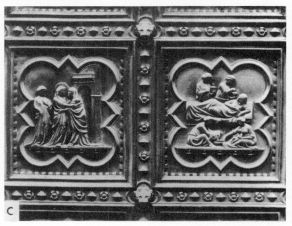

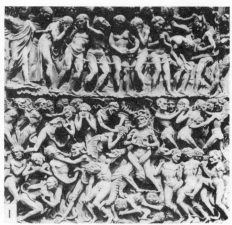

A. Giovanni Pisano. Madonna and Child. Pisa Cathedral. **(Brogi)**

B. Andrea Pisano. S. Doors, Baptistry, Florence. 1336. (Al)

C. Andrea Pisano. Visitation, Birth of John the Baptist. Detail of B. (Al)

D. Andrea Pisano. Painting. 1334–87. Campanile, Florence. (See 93 B.) (And)

E. Andrea Pisano. Architecture. Campanile, Florence. (Al)

F. Andrea Orcagna. Marriage of the Virgin. Tabernacle, Or San Michele, Florence. 1348–59. (Al)

G. Andrea Orcagna. Annunciation of the Death of the Virgin. Tabernacle, Or San Michele, Florence. (Al)

H. Lorenzo Maitani and others. The Last Judgment. Facade of the Orvieto Cathedral. 1320–30. (See 92 G.) (And)

I. Lorenzo Maitani and others. Inferno. Detail of H. (And)

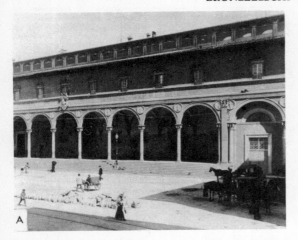

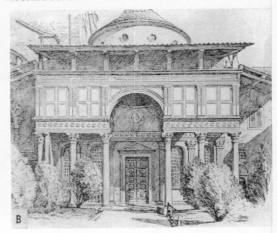

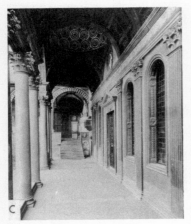

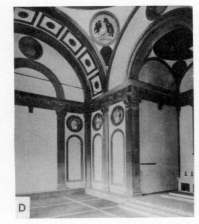

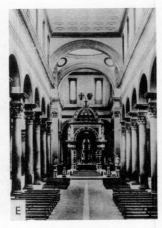

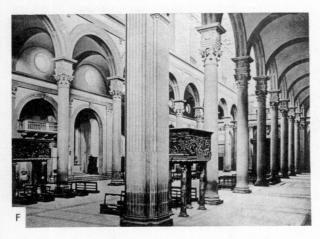

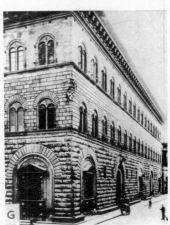

A. Loggia of the Foundlings' Hospital, Florence. 1419–51.
Brunelleschi, architect. (See 111 B.) (Al)

B. Pazzi Chapel, Florence. Façade begun 1429 by Brunelleschi.
(From Moore, "The Character of Renaissance Architecture."
Macmillan Co.)

C. Pazzi Chapel, Florence. Portico. (Al)

D. Pazzi Chapel, Florence. Interior. (Al)

E. Santo Spirito, Florence, 1436–87. Brunelleschi, architect.

F. San Lorenzo, Florence. 1425. Brunelleschi, architect.

G. Medici-Riccardi Palace, Florence. 1444. Michelozzo, ar-
chitect.

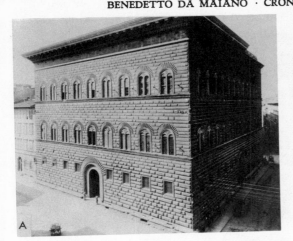

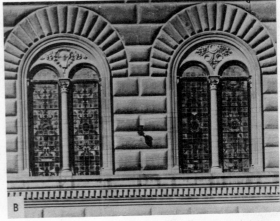

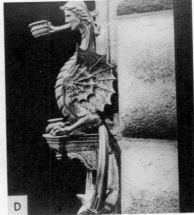

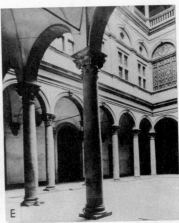

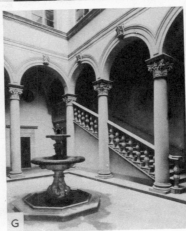

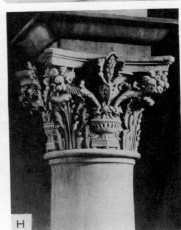

A. Strozzi Palace, Florence. Begun 1489 by Benedetto da Maiano and Simone del Pollaiuolo, called Il Cronaca. Finished 1536. (Al)

B. Strozzi Palace, Florence. Detail of A. (Al)

C. Strozzi Palace, Florence. Detail of A. (Al)

D. Strozzi Palace, Florence. Iron Ring and Torch Holder. XV century. (Al)

E. Strozzi Palace, Florence. Court. Cronaca, architect. (Al)

F. Strozzi Palace, Florence. Detail of A. (Al)

G. Gondi Palace, Florence. Court. 1490. Giuliano da Sangallo, architect. (Al)

H. Gondi Palace, Florence. Capital of court column. Detail of G. (Al)

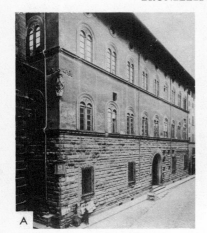

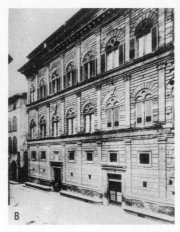

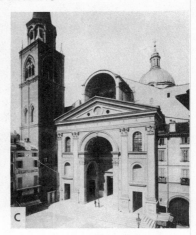

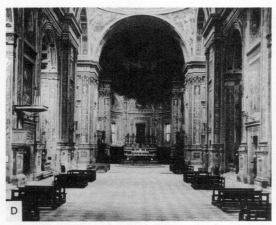

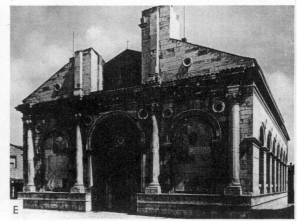

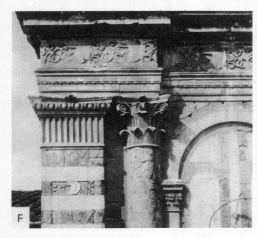

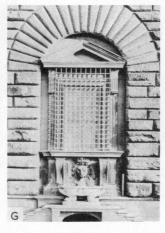

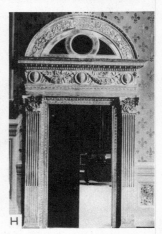

A. Quaratesi Palace, Florence. 1445. Brunelleschi, architect. (Al)

B. Rucellai Palace, Florence. 1451–55. Alberti, architect.

C. Sant' Andrea, Mantua. 1472–1512. Alberti, architect. Campanile, 1414. (Al)

D. Sant' Andrea, Mantua. Interior. XV–XVII century. (Al)

E. San Francesco, Rimini. 1447–1455. Alberti, architect.

F. Santa Maria Novella, Florence. Detail of façade by Alberti 1470. (See 93 E.) (Al)

G. Pitti Palace, Florence. Window. XV century.

H. Palazzo Vecchio, Florence. Interior door. Benedetto da Maiano, architect. (Al)

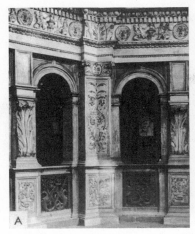

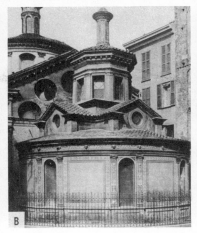

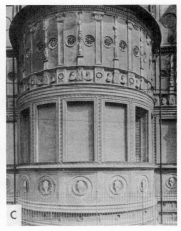

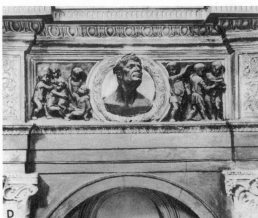

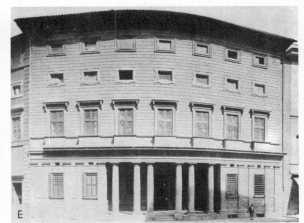

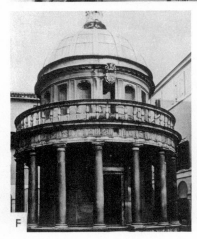

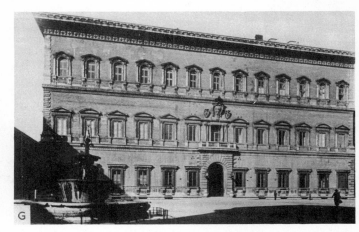

A. Church of San Satiro, Milan. Baptistry. 1472. Bramante, architect. (Al)

B. Church of San Satiro, Milan. Rotunda. 1472. Bramante, architect. (Al)

C. Santa Maria delle Grazie, Milan. Apse. 1492–97. Bramante, architect. (Al)

D. Church of San Satiro, Milan. Detail of Sacristy. 1472. Bramante, architect. (Al)

E. Massimi Palace, Rome. 1536. Baldassare Peruzzi, architect. (Al)

F. The Tempietto, San Pietro in Montorio, Rome. 1502. Bramante, architect. (Al)

G. Farnese Palace, Rome. 1530–80. Designed by Antonio da Sangallo the Younger. Top story by Michelangelo, 1546. (Grafia)

## ST. PETER'S, ROME

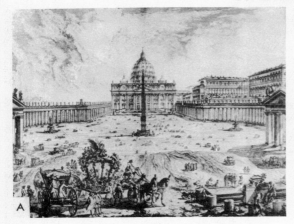

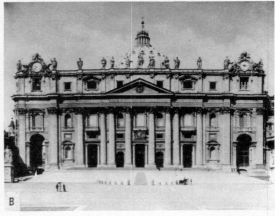

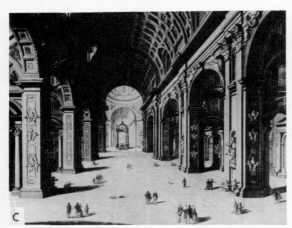

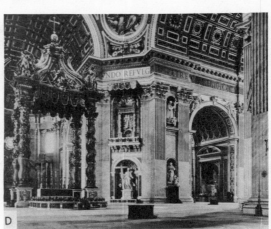

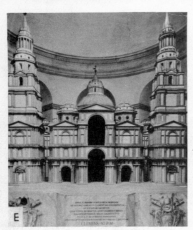

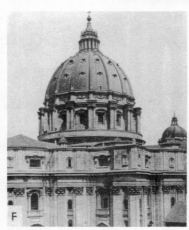

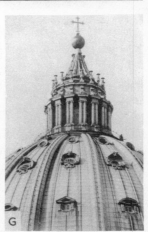

A. XVIII century view of Piazza of St. Peter's, Rome. Work of 14 architects. 1450–1667. Engraving by Piranesi.

B. St. Peter's, Rome. Façade by Carlo Maderna, 1606–12. (Al)

C. St. Peter's, Rome. Interior. 1606–12. Chief architects: Bramante, Michelangelo, Maderna. From an engraving.

D. Detail of C. The Crossing. Baldachino at L. by Bernini, 1633.

E. Model of St. Peter's, Rome, by Antonio da Sangallo, 1546. Vatican Museum. (Al)

F. Dome of St. Peter's, Rome. Rear view. Designed by Michelangelo. Finished 1590. (Al)

G. Cupola. Detail of F. Finished by Giacomo della Porta. 1590. (Grafia)

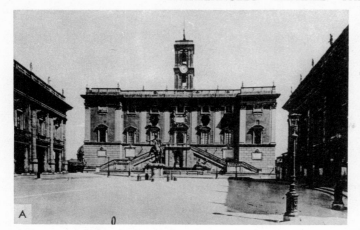

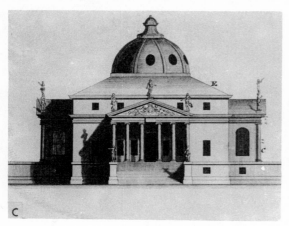

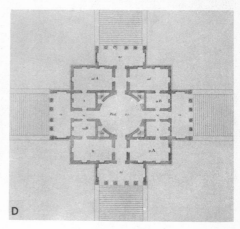

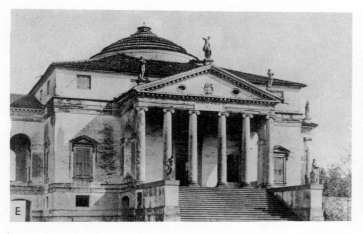

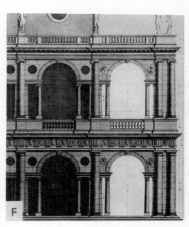

A. Senators' Palace, Rome. After 1546. Facade, 1592 after designs by Michelangelo. (See 49 D.)

B. Villa Madama, Rome. 1516. Raphael and Giulio Romano, architects. Paintings by Romano. (Al)

C. Villa Rotonda (Capra), near Vicenza. 1552. Engraving from Palladio's "Four Books of Architecture." Andrea Palladio, architect.

D. Plan of C.

E. Villa Rotonda today.

F. The Basilica, Vicenza. 1549. Engraving from Palladio's "Four Books of Architecture." Andrea Palladio, architect. (See 104 A.)

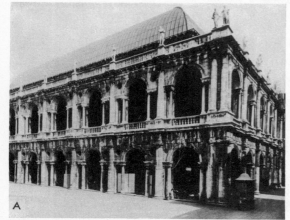

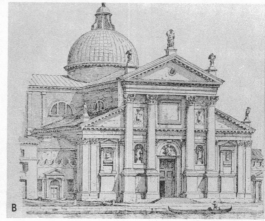

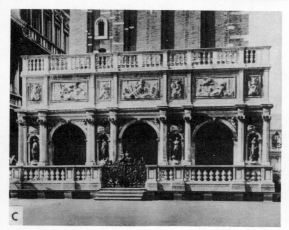

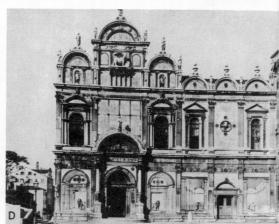

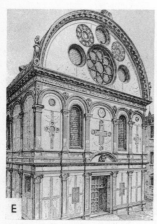

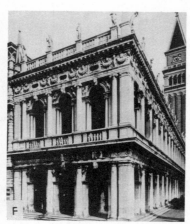

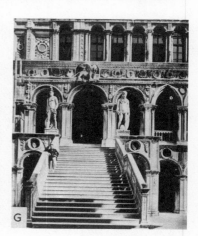

A. The Basilica, Vicenza. 1549. Arcades by Andrea Palladio. (See 103 F.) (Al)

B. San Giorgio Maggiore, Venice. Andrea Palladio, architect. 1560. Facade by Scamozzi, 1575. (From Moore, "The Character of Renaissance Architecture." Macmillan Co.)

C. Logetta of the Campanile, Piazza of St. Mark's, Venice. 1540. Sansovino, architect. (Al)

D. Civil Hospital of St. Mark, Venice. 1485–90. Façade by the Lombardi. (And)

E. Santa Maria dei Miracoli, Venice. 1480. Pietro Lombardo, architect. (From Moore, "The Character of Renaissance Architecture." Macmillan Co.)

F. Library of St. Mark's, Venice. 1536. Andrea Sansovino, architect. (And)

G. Grand Staircase, Court of the Ducal Palace, Venice. Finished c. 1550 by Scarpagnino and Rizzo. Flanking figures of Mars and Neptune by Sansovino. (See 105 A.)

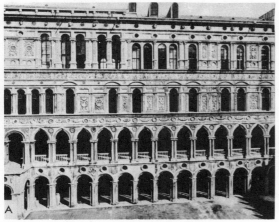

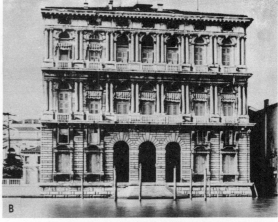

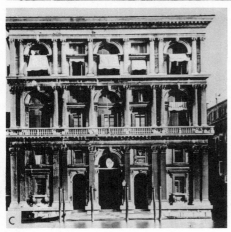

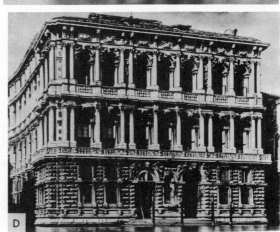

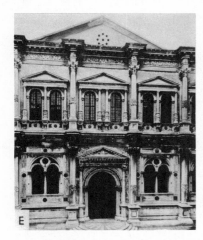

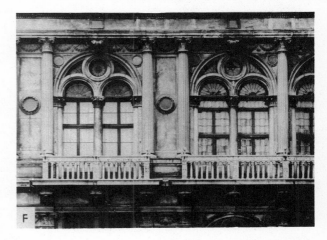

A. Court of the Ducal Palace, Venice. Begun 1486 by Rizzo, continued 1499–1511 by Pietro Lombardo. (See 104 G.) (And)

B. "Corner" Palace, on the Grand Canal, Venice. 1532. Sansovino, architect. (And)

C. Grimani Palace, Venice. 1549. Sanmichele, architect. (And)

D. Pesaro Palace, Venice. 1679. Longhena, architect. (And)

E. Scuola di San Rocco, Venice. 1517. Buon, architect.

F. Vendramin Palace, Venice. Detail of facade. 1481. Pietro Lombardo, architect. (Al)

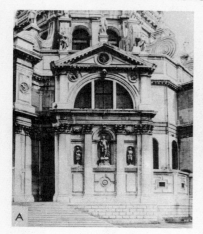

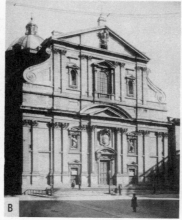

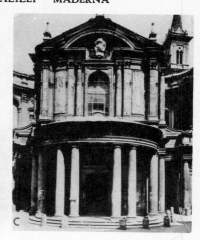

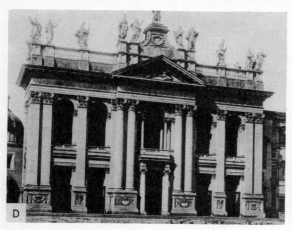

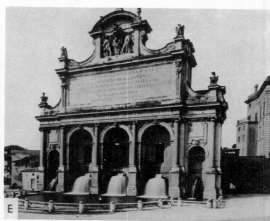

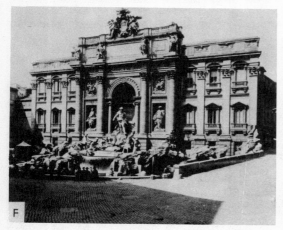

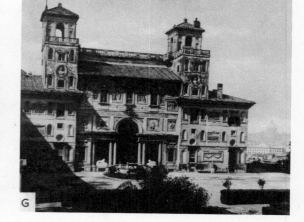

A. Santa Maria della Salute, Venice. Façade detail. 1631–82. Longhena, architect. (See 153 E.) (Al)

B. Church of the Gesù, Rome. 1568–75. Vignola and della Porta, architects.

C. Santa Maria della Pace, Rome. Restored 1655 by Pietro da Cortona. (Al)

D. San Giovanni in Laterano, Rome. 1734. Designed by Alessandro Galilei. (Al)

E. Paolo Fountain, Rome. 1611. Designed by Giovanni Fontana and Carlo Maderna. (Al)

F. Trevi Fountain, Rome. 1735–62. Designed by Ferdinando Fuga (?). (Al)

G. Villa Medici, Rome. XVI century. A. Lippi and Michelangelo, architects. (Al)

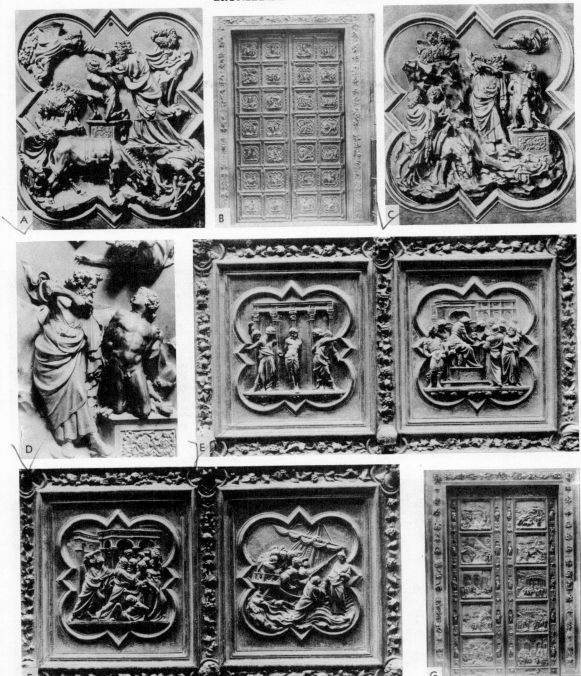

A. Brunelleschi. Competition panel for N. doors of Baptistry, Florence. Sacrifice of Isaac. 1402. National Museum, Florence.

B. Ghiberti. N. doors of Baptistry, Florence. 1403–24. (Al)

C. Ghiberti. Competition panel for N. doors of Baptistry, Florence. Sacrifice of Isaac. 1402. Bargello.

D. Ghiberti. Detail of C.

E. Ghiberti. Detail of B. L., Christ Bound to the Pillar; R., Christ Before Pilate.

F. Ghiberti. Detail of B. L., Christ Driving Money Changers from the Temple; R., Christ and Peter on the Water.

G. Ghiberti. E. doors of Baptistry, Florence. 1425–52. (See 108 A–C.) (Al)

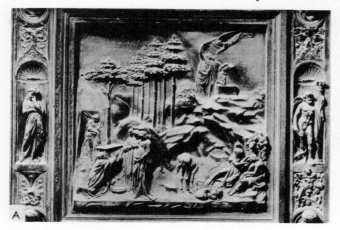

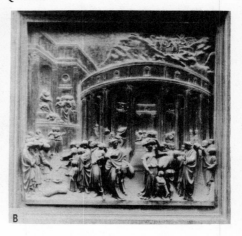

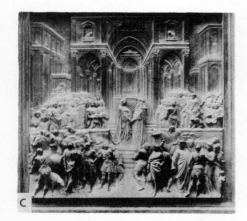

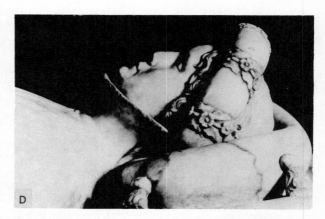

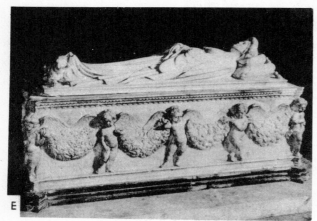

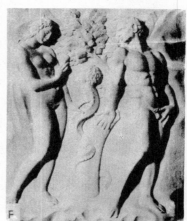

A. Ghiberti. E. doors of Baptistry, Florence. 1425–52. (Detail of 107 G.) Abraham Entertains the Three Angels; Sarah at the Tent; Hagar in the Desert; Sacrifice of Isaac. (Al)

B. Ghiberti. (Detail of 107 G.) Finding of the Cup in Benjamin's Sack. (Al)

C. Ghiberti. (Detail of 107 G.) Solomon Receiving the Queen of Sheba in the Great Temple. (Al)

D. Jacopo della Quercia, attributed to. Tomb of Ilaria del Carretto. 1406. Lucca Cathedral. Detail of E. (Al)

E. Jacopo della Quercia, attributed to. Tomb of Ilaria del Carretto. 1406. Lucca Cathedral. (Al)

F. Jacopo della Quercia. Fall of Man. 1425. San Petronio, Bologna. (See 109 A.)

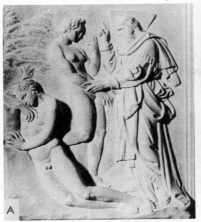
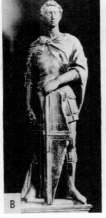
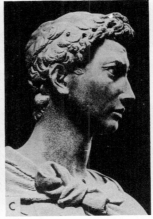
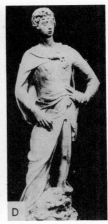

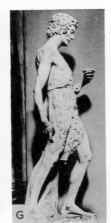
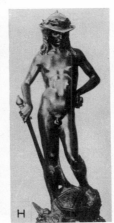
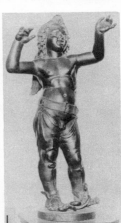

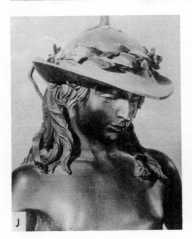

A. Jacopo della Quercia. Creation of Eve. 1425. San Petronio, Bologna.

B. Donatello. St. George. 1416. Bargello. (Al)

C. Donatello. Detail of B. (Al)

D. Donatello. David. 1416 (?). Bargello. (Al)

E. Donatello. King David (Zuccone). c. 1425. Campanile, Florence. (Al)

F. Donatello. John the Baptist. c. 1425. Bargello. (Al)

G. Donatello. John the Baptist. c. 1425. Bargello. (Al)

H. Donatello. David. After 1430. Bargello. (Al)

I. Donatello. Amorino in Breeches. Bargello.

J. Donatello. Detail of H.

K. Donatello (?). Niccolo da Uzzano. c. 1432. Bargello.

L. Donatello. Annunciation. 1430. Santa Croce. (Al)

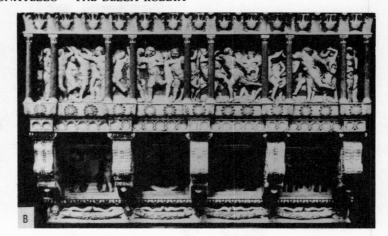

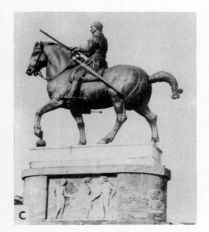

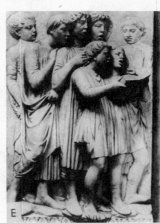

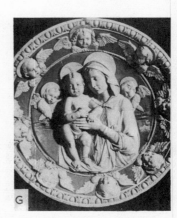

A. Donatello and Michelozzo. Pulpit. 1434. Prato.

B. Donatello. Singing Gallery (Cantoria). 1433–38. Cathedral Museum, Florence.

C. Donatello. Gattamelata (Erasmo da Narni). 1447. Padua. (Al)

D. Donatello. Judith and Holfernes. c. 1440. Loggia dei Lanzi, Florence. (Al)

E. Luca della Robbia. Singing Gallery panel. 1431–38. Cathedral Museum, Florence. (Al)

F. Luca della Robbia. Singing Gallery. 1431–38. Cathedral Museum, Florence. (Al)

G. Andrea della Robbia. Madonna and Child. Bargello. (Al)

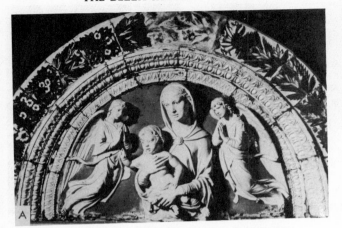

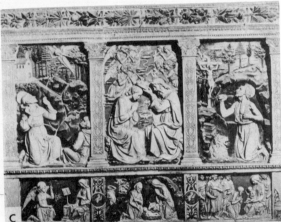

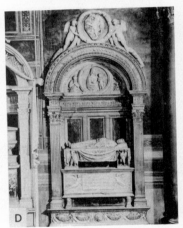

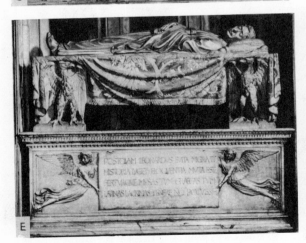

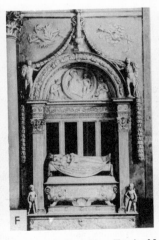

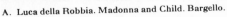

A. Luca della Robbia. Madonna and Child. Bargello.

B. **Andrea della Robbia.** Foundling. 1463–66. Hospital of the Innocents, Florence. (See 98 A.) (Al)

C. **Andrea** della Robbia. Altarpiece. S. Maria degli Angioli, Florence.

D. Bernardo Rossellino. Tomb of Leonardo Bruni. 1444. Santa Croce, Florence. (Al)

E. Bernardo Rossellino. Detail of D.

F. Desiderio da Settignano. Tomb of Carlo Marsuppini. c. 1455. Santa Croce, Florence. (Al)

G. Desiderio da Settignano. Detail of F.

BERNARDO ROSSELLINO · DESIDERIO DA SETTIGNANO · BENEDETTO DA MAIANO

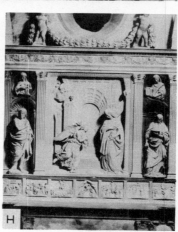

A. Antonio Rossellino (?). Madonna and Child. Morgan Library.

B. Bernardo Rossellino. St. John the Baptist. Bargello. (Al)

C. Desiderio da Settignano. Bust of a Boy. Este Coll., Vienna. (Al)

D. Desiderio da Settignano. Tabernacle. San Lorenzo, Florence. (Al)

E. Desiderio da Settignano. Detail of D. (Al)

F. School of Donatello. John the Baptist. Bargello. (Al)

G. Desiderio da Settignano or Donatello. Madonna and Child. Bargello. (Al)

H. Benedetto da Maiano. Altarpiece. Annunciation. Mte. Oliveto, Naples. (Al)

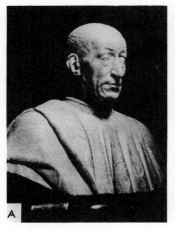

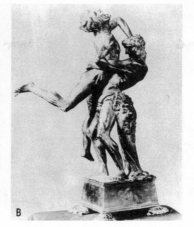

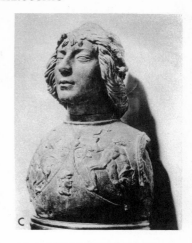

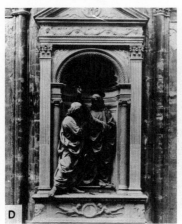

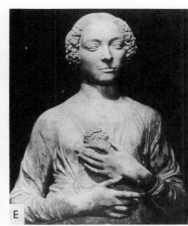

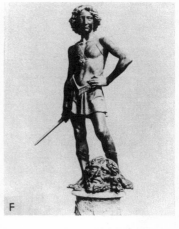

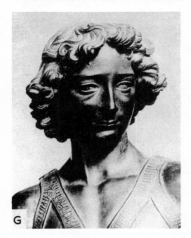

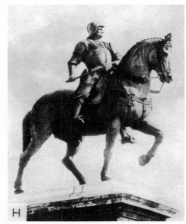

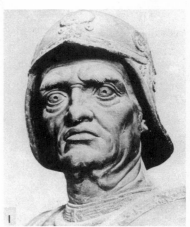

A. Benedetto da Maiano. Pietro Mellini. 1474. Bargello. (Al)

B. Antonio Pollaiuolo. Hercules and Antaeus. Bargello. (Al)

C. Antonio Pollaiuolo. Giuliano de' Medici (?). 1470–78. Bargello. (Al)

D. Verrocchio. Incredulity of Thomas. 1463–83. Or San Michele, Florence. (Al)

E. Verrocchio. Bust of Unknown Woman. Bargello. (Al)

F. Verrocchio. David. Bronze. 1476. Bargello. (Al)

G. Verrocchio. Detail of F.

H. Verrocchio. Colleoni. Bronze. c.1481–88. Venice. (Al)

I. Verrocchio. Detail of H. (And)

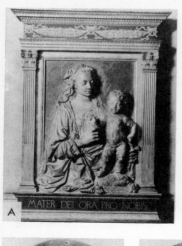

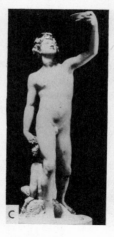
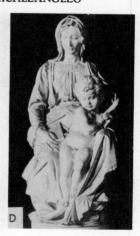

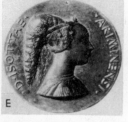

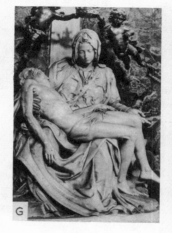
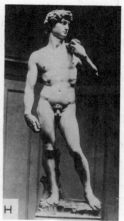

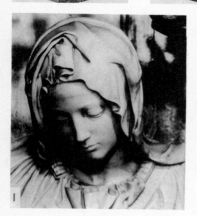
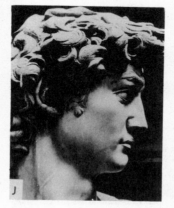
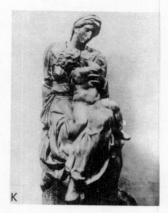

A. Verrocchio. Madonna. Bargello. (Al)

B. Amadeo and Pupils of the Mantegazzi. Certosa of Pavia. Detail of S. side of façade. Visitation. Begun 1473.

C. Sansovino. Bacchus. 1513. Bargello. (Al)

D. Michelangelo. Madonna of Bruges. Notre Dame, Bruges.

E. Pisanello. Obverse and reverse of Medal to Isotta da Rimini. 1446. Bargello. (Al)

F. Pisanello. Obverse and reverse of Medal to John Paleologus. Bargello. (Al)

G. Michelangelo. Pietà. 1499–1500. St. Peter's, Rome. (Al)

H. Michelangelo. David. 1501–03. Academy, Florence.

I. Michelangelo. Detail of G.

J. Michelangelo. Detail of H.

K. Michelangelo. Medici Madonna. New Sacristy, San Lorenzo, Florence. (Al)

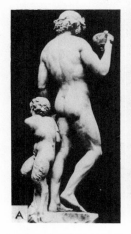

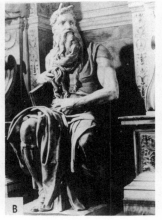

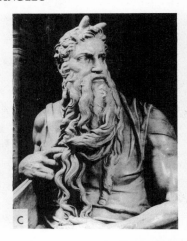

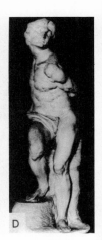

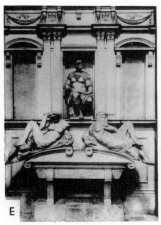

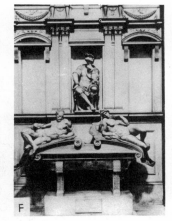

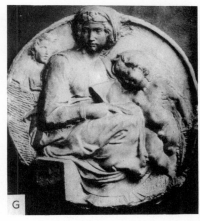

A. Michelangelo. Bacchus. 1496–1501. Bargello. (Al)

B. Michelangelo. Moses, for Tomb of Julius II. 1505–45. S Pietro in Vincoli, Rome. (Al)

C. Michelangelo. Detail of B.

D. Michelangelo. Bound Slave, for Tomb of Julius II. 1513. Louvre. (Al)

E. Michelangelo. Tomb of Giuliano de' Medici. L., Night; R., Day. 1520–34. New Sacristy, San Lorenzo, Florence. (Al)

F. Michelangelo. Tomb of Lorenzo de' Medici. L., Twilight; R., Dawn. 1520–34. New Sacristy, San Lorenzo, Florence. (Al)

G. Michelangelo. Madonna with the Book. Unfinished. Bargello. (Al)

H. Michelangelo. Giuliano de' Medici. Detail of E.

I. Michelangelo. Lorenzo de' Medici. Detail of F. (Al)

J. Michelangelo. Dawn. Detail of F.

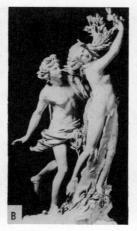

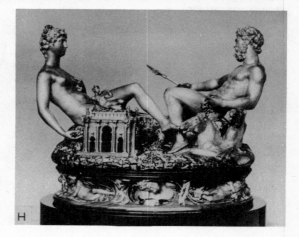

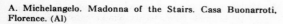

A. Michelangelo. Madonna of the Stairs. Casa Buonarroti, Florence. (Al)

B. Bernini. Apollo and Daphne. 1616. Borghese Gallery. (Al)

C. Bernini. Detail of B.

D. Giovanni da Bologna. Mercury. 1574. Bargello. (Al)

E. Bernini. St. Therese in Ecstasy. 1646. S.M. della Vittoria, Rome. (Al)

F. Cellini. Nymph of Fontainebleau. 1543. Louvre. (Arch. Photo.)

G. Cellini. Rospigliosi Cup. Metropolitan Museum. (Met)

H. Cellini. Saltcellar of Francis I. Kunstgeschichte, Vienna. (Plon)

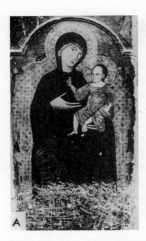

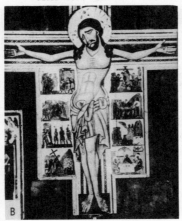

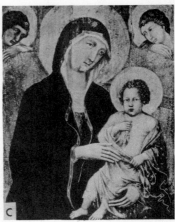

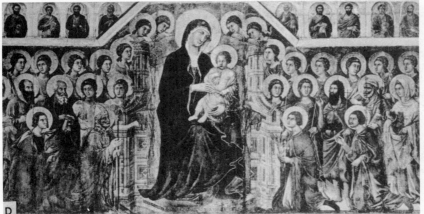

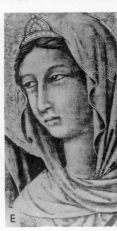

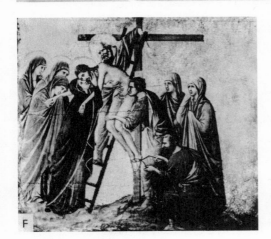

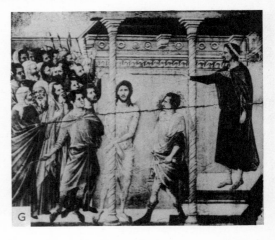

A. Italian School, XIII century. Madonna and Child. Fogg Museum. (Fogg)

B. Italian School, XIII century. Crucifixion. Uffizi.

C. Duccio. Detail of D.

D. Duccio. Majestà. 1308–11. Cathedral Museum, Siena. (Al)

E. Duccio. St. Agnes. Detail of D. (And)

F. Duccio. Deposition. Panel from back of D. (Al)

G. Duccio. Flagellation of Christ. Panel from back of D. (Al)

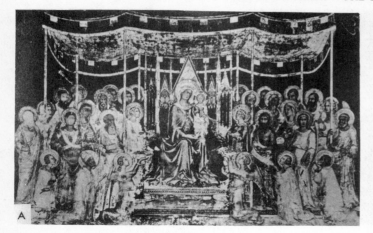

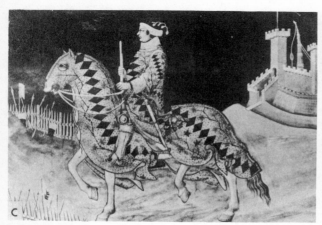

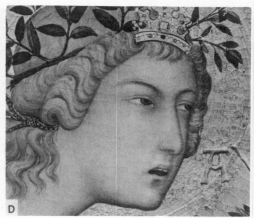

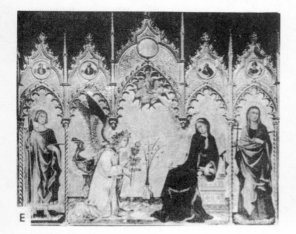

A. Simone Martini. Majestà. 1315. Palazzo Pubblico, Siena. (And)

B. Ambrogio Lorenzetti. Peace. Detail of Allegory of Good Government. 1337–43. Palazzo Pubblico, Siena. (Venturini)

C. Simone Martini. Guidoriccio da Fogliano. 1323. Palazzo Pubblico, Siena. (And)

D. Simone Martini. Detail of E.

E. Simone Martini and Lippo Memmi. Annunciation with SS. Ansano and Juliet. 1333. Uffizi. (Al)

F. Pietro Lorenzetti (?). Madonna and Child with Saints. San Francesco, Assisi. (Al)

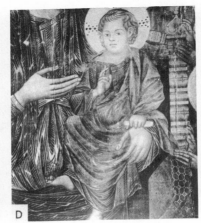

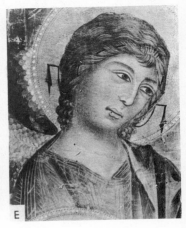

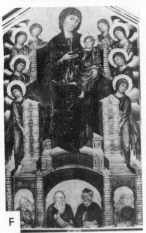

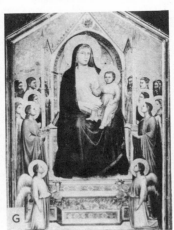

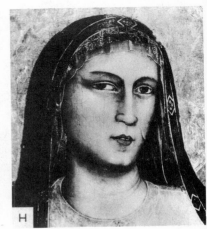

A. Ambrogio Lorenzetti, attributed to the followers of. Triumph of Death. Between 1350 and 1375. Campo Santo, Pisa. (Al)

B. Sassetta. Betrothal of St. Francis to Poverty. 1444. Musée Condé, Chantilly. (Al)

C. Master of the Rucellai Madonna. Sometimes attributed to Duccio. Detail of the Rucellai Madonna. 1285? Santa Maria Novella, Florence. (And)

D. Cimabue. Detail of F. (Brogi)

E. Cimabue. Detail of F. (Brogi)

F. Cimabue. Virgin Enthroned. Uffizi. (Brogi)

G. Giotto. Virgin Enthroned. Uffizi. (And)

H. Giotto. Detail of G.

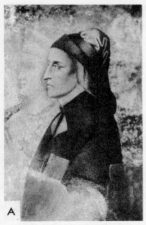

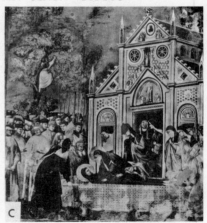

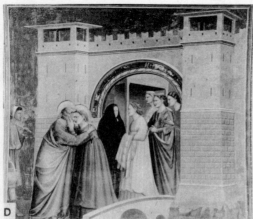

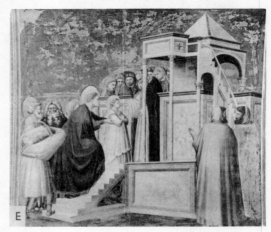

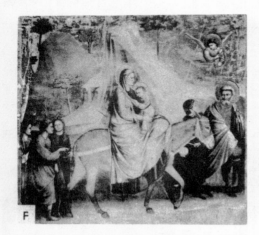

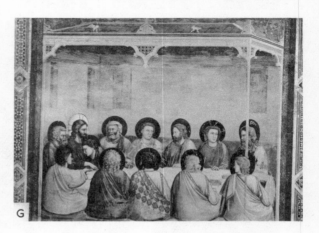

A. Giotto. Portrait of Dante. c. 1330. Bargello. (Al)

B. Giotto. St. Francis Preaching to the Birds. c. 1300. San Francesco, Upper Church, Assisi. (See 92 C.) (And)

C. School of Giotto. Body of St. Francis received by St. Clara before the Church of St. Damian. San Francesco, Upper Church, Assisi. (Al)

D. Giotto. Meeting of Joachim and Anna. c. 1305. Arena Chapel, Padua. (Al)

E. Giotto. Presentation of the Virgin in the Temple. c. 1305. Arena Chapel, Padua. (Al)

F. Giotto. Flight into Egypt. c. 1305. Arena Chapel, Padua. (Al)

G. Giotto. Last Supper. c. 1305. Arena Chapel, Padua. (See 121 A.) (Al)

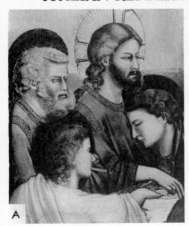

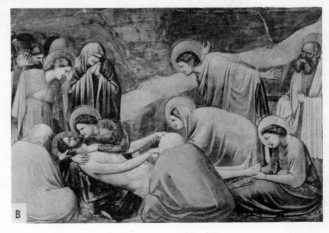

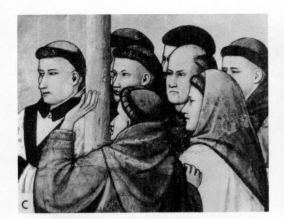

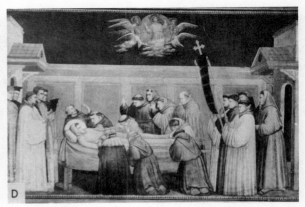

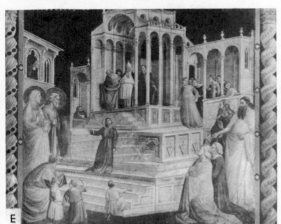

A. Giotto. Detail of Last Supper. c. 1305. Arena Chapel, Padua. (See 120 G.) (Al)

B. Giotto. Pietà. Detail. c. 1305. Arena Chapel, Padua. (Al)

C. Giotto. Detail of the Vision of St. Francis. c. 1325. Santa Croce, Florence. (Al)

D. Giotto. Death of St. Francis. c. 1325. Bardi Chapel, Santa Croce, Florence. (And)

E. Taddeo Gaddi. Presentation of the Virgin in the Temple. c. 1335. Baroncelli Chapel, Santa Croce, Florence. (Al)

F. Taddeo Gaddi. Adoration of the Kings. c. 1335. Baroncelli Chapel, Santa Croce, Florence. (Al)

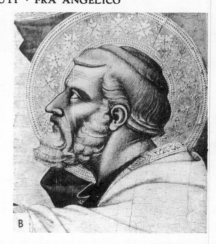

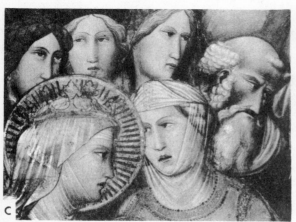

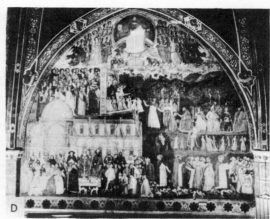

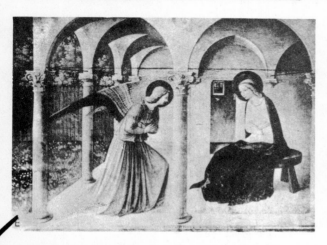

A. Agnolo Gaddi. Story of the True Cross. 1380. Santa Croce, Florence. (Al)

B. Orcagna. Detail of Christ Enthroned. 1357. Santa Maria Novella, Florence. (Brogi)

C. Agnolo Gaddi. Detail of Story of the True Cross. 1380. Santa Croce, Florence. (Al)

D. Andrea Bonaiuti (Andrea da Firenze). Dominican Allegory of Church Militant and Triumphant. c. 1370. Spanish Chapel, Santa Maria Novella, Florence. (And)

E. Fra Angelico. Annunciation. 1439–45. San Marco, Florence. (Al)

F. Fra Angelico. Coronation of the Virgin. 1439–45. San Marco, Florence. (Al)

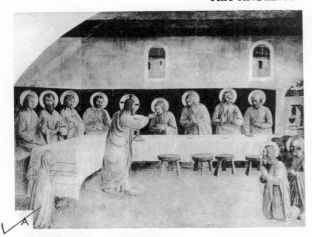

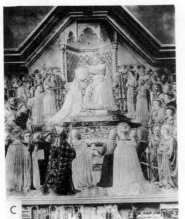

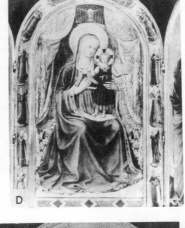

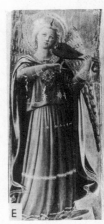

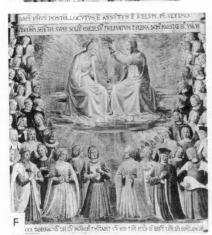

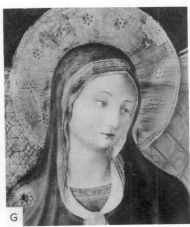

A. **Fra Angelico.** Last Supper. 1439–45. San Marco, Florence.

B. **Fra Angelico.** Flight into Egypt. San Marco, Florence.

C. **Fra Angelico.** Coronation of the Virgin. 1435. Louvre. (Louvre)

D. **Fra Angelico.** Madonna of the Linaiuoli. 1433. San Marco, Florence. (And)

E. **Fra Angelico.** Angel Musician. Detail of Border of D.

F. **School of Fra Angelico.** Detail of Coronation of the Virgin. San Marco, Florence.

G. **Fra Angelico.** Detail of Madonna. Pinacotheca, Perugia.

H. **Masaccio.** Expulsion of Adam and Eve. c. 1425–28. Brancacci Chapel, Santa Maria del Carmine, Florence. (Al)

A. Masaccio. Detail of the Tribute Money. c. 1425–28. Brancacci Chapel, Santa Maria del Carmine, Florence. (And)

B. Masaccio. Detail of the Tribute Money. c. 1425–28. Brancacci Chapel, Santa Maria del Carmine, Florence. (Al)

C. Masaccio. SS. Peter and John Distributing Alms. c. 1425–28. Brancacci Chapel, Santa Maria del Carmine, Florence. (And)

D. Masaccio. St. Peter. Detail of C.

E. Masaccio or Filippino Lippi. Portrait of an Unknown Man. Uffizi.

F. Masolino. Feast of Herod. c. 1435. Castiglione d' Olona, Baptistry.

G. Uccello. Rout of San Romano. c. 1435. National Gallery, London.

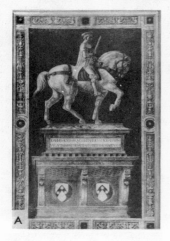

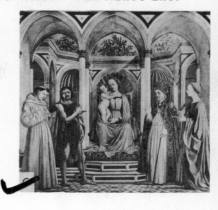

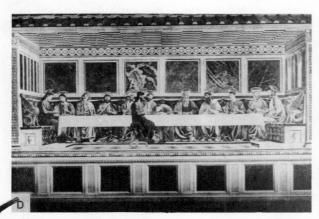

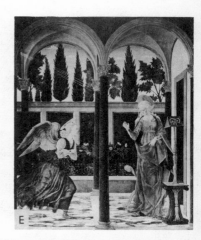

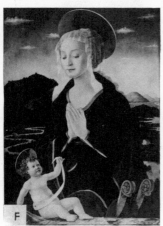

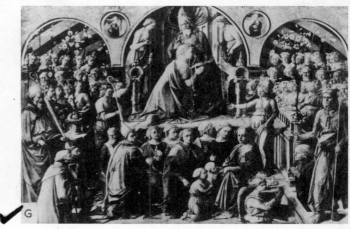

**A. Uccello. Tomb Portrait of Sir John Hawkwood. 1437. Cathedral, Florence. (Al)**

**B. Andrea del Castagno. Pippo Spano. c. 1434. Sant' Apollonia, Florence. (Al)**

**C. Domenico Veneziano. Madonna Enthroned. Uffizi.**

**D. Andrea del Castagno. Last Supper. 1450 Sant' Apollonia, Florence. (Al)**

**E. Baldovinetti. Also attributed to Pesellino. Annunciation. Uffizi.**

**F. Baldovinetti. Madonna and Child. c. 1460. Louvre. (Al)**

**G. Fra Filippo Lippi. Coronation of the Virgin. 1441. Uffizi. (See 126 A.) (Al)**

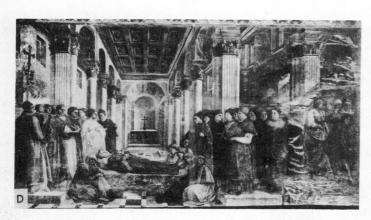

A. Fra Filippo Lippi. Self Portrait. (Detail of 125 G.)

B. Fra Filippo Lippi. Madonna and Child. Early work. Uffizi. (Al)

C. Benozzo Gozzoli. Detail of Journey of the Magi. Lorenzo de' Medici. 1459–63. Chapel of Medici Palace, Florence. (Al)

D. Fra Filippo Lippi. Funeral of St. Stephen. 1464. Cathedral, Prato. (Al)

E. Benozzo Gozzoli. Detail of Journey of the Magi. 1459-63. Chapel of Medici Palace, Florence. (Al)

F. Benozzo Gozzoli. Detail of E. Cosimo de' Medici, Salviati and Piero de' Medici. (Al)

G. Benozzo Gozzoli. Detail of E. Self Portrait. (Al)

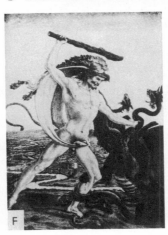

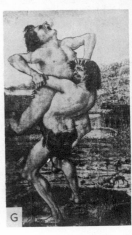

A. Benozzo Gozzoli. Detail of Journey of the Magi. 1459–63. John Paleologus. Chapel of Medici Palace, Florence. (Al)

B. Benozzo Gozzoli. St. Augustine as a Teacher of Rhetoric. 1463–67. San Gimignano. (Al)

C. Antonio Pollaiuolo. Tobias and the Angel. Turin.

D. Antonio Pollaiuolo. Battle of the Nudes. Engraving. 1465–80. Collection Paul J. Sachs. (Fogg)

E. Antonio Pollaiuolo. Apollo and Daphne. National Gallery, London.

F. Antonio Pollaiuolo. Hercules and the Hydra. 1460. Uffizi.

G. Antonio Pollaiuolo. Hercules and Antaeus. 1460. Uffizi.

## FIORENZO DI LORENZO · PIERO DELLA FRANCESCA · DOMENICO GHIRLANDAIO

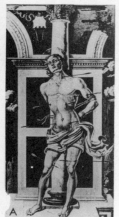

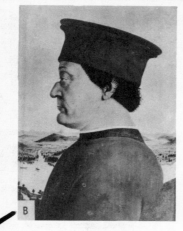

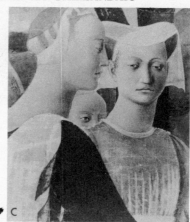

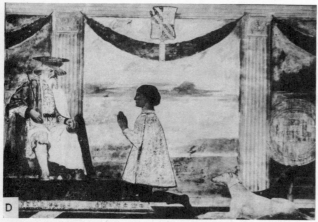

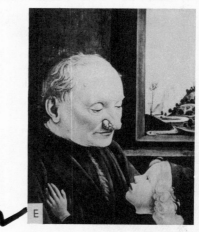

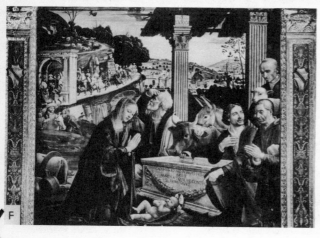

A. Fiorenzo di Lorenzo. St. Sebastian. Early work. Perugia.

B. Piero della Francesca. Federigo da Montefeltro, Duke of Urbino. 1465. Uffizi. (And)

C. Piero della Francesca. Detail of Visit of Queen of Sheba. 1452–66. San Francesco, Arezzo. (Al)

D. Piero della Francesca. Sigismund Malatesta Kneeling Before his Patron St. Sigismund. 1451. San Francesco, Rimini. (Brogi)

E. Domenico Ghirlandaio. Old Man and Boy. Louvre. (Louvre)

F. Domenico Ghirlandaio. Adoration of the Shepherds. 1485. Academy, Florence.

G. Domenico Ghirlandaio. St. Jerome. c. 1480. Church of the Ognissanti, Florence. (Al)

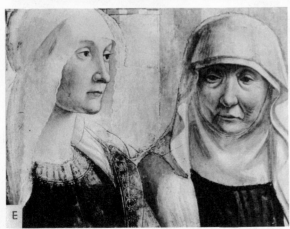

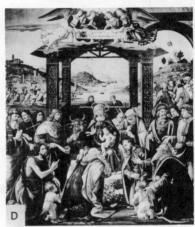

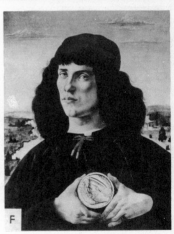

A. Domenico Ghirlandaio and Pupils. Last Supper. c. 1480. San Marco, Florence.

B. Domenico Ghirlandaio and Pupils. Detail of C.

C. Domenico Ghirlandaio and Pupils. Birth of the Virgin. 1486–90. Santa Maria Novella, Florence.

D. Domenico Ghirlandaio and Pupils. Adoration of the Magi. 1488. Hospital of the Innocents, Florence. (And)

E. Domenico Ghirlandaio and Pupils. Detail of C.

F. Botticelli. Giovanni di Cosimo de' Medici (?). Early Work. Uffizi.

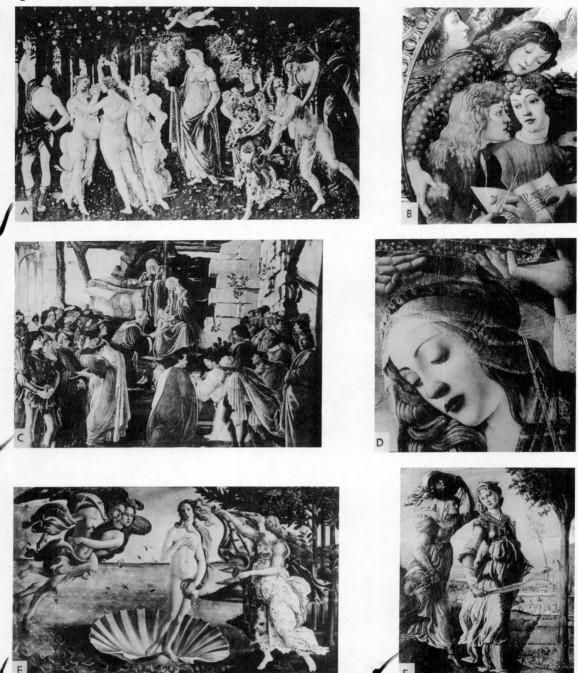

A. Botticelli. Spring (Primavera). c. 1475. Uffizi. (Al)

B. Botticelli. Detail of the Madonna of the Magnificat. c. 1466. Uffizi. (And)

C. Botticelli and Followers. Adoration of the Kings. 1478. Uffizi. (Al)

D. Botticelli. Detail of the Madonna of the Magnificat. Head of the Madonna. c. 1466. Uffizi. (Al)

E. Botticelli. Birth of Venus. c. 1485. Uffizi. (Al)

F. Botticelli. Judith with the Head of Holfernes. c. 1475. Uffizi.

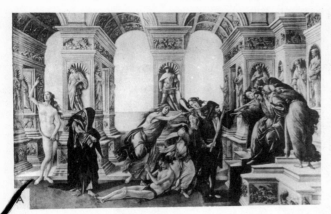

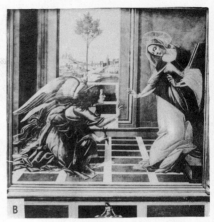

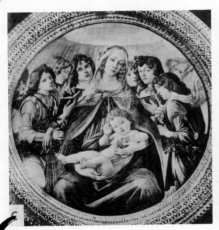

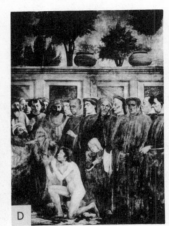

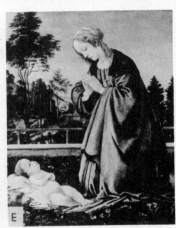

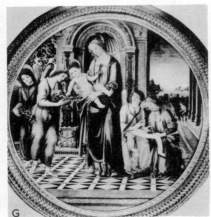

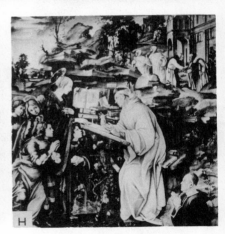

A. Botticelli. Calumny of Apelles. c. 1490. Uffizi. (And)

B. Botticelli. Annunciation. 1490. Uffizi.

C. Botticelli. Madonna with Six Angels. 1478. Uffizi.

D. Masaccio and Filippino Lippi. Raising of King Theophilus' Son by St. Peter. 1484–85. Brancacci Chapel, Santa Maria del Carmine, Florence. (See p. 124.) (Al)

E. Filippino Lippi. Madonna Adoring Child. Uffizi. (Al)

F. Filippino Lippi. Detail of D.

G. Filippino Lippi. Madonna and Child with Angels. Early work. Corsini Palace, Florence. (And)

H. Filippino Lippi. Vision of St. Bernard. 1480. Badia, Florence.

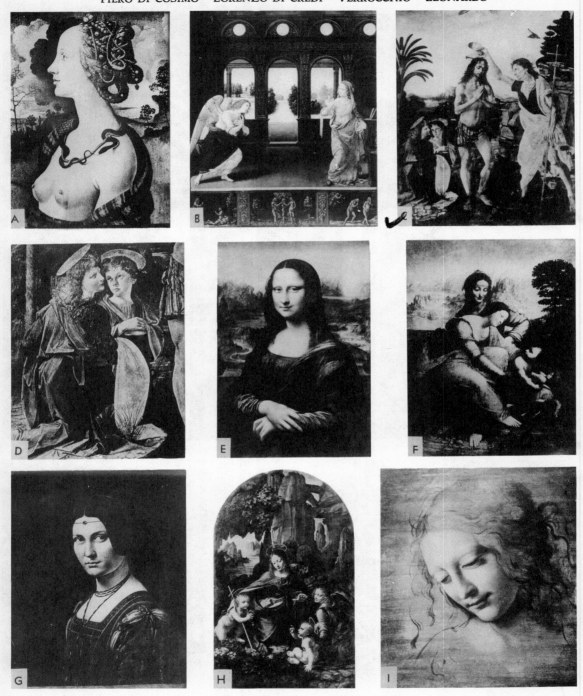

A. Piero di Cosimo. Simonetta Vespucci (La Bella Simonetta).
Musée Condé, Chantilly.

B. Lorenzo di Credi. Annunciation. Early work. Uffizi.

C. Verrocchio and Leonardo. Baptism of Christ. Before 1470.
Uffizi.

D. Leonardo. Detail of C.

E. Leonardo. Mona Lisa. 1500–04. Louvre. (Al)

F. Leonardo. St. Anne, Madonna and Child. c. 1510. Louvre.
(Louvre)

G. Leonardo. La Belle Ferronière. Louvre.

H. Leonardo. Madonna of the Rocks. Before 1499. National
Gallery, London.

I. Leonardo. Study for Head of Leda. Windsor Castle, London.

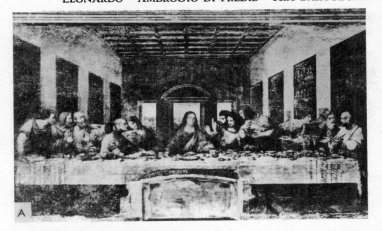

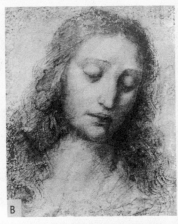

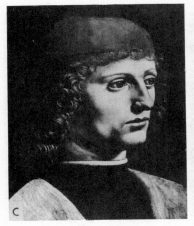

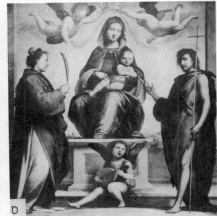

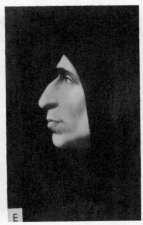

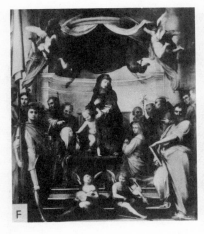

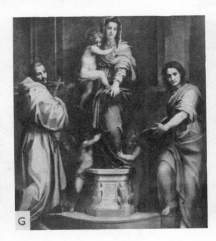

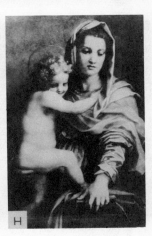

A. Leonardo. Last Supper. c. 1495–98. Refectory of Monastery of Santa Maria delle Grazie, Milan. (And)

B. Attributed to Leonardo. Head of Christ. Brera, Milan. (Al)

C. Leonardo (?). Portrait of a Man. Attributed also to Ambrogio di Predis. Detail. Ambrosiana, Milan. (Al)

D Fra Bartolommeo. Madonna and Saints. 1509. San Martino, Lucca. (Al)

E. Fra Bartolommeo. Savonarola. Detail. San Marco, Florence.

F. Fra Bartolommeo. Virgin Enthroned. Uffizi

G. Andrea del Sarto. Madonna of the Harpies. 1517. Uffizi. (Al)

H. Andrea del Sarto. Detail of G.

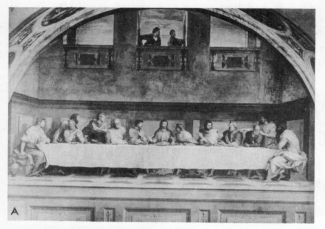

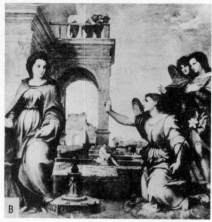

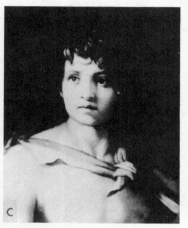

A. Andrea del Sarto. Last Supper. 1527. San Salvi, Florence.

B. Andrea del Sarto. Annunciation. 1528. Pitti.

C. Andrea del Sarto. St. John the Baptist. Detail. Pitti. (Al)

D. Andrea del Sarto. Holy Family. Barberini Gallery, Rome.

E. Andrea del Sarto. Charity. c. 1520. Scalzo Cloister, Florence. (Al)

F. Pontormo. Cosimo de' Medici. Uffizi. (Traldi)

G. Bronzino. Don Garzia de' Medici. Uffizi.

H. Gentile da Fabriano. Detail of Adoration of the Magi. Uffizi. (See 135 A.) (Al)

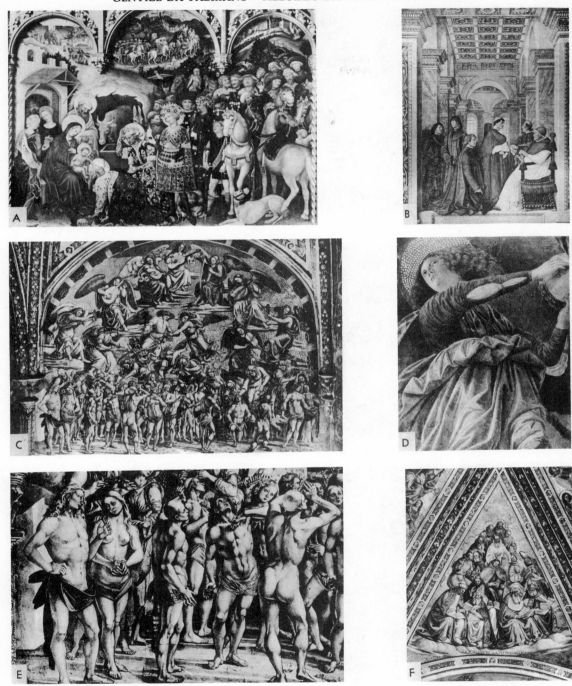

A. Gentile da Fabriano. Adoration of the Magi. 1423. Uffizi. (See 134 H.) (Al)

B. Melozzo da Forli. Pope Sixtus IV Giving Audience to Platina. 1473–81. Vatican: (And)

C. Signorelli. Paradise. c. 1500. Cathedral, Orvieto. (And)

D. Melozzo da Forli. Angel with Tambourine. 1475–80. Vatican Museum. (And)

E. Signorelli. Detail of C. (And)

F. Signorelli. Church Fathers. c. 1500. Cathedral, Orvieto. (And)

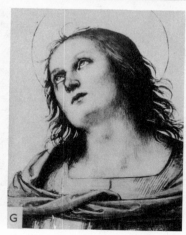

A. Signorelli. The Damned. c. 1500. Cathedral, Orvieto. (Al)

B. Signorelli and Pupils. Madonna and Child with SS. Jerome and Bernard. Corsini Palace, Florence. (And)

C. Signorelli. Detail of the Overthrow of the Anti-Christ. Portraits of Signorelli and Fra Angelico. c. 1500. Cathedral, Orvieto. (And)

D. Signorelli. Detail of the Resurrection. c. 1500. Cathedral, Orvieto. (And)

E. Perugino. Madonna and Saints. Pinacotheca, Bologna. (And)

F. Perugino. Christ Delivering the Keys to St. Peter. c. 1481. Sistine Chapel, Vatican. (Traldi)

G. Perugino. (Detail of 137 A, B.)

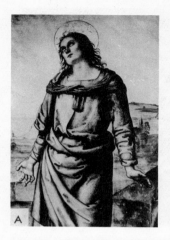

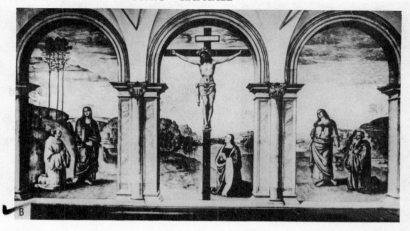

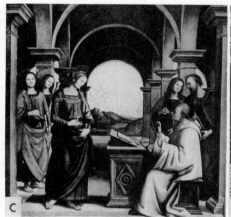

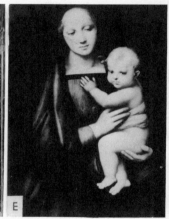

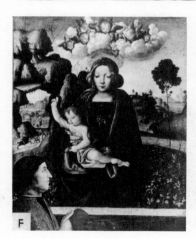

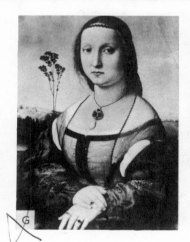

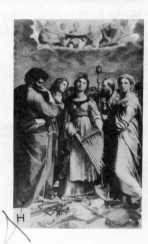

A. Perugino. Detail of B.

B. Perugino. Mystical Crucifixion. 1495. Santa Maria Maddalena dei Pazzi, Florence. (Al)

C. Perugino. Vision of St. Bernard. 1496–1500. Munich.

D. Pinturicchio. Aeneas Silvius Piccolomini (Pius II) at Ancona. 1464. Cathedral Library, Siena.

E. Raphael. Madonna del Granduca. 1505. Pitti. (Al)

F. Pinturicchio. Madonna and Child. Ambrosiana, Milan. (Brogi)

G. Raphael. Maddalena Doni. 1505. Pitti. (Traldi)

H. Raphael. St. Cecilia. 1513. Bologna. (And)

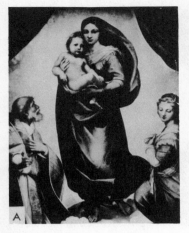

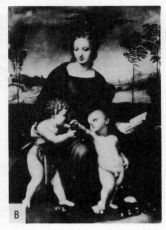

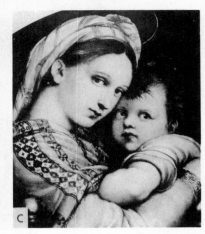

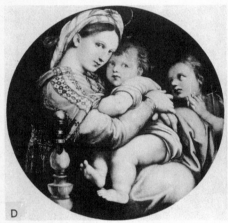

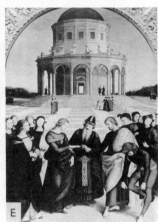

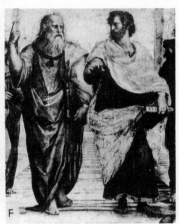

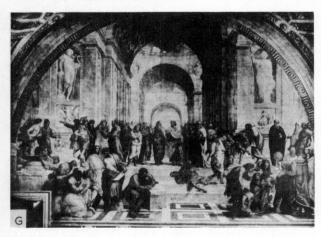

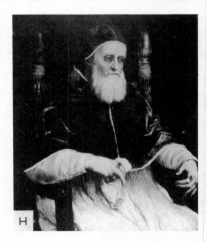

A. Raphael. Detail of Sistine Madonna. 1515. Gallery, Dresden. (Al)

B. Raphael. Madonna del Cardellino. 1506. Uffizi. (Brogi)

C. Raphael. Detail of D.

D. Raphael. Madonna of the Chair. c. 1516. Pitti. (And)

E. Raphael. Marriage of the Virgin (Sposalizio). 1504. Brera, Milan. (Al)

F. Raphael. Detail of G. Plato and Aristotle.

G. Raphael. School of Athens. 1509–11. Camera della Segnatura, Vatican. (And)

H. Raphael, attributed to. Pope Julius II. 1511–13. Uffizi. (And)

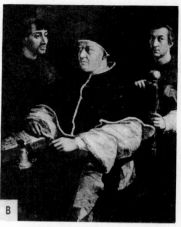

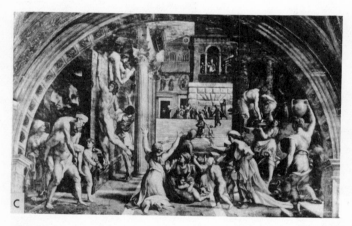

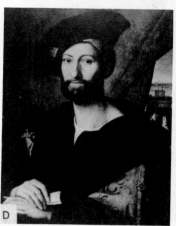

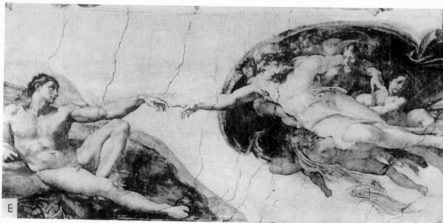

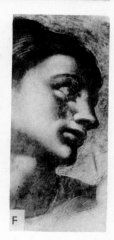

A. Raphael. Dispute of the Sacrament. 1509–11. Camera della Segnatura, Vatican. (Al)

B. Raphael. Leo X with Cardinals Rossi and Giulio de' Medici. 1519. Pitti. (And)

C. Design by Raphael, executed by Giulio Romano. The Fire in the Borgo. Finished 1517. Stanze of Raphael, Vatican. (Al)

D. Raphael. Giuliano de' Medici, duc de Nemours. 1514–15. Collection of Jules S. Bache, New York. (Jules S. Bache)

E. Michelangelo. Detail of the Sistine Chapel. Creation of Adam. 1508–12. Vatican.

F. Michelangelo. Detail of E. Head of Adam.

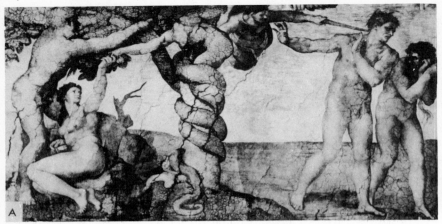

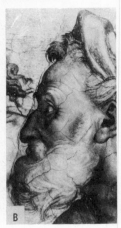

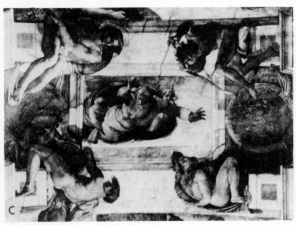

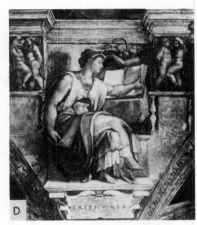

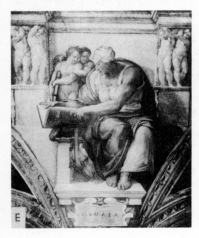

A. Michelangelo. Detail of the Ceiling of the Sistine Chapel. Temptation and Expulsion of Adam and Eve. 1508–12. Vatican.

B. Michelangelo. Detail of the Ceiling of the Sistine Chapel. Head of Ezekiel. (And)

C. Michelangelo. Detail of the Ceiling of the Sistine Chapel. God Hovering over the Waters.

D. Michelangelo. Detail of the Ceiling of the Sistine Chapel. The Erythraean Sibyl. (Al)

E. Michelangelo. Detail of the Ceiling of the Sistine Chapel. The Cumaean Sibyl. (Al)

F. Michelangelo. Detail of the Ceiling of the Sistine Chapel. The Prophet Jeremiah.

G. Michelangelo. Detail of the Ceiling of the Sistine Chapel. The Prophet Joel.

A. Michelangelo. Detail of the Ceiling of the Sistine Chapel. Libyan Sibyl. 1508–12.

B. Michelangelo. Detail of the Ceiling of the Sistine Chapel. Delphic Sibyl.

C. Michelangelo. Detail of B.

D. Michelangelo. Last Judgment. 1534–41. Sistine Chapel, Vatican. (And)

E. Michelangelo. Detail of D. Christ and the Virgin.

F. Michelangelo. Holy Family of the Doni. 1505. Uffizi. (Traldi)

G. Michelangelo. Detail of F.

H. Michelangelo. Entombment of Christ. National Gallery, London.

I. Copy of a Michelangelo cartoon for the Battle of Pisa. An engraving by Marcantonio Raimondi. 1505 (?), (Al)

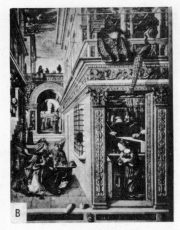

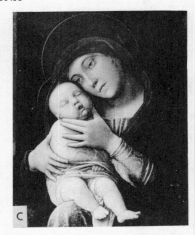

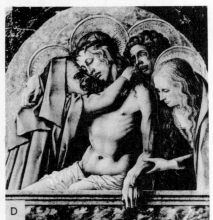

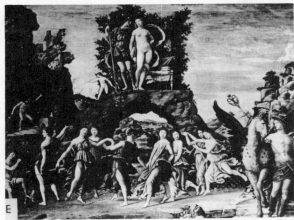

A. Vasari. Lorenzo de' Medici. Uffizi.

B. Carlo Crivelli. Annunciation. 1486. National Gallery, London.

C. Mantegna. Madonna and Child. Late work. Poldi-Pezzoli, Milan. (And)

D. Carlo Crivelli. Pietà. Metropolitan Museum. (Met)

E. Mantegna. Parnassus. c. 1500. Louvre.

F. Mantegna. Presentation of Christ in the Temple. Late work. Berlin.

G. Mantegna. Pietà. Late work. Brera, Milan. (And)

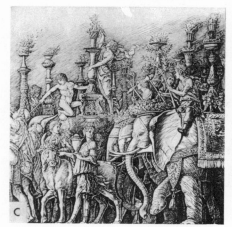

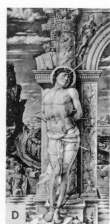

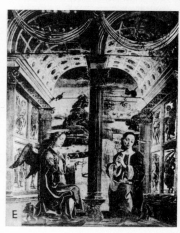

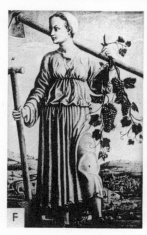

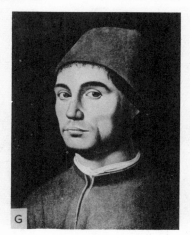

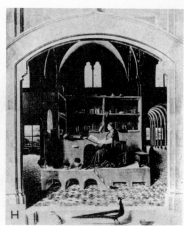

A. Mantegna. Agony in the Garden. Early work. National Gallery, London.

B. Mantegna. Holy Family. Late work. Gallery, Dresden.

C. School of Mantegna. Triumph of Caesar. Engraving.

D. Mantegna. St. Sebastian. Imperial Museum, Vienna. (Brogi)

E. Cosimo Tura. Annunciation. 1469. Duomo, Ferrara.

F. Francesco Cossa. Autumn. Berlin.

G. Antonello da Messina. Portrait of a Man (Il Condottière). 1475. Formerly Collection Somzée, Brussels.

H. Antonello da Messina. St. Jerome in his Study. National Gallery, London.

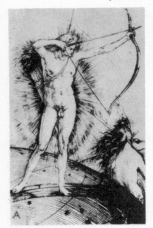

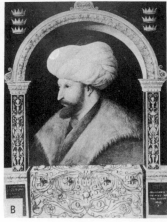

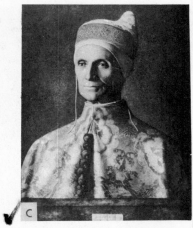

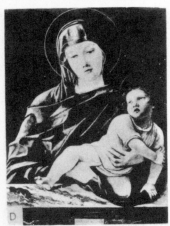

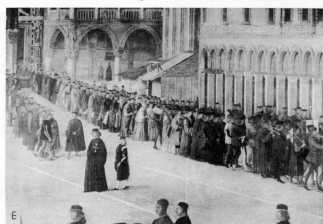

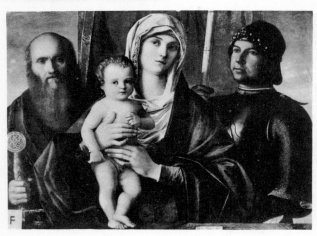

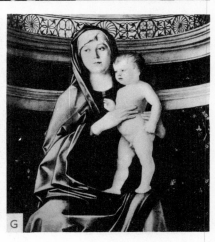

A. Jacopo da Barbari. Apollo and Diana. Engraving. Museum of Fine Arts. (M.F.A.)

B. Gentile Bellini. Sultan Mahomet II. 1480. National Gallery, London. (And)

C. Giovanni Bellini. Doge Loredano. 1505. National Gallery, London. (Hanf)

D. Giovanni Bellini. Madonna and Child. Collection of Carrara-Morelli, Bergamo.

E. Gentile Bellini. Detail of Corpus Christi Procession in Piazza San Marco, Venice. 1496. Academy, Venice. (And)

F. Giovanni Bellini. Madonna with SS. Paul and George. Between 1490 and 1510. Academy, Venice.

G. Giovanni Bellini. Detail of the Madonna and Saints. 1488. Frari. (Al)

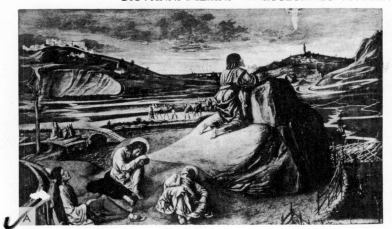

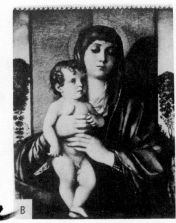

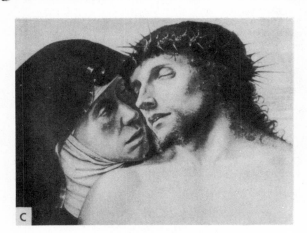

A. Giovanni Bellini. Agony in the Garden. c. 1470. National Gallery, London.

B. Giovanni Bellini. Madonna of the Trees. 1487. Academy, Venice. (Al)

C. Giovanni Bellini. Formerly attributed to Mantegna. Detail of Pietà. Heads of Christ and the Virgin. c. 1460. Brera, Milan.

D. Bartolommeo Vivarini. Madonna and Child with Saints. 1465. National Museum, Naples. (Al)

E. Carpaccio. Visitation. Late work. Academy, Venice. (Al)

F. Carpaccio. Legend of St. Ursula. The English Ambassadors Return to Their King. c. 1495. Academy, Venice. (And)

A. Carpaccio. Dream of St. Ursula. 1495. Academy, Venice. (And)

B. Carpaccio. Detail of C.

C. Carpaccio. Presentation of Christ in the Temple. 1510. Academy, Venice. (And)

D. Giorgione. Pastoral Symphony. Louvre.

E. Giorgione. Castelfranco Madonna. SS. Liberale and Francis. 1504. Castelfranco. (Al)

F. Giorgione. The Fire Ordeal of the Infant Moses. Early work. Uffizi.

G. Giorgione. Knight of Malta. Uffizi.

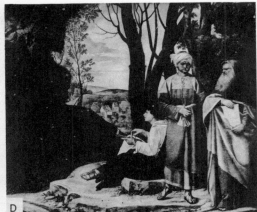

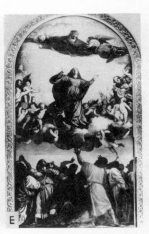

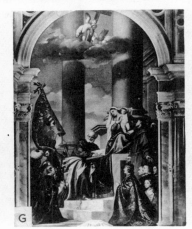

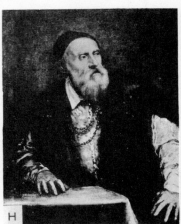

A. Giorgione. Also attributed to Titian. The Concert. c. 1510. Pitti. (Brogi)

B. Giorgione. Sleeping Venus. Landscape by Titian. Designed c. 1505. Gallery, Dresden. (Al)

C. Giorgione (?). Detail of A.

D. Giorgione (?). The Three Philosophers. Imperial Museum, Vienna. (Bruck)

E. Titian. Assumption of the Virgin. 1518. Frari, Venice. (And)

F. Titian. Detail of E.

G. Titian. Madonna of the Pesaro Family. 1526. Church of the Frari, Venice. (And)

H. Titian. Self Portrait. c. 1550. Berlin. (And)

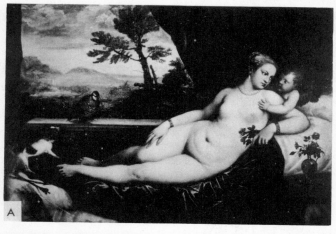

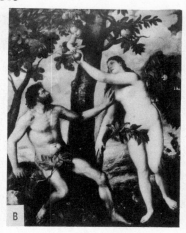

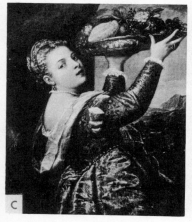

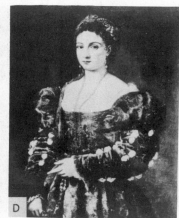

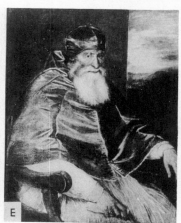

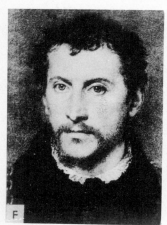

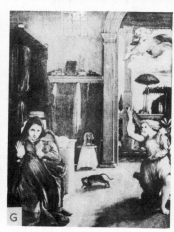

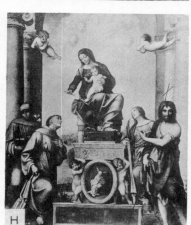

A. Titian. Venus. Late work. Uffizi. (And)

B. Titian. The Forbidden Fruit. c. 1565–70. Prado, Madrid. (And)

C. Titian. Lavinia. c. 1550. Berlin.

D. Titian. Eleanora Gonzaga, Duchess of Urbino (La Bella). Pitti. (Traldi)

E. Titian. Pope Paul III. 1543. National Museum, Naples. (Al)

F. Titian. Detail of Portrait of an Unknown Man. Sometimes called the Duke of Norfolk. 1540–45. Pitti. (Al)

G. Lotto. Annunciation. Santa Maria sopra Mercanti, Recanati. (Al)

H. Correggio. Madonna and Child with Saints. 1515. Dresden. (Al)

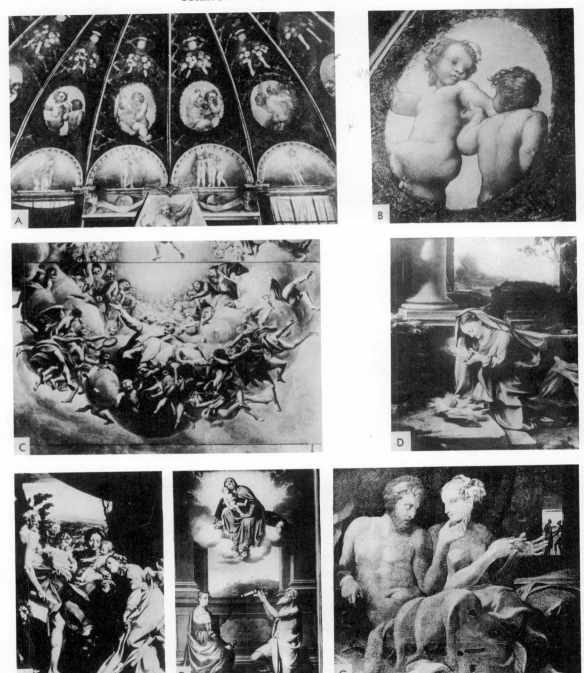

A. Correggio. Detail of Vault of Convent of San Paolo, Parma. 1518. (Al)

B. Correggio. Detail of A.

C. Correggio. Detail of Cupola of the Cathedral, Parma. The Assumption of the Virgin. 1518. (Al)

D. Correggio. The Virgin Adoring Her Son. Uffizi. (And)

E. Correggio. Madonna of St. Jerome. Parma. (Al)

F. Moroni. Madonna with SS. Catherine and Jerome. Cathedral, Bergamo.

G. Primaticcio. Ulysses and Penelope. Castle Howard.

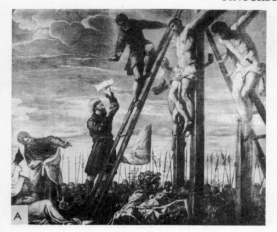

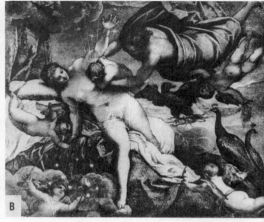

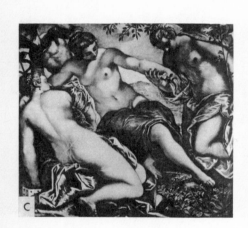

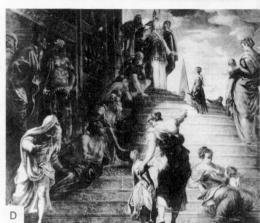

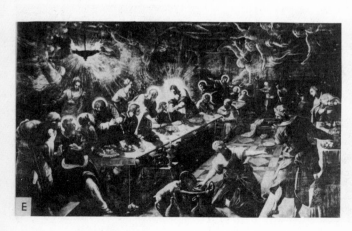

A. Tintoretto. The Crucifixion. c. 1575. San Cassiano, Venice. (And)

B. Tintoretto. Origin of the Milky Way. National Gallery, London.

C. Tintoretto. Mercury and the Three Graces. 1578. Anti-Collegio, Palace of the Doges, Venice. (Al)

D. Tintoretto. Presentation of the Virgin in the Temple. Early work. Santa Maria dell' Orto, Venice. (And)

E. Tintoretto. Last Supper. San Giorgio Maggiore, Venice.

F. Veronese. Rape of Europa. Detail. Anti-Collegio, Palace of the Doges, Venice. (And)

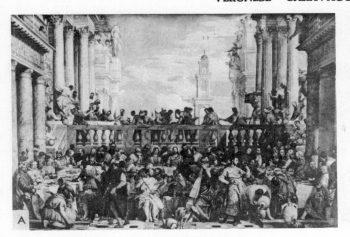

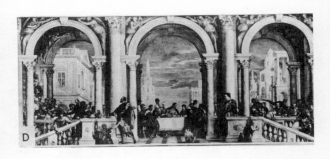

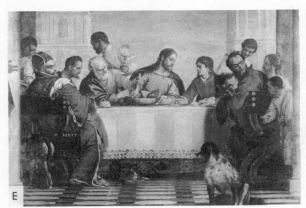

A. Veronese. Marriage at Cana. 1563. Louvre. (Al)

B. Veronese. Detail of Marriage at Cana. Head of Christ. Gallery, Dresden.

C. Veronese. Detail of A.

D. Veronese. Feast in the House of Levi. 1573. Academy, Venice. (Al)

E. Veronese. Detail of D.

F. Caravaggio. Conversion of St. Paul. Santa Maria del Popolo, Rome. (Al)

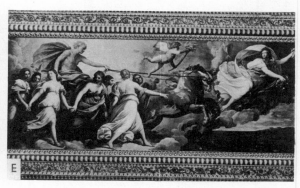

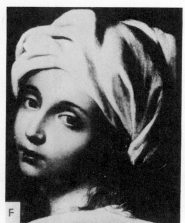

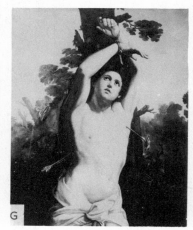

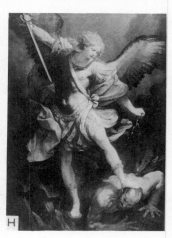

A. Caravaggio. Death of the Virgin. Louvre.

B. Caravaggio. Entombment. Vatican.

C. Ludovico Caracci. Ecstasy of St. Catherine. Borghese.

D. Salvator Rosa. Port Scene. Pitti.

E. Guido Reni. Aurora. c. 1615. Rospigliosi Palace, Rome. (Al)

F. Guido Reni. Beatrice Cenci. Barberini Gallery, Rome.

G. Guido Reni. St. Sebastian. Palazzo Rosso, Genoa. (And)

H. Guido Reni. Archangel Michael·Overcoming Satan. Santa Maria della Concezione, Rome. (And)

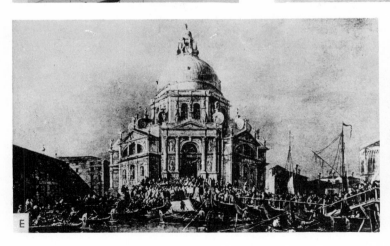

A. Tiepolo. Ceiling Decoration. The Rosary of St. Dominic. Santa Maria del Rosario, Venice.

B. Canaletto. The Arno in Florence. Budapest.

C. Tiepolo. Wash Drawing. Holy Family. Detail. Fogg Museum. (Fogg)

D. Pietro Longhi. The Coffee Shop. Venice.

E. Guardi. Procession in Front of Santa Maria della Salute. Louvre.

F. Liberale da Verona. XVI Cent. St. Martin Dividing His Cloak. Initial from a Choir Book. Piccolomini Library, Cathedral, Siena. (Al)

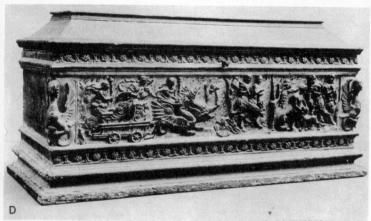

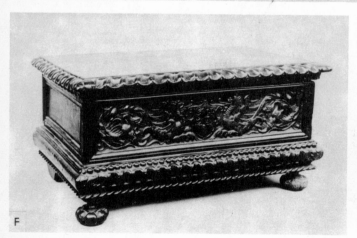

A. Armor. Royal Palace, Turin. (Al)

B. Velvet. XVI cent. Museum of Fine Arts. (M.F.A.)

C. Chair. XVI cent. Metropolitan Museum. (Met)

D. Cassone of Carved and Gilded Wood. Demeter and Hecate

Searching for Persephone. 1450–1500. Metropolitan Museum. (Met)

E. Stool of Carved Wood. Late XVI or early XVII cent. Metropolitan Museum. (Met)

F. Chest from Venice. XVI cent. Metropolitan Museum. (Met)

G. Choir Stalls. 1487–98. The Certosa, Pavia. (Brogi)

A. Jean Malouel (French) and Henri Bellechose. The Martyrdom of St. Denis. c. 1415. Louvre. (Gir)

B. Hubert and Jan van Eyck. The Ghent Altarpiece, outer panel. Angel of the Annunciation. Above, Zacharias. 1415–32. Church of St. Bavon, Ghent.

C. Hubert and Jan van Eyck. The Ghent Altarpiece, outer panel. Madonna of the Annunciation. Above, Matthew. 1415–32. Church of St. Bavon, Ghent.

D. Hubert and Jan van Eyck. The Ghent Altarpiece, open. (Adoration of the Lamb.) 1415–32. Church of St. Bavon, Ghent.

E. Detail of D.

F. Detail of D.

G. Hubert van Eyck. The Three Marys at the Tomb. Collection of Sir Herbert Cook, Richmond.

H. Jan van Eyck. Portrait of His Wife Margaret. 1439. Bruges Museum.

A. Jan van Eyck. Also attributed to Hubert. Madonna of Chancellor Rolin. c. 1432. Louvre. (X)

B. Jan van Eyck. Jan Arnolfini and His Wife. 1434. National Gallery, London.

C. Robert Campin. Portrait of a Man, perhaps Niccolo Strozzi. Kaiser Friedrich Museum.

D. Jan van Eyck. Detail of the Madonna with the Canon van der Paele. Portrait of the Canon. 1436. Bruges Museum. (Bruck)

E. Rogier van der Weyden. Portrait of a Lady. Collection of A. W. Mellon Educational and Charitable Trust. (Courtesy of the Trustees)

F. Robert Campin. The von Werl Altarpiece. Detail of one wing. St. Barbara. Prado. (And)

G. Rogier van der Weyden. Descent from the Cross. 1435–50. Escorial, Madrid.

H. Rogier van der Weyden. Madonna and Child. Kaiser Friedrich Museum.

A. Rogier van der Weyden. Adoration of the Magi. Gallery, Munich.

B. Petrus Christus. Legend of SS. Eligius and Godeberta. 1449. Collection of Philip Lehman, New York. (Philip Lehman)

C. Petrus Christus. Portrait of Dionysius the Carthusian (?). Collection of Jules S. Bache. (Duveen Brothers)

D. Petrus Christus. Portrait of a Lady of the Talbot Family. Kaiser Friedrich Museum.

E. Memlinc. R. panel from Diptych of Martin van Nieuwenhoven. 1487. Hospital of St. John, Bruges. (Bruck)

F. Justus of Ghent. The Last Supper. Ducal Gallery, Urbino.

G. Memlinc. Shrine of St. Ursula. 1489. Hospital of St. John, Bruges. (See 158 A, B)

A. Memlinc. Shrine of St. Ursula. 1489. Hospital of St. John, Bruges. (Bruck)

B. Memlinc. Shrine of St. Ursula. 1489. (Detail of 157 G.) Martyrdom of St. Ursula. (Bruck)

C. Memlinc. Central Panel of Altarpiece. Vienna, Imperial Museum.

D. Hugo van der Goes. Portinari Altarpiece. Central panel. Adoration of the Shepherds. 1476. Uffizi. (Brogi)

E. Hugo van der Goes. Detail of D.

F. Hugo van der Goes. Descent from the Cross. Copy. National Museum, Naples.

G. Hugo van der Goes. Portinari Altarpiece. Right panel. Wife and Daughter of the Donor with SS. Margaret and Mary Magdalene. 1476. Uffizi. (Brogi)

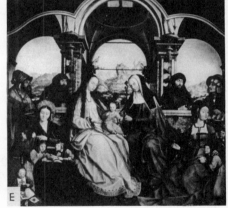

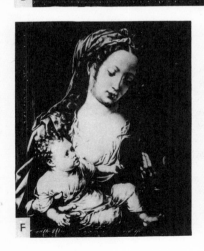

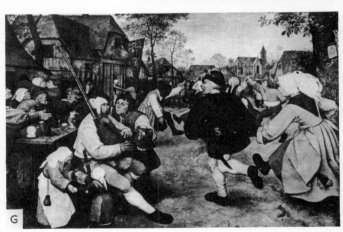

A. David. Canon and Saints. 1501. National Gallery, London.

B. David. Head of Christ. John G. Johnson Art Collection, Philadelphia. (John G. Johnson Art Coll.)

C. Massys (Matsys). Madonna and Child. Kaiser Friedrich Museum. (Berlin)

D. Massys. Banker and Wife. 1518. Louvre. (Gir)

E. Massys. Altarpiece of St. Anne. Central panel. 1509. Royal Museum, Brussels. (Bruck)

F. Gossaert (Mabuse). Madonna with Grapes. Kaiser Friedrich Museum.

G. Pieter Bruegel the elder (Breughel). Peasant Dance. 1568 (?). Vienna.

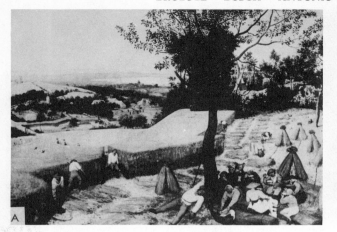

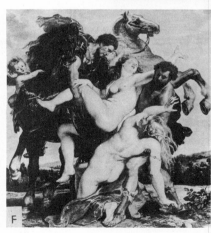

A. Pieter Bruegel the elder. Harvesters (August). Metropolitan Museum. (Met)

B. Bosch. Mocking of Christ. Escorial, Madrid.

C. Pieter Bruegel the elder. The Blind Beggars. 1568. National Museum, Naples. (And)

D. Antonio Moro. Alessandro Farnese. Parma.

E. Pieter Bruegel the elder. Massacre of the Innocents. Detail. 1566 (?). Vienna, Gallery. (Bruck)

F. Rubens. Rape of the Daughters of Leucippus. 1619 or 1620. Picture Gallery, Munich.

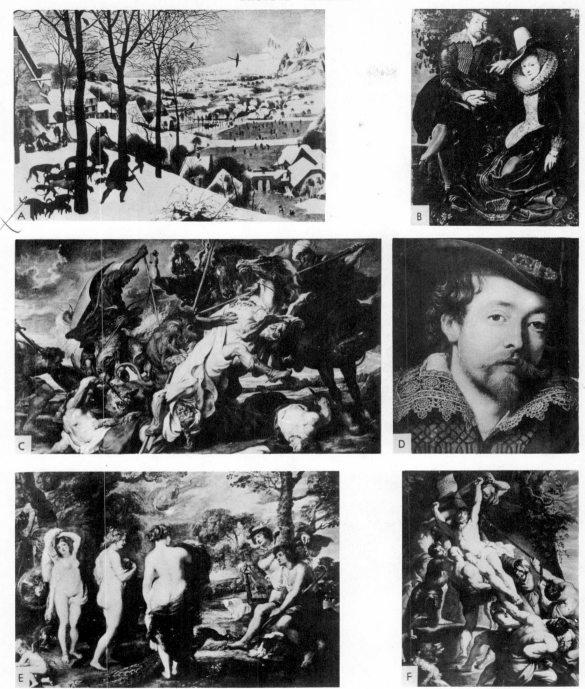

A.  Pieter Bruegel the elder. Hunters in the Snow. 1565. Vienna.

B.  Rubens. Self Portrait with Isabella Brant. 1609–10. Gallery, Munich. (Bruck)

C.  Rubens. Lion Hunt. 1616–21. Gallery, Munich.

D.  Rubens. Self Portrait. Detail of B.

E.  Rubens. Judgment of Paris. c. 1625. National Gallery, London.

F.  Rubens. Elevation of the Cross. Central panel of a Triptych. 1610–11. Antwerp.

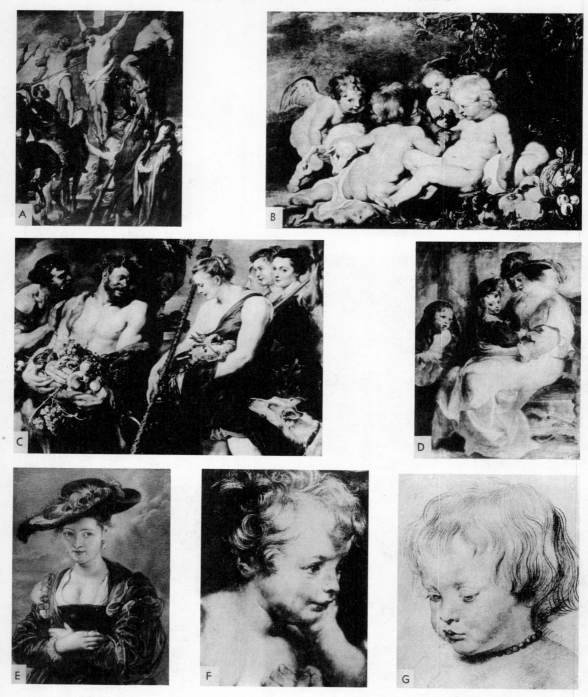

A. Rubens. Crucifixion (Coup de Lance). 1620. Antwerp.

B. Rubens (School Work). Infants Christ, St. John and Angels. c. 1615–20. Vienna.

C. Rubens. Return of Diana from the Hunt. 1615–17. Picture Gallery, Dresden. (Al)

D. Rubens. Helena Fourment and Children. c. 1635–38. Louvre.

E. Rubens. Suzanne Fourment (The Straw Hat). c. 1620. National Gallery, London. From a wood engraving by Timothy Cole, 1905. Collection of F. J. Roos, Jr. (See p. 309 D for magnified detail)

F. Rubens. Head of Infant St. John. Detail of a Holy Family. Pitti. (And)

G. Rubens. Head of Nicholas Rubens. Drawing. Vienna.

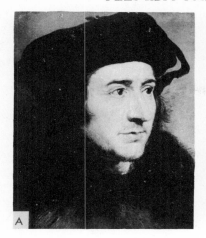

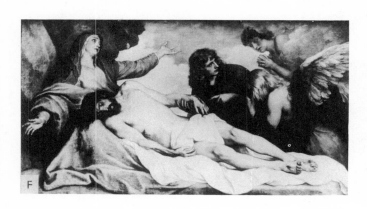

A. Rubens. Sir Thomas More. Detail. Prado, Madrid.

B. Rubens. Landing of Marie de' Medici at Marseilles. 1621–25. Louvre. (Al)

C. Van Dyck. Charles I of England. 1635. Louvre. (See 164 B, F)

D. Rubens. Kermess. c. 1635. Louvre.

E. Van Dyck. Children of Charles I. 1635. Picture Gallery, Turin. (L'Epi)

F. Van Dyck. Pietà, with Madonna, St. John and Angels. 1634. Royal Museum, Antwerp.

G. Van Dyck. James II, son of Charles I. Detail of E.

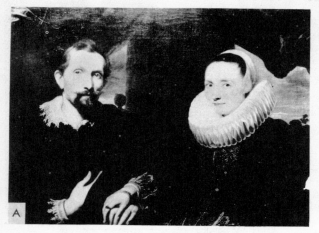

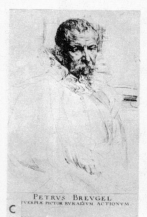

PETRVS BREVGEL
IVERPIÆ PICTOR RVRALIVM ACTIONVM.

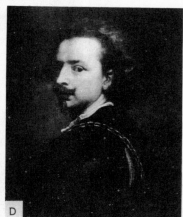

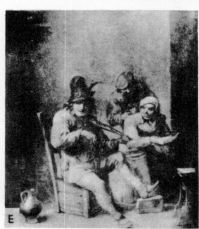

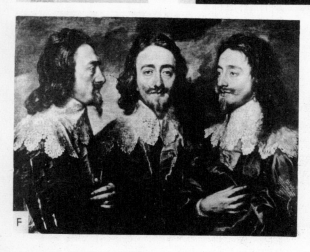

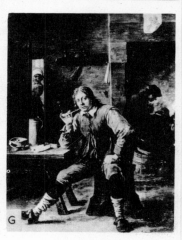

A. Van Dyck. Frans Snyders and His Wife. Picture Gallery Cassel. (L'Epi)

B. Van Dyck. Charles I on Horseback. c. 1636. National Gallery, London. (See 163 C)

C. Van Dyck. Pieter Bruegel the younger. Etching. Fogg Museum. (Fogg)

D. Van Dyck. Self Portrait. Uffizi. (Al)

E. David Teniers the younger. Peasant Interior. Louvre. (Al)

F. Van Dyck. Triple Portrait of Charles I. c. 1637. Windsor Castle.

G. David Teniers the younger. The Smoker. Louvre. (Bruck)

# FLEMISH PAINTING · XVII CENT. · TENIERS
# GERMAN ARCHITECTURE · XVII–XVIII CENT.

165

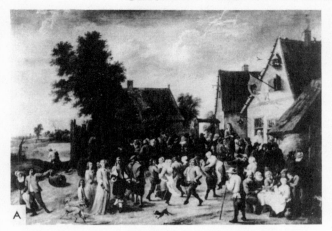

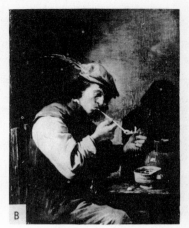

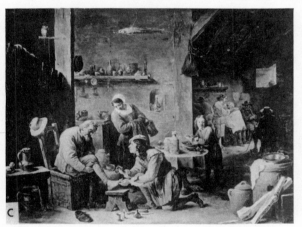

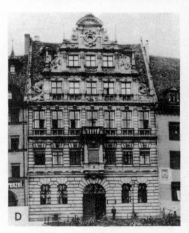

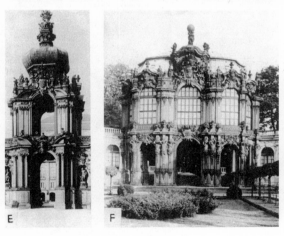

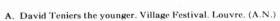

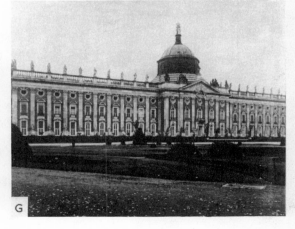

A. David Teniers the younger. Village Festival. Louvre. (A.N.)

B. David Teniers the younger. Man Lighting a Pipe. Art Institute. (Art Inst.)

C. David Teniers the younger. Barber Shop. Picture Gallery, Cassel.

D. Peller House, Nuremberg. 1605.

E. Zwinger Palace, Dresden. 1711.

F. Zwinger Palace, Dresden. 1711.

G. New Palace, Potsdam. 1763–69.

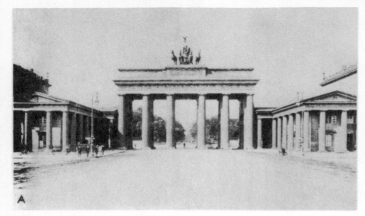

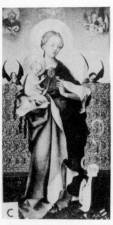

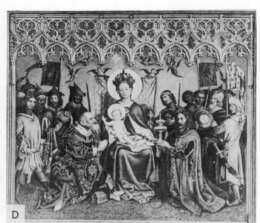

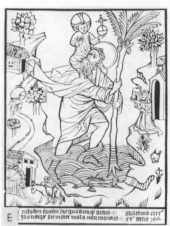

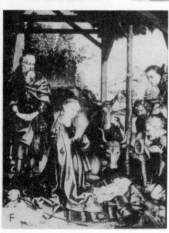

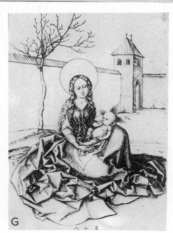

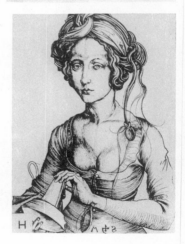

A. Brandenburg Gate, Berlin. 1788–91. Langhans, architect.

B. Peter Vischer the elder. King Arthur. XVI cent. Innsbruck.
(Reiffenstein)

C. Lochner. Madonna with the Violet. Archiepiscopal Palace,
Cologne. (Bruck)

D. Lochner. Altarpiece. Central panel. Cologne Cathedral.
(Bruck)

E. German School. St. Christopher Bearing the Infant Christ.
Woodcut. 1423. John Rylands Library, Manchester. (Fogg)

F. Schongauer. Nativity. Kaiser Friedrich Museum.

G. Schongauer. Madonna and Child in a Courtyard. Engrav-
ing. Museum of Fine Arts. (M.F.A.)

H. Schongauer. Foolish Virgin. Engraving. Fogg Museum.
(Fogg)

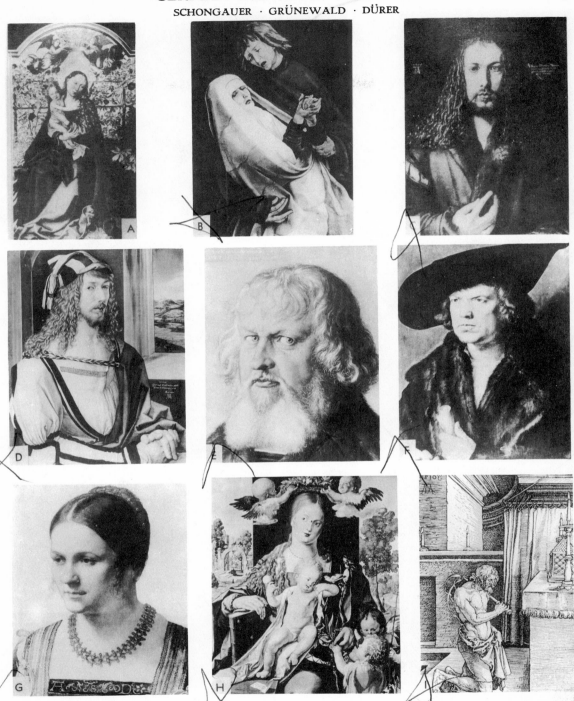

A. Schongauer. Madonna in a Rose Hedge. 1473. Church of St. Martin, Colmar. (Bruck)

B. Grünewald. Detail of Central Panel of a Crucifixion. Virgin with St. John the Evangelist. 1510–14. Museum, Colmar.

C. Dürer. Self Portrait. 1500. Old Picture Gallery, Munich. (Bruck)

D. Dürer. Self Portrait. 1498. Prado, Madrid. (And)

E. Dürer. Heironymus Holzschuher. 1526. Kaiser Friedrich Museum.

F. Dürer. Jobst Plankfelt of Antwerp. Formerly called Hans Imhof. 1521. Prado, Madrid. (And)

G. Dürer. Portrait of a Young Woman. 1506 (?). Kaiser Friedrich Museum.

H. Dürer. Virgin with the Siskin. 1506. Kaiser Friedrich Museum.

I. Dürer. The Penitent. Woodcut. 1510. Fogg Museum. (See p. 309 A for magnified detail.) (Fogg)

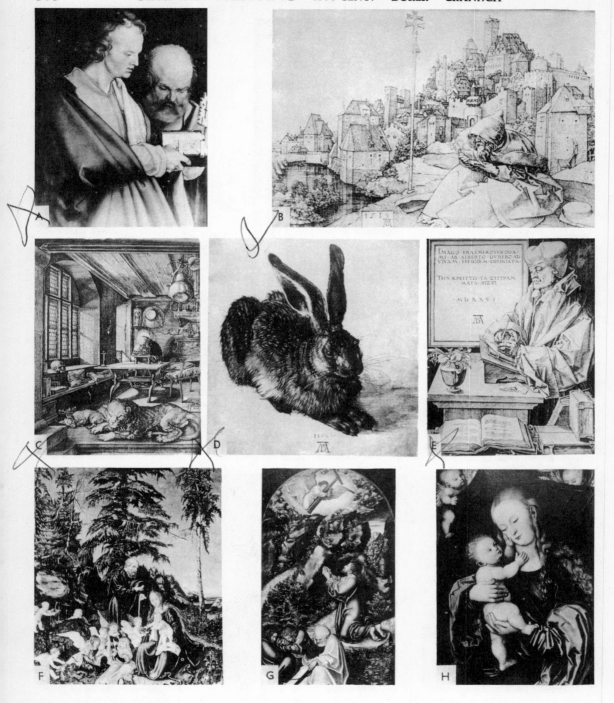

A. Dürer. SS. John the Evangelist and Peter. Detail. 1526. Old Picture Gallery, Munich. (Bruck)

B. Dürer. St. Anthony. Engraving. 1519. Fogg Museum. (Fogg)

C. Dürer. St. Jerome in His Study. Engraving. 1514. Fogg Museum. (Fogg)

D. Dürer. Young Hare. Water color. 1502. Albertina, Vienna. (Wolfrum)

E. Dürer. Erasmus. Engraving. 1526. Fogg Museum. (Fogg)

F. Lucas Cranach the elder. Rest on the Flight into Egypt. Kaiser Friedrich Museum.

G. Cranach. Christ in the Garden of Gethsemane. Picture Gallery, Dresden.

H. Cranach. Madonna and Child. Frankfurt-am-Main.

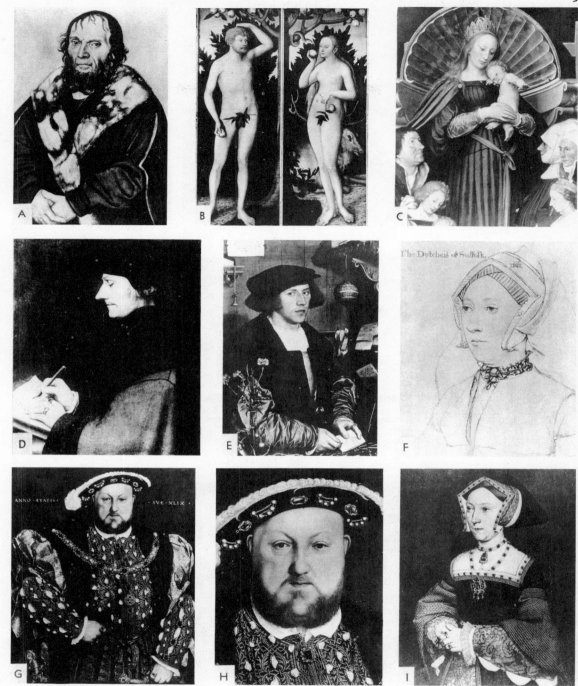

A. Lucas Cranach the elder. Dr. Scheuring. Royal Museum, Brussels.

B. Cranach. Adam and Eve. Picture Gallery, Dresden.

C. Hans Holbein the younger. Madonna of the Burgomaster Meyer. Detail. 1526 (?). Ducal Palace, Darmstadt. (Bruck)

D. Holbein. Erasmus. 1523. Picture Gallery, Basel.

E. Holbein. George Gisze. Detail. 1532. Kaiser Friedrich Museum.

F. Holbein. Duchess of Suffolk. Between 1527–40. Windsor Castle.

G. Holbein. Henry VIII. c. 1537. Corsini Gallery, Rome. (And)

H. Holbein. Henry VIII. Detail of G.

I. Holbein. Jane Seymour. 1537. Imperial Museum, Vienna.

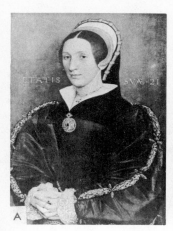

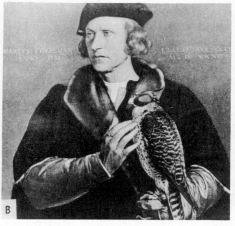

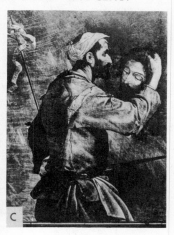

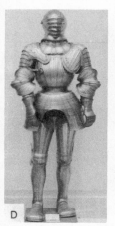

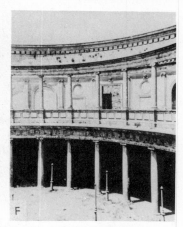

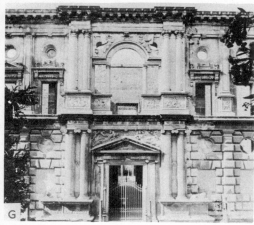

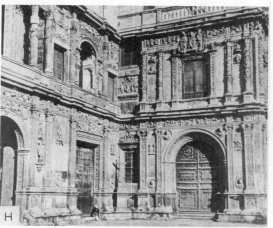

A. Holbein. Catherine Howard. 1540–41. Edward Drummond Libby Collection, Toledo Museum. (Toledo Museum)

B. Holbein. Robert Cheseman. 1533. Detail. Royal Museum, The Hague. (Bruck)

C. Prince Rupert. The Large Executioner. After 1660. Mezzotint. Museum of Fine Arts. (See p. 309 B for magnified detail.) (M.F.A.)

D. Suit of Armor, Maximilian Style. c. 1520. Cleveland Museum. (Clev. Mus.)

E. Salamanca University. Detail of portal. Plateresque. c. 1530. (See 90 H)

F. Court of the Palace of Charles V, Granada. 1527. (Gonzalez)

G. Palace of Charles V, Granada. 1527. (Gonzalez)

H. Town Hall, Seville. Plateresque. 1534–72.

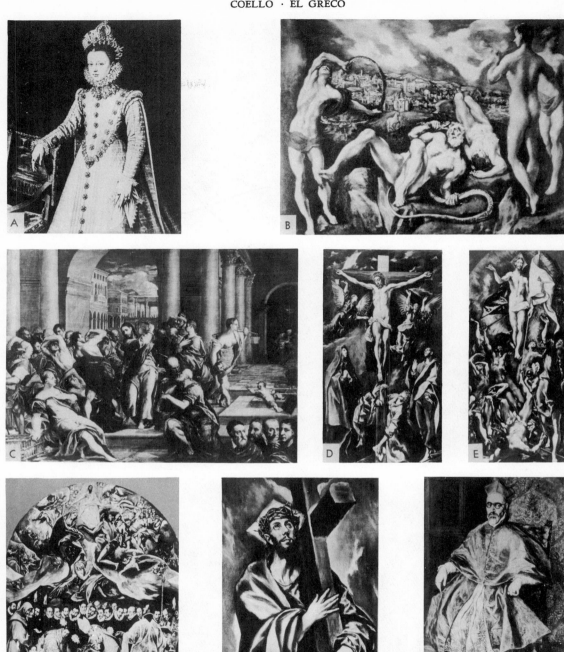

A. Coello. Infanta Isabel, Daughter of Philip II. XVI cent. (Prado)

B. El Greco. Laocoön. c. 1606–10. National Gallery, London (Nat. Gall.)

C. El Greco. Christ Driving the Money Changers from the Temple. c. 1575. Minneapolis Institute of Arts. (Minn. Inst.)

D. El Greco. Christ on the Cross. 1584–90. Prado. (And)

E. El Greco. Resurrection. 1595–1603. Prado.

F. El Greco. Burial of the Count of Orgaz. c. 1584. Santo Tomé Toledo. (And)

G. El Greco. Christ with the Cross. 1587–92. Prado. (And)

H. El Greco. Don Fernando Niño de Guevara, Cardinal and Archbishop of Seville. Metropolitan Museum. (Met)

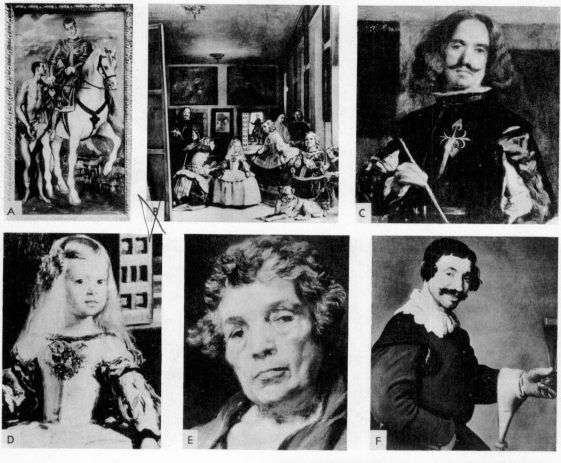

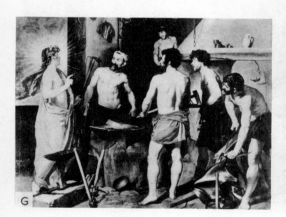

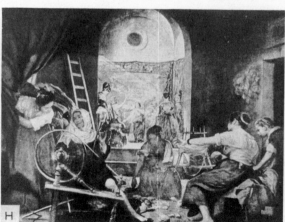

A. El Greco. St. Martin Dividing His Cloak. Collection of Joseph E. Widener, Philadelphia. (Joseph E. Widener)

B. Velásquez. Maids of Honor (Las Meninas). 1656–57. Prado. (And)

C. Velásquez. Self Portrait. Detail of B.

D. Velásquez. The Infanta. Detail of B.

E. Velásquez. Aesop. Detail. c. 1650. Prado. (And)

F. Velásquez. Man with a Wine Glass. c. 1623. Edward Drummond Libby Collection, Toledo Museum. (Toledo Museum)

G. Velásquez. The Forge of Vulcan. 1629. Prado. (And)

H. Velásquez. The Tapestry Weavers. 1656. Prado. (And)

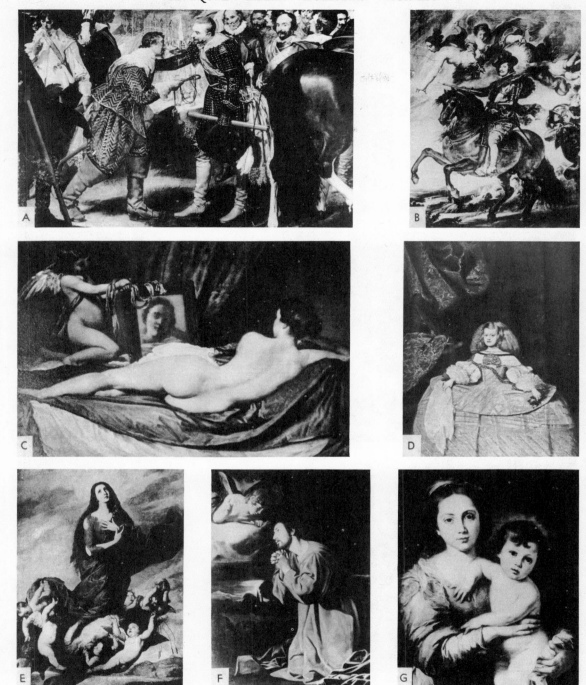

A. Velásquez. Surrender of Breda. Detail. Between 1639–47. Prado. (And)

B. Velásquez. Philip IV of Spain. Uffizi. (And)

C. Velásquez. The Rokeby Venus. c. 1642. National Gallery, London.

D. Velásquez. The Infanta Maria Theresa. Prado. (And)

E. Ribera. Ecstasy of Mary Magdalene. Academy of St. Ferdinand, Madrid.

F. Zurbarán. Christ at Gethsemane. Collection of Eugen Boross. (Met)

G. Murillo. Detail of Madonna and Child. Pitti. (Al)

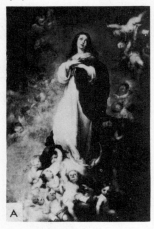

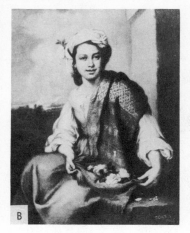

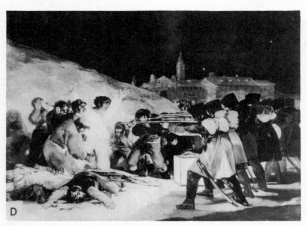

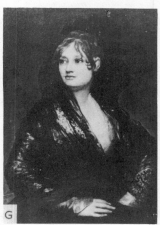

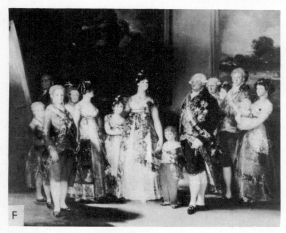

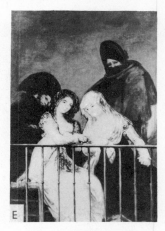

A. Murillo. The Immaculate Conception. Louvre. (Louvre)

B. Murillo. Flower Girl. Dulwich College Gallery.

C. Goya. Self Portrait. 1808–14. Collection Smith College Museum of Art. (Smith College)

D. Goya. The Shooting of a Group of Citizens by the Soldiers of Murat on the Night of May 3, 1808. Prado. (And)

E. Goya. Majas on a Balcony. Metropolitan Museum. (Met)

F. Goya. Family of Carlos IV. 1800. Prado. (And)

G. Goya. Doña Isabel Corbo de Porcel. National Gallery, London.

A. Goya. La Maja Desnuda. 1795–97. Prado. (Moreno)

B. Goya. La Maja Vestida. 1797–99. Prado. (Moreno)

C. Goya. Maria Louisa of Parma, wife of Carlos IV. 1799. Taft Museum, Cincinnati. (Taft)

D. Goya. Bull Fight. Lithograph. Museum of Fine Arts. (M.F.A.)

E. Goya. Maria Louisa of Parma, wife of Carlos IV. 1799. Prado. (And)

F. Goya. Los Proverbios. The Bird-Men. Detail. Etching and Aquatint. Fogg Museum. (Fogg)

G. Goya. Old Age: Then and Now. c. 1817–19. Palace of Fine Arts, Lille. (Gir)

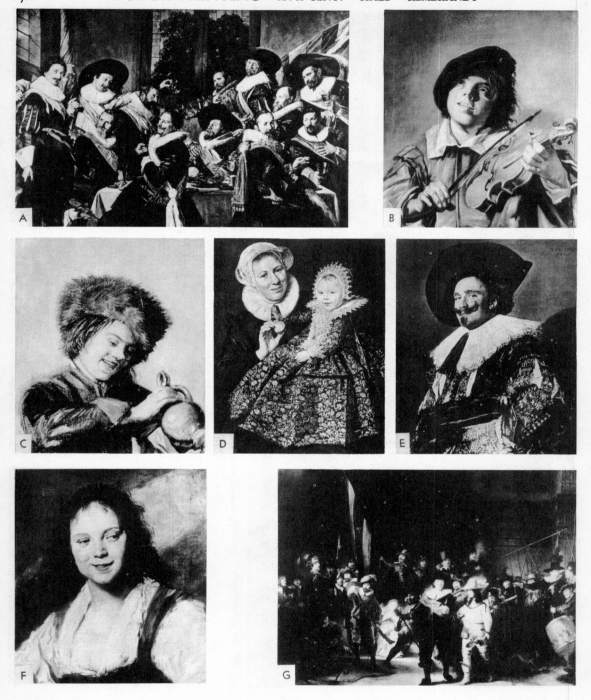

A. Hals. Officers of the Company of St. Adrian. 1627. Hals Museum, Haarlem.

B. Hals. Young Violin Player. Collection of Leo M. Flesh, Piqua, O. (John Levy Galleries)

C. Hals. Young Man in Fur Cap. Brooklyn Institute of Arts and Sciences. (Brooklyn Inst.)

D. Hals. Child and Nurse. 1630–35. Kaiser Friedrich Museum.

E. Hals. Laughing Cavalier. 1624. Wallace Collection, London.

F. Hals. Portrait of a Girl. 1630. Louvre. (L. L.)

G. Rembrandt. The Sortie of the Civic Guard (Night Watch). 1642. Rijksmuseum.

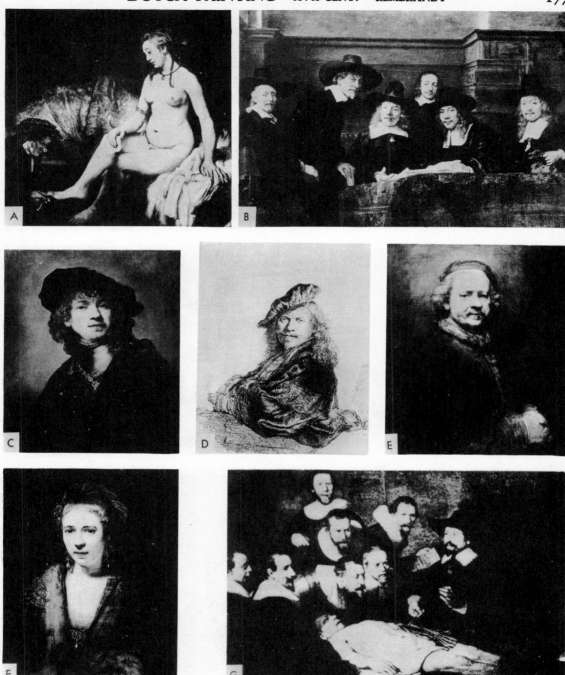

A.  Rembrandt. Bathsheba. 1654. Louvre. (Al)

B.  Rembrandt. The Syndics of the Cloth Guild. 1662. Rijks-museum.

C.  Rembrandt. Self Portrait. 1634. Pitti. (Brogi)

D.  Rembrandt. Self Portrait. 1639. Etching. Fogg Museum. (Fogg)

E.  Rembrandt. Self Portrait. 1659. National Gallery, London. (Nat. Gall.)

F.  Rembrandt. Hendrickje Stoffels. 1652. Louvre. (Al)

G.  Rembrandt. Dr. Tulp's Anatomy Lesson. Detail. 1632. Royal Museum, The Hague.

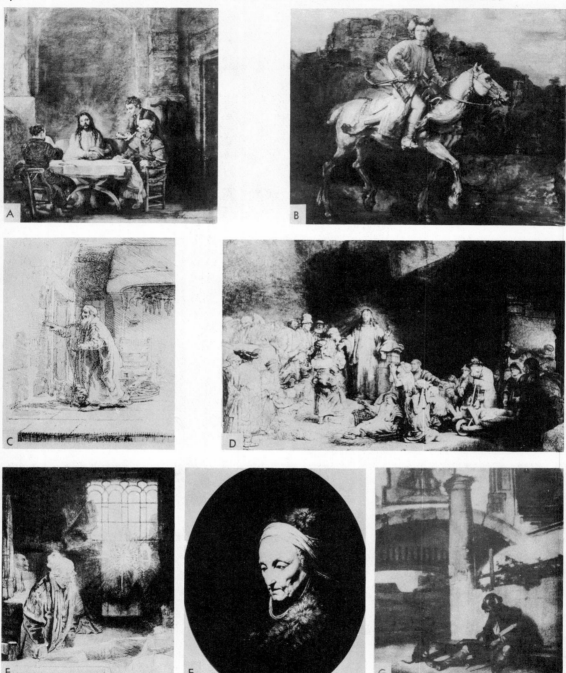

A. Rembrandt. Supper at Emmaus. 1648. Louvre. (Al)

B. Rembrandt. The Polish Rider (A Patrician of the Lysowski Regiment). 1655. Frick Gallery, New York. (Courtesy Trustees of the Frick Gallery)

C. Rembrandt. The Blindness of Tobit. 1651. Etching. Fogg Museum. (Fogg)

D. Rembrandt. Christ Healing the Sick (The Hundred Guilder Print). Etching. 1649. Fogg Museum. (Fogg)

E. Rembrandt. Dr. Faust in His Study. c. 1651. Etching. Fogg Museum. (Fogg)

F. Gerard Dou. Rembrandt's Mother. c. 1630. Kaiser Friedrich Museum.

G. Carel Fabritius. The Guard.   654. Museum, Schwerin.

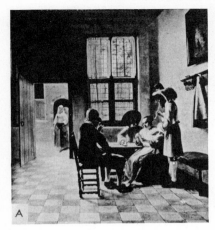

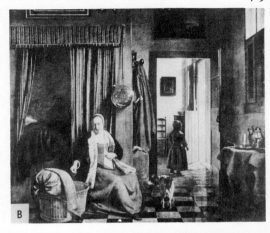

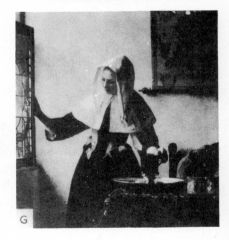

A. De Hooch. Interior with Cardplayers. 1658. Buckingham Palace.

B. De Hooch. Mother and Child. Kaiser Friedrich Museum.

C. De Hooch. Courtyard of a Dutch House. 1672. National Gallery, London. (Nat. Gall.)

D. De Hooch. Dutch Interior. Detail. National Gallery, London. (Nat. Gall.)

E. De Hooch. The Buttery. c. 1658. Rijksmuseum.

F. Vermeer. Interior with Cavalier and Girl Drinking Wine. Kaiser Friedrich Museum. (Berlin)

G. Vermeer. Young Woman with a Water Jug. Metropolitan Museum. (Met)

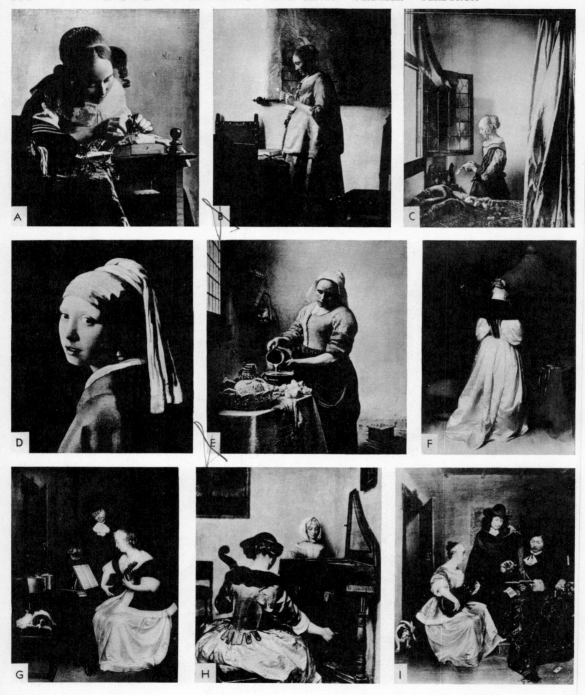

A. Vermeer. The Lace Maker. Louvre. (Al)

B. Vermeer. Young Woman Reading a Letter. Rijksmuseum.

C. Vermeer. Young Girl Reading a Letter. Picture Gallery, Dresden.

D. Vermeer. Head of a Young Girl. Mauritz Haus, The Hague.

E. Vermeer. Servant Girl Pouring Milk. Rijksmuseum.

F. Terborch. Woman in a Room. Dresden. (Al)

G. Terborch. A Lesson on the Lute. Isabella Stewart Gardner Museum, Boston. (Gardner Museum)

H. Terborch. The Concert. Kaiser Friedrich Museum.

I. Terborch. The Music Lesson. National Gallery, London. (Nat. Gall.)

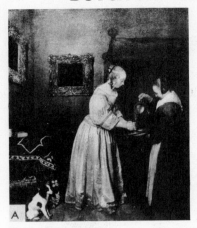

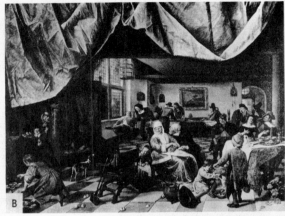

A. Terborch. Woman Washing Her Hands. Picture Gallery, Dresden. (Bruck)

B. Steen. The Brewery of Jan Steen. The Hague. (Bruck)

C. Ruisdael. Jewish Burial Ground. Picture Gallery, Dresden.

D. Steen. Sick Lady. Taft Museum, Cincinnati. (Taft)

E. Ruisdael. The Mill Near Wijk. Rijksmuseum. (Bruck)

F. Ruisdael. Landscape with Castle. Collection of Earl of Northbrook.

A. Ruisdael. Wheatfields. Metropolitan Museum. (Met)

B. Paul Potter. Head of a Bull. 1647. The Hague. (Bruck)

C. Potter. The Young Bull. 1645. The Hague. (Bruck)

D. A. van Ostade. Group of Peasants in an Interior. Dulwich Gallery.

E. Hobbema. Middelharnis Avenue. 1689. National Gallery, London.

F. A. van Ostade. The Herring Woman. Rijksmuseum.

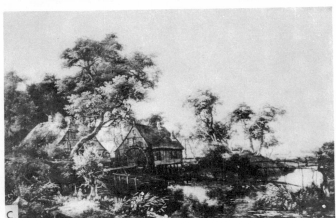

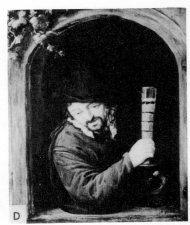

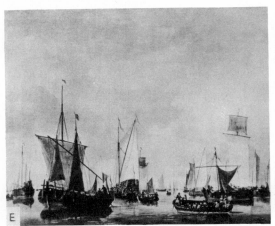

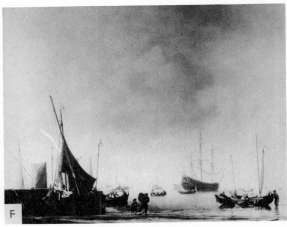

A. Hobbema. The Travellers. c. 1660. Collection Joseph E. Widener. (Joseph E. Widener)

B. A. van Ostade. The Golden Wedding. Art Institute. (Art Inst.)

C. Hobbema. The Mill. Gallery, Dresden. (Al)

D. A. van Ostade. Peasant at a Window. Brooklyn Institute of Arts and Sciences. (Brooklyn Inst.)

E. William van de Velde the younger. Calm Sea with Ships. Buckingham Palace.

F. William van de Velde the younger. Entrance to a Dutch Port. Metropolitan Museum. (Met)

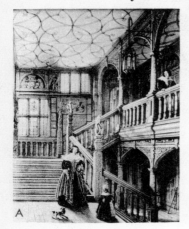

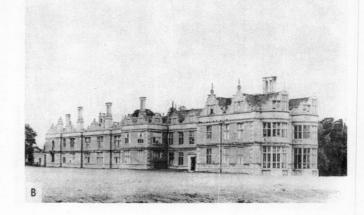

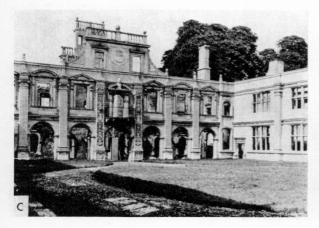

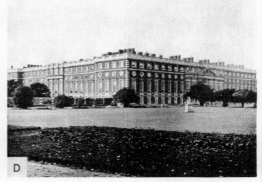

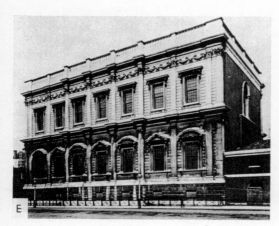

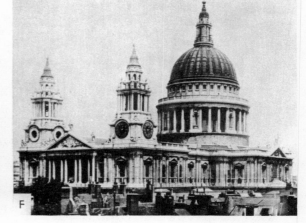

A. Staircase, Knole House, Kent. 1570.

B. Kirby Hall, Northants. Designed by John Thorpe. 1570.

C. Kirby Hall, Northants. Designed by John Thorpe. 1570.

D. Hampton Court. Sir Christopher Wren, architect. 1689–1703.

E. Banqueting Hall, Whitehall, London. Inigo Jones, architect. 1619–22.

F. St. Paul's Cathedral, London. Sir Christopher Wren, architect. 1675–1710. (See p. 185)

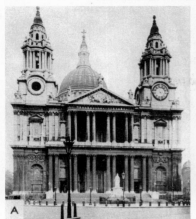
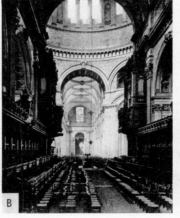
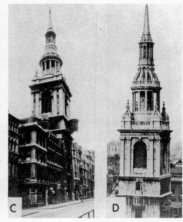

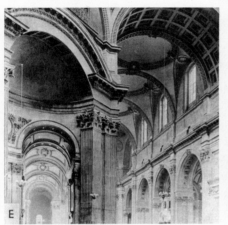
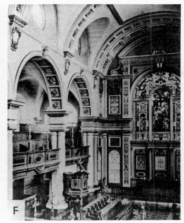
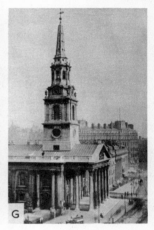

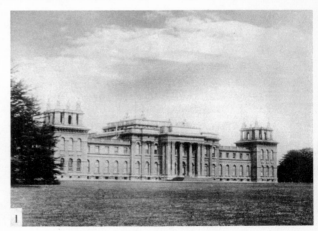

A. St. Paul's Cathedral, London. Sir Christopher Wren, architect. 1675–1710. (See 184 F)

B. St. Paul's Cathedral, London. Interior.

C. St. Mary-le-Bow, London. Sir Christopher Wren, architect. 1680.

D. St. Mary-le-Bow, London. Spire.

E. St. Paul's Cathedral, London. Detail of B.

F. St. Bride's, Fleet Street, London. Sir Christopher Wren, architect. 1680–1702.

G. St. Martin's in the Fields, London. James Gibbs, architect. 1721–26.

H. St. Stephen's Walbrook, London. Interior. Sir Christopher Wren, architect. 1672–79.

I. Blenheim Palace, Oxfordshire. Sir John Vanbrugh, architect. 1705–24.

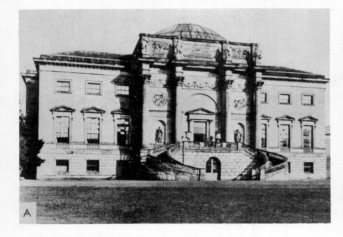

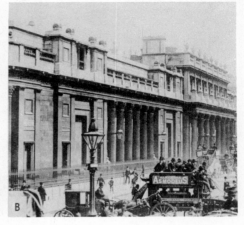

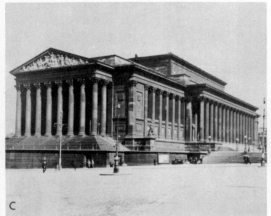

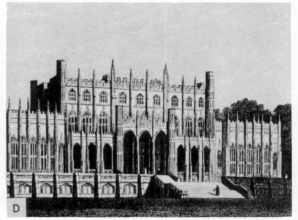

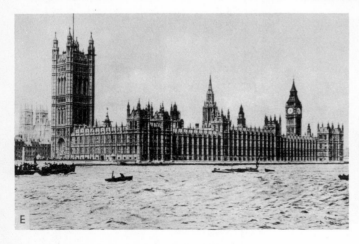

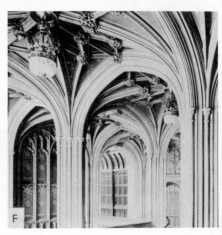

A. Kedleston. The Garden Front. Robert Adam and others, architects. c. 1760.

B. Bank of England, London. Sir John Soane, architect. 1795–1827.

C. St. George's Hall, Liverpool. H. L. Elmes, architect. 1839.

D. Eaton Hall, Cheshire. William Porden, architect.

E. Parliament Buildings, London. Sir Charles Barry, architect. 1840–68.

F. House of Parliament, London. Peers' Corridor.

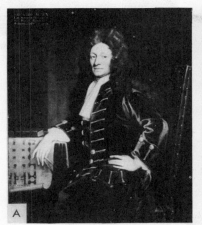

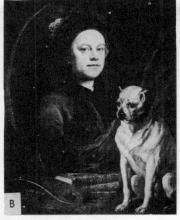

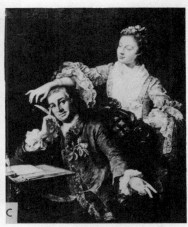

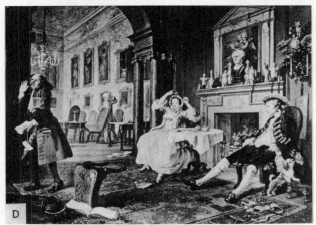

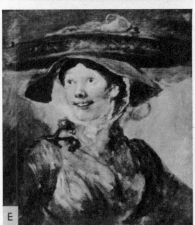

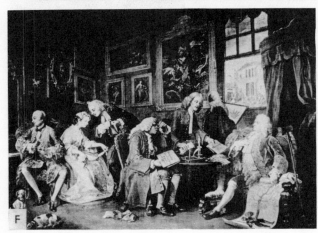

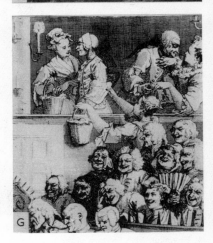

A. Sir Godfrey Kneller. Sir Christopher Wren. National Gallery, London.

B. William Hogarth. Self Portrait. c. 1740. National Gallery, London.

C. Hogarth. Garrick and His Wife. 1757. Royal Collection, Windsor.

D. Hogarth. Marriage à la Mode. After Breakfast. 1745 National Gallery, London. (Berlin)

E. Hogarth. Shrimp Girl. National Gallery, London.

F. Hogarth. Marriage à la Mode. The Marriage Counter. 1745. National Gallery, London. (Berlin)

G. Hogarth. The Laughing Audience. Etching. 1733. Fogg Museum. (Fogg)

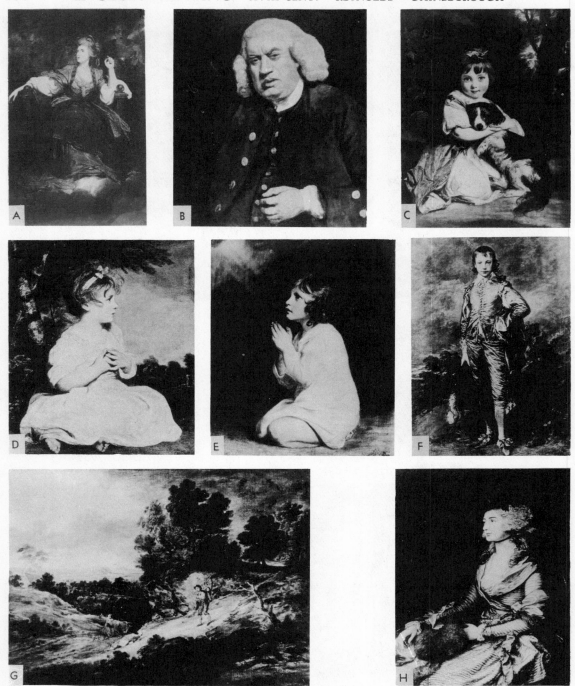

A. Reynolds. Mrs. Siddons as the Tragic Muse. 1784. Huntington Coll., San Marino, Cal.

B. Reynolds. Samuel Johnson. 1772. National Gallery, London. (Nat. Gall.)

C. Reynolds. Miss Bowles. 1776. Wallace Collection, London.

D. Reynolds. The Age of Innocence. 1788. National Gallery, London. (Berlin)

E. Reynolds. Little Samuel. 1777. Fabre Museum, Montpellier. (Gir)

F. Gainsborough. The Blue Boy. 1770. Huntington Collection, San Marino, California. (Huntington Collection)

G. Gainsborough. Skirts of the Woods. Art Institute. (Art Inst.)

H. Gainsborough. Mrs. Siddons. 1784. National Gallery, London. (Berlin)

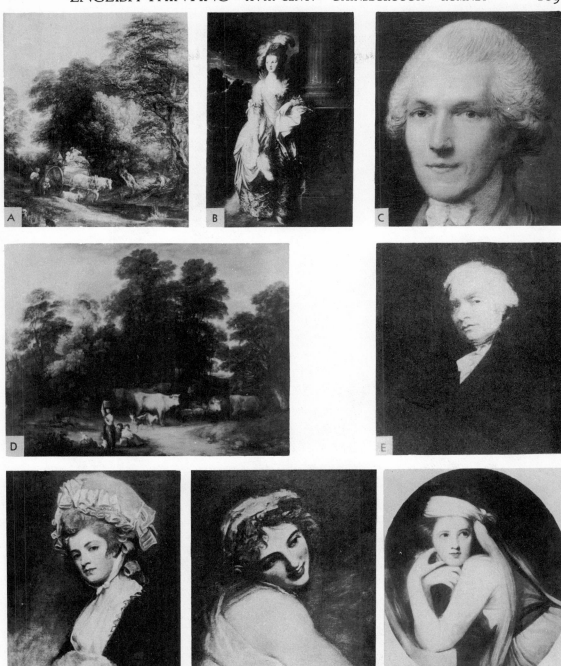

A. Gainsborough. The Market Cart. 1767–68. National Gallery, London.

B. Gainsborough. Mrs. Graham. 1784–86. National Gallery, Edinburgh.

C. Gainsborough. Sir Benjamin Thompson, Count Rumford. Detail. Fogg Museum. (Fogg)

D. Gainsborough. Landscape with Figures and Cattle. Taft Museum, Cincinnati. (Taft)

E. Romney. Self Portrait. 1795. Metropolitan Museum. (Met)

F. Romney. Mrs. Robinson (Perdita). c. 1783. Wallace Collection, London.

G. Romney. Study of Lady Hamilton as a Bacchante. 1786. National Gallery, London.

H. Romney. Lady Hamilton. National Gallery, London.

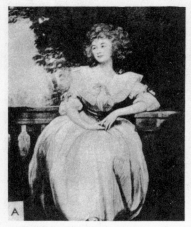

A. Romney. Mrs. Mark Currie. 1789. National Gallery, London.

B. Raeburn. The McNab. c. 1796. Collection of John Dewar and Sons, London.

C. Raeburn. Mrs. Scott Moncriff. National Gallery, Edinburgh.

D. Turner. Dido Directing Equipment. c. 1814. National Gallery, London.

E. Hoppner. The Countess of Oxford. National Gallery, London.

F. Turner. Dido Building Carthage. 1815. National Gallery, London.

G. Lawrence. Arthur Wellesley, 1st Duke of Wellington. Copy of original in the Wellington Collection. Huntington Collection, San Marino, California. (Huntington Collection)

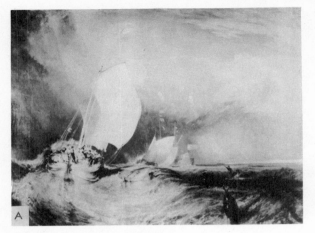

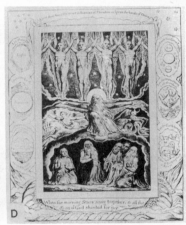

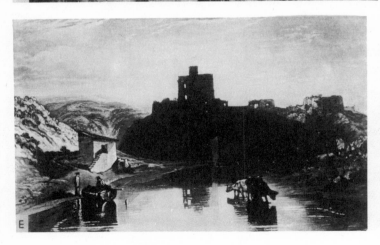

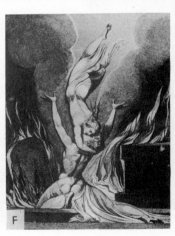

A. Turner. Dutch Fishing Boats. c. 1826. Art Institute. (Art Inst.)

B. Lawrence. Mrs. Siddons. National Gallery, London.

C. Turner. Bridge of Sighs. c. 1833. Art Gallery, Leicester.

D. Blake. When the Morning Stars Sang Together. From the Book of Job. 1820. Engraving. Fogg Museum. (See 192 B.) (Fogg)

E. Turner. Norham Castle on the Tweed. From the Liber Studiorum. Mezzotint. 1807–19. Fogg Museum. (Fogg)

F. Blake. Reunion of the Soul and the Body. From Blair's Grave. Engraving by Schiavonetti. Collection of F. J. Roos, Jr.

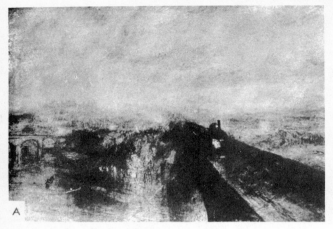

A. Turner. Rain, Steam and Speed. 1844. National Gallery, London.

B. Blake. Then the Lord Answered Job Out of a Whirlwind. From the Book of Job. 1820. Engraving. Fogg Museum. (Fogg)

C. Constable. Hay Wain. 1821. National Gallery, London.

D. Constable. The Cornfield. 1826. National Gallery, London.

E. Constable. The Glebe Farm. 1826. National Gallery, London.

F. Bonington. The Clock Tower, Evreux. Lithograph. Fogg Museum. (Fogg)

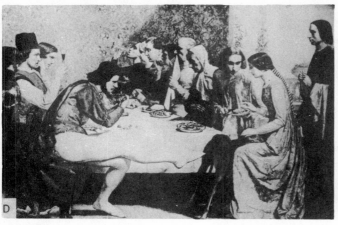

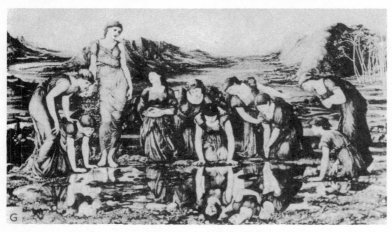

A. Watts. Hope. 1891. National Gallery, London.

B. Watts. Love and Life. 1890. National Gallery, London.

C. Rossetti. Annunciation. 1850. National Gallery, London.

D. Millais. Lorenzo at the Home of Isabella. 1849. Walker Art Gallery, Liverpool.

E. Holman Hunt. Light of the World. 1855. Keble College Chapel, Oxford.

F. Burne-Jones. The Golden Stairs. 1876–80. National Gallery, London.

G. Burne-Jones. Mirror of Venus. 1873–77. Collection Sidney Goldmann, London.

H. Burne-Jones. King Cophetua and the Beggar Maid. 1876–80. National Gallery, London.

A. Brangwyn. Unloading Oranges. Wood engraving.

B. Orpen. Sir William McCormick. 1920. National Gallery of British Art.

C. Zuloaga. The Victim of the Fête. 1910.

D. Sorolla. Valencia. 1913–19. Museum of the Hispanic Society of America. (Hispanic Society)

E. Sorolla. On the Beach. 1908. Carnegie Institute, Pittsburgh. (Carnegie Inst.)

F. Zorn. Auguste Rodin. Etching. (Fogg)

G. Zorn. Bather. (Met)

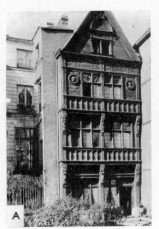

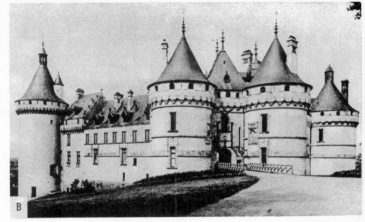

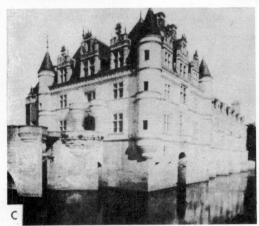

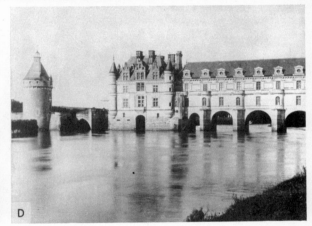

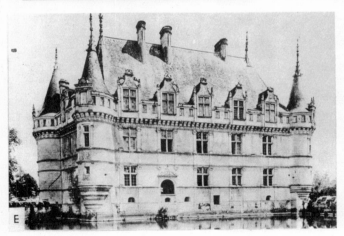

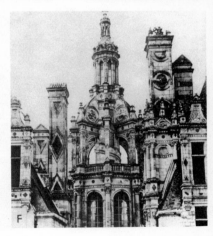

A. House of Diane de Poitiers, Rouen. XVI cent. (N.D.)

B. Château of Chaumont. XV–XVI cent.

C. Château of Chenonceaux. 1515–23. (N.D.)

D. Château of Chenonceaux  1515–23. (N.D.)

E. Château of Azay-le-Rideau. 1521.

F. Château of Chambord. The Lantern. 1526–44. (See 196 C)

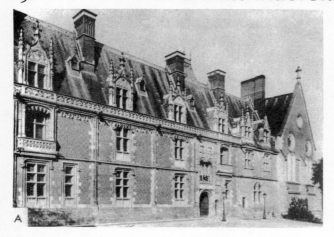

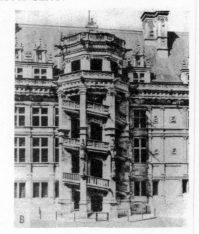

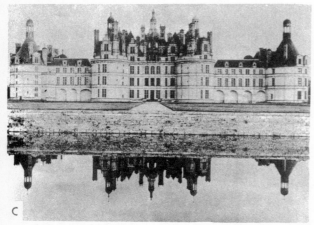

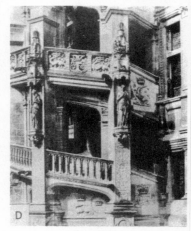

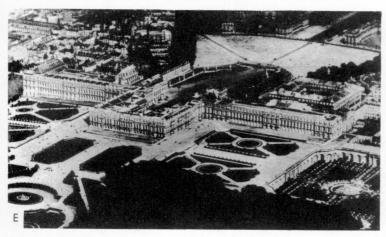

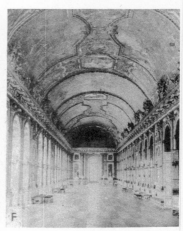

A. Château of Blois. Wing of Louis XII. c. 1200.

B. Château of Blois. Stairway, Wing of Francis I. 1520–30.

C. Château of Chambord. 1526–44. (See 195 F.) (N.D.)

D. Château of Blois. Detail of B.

E. Versailles. XVII–XVIII cent.

F. Versailles. Hall of Mirrors. 1680. Mansard, architect; Le Brun, decorator.

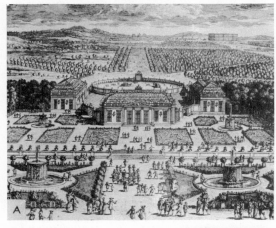

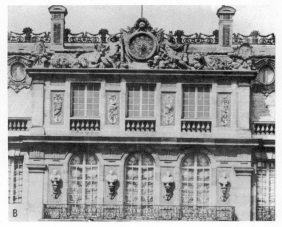

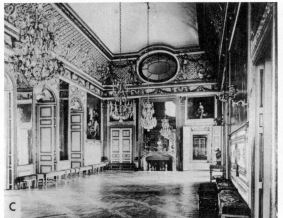

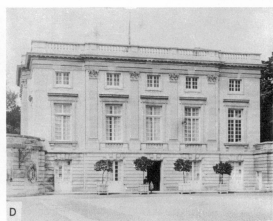

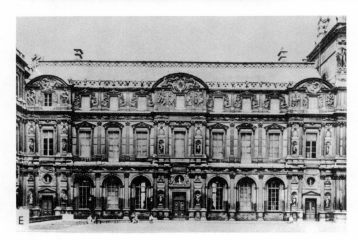

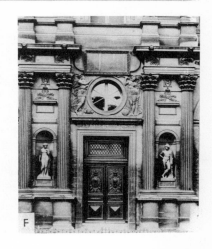

A. Versailles. The Park. By Le Notre. An engraving by Perelle.

B. Versailles. Court of the Statues. 1665–70. Louis le Vau, architect. (Gir)

C. Versailles. Hall of the Oval Window. (Gir)

D. Versailles. The Petit Trianon. 1762–68. Gabriel, architect. (X)

E. Louvre, Paris. Court of Lescot and Goujon. 1546–76.

F. Louvre, Paris. Detail of E.

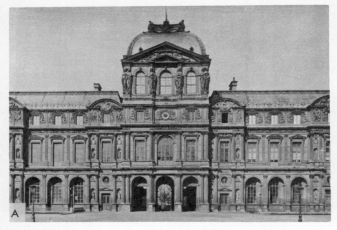

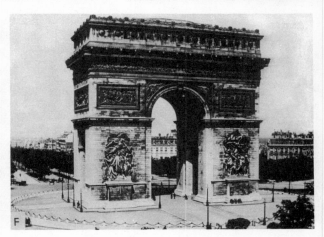

A. Louvre, Paris. W. façade of Pavilion Sully. Lescot, architect. XVI cent. (X)

B. Louvre, Paris. Detail of A.

C. Louvre, Paris. Colonnade by Perrault. 1665.

D. Hôtel des Invalides Chapel, Paris. Mansard, architect. 1699–1704.

E. Panthéon, Paris. Soufflot, architect. 1755–80. (X)

F. Arc de l'Etoile, Paris. Chalgrin, architect. 1806–36.

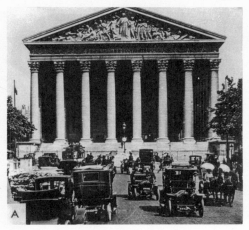

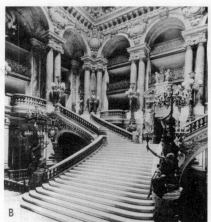

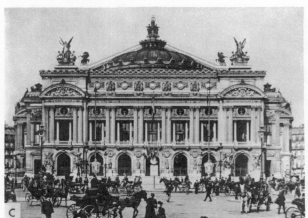

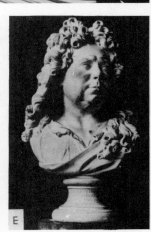

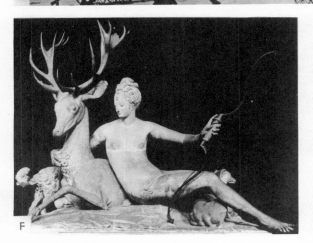

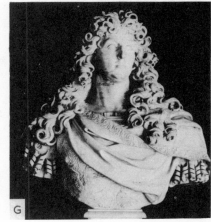

A. The Madeleine, Paris. Vignon, architect. 1807–42.

B. The Opéra, Paris. Interior. Charles Garnier, architect. 1861–74. (X)

C. The Opéra, Paris. Charles Garnier, architect. 1861–74. (X)

D. Goujon. Water Nymph from Fountain of the Innocents. 1547–49. Paris.

E. Coysevox. Portrait of the Artist. Early XVIII cent. Louvre.

F. Goujon, attributed to. Diane de Poitiers as Diana. From Château d'Anet. XVI cent. Louvre. (Al)

G. Coysevox. Louis XIV. Before 1715. Versailles. (Gir)

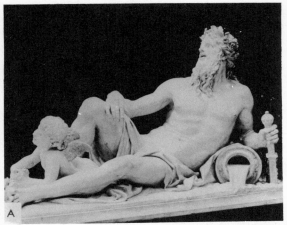

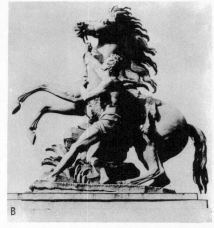

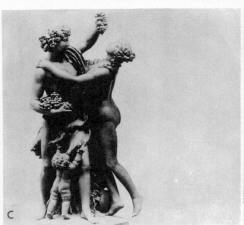

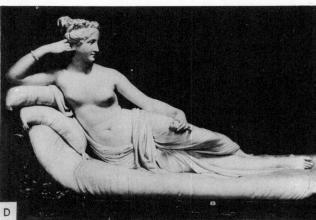

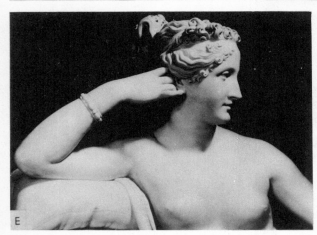

A. Coysevox. River God of the Rhône. Early XVIII cent.
Versailles.

B. Coustou. The Horses of Marly. XVIII cent. Place de la
Concorde, Paris.

C. Clodion. The Intoxication of Wine. XVIII cent. Metro-
politan Museum. (Met)

D. Canova. Pauline Borghese as Venus Victrix. Early XIX
cent. Borghese Gallery, Rome. (Al)

E. Canova. Detail of D.

F. Houdon. George Washington. 1785. Mount Vernon, Vir-
ginia. (Courtesy of Mount Vernon Ladies' Association)

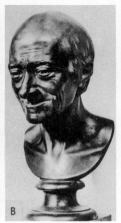

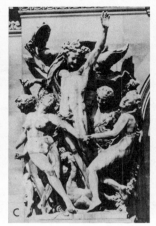

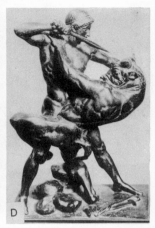

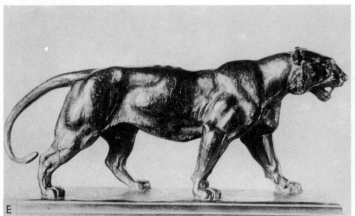

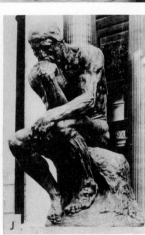

A. Houdon. Benjamin Franklin. 1778. Louvre.

B. Houdon. Voltaire. 1781. Louvre. (Gir)

C. Carpeaux. The Dance. Façade of the Opéra, Paris.

D. Barye. Theseus Slaying the Minotaur. 1848. Metropolitan Museum. (Met)

E. Barye. Tiger Walking. Louvre.

F. Chapu. Joan of Arc. Luxembourg. (Lux)

G. Rodin. St. John the Baptist. 1878. (Arch. Photo.)

H. Rodin. Eve. 1881. Rodin Museum, Paris. (Rodin Museum)

I. Rodin. The Kiss. 1886. Rodin Museum, Paris.

J. Rodin. The Thinker. 1889. Rodin Museum, Paris.

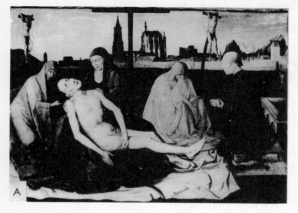

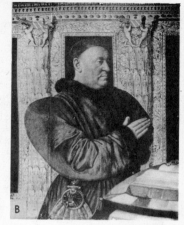

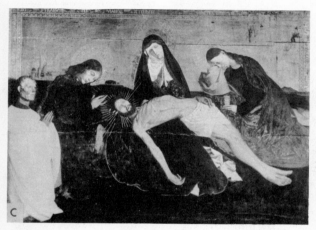

A. Franco-Italian Pieta. XV cent. Frick Collection, New York. (Courtesy of the Trustees of the Frick Collection)

B. J. Fouquet. Guillaume Jouvenal des Ursins. 1461–75. Louvre. (Bruck)

C. Pietà from Avignon. Late XV cent. Louvre. (Gir)

D. Detail of C. Head of Donor.

E. Man with a Glass of Wine. c. 1475. Louvre. (Arch. Photo.)

F. J. Clouet, attributed to. François, Dauphin of France. Royal Museum, Antwerp.

G. J. Clouet, attributed to. Francis I. After 1518. Louvre.

A. Clouet, attributed to Francis I. c. 1540. Louvre. (Louvre)

B. Poussin. Triumph of David. Gallery, Dulwich.

C. François Clouet, attributed to. Henry II of France. Collection of A. M. Lawrie, London. (Gir)

D. Poussin. Rape of Sabine Women. c. 1637. Collection of Sir

Herbert Cook, Richmond. (And)

E. Poussin. Orpheus Asking the Way to Hades. Metropolitan Museum. (Met)

F. Claude Mellan. The Veronica. Engraving. 1649. Fogg Museum. (See p. 309 C for magnified detail.) (Fogg)

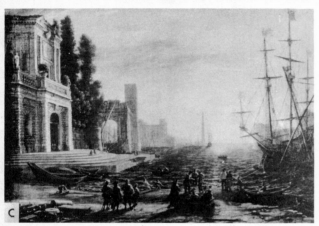

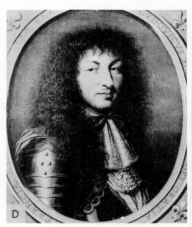

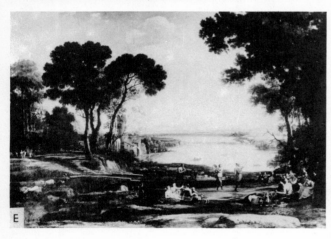

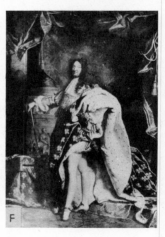

A. Poussin. Shepherds of Arcadia. Louvre. (Gir)

B. Claude Mellan. Fabri de Peyresc. Engraving. Fogg Museum (Fogg)

C. Claude Lorrain. Seaport at Sunset. c.1644. National Gallery, London.

D. Nanteuil. Louis XIV. Engraving. 1669. Fogg Museum. (Fogg)

E. Claude Lorrain. Landscape with Mill. Doria Palace, Rome. (Al)

F. Rigaud. Louis XIV. 1701. Louvre. (Gir)

A. Watteau. Embarkation for Cythera. c. 1717. Louvre.

B. Rigaud. Jacques Bossuet, Bishop of Meaux. 1693. Uffizi. (Al)

C. Charles Le Brun. Portrait of the Cologne Banker Eberhard Jabach and His Family. Kaiser Friedrich Museum. (Berlin)

D. Watteau. Picnic in the Woods. Kaiser Friedrich Museum. (Berlin)

E. Lancret. Mlle. Camargo. c.1742. Wallace Collection, London.

F. Watteau. Gilles. Detail. c. 1719–21. Louvre. (Gir)

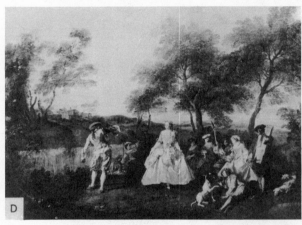

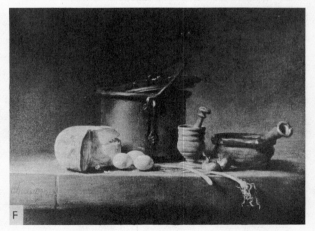

A. Watteau. L'Indifferent. c. 1710–16. Louvre. (Gir)

B. Lancret. L'Été. 1738. Louvre.

C. Lancret. The Music Lesson. Louvre.

D. Lancret. Pastoral. Kaiser Friedrich Museum. (Berlin)

E. Chardin. Self Portrait. 1775. Louvre.

F. Chardin. Corner of the Kitchen Table. Collection of Dr. Bredius, The Hague.

A. Chardin. The Blessing. 1740. Louvre. (Gir)

B. Chardin. Housewife. 1739. Louvre. (Al)

C. Chardin. The Cook. Old Gallery, Munich.

D. Boucher. Mme. Pompadour. National Gallery, Edinburgh.

E. Boucher. Toilet of Venus. 1751. Metropolitan Museum. (Met)

F. Boucher. The Judgment of Paris. Wallace Collection, London.

G. Boucher. Pastoral. Louvre.

H. Nattier. Princesse de Condé as Diana. 1756. Metropolitan Museum. (Met)

A. Nattier. Mme. Henriette as Flora. Uffizi. (Al)

B. Fragonard. The Rendezvous. 1773. Frick Collection, New York. (Courtesy of the Trustees of the Frick Collection)

C. Fragonard. The Schoolmistress. c. 1780. Wallace Collection, London.

D. Fragonard. The Swing. Wallace Collection, London.

E. Greuze. Milkmaid. Louvre. (Al)

F. Prud'hon. Psyche. 1808. Louvre. (Gir)

G. Prud'hon. Josephine, Empress of the French. Detail. 1805. Louvre. (Al)

A. Vigée Le Brun. Self Portrait with Her Daughter. c. 1787. Louvre. (Al)

B. J. L. David. Coronation of Napoleon and Josephine. Detail. 1806. Louvre.

C. David. Mme. Récamier. c. 1809. Louvre. (Louvre)

D. David. Death of Marat. Brussels Museum. (Al)

E. David. Oath of the Horatii. 1784. Louvre. (Gir)

F. Constance Charpentier. Mlle. Charlotte du Val d'Ognes. C. 1801. Formerly attributed to David. Metropolitan Museum. (Met)

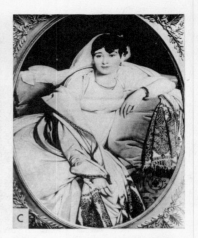

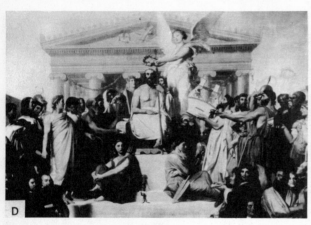

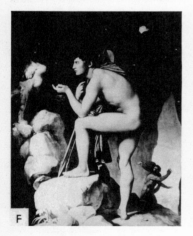

A. David. Paris and Helen. Detail. 1788. Louvre. (Al)

B. David. Mme. Tangry and Daughters. Louvre.

C. Ingres. Mme. Rivière. 1805. Louvre. (Gir)

D. Ingres. Apotheosis of Homer. 1827. Louvre. (Louvre)

E. Ingres. Cherubini. 1841. Cincinnati Museum. (Cincinnati Mus.)

F. Ingres. Oedipus and the Sphinx. 1808. Louvre. (Gir)

G. Ingres. Comtesse d'Haussonville. 1842–45. Frick Collection, New York. (Courtesy of the Trustees of the Frick Collection)

H. Ingres. M. Bertin. 1832. Louvre.

A. Ingres. The Source 1856. Louvre. (Gir)

B. Ingres. Joan of Arc at the Coronation of Charles VII. 1854. Louvre.

C. Ingres. Turkish Bath. 1859–1863. Louvre. (Gir)

D. Ingres. The Bather. 1808. Louvre. (Gir)

E. Gerard. Mme. Récamier. Petit Palais, Paris. (Gir)

F. Gros. Bonaparte on the Bridge at Arcola. Detail. Louvre. (Louvre)

G. Gros. Napoleon Among the Plague-Stricken at Jaffe. Study for the original in the Louvre. 1804. Musée Condé. Chantilly. (Gir)

H. Bouguereau. Birth of Venus. Luxembourg.

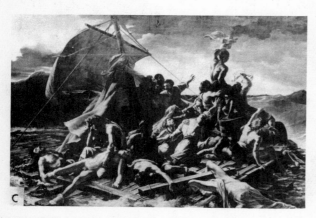

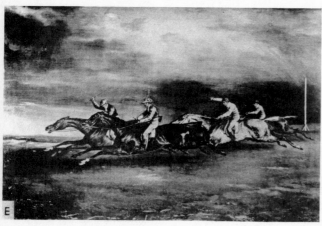

A. Gérôme. Cock Fight. Louvre. (Louvre)

B. Géricault. Officer of the Guard. 1812. Louvre. (Gir)

C. Géricault. Raft of the Medusa. 1819. Louvre. (Gir)

D. Delacroix. Self Portrait. 1837. Louvre.

E. Géricault. The Derby at Epsom. 1821. Louvre. (Gir)

F. Delacroix. The Massacre of Scio. 1824. Louvre. (Al)

A. Delacroix. Dante and Virgil in Hell. 1822. Louvre. (Gir)

B. Millet. The Cooper. Museum of Fine Arts. (M.F.A.)

C. Delacroix. Liberty on the Barricade (July 28, 1830). 1830. Louvre. (Louvre)

D. Millet. The Sower. 1850. Museum of Fine Arts. (M.F.A.)

E. Delacroix. Death of Sardanapalus. 1822–27. Louvre. (Louvre)

F. Millet. The Knitting Lesson. Museum of Fine Arts. (M.F.A.)

A. Millet. The Angelus. Louvre. (Louvre)

B. Millet. Autumn. Metropolitan Museum. (Met)

C. Millet. The Gleaners. 1856. Louvre. (Gir)

D. Millet. Maternity. Collection of Grenville Winthrop, New York. (Grenville Winthrop)

E. Corot. Spring. Detail. Louvre.

F. Corot. Bacchante by the Sea. 1865. Metropolitan Museum. (Met)

## COROT · ROUSSEAU · BRETON · MEISSONIER

A. Corot. View of the Colosseum. Louvre.

B. Corot. Woman with the Pearl. Louvre. (Louvre)

C. Théodore Rousseau. The Oaks. Louvre.

D. Breton. Song of the Lark. 1884. Art Institute. (Art Inst.)

E. Meissonier. Campaign of France, 1814. Louvre. (Louvre)

F. Meissonier. Cavalier. 1861. Wallace Collection, London.

A. Courbet. Deer in Wood. 1863. Louvre. (Louvre)

B. Courbet. Man with a Pipe. 1847. Museum, Montpellier. (Gir)

C. Courbet. Deer in Forest. Louvre. (Louvre)

D. Courbet. The Woman with the Mirror. 1886. Metropolitan Museum. (Met)

E. Courbet. The Source. 1868. Louvre. (Louvre)

F. Puvis de Chavannes. Summer. Detail. 1873. Museum, Chartres.

A. Puvis de Chavannes. Pro Patria Ludus. 1881. Picardy Museum, Amiens.

B. Puvis de Chavannes. Fisherman's Family. 1887. Art Institute. (Art Inst.)

C. Daumier. The Drinkers. Collection of Adolph Lewisohn, New York. (Met)

D. Daumier. The Uprising. Phillips Memorial Gallery. (Phillips Gall.)

E. Daumier. The Rue Transnonain, April 13, 1834. Lithograph. Museum of Fine Arts. (M.F.A.)

F. Daumier. Peace. Bibliothèque Nationale. (Bib. Nat.)

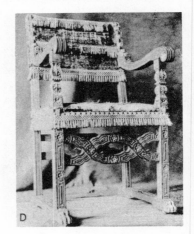

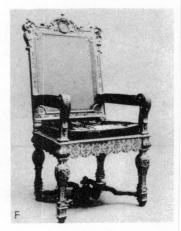

A. Daumier. Crispin and Scapin. Louvre. (Louvre)

B. Daumier. Salle des Pas-Perdus. Bibliothèque Nationale. (Bib. Nat.)

C. Daumier. The Third Class Carriage. Metropolitan Museum. (Met)

D. Chair, Henry II. XVI cent. Museum of Decorative Arts, Paris.

E. Daumier. Soup. Drawing. Louvre. (Louvre)

F. Chair, Louis XIV. Metropolitan Museum. (Met)

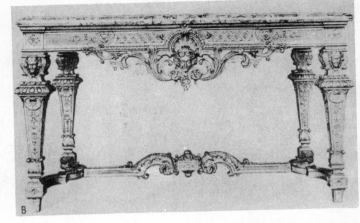

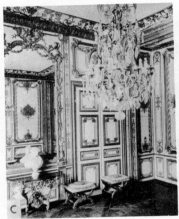

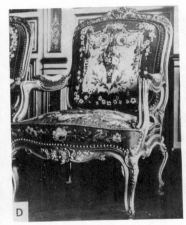

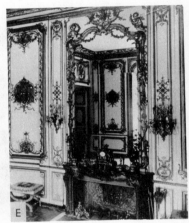

A.  Armchair, Louis XIV. Louvre. (Louvre)

B.  Table, Louis XIV. Louvre. (Louvre)

C.  King's Study, Versailles. Louis XIV–XV. (Gir)

D.  Chair, Louis XV. Fontainbleau. (L.P.)

E.  Room, Versailles. Louis XV. (L.P.)

F.  Chair, Louis XVI. Metropolitan Museum. (Met)

G.  Chair, Louis XVI. Louvre. (Louvre)

H.  Cabinet, Made by Riesener for Marie Antoinette. 1780–90. Louis XVI. (Met)

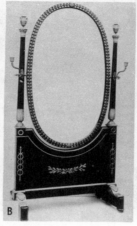

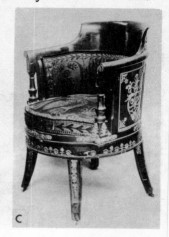

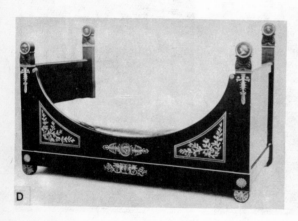

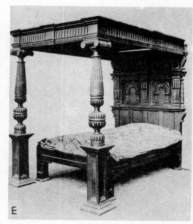

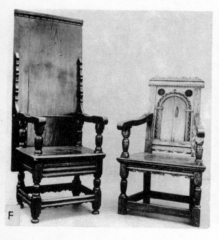

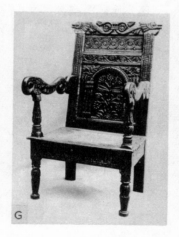

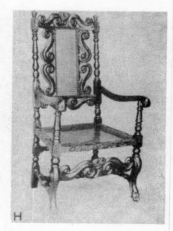

A. Cylinder Desk, Louis XVI. Style of Riesener. (Met)

B. Mirror, Empire. Metropolitan Museum. (Met)

C. Chair, Empire. Metropolitan Museum. (Met)

D. Bed, Empire. Metropolitan Museum. (Met)

E. Bed, Elizabethan. 1593. Victoria and Albert Museum. (Vict. Alb.)

F. Chairs, Jacobean, American. L., table top chair, 1625–75; R., wainscot arm chair, 1650–60. Metropolitan Museum. (Met)

G. Wainscot Chair, Jacobean, American. Late XVII cent. Metropolitan Museum. (Met)

H. Chair, Stuart. English. 1660-80. Metropolitan Museum. (Met)

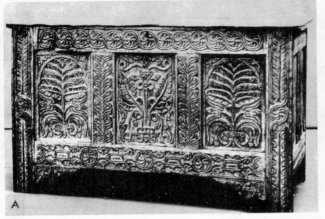

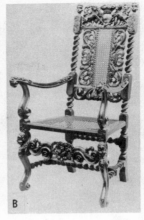

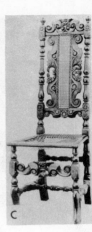

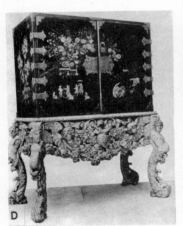

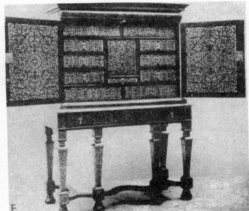

A. Chest, Stuart. 1650–75. American. Metropolitan Museum. (Met)

B. Chair, Stuart. English. 1680–85. Metropolitan Museum. (Met)

C. Chair, Stuart. English. 1660–75. Metropolitan Museum. (Met)

D. Cabinet, Restoration. English. c. 1680. Victoria and Albert Museum. (Vict. Alb.)

E. Cabinet, William and Mary. English. 1688–1702. Metropolitan Museum. (Met)

F. Chair, Queen Anne. English. 1720–30. Metropolitan Museum. (Met)

G. Mirror, Early Georgian. English. Metropolitan Museum. (Met)

H. Highboy, Early Georgian. American. 1725–50. Metropolitan Museum. (Met)

I. Lowboy, Early Georgian. American. 1700–25. Metropolitan Museum. (Met)

A. Chair, Chippendale. English. 1750–95. Metropolitan Museum. (Met)

B. Chair, Chippendale. Gothic Influence. English. 1700–70. Metropolitan Museum. (Met)

C. Chair, Chippendale. Chinese Influence. English. 1755–60. Metropolitan Museum. (Met)

D. Chair, Ladder Back, Chippendale. English. 1765–75. Metropolitan Museum. (Met)

E. Chair, Chippendale. English. 1740–50. Metropolitan Museum. (Met)

F. Bed, Chippendale. Chinese Influence. English. 1760. Metropolitan Museum. (Met)

G. Card Table, Chippendale. English. 1760. Metropolitan Museum. (Met)

H. Desk, American. XVIII cent. Metropolitan Museum. (Met)

I. Chair, Sheraton. American. 1790–1800. Metropolitan Museum. (Met)

A. Table, Sheraton. American. 1800–10. Metropolitan Museum. (Met)

B. Chair, Heppelwhite. American. 1785–95. Metropolitan Museum. (Met)

C. Mirror, Heppelwhite. English. 1775–85. Metropolitan Museum. (Met)

D. Chair, Adam Style. English. 1760–70. Metropolitan Museum. (Met)

E. Settee, Adam Style. English. 1778–80. Metropolitan Museum. (Met)

F. Drop Leaf Table, Phyfe. American. 1810–15. Metropolitan Museum. (Met)

G. Chair Back, Phyfe. American. 1800–10. Taft Museum. (Roos)

H. Ceiling Detail of 15 Hanover Sq., London. Adam. Late XVIII cent. Victoria and Albert Museum. (Vict. Alb.)

I. Mantel and Grate, Adam. English. Late XVIII cent. Metropolitan Museum. (Met)

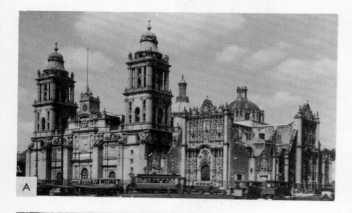

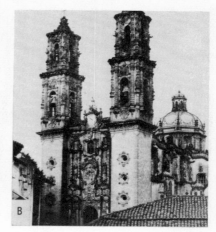

A. Cathedral, Mexico City. Completed 1667.

B. Church of San Sebastián and Santa Prisca, Taxco, Mexico.
XVIII century.

C. Detail of B.

D. Cathedral, Puebla, Mexico. Begun 1552, consecrated 1649.

E. Church of San Martin. Tepotzotlán, Mexico. XVIII
century.

F. Mission of San Antonio de Valero (The Alamo), San
Antonio, Texas. 1774. (H. L. Summerville from San Antonio
C. of C.)

G. Mission, Santa Barbara, Cal. 1787–1800. (Karl Obert from
Santa Barbara C. of C.)

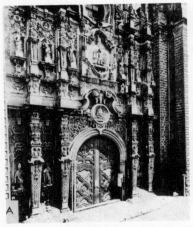

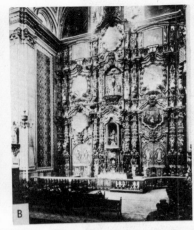

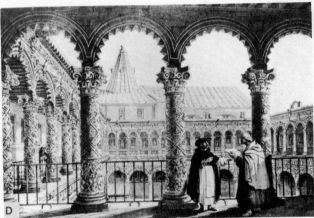

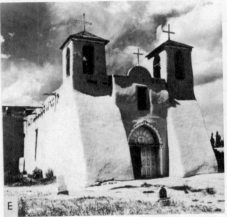

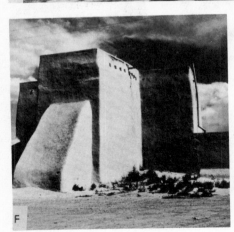

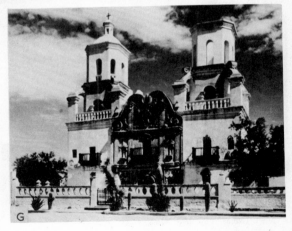

A. Church of La Santísima Trinidad, Mexico City. 1755–83. Façade. (Monumentos Coloniales)

B. Church of Santo Domingo, Mexico City. c. 1736. Altar. (Monumentos Coloniales)

C. Mission San José, San Antonio, Texas. Started 1720. Baptistry Window. (Wayne Andrews)

D. Convent of La Merced, Mexico City. c. 1700. Patio. (Monumentos Coloniales)

E. Mission St. Francis of Assisi, Ranchos de Taos, New Mexico. Rebuilt 1772. (Wayne Andrews)

F. Mission St. Francis of Assisi, Ranchos de Taos, New Mexico. (Wayne Andrews)

G. Mission San Xavier del Bac, Tucson, Arizona. 1784–97. (Wayne Andrews)

A. Capen House, Topsfield, Mass. 1683. (Roos)

B. Paul Revere House, Boston, Mass. 1680. (Roos)

C. Whitman House, Farmington, Conn. c. 1660. (Roos)

D. Bacon's Castle, near Smithfield, Va. 1655. (Turpin Bannister)

E. McPhedris-Warner House, Portsmouth, N. H. c. 1720. (Roos)

F. Moffatt-Ladd House, Portsmouth, N. H. 1763. (Roos)

G. Usher-Royall House, Medford, Mass. Stairway. c. 1737. (Roos)

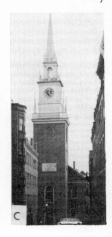

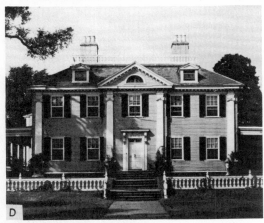

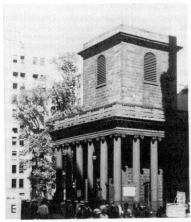

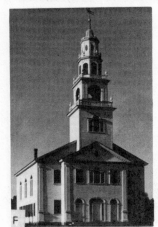

A. McPhedris-Warner House. Door. Detail of 226 E. (Roos)

B. Jones House, Hatfield, Mass. Door. c. 1730. (Roos)

C. Old North Church, Boston, Mass. 1723. Spire by Bulfinch, 1807. (Roos)

D. Craigie (Longfellow) House, Cambridge, Mass. 1759. (Roos)

E. King's Chapel, Boston, Mass. 1753. (Roos)

F. Church, Acworth, N. H. c. 1825. (Roos)

G. Old City Hall, Newport, R. I. Peter Harrison, architect. 1761. (Wayne Andrews)

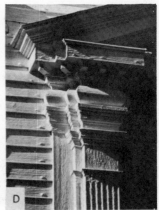

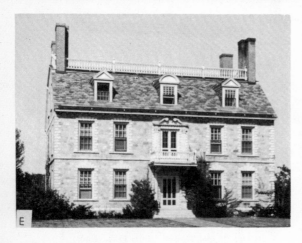

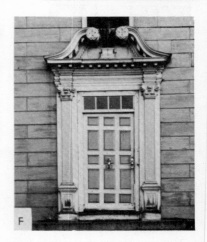

A. Old State House, Boston, Mass. 1748. (Roos)

B. Moffatt-Ladd House. Interior. (See 226 F.) (Roos)

C. Meeting House, Rockingham, Vt. 1787. (Roos)

D. Detail of C. (Roos)

E. Governor Hancock House, Boston, Mass. 1737–40. A replica at Ticonderoga, N. Y. Original destroyed. (Roos)

F. Wentworth-Gardner House, Portsmouth, N. H. Door. 1760. (Roos)

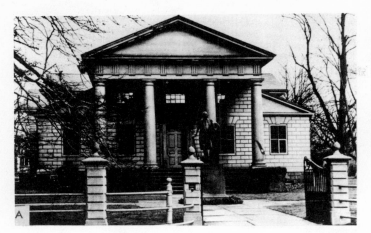

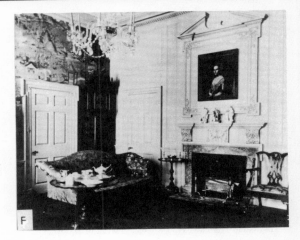

A. Redwood Library, Newport, R. I. Peter Harrison, architect. c. 1798. (U. of Ill.)

B. Christ Church, Philadelphia, Pa. Detail. 1727. (Roos)

C. St. Paul's Chapel, New York, N. Y. 1756–94. (Essex Inst.)

D. Dyckman House, New York, N. Y. 1798. (Roos)

E. Federal Hall, New York, N. Y. As remodeled by P. C. L'Enfant, 1788. Destroyed 1830's. (U. of Ill.)

F. Room from the Powell House, Philadelphia, Pa. c. 1768. Metropolitan Museum. (Met)

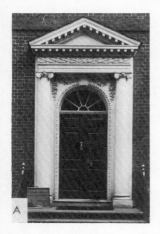

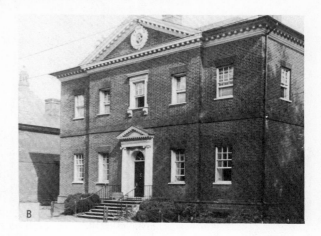

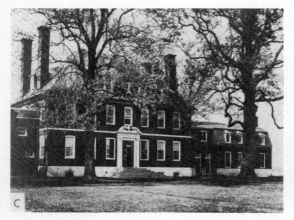

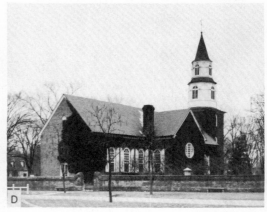

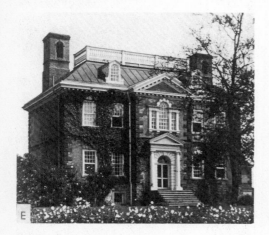

A.  Hammond-Harwood House. Door. Detail of B. (Roos)

B.  Hammond-Harwood House, Annapolis, Md. 1774. (Roos)

C.  Westover, Charles City Co., Va. c. 1726. (H. P. Cook)

D.  Bruton Parish Church, Williamsburg, Va. 1710–15. (Roos)

E.  Mt. Pleasant, Philadelphia, Pa. After 1761. (Roos)

F.  President's House, College of William and Mary, Williamsburg, Va. 1732. (Roos)

A. The Capitol, Williamsburg, Va. 1705. (Roos)

B. Wythe House, Williamsburg, Va. 1755. (Roos)

C. St. Michael's Church, Charleston, S. C. 1752–61. (Wayne Andrews)

D. William Gibbes House, Charleston, S. C. c. 1779. (Wayne Andrews)

E. The Cabildo, New Orleans, La. 1795. (U. of Ill.)

F. Parlange Plantation, near New Roads, La. c. 1750. (U. of Ill.)

A. John Pierce House, Portsmouth, N. H. 1799. Sometimes attributed to Bulfinch. (Roos)

B. First Church, Lancaster, Mass. Charles Bulfinch, architect. 1818. (Roos)

C. Detail of B. Tower. (Roos)

D. Assembly Hall, Salem, Mass. Remodeled by Samuel McIntire, 1793. (Roos)

E. Church, Fitzwilliam, N. H. 1817. (Roos)

F. Park Street Church, Boston, Mass. Peter Banner, architect. 1819. (Roos)

G. State House, Boston, Mass. Charles Bulfinch, architect. 1790–98. (Roos)

H. Church, Bennington, Vt. Tower. Asher Benjamin, architect. 1806. (Roos)

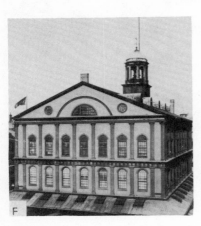

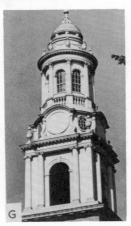

A. Center Congregational Church, New Haven, Conn. Ithiel Town, architect. 1812–15. (Roos)

B. Detail of A. Tower. (Roos)

C. Harrison Gray Otis House, Boston, Mass. Detail. Charles Bulfinch, architect. 1800–01. (Roos)

D. Gardner-White-Pingree House, Salem, Mass. Samuel McIntire, architect. 1805–10. (Roos)

E. Room from the Derby House, Salem, Mass. Samuel McIntire, architect. Philadelphia Museum. (Phila. Mus.)

F. Faneuil Hall, Boston, Mass. Built 1742, Rebuilt 1764, Remodeled by Charles Bulfinch, 1805. (Roos)

G. United Church, New Haven, Conn. Tower. David Hoadley, architect. 1813–15. (Roos)

H. Merchant's Exchange, Philadelphia, Pa. Tower. William Strickland, architect. 1834. (Roos)

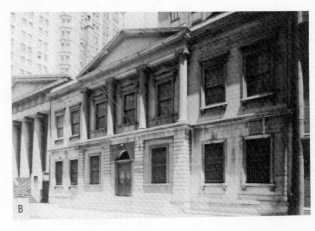

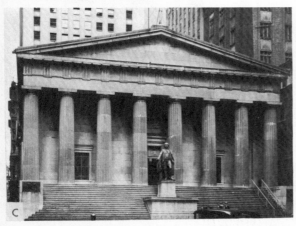

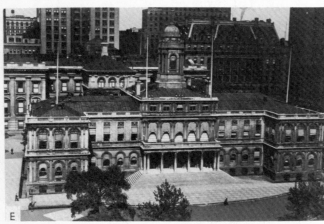

A. City Hall, New York, N. Y. Detail of E. (Roos)

B. Bank of the United States (Assay Office), New York, N. Y. 1822–24. Martin Thompson, architect. Removed 1922 to Metropolitan Museum. (Essex Inst.)

C. Old Customs House (U. S. Sub-Treasury), New York, N. Y. Ithiel Town and A. J. Davis, architects. 1834–41. (See 243 D.) (Roos)

D. Portico, Number 12, Washington Square, New York, N. Y. c. 1835. (Roos)

E. City Hall, New York, N. Y. McComb and Mangin, architects. 1803–12. (Roos)

F. Independence Hall, Philadelphia, Pa. Spire. Remodeled 1828. William Strickland, architect. (Roos)

A. Homewood, Baltimore, Md. 1798–1800. (Roos)

B. Original Design for Washington Monument, Washington, D. C. Robert Mills, architect. Started 1848. (U. of Ill.)

C. Capitol, Washington, D. C. Central Pavilion, W. facade. Detail of D. (Roos)

D. Capitol, Washington, D. C. Begun 1793. Thornton, Latrobe, Bulfinch and others, architects. Dome designed by T. U. Walter, finished 1865. (Roos)

E. Capitol, Washington, D. C. Exterior from S.E. As was in 1840.

F. Tobacco Capital, designed by B. H. Latrobe for National Capitol. Model at Monticello. c. 1817. (Roos)

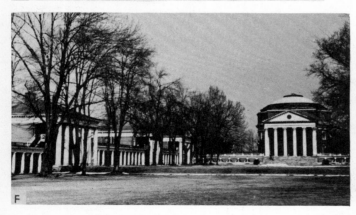

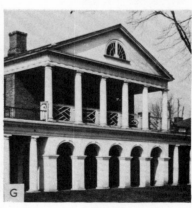

A. Corn Order, designed by B. H. Latrobe for National Capitol. c. 1809.

B. White House, Washington, D. C. James Hoban, architect. 1792–1829. Portico by B. H. Latrobe, 1818. (Roos)

C. Detail of B. (Roos)

D. City Plan, Washington, D. C. P. C. L'Enfant, architect. 1791.

E. Monticello, near Charlottesville, Va. Detail of the Portico. (See 237 A.) (Roos)

F. University of Virginia, Charlottesville, Va. Thomas Jefferson, architect. 1817–24. (Roos)

G. Pavilion VII, University of Virginia. 1817. (Roos)

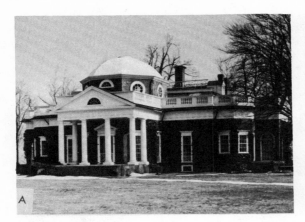

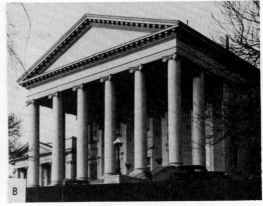

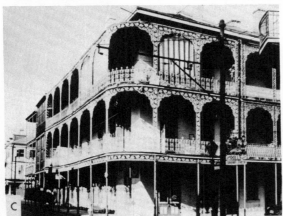

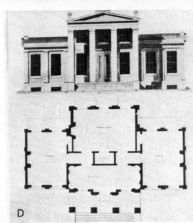

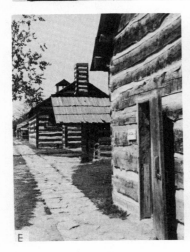

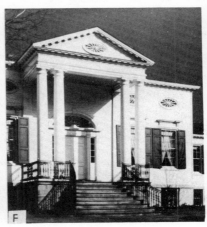

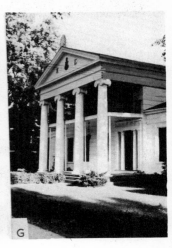

A. Monticello, near Charlottesville, Va. Thomas Jefferson, architect. 1796–1808. (See 236 E.) (Roos)

B. Capitol, Richmond, Va. Design influenced by Thomas Jefferson, 1785–98. (Roos)

C. Labranche Building, New Orleans, La. c. 1835. (Wayne Andrews)

D. Design for a Country Villa, from Minard Lafever, *Modern Builder's Guide*, 1833.

E. Moravian Village reconstruction, Schoenbrunn, Ohio. Settled 1772. (Roos)

F. Taft House, Cincinnati, Ohio. c. 1820. B. H. Latrobe (?) architect. (Roos)

G. Avery-Downer House, Granville, Ohio. 1842. (Roos)

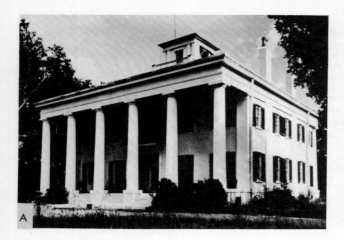

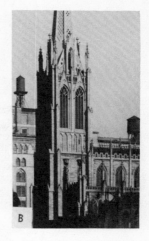

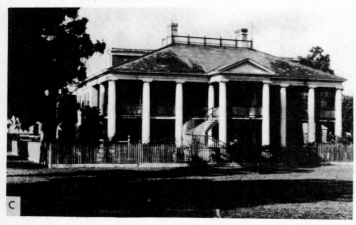

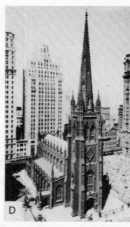

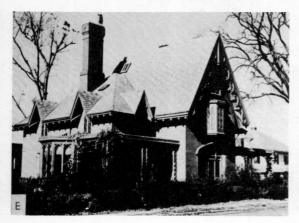

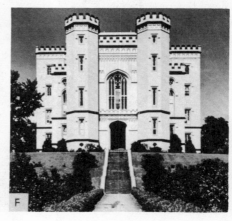

A. D'Evereaux Plantation, Natchez, Miss. 1840. (Wayne Andrews)

B. Grace Church, New York, N. Y. James Renwick, architect. 1843–46. (Roos)

C. Evergreen Plantation, near Edgard, La. c. 1840. (U. of Ill.)

D. Trinity Church, New York, N. Y. Richard Upjohn, architect. 1839–46. (Wurts Bros.)

E. Rotch House, New Bedford, Mass. A. J. Davis, architect. 1845. (Wayne Andrews)

F. State Capitol, Baton Rouge, La. 1847–50. Reconstructed 1882. (Wayne Andrews)

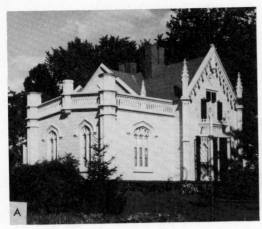

A. Schoolcraft House, Guilderland, N. Y. (Roos)

B. Wedding Cake House, Kennebunk, Me. c. 1850. Original house, c. 1800. (Wayne Andrews)

C. Longwood Plantation, Natchez, Miss. Started c. 1858. (U. of Ill.)

D. Carson House, Eureka, Cal. c. 1885. (U. of Ill.)

E. Museum of Fine Arts, Boston, Mass. Sturgis and Brigham, architects. 1871–76. (U. of Ill.)

F. Provident Trust Co., Philadelphia, Pa. c. 1878. (Wayne Andrews)

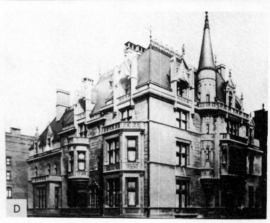

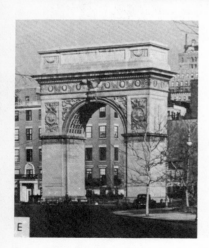

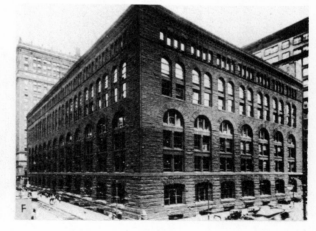

A. Court of Honor, World's Columbian Exposition, Chicago. 1893. Burnham, Root, R. M. Hunt and others, architects. (See 244 C.) (Met)

B. Biltmore, Ashville, N. C. R. M. Hunt, architect. 1890–95. (Wayne Andrews)

C. New York University Library. McKim, Mead and White, architects. 1899. (Roos)

D. W. K. Vanderbilt House, New York, N. Y. R. M. Hunt, architect. 1879–81. Destroyed c. 1926. (U. of Ill.)

E. Washington Square Arch, New York, N. Y. Stanford White, architect. 1892. (Roos)

F. Marshall Field Wholesale Building, Chicago. H. H. Richardson, architect. 1885–87. (U. of Ill.)

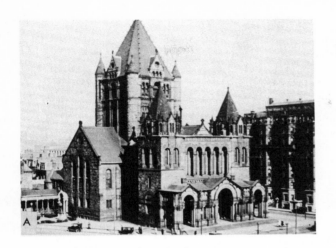

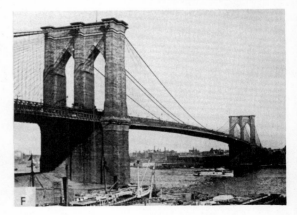

A. Trinity Church, Boston, Mass. H. H. Richardson, chief architect. Mostly 1872–77. Porch and turrets, 1894–98. (U. of Ill.)

B. Detail of A. Interior. Decoration by John La Farge. (Met)

C. Glessner House, Chicago. H. H. Richardson, architect. 1885–87. (U. of Ill.)

D. A. T. Stewart Store, New York, N. Y. 1862. (Wayne Andrews)

E. Design for the Bogardus Factory showing the strength of cast iron construction. James Bogardus, architect. 1856. (U. of Ill.)

F. Brooklyn Bridge, New York, N. Y. John and W. A. Roebling, architects. 1883. (U. of Ill.)

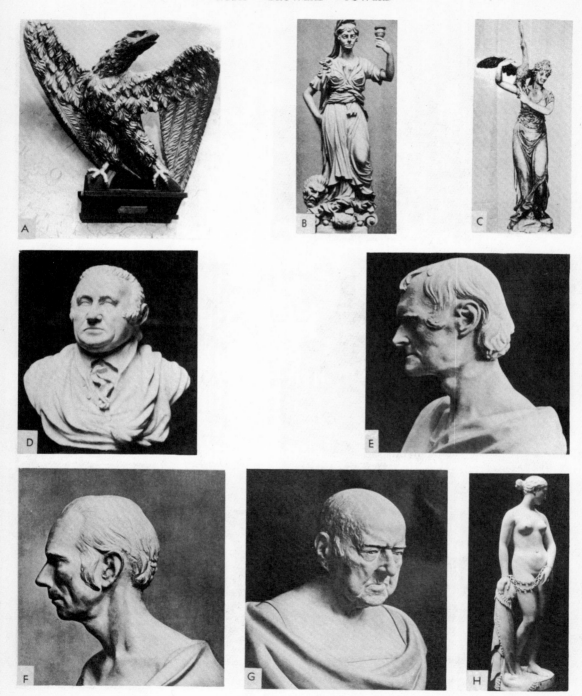

A. William Rush. Eagle. 1808–10. Pennsylvania Academy of the Fine Arts, Philadelphia. (Pa. Acad.)

B. William Rush. Tragedy. 1808. Philadelphia Museum of Art. (Phila. Mus.)

C. William Rush. Water Nymph and Bittern. c. 1809. Philadelphia Museum of Art. (Phila. Mus.)

D. William Rush. Dr. Caspar Wistar. c. 1813. Pennsylvania Academy of the Fine Arts,.Philadelphia. (Pa. Acad.)

E. John Browere. Thomas Jefferson, age 82. Life mask. 1825. New York State Historical Assoc., Cooperstown, N. Y. (N.Y.S.H.A.)

F. John Browere. Henry Clay, age 48. Life mask. 1825. New York State Historical Assoc., Cooperstown, N. Y. (N.Y.S.H.A.)

G. John Browere. John Adams, age 90. Life mask. 1825. New York State Historical Assoc., Cooperstown, N. Y. (N.Y.S.H.A.)

H. Hiram Powers. Greek Slave. 1846. Corcoran Collection, Washington, D. C. (Corcoran Coll.)

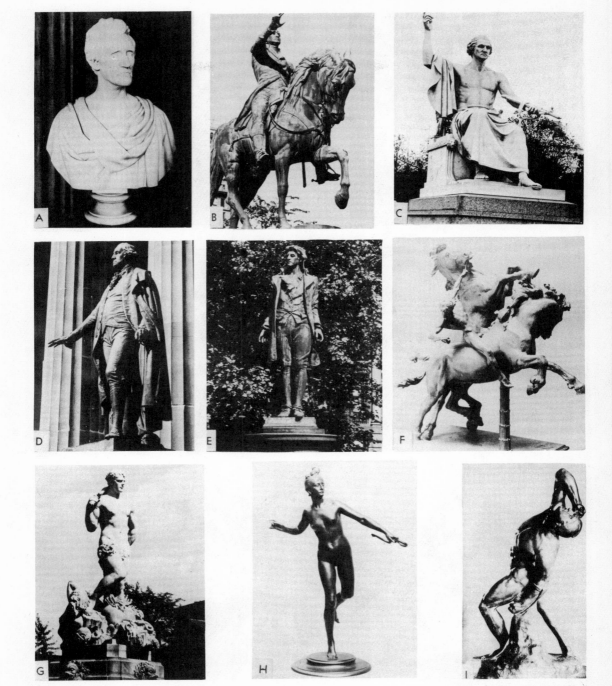

A. Hiram Powers. Andrew Jackson. Metropolitan Museum, New York. (Met)

B. H. K. Brown and J. Q. A. Ward. George Washington. 1856. Union Square, New York, N. Y. (Roos)

C. Horatio Greenough. George Washington. 1832–41. Smithsonian Institution, Washington, D. C. (Met)

D. J. Q. A. Ward. George Washington. 1883. Wall St., New York, N. Y. See 234 C. (Roos)

E. Frederick Macmonnies. Nathan Hale. 1890. New York, N. Y. (Roos)

F. Frederick Macmonnies. Horse Tamers. 1898. New York, N. Y. (Met)

G. Frederick Macmonnies. Civic Virtue. 1922. New York, N. Y. (Roos)

H. Frederick Macmonnies. Diana. 1890. Metropolitan Museum, New York. (Met)

I. William Rimmer. Falling Gladiator. Museum of Fine Arts, Boston. (M.F.A.)

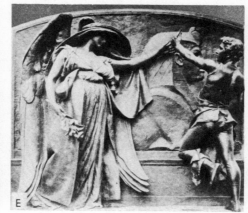

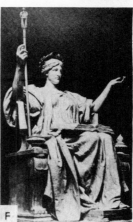

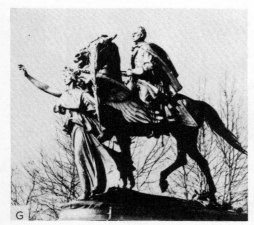

A. George Gray Barnard. The Burden of Life and Relief in Labor. 1917. Capitol, Harrisburg, Pa. (Roos)

B. Detail of A. (Roos)

C. Daniel Chester French. The Republic. 1893. Jackson Park, Chicago. (See 240 A.) (Winston Weisman)

D. Daniel Chester French. Abraham Lincoln. 1923. Lincoln Memorial, Washington, D. C. (Roos)

E. Daniel Chester French. Death Staying the Hand of the Sculptor. c. 1883. Replica in the Metropolitan Museum. (Met)

F. Daniel Chester French. Alma Mater. 1902–03. Columbia University, New York. (Courtesy Mrs. William Penn Cresson)

G. Augustus Saint-Gaudens. The Sherman Monument. 1887–1903. New York. (Roos)

H. Detail of G. (Roos)

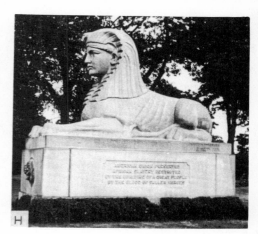

A. Augustus Saint-Gaudens. Robert Louis Stevenson. 1887. Metropolitan Museum. (Met)

B. Augustus Saint-Gaudens. The Shaw Memorial. 1884–97. Boston Common. (Lorado Taft)

C. Augustus Saint-Gaudens. The Farragut Monument. 1875. New York, N. Y. (Roos)

D. Augustus Saint-Gaudens. Diana. 1888. Philadelphia Museum of Art. (Phila. Mus.)

E. H. K. Brown. Abraham Lincoln. 1868. Union Square, New York, N. Y. (Roos)

F. George Gray Barnard. Head of Abraham Lincoln. Metropolitan Museum. New York. (Met)

G. Cyrus Dallin. Appeal to the Great Spirit. 1909. Museum of Fine Arts. (M.F.A.)

H. Martin Milmore. Sphinx. 1872. Mt. Auburn Cemetery, Cambridge, Mass. (Roos)

A. Paul Manship. Prometheus. Rockefeller Plaza, New York.
(See 278 A.) (Roos)

B. Paul Manship. Diana. 1920. (DeWitt Ward)

C. Paul Manship. Detail of A. (Roos)

D. Anna Hyatt Huntington. Joan of Arc. c. 1924. New York,
N. Y. (Roos)

E. Paul Manship. Dancer and Gazelles. 1916. Art Institute.
(Art Inst.)

F. Lorado Taft. Abraham Lincoln. 1926–27. Urbana, Ill.
(Lorado Taft)

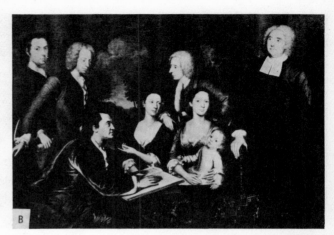

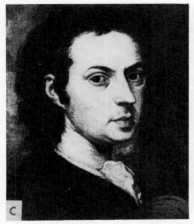

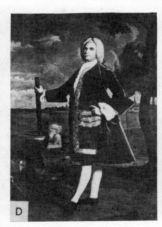

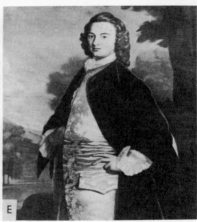

A. The Mason Limner. Alice Mason. 1670. Adams National Historic Site, Quincy, Mass. (Dept. of Interior)

B. John Smibert. Dean Berkeley and His Entourage. 1729. Yale University Art Gallery. (Yale Univ.)

C. John Smibert. Detail of B. Self Portrait.

D. Robert Feke. Gen. Samuel Waldo. c. 1748–50. Bowdoin College, Brunswick, Me. (Bowdoin Coll.)

E. Robert Feke. Gov. James Bowdoin II. 1748. Bowdoin College, Brunswick, Me. (Bowdoin Coll.)

F. Ralph Earl, Maj. Gen. William Augustin, Baron von Steuben. c. 1786. Yale University Art Gallery. (Yale Univ.)

G. Gustavus Hesselius. Self Portrait. c. 1740. Historical Society of Pennsylvania, Philadelphia. (Hist. Soc. Pa.)

# AMERICAN PAINTING · XVIII CENT.
## SMIBERT · J. HESSELIUS · COPLEY

A. John Smibert. Nathaniel Byfield. 1730. Metropolitan Museum, New York. (Met)

B. John Hesselius. Mrs. Richard Galloway, Jr. 1764. Metropolitan Museum, New York. (Met)

C. John Hesselius. Charles Calvert and Colored Slave. 1761. Baltimore Museum of Art. (Balt. Mus.)

D. John Singleton Copley. Watson and the Shark. 1782. Detroit Institute of Arts. (Det. Inst.)

E. John Singleton Copley. John Quincy Adams. 1795. Museum of Fine Arts. (M.F.A.)

F. John Singleton Copley. Gov. and Mrs. Thomas Mifflin. 1773. Historical Society of Pennsylvania, Philadelphia. (Hist. Soc. Pa.)

G. John Singleton Copley. John Adams. 1783. Harvard University. (Fogg)

H. John Singleton Copley. Nicholas Boylston. Museum of Fine Arts. (M.F.A.)

I. John Singleton Copley. John Hancock. 1765. Courtesy City of Boston through the Museum of Fine Arts. (M.F.A.)

A. Gilbert Stuart. Portrait of Elizabeth Boardley. Pennsylvania Academy of the Fine Arts, Philadelphia. (Pa. Acad.)

B. Gilbert Stuart. George Washington. Gibbs-Channing-Avery Portrait. 1795. Metropolitan Museum, New York. (Met)

C. Gilbert Stuart. George Washington. Unfinished. 1796. Deposited in the Museum of Fine Arts by the Boston Atheneum. (M.F.A.)

D. Gilbert Stuart. William Redwood. c. 1774. Redwood Library and Atheneum, Newport, R. I. (Redwood Lib.)

E. Gilbert Stuart. Benjamin West. National Portrait Gallery, London. (Nat. Port. Gall.)

F. Gilbert Stuart. Mrs. Pérez Morton. After 1802. Worcester Art Museum. (Worcester Mus.)

G. Gilbert Stuart. James Ward. Minneapolis Institute of Art. (Minn. Inst.)

H. Matthew Pratt. The American School. 1765. Metropolitan Museum, New York. (Met)

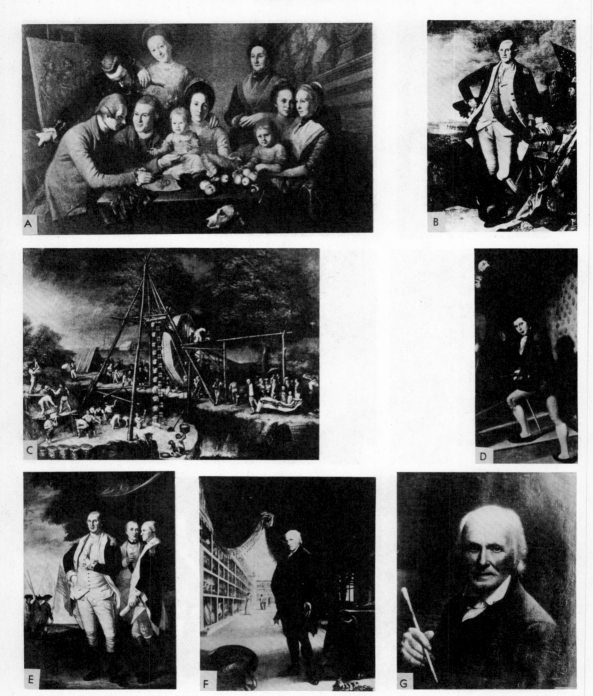

A. Charles Willson Peale. The Peale Family. New-York Historical Society, New York. (N. Y. Hist. Soc.)

B. Charles Willson Peale. General Washington. 1779. Pennsylvania Academy of the Fine Arts, Philadelphia. (Pa. Acad.)

C. Charles Willson Peale. Exhuming of the First American Mastodon. 1806–10. The Peale Museum, Baltimore, Md. (Peale Mus.)

D. Charles Willson Peale. Staircase Group—Portrait of the Sons of the Artist. 1795. Philadelphia Museum of Art. (Phila. Mus.)

E. Charles Willson Peale. Gen. Washington, Lafayette and Tench Tilghman. 1786. State House, Annapolis, Md. (State Ho.)

F. Charles Willson Peale. Portrait of the Artist in his Museum. 1824. Pennsylvania Academy of the Fine Arts, Philadelphia. (Pa. Acad.)

G. Charles Willson Peale. Self Portrait. Pennsylvania Academy of the Fine Arts, Philadelphia. (Pa. Acad.)

A. Charles Willson Peale. Worthy of Liberty, Mr. Pitt scorns to invade the liberties of other people. 1768. (U. of Ill.)

B. Rembrandt Peale. Thomas Jefferson. 1805. New-York Historical Society, New York. (N. Y. Hist. Soc.)

C. Raphaelle Peale. After the Bath. 1823. Nelson-Atkins Gallery of Art, Kansas City, Mo. (Nelson-Atkins Gall.)

D. Charles Willson Peale. Benjamin Franklin. 1787. Pennsylvania Academy of the Fine Arts, Philadelphia. (Pa. Acad.)

E. Benjamin West. Penn's Treaty with the Indians. 1771. Pennsylvania Academy of the Fine Arts, Philadelphia. (Pa. Acad.)

F. Benjamin West. Charles Willson Peale. 1767–69. New-York Historical Society, New York. (N. Y. Hist. Soc.)

G. Raphaelle Peale. Still Life with Vegetables. c. 1823. Wadsworth Atheneum, Hartford, Conn. (Wadsworth Atheneum)

A. John Vanderlyn. Ariadne. c. 1812. Pennsylvania Academy of the Fine Arts, Philadelphia. (Pa. Acad.)

B. John Vanderlyn. Portrait of the Artist. c. 1815. Metropolitan Museum, New York. (Met)

C. Washington Allston. Moonlit Landscape. 1819. Museum of Fine Arts. (M.F.A.)

D. Washington Allston. The Dead Man Restored to Life by Touching the Bones of the Prophet Elisha. 1811–13. Pennsylvania Academy of the Fine Arts, Philadelphia. (Pa. Acad.)

E. Washington Allston. Belshazzar's Feast. Begun 1817. Washington Allston Trust, Boston. (Wash. Allston Trust)

F. Washington Allston. Italian Landscape. c. 1830. Detroit Institute of Arts. (Det. Inst.)

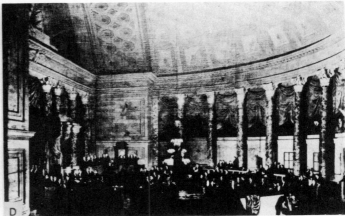

A. Thomas Sully. The Torn Hat. 1820. Museum of Fine Arts. (M.F.A.)

B. John Trumbull. The Death of General Mercer at the Battle of Princeton. 1777. Yale University Art Gallery. (Yale Univ.)

C. Thomas Sully. Portrait of the Artist. 1860. Historical Society of Pennsylvania, Philadelphia. (Hist. Soc. Pa.)

D. Samuel F. B. Morse. Old House of Representatives. 1882. Corcoran Collection, Washington, D. C. (Corcoran Coll.)

E. John Neagle. Pat Lyon at his Forge. 1829. Pennsylvania Academy of the Fine Arts, Philadelphia. (Pa. Acad.)

F. Samuel F. B. Morse. The Gallery of the Louvre. 1832. Syracuse University. (Syracuse Univ.)

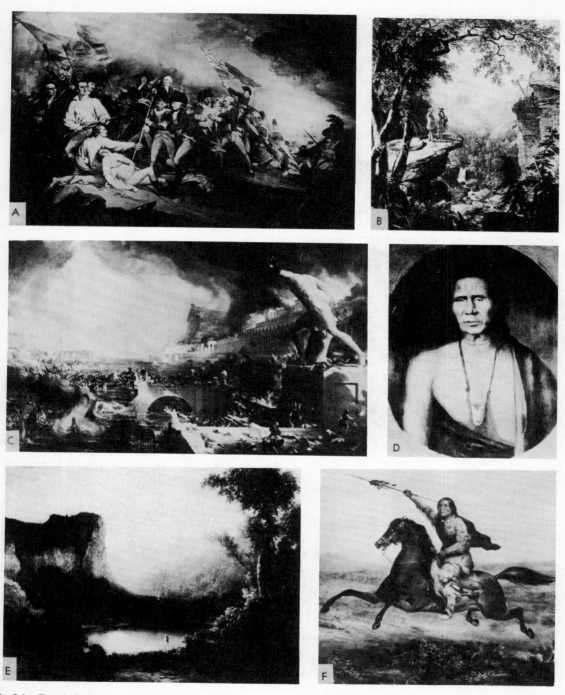

A. John Trumbull. Battle of Bunker Hill. 1786. Yale University Art Gallery. (Yale Univ.)

B. Asher Durand. Kindred Spirits, William C. Bryant and Thomas Cole. 1849. New York Public Library. (N.Y.P.L.)

C. Thomas Cole. Destruction of the Empire. 1836. New-York Historical Society, New York. (N. Y. Hist. Soc.)

D. Gustavus Hesselius. Lapowinsa. 1735. Historical Society of Pennsylvania, Philadelphia. (Hist. Soc. Pa.)

E. Thomas Doughty. In Nature's Wonderland. 1835. Detroit Institute of Arts. (Det. Inst.)

F. John Mix Stanley. Ko-kak-koo-kiss, a Towoccono Warrior. 1844. U. S. National Museum, Washington. (Smithsonian Institution.)

A. George Catlin. Osceola. Before 1838. American Museum of Natural History, New York. (Am. Mus. Nat. Hist.)

B. Charles Wimar. The Captive Charger. 1854. St. Louis City Art Museum. (St. Louis C. A. M.)

C. Anonymous American. Henry Ward Beecher. 1850–60? Metropolitan Museum of Art, New York. (Met)

D. Anonymous American. Cigar Store Indian. XIX century. Index of American Design, U. S. National Gallery of Art, Washington. (Index of Am. Des.)

E. Albert Bierstadt. Starr King Mountain, California. 1866. Cleveland Museum of Art, The Hinman B. Hurlbut Coll. (Clev. Mus. Art)

F. George Catlin. Ha-won-je-tah, the One Horn; First Chief of the Tribe, Sioux, (Dak-co-ta). c. 1832. U. S. National Museum, Washington. (Smithsonian Institution)

G. Anonymous American. Samuel Houston as Marius. 1831. From a copy, 1912. State Capitol, Austin, Texas. (Texas State Lib.)

H. Anonymous American. Baby in Red High Chair. c. 1790. Metropolitan Museum of Art, New York. (Met)

A. Edmond Brown. Carrousel Rooster. 19th c. Index of American Design, U. S. National Gallery of Art, Washington. (Index of Am. Des.)

B. Joseph Pickett. Manchester Valley. c. 1916. Museum of Modern Art, New York. (Mus. Mod. Art)

C. "Deacon" Shem Drowne. Weathervane, Indian Archer. c. 1716. Massachusetts Historical Society, Boston. (Mass. Hist. Soc.)

D. John James Audubon. Virginia Deer. Brooklyn Museum. (Brooklyn Mus.)

E. William Harnett. Old Models. 1892. Museum of Fine Arts, Boston. (M.F.A.)

F. John Quidor. Wolfert's Will. 1856. Brooklyn Museum. (Brooklyn Mus.)

A. Erastus Field. Historical Monument of the American Republic. c. 1876. Springfield Museum of Fine Arts, Mass. (Spr. Mus.)

B. Richard C. Woodville. Politics in an Oyster House. 1848. Walters Art Gallery, Baltimore, Md. (Walters Art Gall.)

C. Eastman Johnson. Family Group. 1871. Metropolitan Museum, New York. (Met)

D. Henry Sargent. The Tea Party. c. 1825. Museum of Fine Arts. (M.F.A.)

E. William S. Mount. The Banjo Player. Detail. c. 1858. Detroit Institute of Arts. (Det. Inst.)

F. Eastman Johnson. Old Kentucky Home—Life in the South. 1859. New York Public Library. (N.Y.P.L.)

A. George Caleb Bingham. Figure of an Elderly Gentleman Smoking a Long Pipe. c. 1850. St. Louis Mercantile Library Association. (St. Louis M.L.A.)

B. George Caleb Bingham. Raftsmen Playing Cards. 1847. St. Louis City Art Museum. (St. Louis C.A.M.)

C. George Caleb Bingham. Senile Old Man Tottering Down Steps. c. 1850. St. Louis Mercantile Library Association. (St. Louis M.L.A.)

D. Winslow Homer. Sloop, Bermuda. 1899. Metropolitan Museum, New York. (Met)

E. George Caleb Bingham. Two Citizens Engaged in a Conversation. c. 1850. St. Louis Mercantile Library Association. (St. Louis M.L.A.)

F. Winslow Homer. Detail of D.

A. Winslow Homer. All's Well. 1896. Museum of Fine Arts. (M.F.A.)

B. Winslow Homer. The Herring Net. 1885. Art Institute. (Art Inst.)

C. Winslow Homer. Breezing Up. 1876. U. S. National Gallery of Art, Washington. (U. S. Nat. Gall.)

D. Thomas Eakins. Walt Whitman. 1887. Pennsylvania Academy of the Fine Arts, Philadelphia. (Pa. Acad.)

E. Thomas Eakins. The Agnew Clinic. University of Pennsylvania, Philadelphia. (Univ. of Pa.)

F. Thomas Eakins. The Gross Clinic. 1875. Jefferson Medical College, Philadelphia. (Jeff. Med. Coll.)

A. Thomas Eakins. Salutat. 1898. Addison Gallery, Phillips Academy, Andover, Mass. (Addison Gall.)

B. Thomas Eakins. Max Schmidt in a Single Scull. 1871. Metropolitan Museum, New York. (Met)

C. A. P. Ryder. The Temple of the Mind. c. 1888. Albright Art Gallery, Buffalo, N. Y. (Albright Art Gall.)

D. A. P. Ryder. Death on a Pale Horse. c. 1910. Cleveland Museum of Art, The J. H. Wade Collection. (Clev. Mus.)

E. A. P. Ryder. Siegfried and the Rhine Maidens. U. S. National Gallery of Art, Washington. (U. S. Nat. Gall.)

F. A. P. Ryder. Toilers of the Sea. c. 1900. Addison Gallery, Phillips Academy, Andover, Mass. (Addison Gall.)

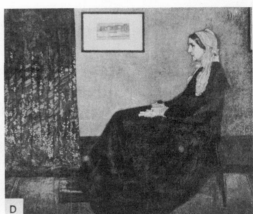

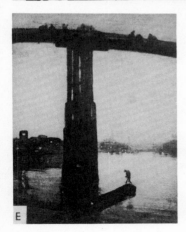

A. James M. Whistler. Thomas Carlyle. Glasgow Corporation Gallery. (Glasgow Corp.)

B. James M. Whistler. Black Lion Wharf. Etching. 1859. (See 309 F for Detail.) (Fogg)

C. John S. Sargent. Robert Louis Stevenson. 1885. Taft Museum, Cincinnati, Ohio. (Taft Mus.)

D. James M. Whistler. Portrait of the Artist's Mother. 1871. Louvre.

E. James M. Whistler. Old Battersea Bridge. Tate Gallery, London. (Nat. Gall.)

F. James M. Whistler. Nocturne in Black and Gold (The Fire Wheel). Collection Mr. A. H. Studd. (Met)

A. W. M. Hunt. Flight of Night. Pennsylvania Academy of the Fine Arts, Philadelphia. (Pa. Acad.)

B. W. M. Hunt. The Bathers. 1887. Worcester Art Museum. (Worcester Mus.)

C. George de Forest Brush. Mother and Child. 1895. Museum of Fine Arts. (M.F.A.)

D. George Inness. Peace and Plenty. Metropolitan Museum, New York. (Met)

E. Frank Duveneck. Whistling Boy. 1872. Taft Museum, Cincinnati, Ohio. (Taft Mus.)

F. Homer Martin. Harp of the Winds; a View of the Seine. 1895. Metropolitan Museum, New York. (Met)

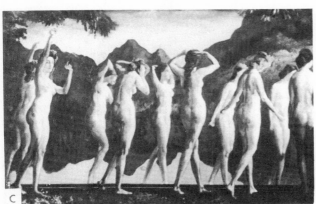

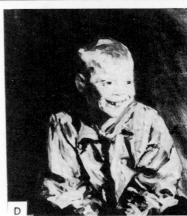

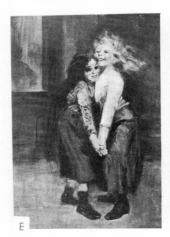

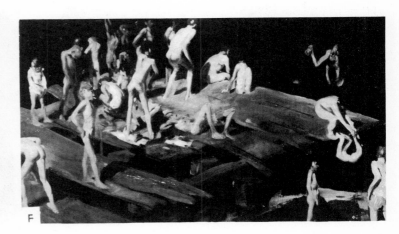

A. George Bellows. Dempsey, Firpo. 1924. Whitney Museum of American Art, New York. (Whitney Mus.)

B. George Bellows. Eleanor, Jean and Anna. 1920. Albright Art Gallery, Buffalo, N. Y. (Albright Gall.)

C. Arthur B. Davies. Maya, Mirror of Illusions. Before 1910. Art Institute. (Art Inst.)

D. Robert Henri. Dutch Joe. 1910. Milwaukee Art Institute. (Met)

E. George Luks. The Spielers. 1905. Addison Gallery, Phillips Academy, Andover, Mass. (Addison Gall.)

F. George Bellows. Forty-Two Kids. Detail. 1907. Corcoran Collection, Washington, D. C. (Corcoran Coll.)

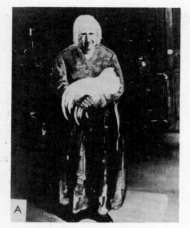

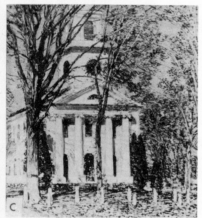

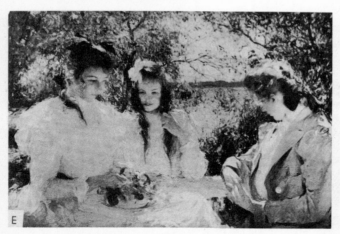

A. George Luks. Portrait of Mrs. Gamley. Whitney Museum of American Art, New York. (Whitney Mus.)

B. William J. Glackens. Chez Mouquin. 1905. Art Institute. (Art Inst.)

C. Childe Hassam. Church at Old Lyme, Connecticut. 1905. Albright Art Gallery, Buffalo, N. Y. (Albright Gall.)

D. Maurice Prendergast. Ponte della Paglia. Phillips Collection, Washington, D. C. (Phillips Coll.)

E. Frank W. Benson. My Daughters. 1907. Worcester Art Museum. (Worcester Mus.)

F. Mary Cassatt. Mother and Child. 1903. Worcester Art Museum. (Worcester Mus.)

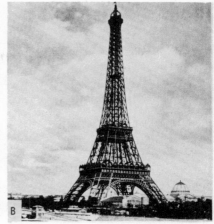

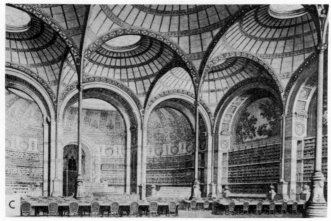

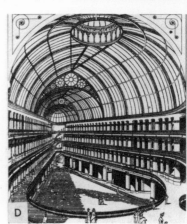

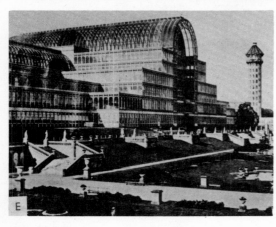

A. Bibliothèque Sainte Geneviève, Paris. Interior, Second Floor. Henri Labrouste, architect. 1843–50. (U. of Ill.)

B. Eiffel Tower, Paris. Gustave Eiffel, engineer. 1889. (U. of Ill.)

C. Bibliothèque Nationale, Paris, Reading Room. Henri Labrouste, architect. 1858–68.

D. Arcade, Victoria Buildings, Manchester. c. 1873. (U. of Ill.)

E. Crystal Palace, London. Joseph Paxton, architect. 1851. (U. of Ill.)

F. Iron Column and Staircase, 12 Rue de Turin, Brussels, Victor Horta, architect. (U. of Ill.)

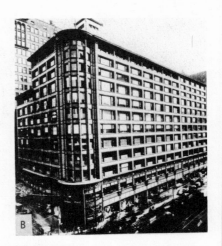

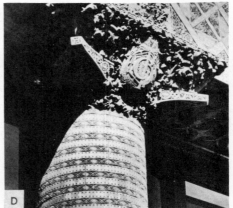

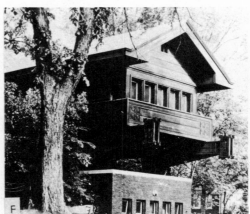

A. Transportation Building, Chicago. Louis Sullivan, architect. 1893. (Ralph Line)

B. Carson Pirie Scott Store, Chicago. Louis Sullivan, architect. 1899. (Chgo. Architectural Photo. Co.)

C. Prudential Building, Buffalo, N. Y. Louis Sullivan, architect. 1894–95. (Ralph Line)

D. Detail of C. (Ralph Line)

E. Auditorium Building, Chicago. Louis Sullivan, architect. 1887–89. (Ralph Line)

F. Josephine Bradley House, Madison, Wis. Louis Sullivan, architect. 1909. (Ralph Line)

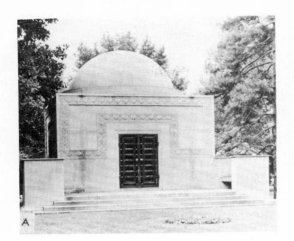

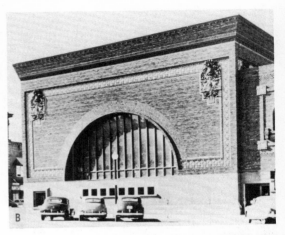

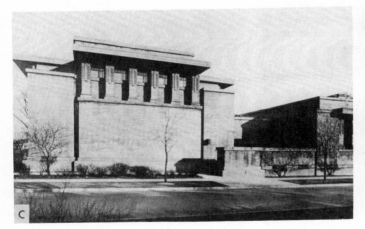

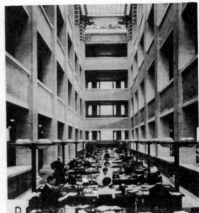

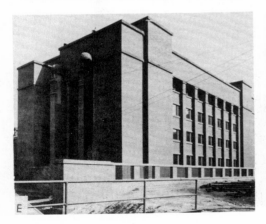

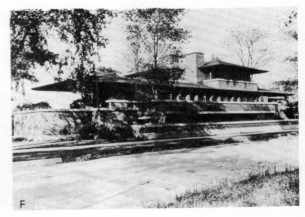

A. Charlotte Wainright Tomb, St. Louis, Mo. Louis Sullivan, architect. 1892. (Ralph Line)

B. National Farmer's Bank, Owatonna, Minn. Louis Sullivan, architect. 1907–08. (Ralph Line)

C. Unity Temple, Oak Park, Ill. Frank Lloyd Wright, architect. 1906. (U. of Ill.)

D. Larkin Building, Buffalo, N. Y. Interior. Destroyed 1947. (F. L. Wright)

E. Larkin Building, Buffalo, N. Y. Frank Lloyd Wright, architect. 1903–05. (F. L. Wright)

F. Robie House, Chicago. Frank Lloyd Wright, architect. 1909. (F. L. Wright)

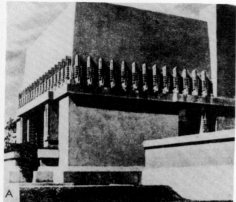

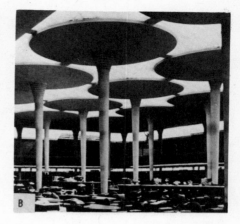

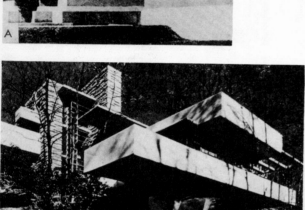

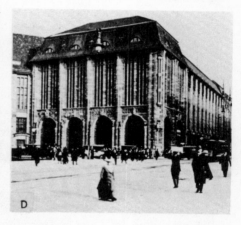

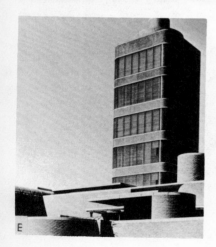

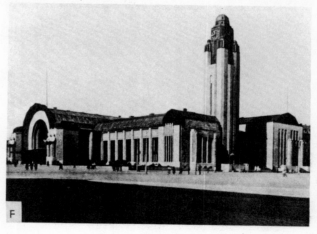

A. Barnsdall House, Los Angeles, Cal. Frank Lloyd Wright, architect. 1917. (F. L. Wright)

B. Johnson Wax Co., Administration Building. Racine, Wis. Frank Lloyd Wright, architect. 1936–39. (Wayne Andrews)

C. Falling Water, Bear Run, Pa. Frank Lloyd Wright, architect. 1937–39. (Mus. Mod. Art)

D. Wertheim Department Store, Berlin. Alfred Messel, architect. 1897–1904. (U. of Ill.)

E. Johnson Wax Co., Administration Building, Tower. Racine, Wis. Frank Lloyd Wright, architect. 1949. (U. of Ill.)

F. R. R. Station, Helsingfors, Finland. Eliel Saarinen, architect. 1906–14. (U. of Ill.)

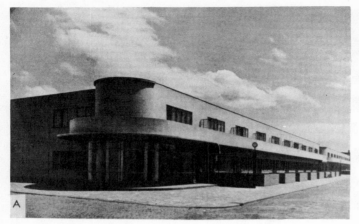

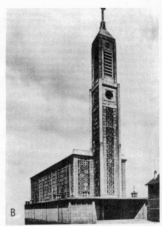

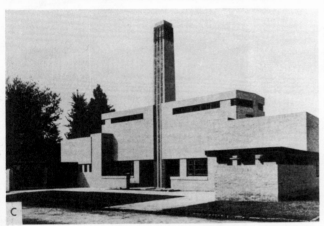

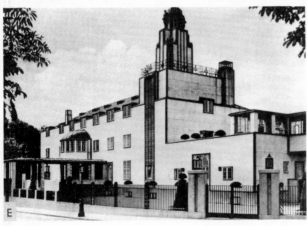

A. Workers' Houses, Hook of Holland. J. J. P. Oud, architect. 1924–26. (U. of Ill.)

B. Church of St. Therese, Montmagny, France. Auguste and Gustave Perret, architects. 1925. (U. of Ill.)

C. Bath House, Hilversum, Holland. Willem Dudok, architect. 1921. (U. of Ill.)

D. Interior of B. (U. of Ill.)

E. Stoclet Palace, Brussels. Josef Hoffmann, architect. 1905–11. (U. of Ill.)

F. Dirigible Hangar, Orly, France. Eugene Freyssinet, architect. 1916. (U. of Ill.)

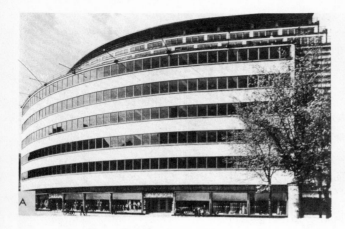

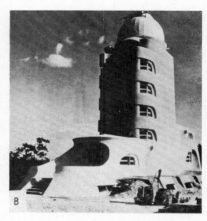

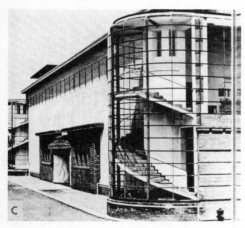

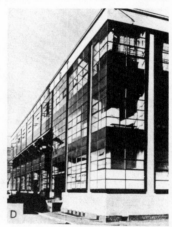

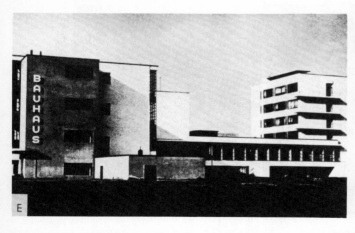

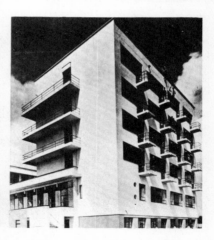

A. Schocken Department Store, Chemnitz, Germany. Eric Mendelsohn, architect. 1928. (U. of Ill.)

B. Einstein Tower, Potsdam, Germany. Eric Mendelsohn, architect. 1921. (U. of Ill.)

C. Model Factory, Exhibition Building, Cologne, Germany. Walter Gropius, architect. 1914. (U. of Ill.)

D. Fagus Factory, Alfeld-an-der-Leine, Germany. Walter Gropius and Adolph Meyer, architects. 1911. (U. of Ill.)

E. Bauhaus, Dessau, Germany. Walter Gropius, architect. 1925. (U. of Ill.)

F. Bauhaus, Student's Studio Building, Dessau. Walter Gropius, architect. 1926. (U. of Ill.)

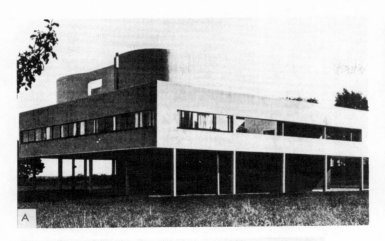

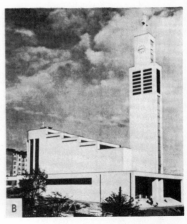

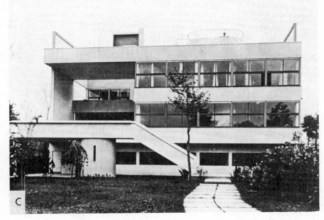

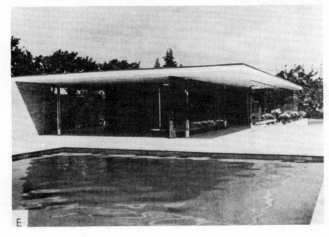

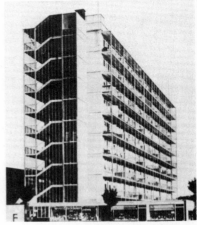

A. Savoye House, Poissy-sur-Seine, France. Le Corbusier, architect. 1929–30. (U. of Ill.)

B. St. Wenceslas, Prague. Josef Gocar, architect. c. 1930. (Arch. Record)

C. Gertrude Stein House, Garches, France. Le Corbusier, architect. 1927–28. (U. of Ill.)

D. German Pavilion, International Exposition, Barcelona. Plan. Miës van der Rohe, architect. 1929. (U. of Ill.)

E. German Pavilion, International Exposition, Barcelona. Miës van der Rohe, architect. 1929. (U. of Ill.)

F. Bergpolder Apartments, Rotterdam. J. Brinkman and Van der Vlugt, architects. 1934. (U. of Ill.)

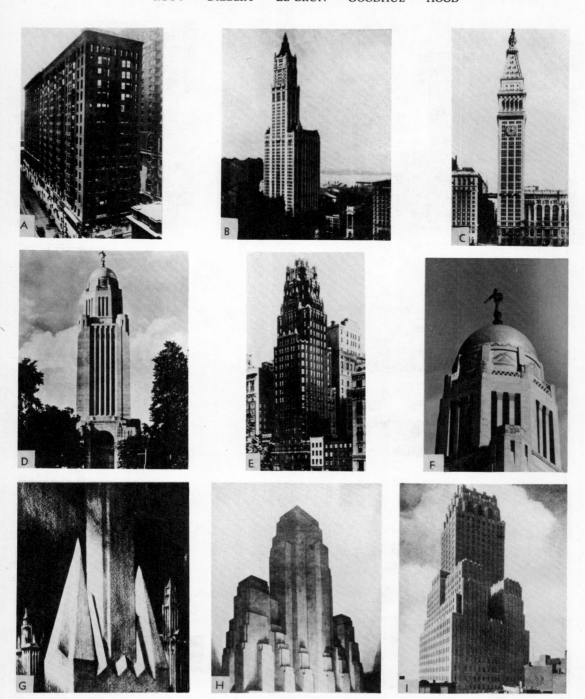

A. Monadnock Block, Chicago. J. W. Root, architect. 1891. (U. of Ill.)

B. Woolworth Building, New York. Cass Gilbert, architect. 1913. (U. of Ill.)

C. Metropolitan Life Insurance Co., New York. N. le Brun and Sons, architects. 1909. (U. of Ill.)

D. State Capitol, Lincoln, Neb. Bertram Goodhue, architect. 1922–26. (U. of Ill.)

E. American Radiator Building, New York. Raymond Good, architect. 1924. (U. of Ill.)

F. State Capitol, Lincoln, Neb. Detail of D. Lee Lawrie, sculptor. (Winston Weisman)

G. Application of Building Zone Law to a Block 200′ x 800′, New York. H. W. Corbett, architect. Drawing by Hugh Ferriss.

H. Fourth State of G.

I. Barclay-Vesey Telephone Building, New York. McKenzie, Voorhees and Gmelin, architects. 1925–26. (U. of Ill.)

A. Tribune Tower, Chicago. Raymond Hood, architect. 1922. (Chgo. Trib.)

B. Tribune Building Competition. Second Prize. Eliel Saarinen. (Chgo. Trib.)

C. Tribune Building Competition. Design by Walter Gropius. (Chgo. Trib.)

D. Tribune Building Competition. Design by Adolph Loos, (Chgo. Trib.)

E. Tribune Building Competition. Design by Frank Fort. (Chgo. Trib.)

F. Travel and Transport Building, Century of Progress Exposition, Chicago. Bennett, Burnham, Holabird and Skidmore, architects. 1933. (Roos)

G. Electrical Building, Century of Progress Exposition, Chicago. Raymond Hood, architect. 1933. (Roos)

H. McGraw-Hill Building, New York. Raymond Hood, architect. 1930. (Roos)

I. Empire State Building, New York. Shreve, Lamb and Harmon, architects. 1931. (U. of Ill.)

A. Tabernacle Church of Christ, Columbus, Ind. Eliel and Eero Saarinen, architects. 1941. (Arch. Forum, Hedrich-Blessing)

B. Generator Hall, Pickwick Landing Dam, Savannah, Tenn. (T.V.A.)

C. Rockefeller Center, New York. Associated architects. 1937–40. (Thomas Airviews)

D. Tuberculosis Clinic, Alexandria, Egypt. I. Gardella and L. Martini, architects. 1938. (Arch. Forum)

E. Loggia, Cranbrook Academy of Art, Bloomfield Hills, Mich. Eliel Saarinen, architect. 1941. (Cranbrook Acad.)

F. Museum of Modern Art, New York. Philip L. Goodwin and Edward Stone, architects. 1939. (Mus. Mod. Art)

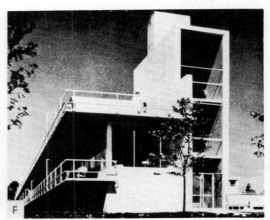

A. Philip Johnson House, Cambridge, Mass. Philip Johnson, architect. 1942. (Mus. Mod. Art)

B. Columbia Broadcasting Studios, Hollywood, Cal. William Lescaze, architect. 1938. (Arch. Forum)

C. Welfare Building, Naval Training Station, Great Lakes, Ill. Skidmore, Owings and Merrill, architects. 1942. (Arch. Forum, Hedrich-Blessing)

D. Breuer House, Lincoln, Mass. Marcel Breuer, architect. 1939. (Wayne Andrews)

E. Normal School, Mexico City. Mario Pani, architect. 1946. (Arch. Record)

F. Lake County Tuberculosis Sanatorium, Waukegan, Ill. W. A. Ganster and W. L. Pereira, architects. 1939. (Arch. Forum, Hedrich-Blessing)

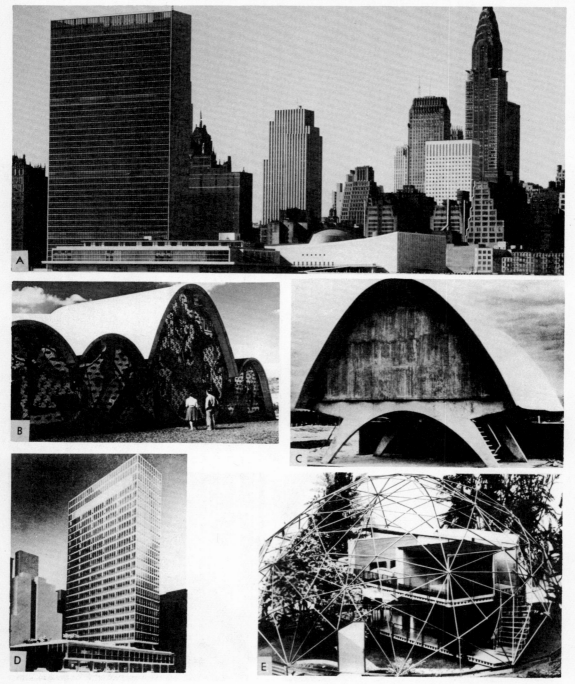

A. United Nations Secretariat, New York. Wallace K. Harrison, Director of Planning. 1952. (UNations)

B. St. Francis of Assisi, Pampulha, Minas Gerais, Brazil. Oscar Niemeyer, architect. Ceramic tile mural by Portinari. 1942. (Three Lions)

C. Nuclear Physics Laboratory, University of Mexico, Mexico City. 1951. J. G. Reyna, architect. (Erwin G. Lang)

D. Lever House, New York. Model. Skidmore, Owings and Merrill, architects. 1951. (Arch. Forum)

E. Geodesic Dome House. Model. Buckminster Fuller, architect. 1950. (Buckminster Fuller)

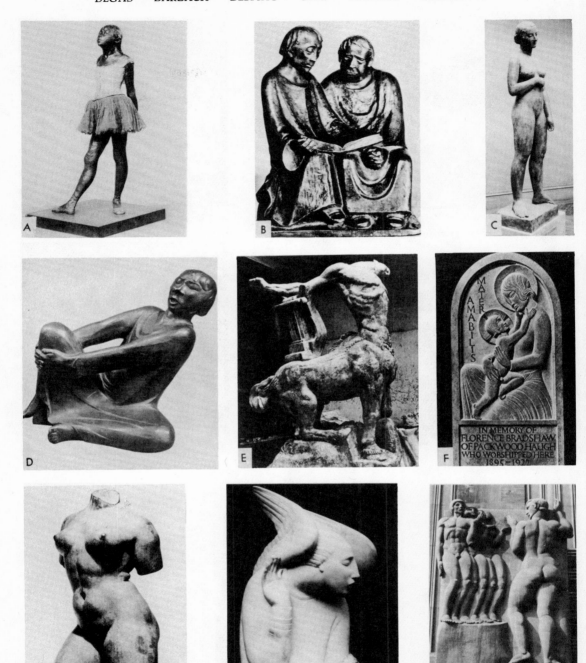

A. Edgar Degas. Ballet Dancer, Dressed. Bronze. 1880. (U. of Ill.)

B. Ernst Barlach. Monks Reading. Art Institute. (Art Inst.)

C. Charles Despiau. Standing Nude. Luxembourg (Librarie de France)

D. Ernst Barlach. Singing Man. 1928. Museum of Modern Art, New York. (Mus. Mod. Art)

E. Émile Bourdelle. Centaur. One of several copies. (U. of Ill.)

F. Eric Gill. Mater Amabalis. 1923. (Met)

G. Aristide Maillol. Torso. Metropolitan Museum, New York. (Met)

H. Ivan Meštrovič. Archangel Gabriel. Brooklyn Museum. (Brooklyn Mus.)

I. Leo Friedlander. Spirit of Radio. 1932–33. R.C.A. Building, Rockefeller Center, New York. (Roos)

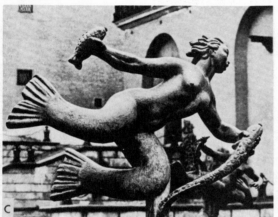

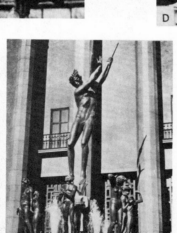

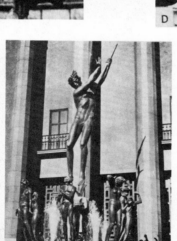

A. Lee Lawrie. Architectural Figure. R.C.A. Building, Rockefeller Center, New York. (See 246 A.) (Roos)

B. Carl Milles. Europa and the Bull. Gothenburg Museum, Sweden. (U. of Ill.)

C. Carl Milles. Fountain Detail. 1930. Gothenburg, Sweden. (U. of Ill.)

D. Leo Friedlander. Valor, for Arlington Memorial Bridge, Washington, D. C. 1916. (Leo Friedlander)

E. Wilhelm Lehmbruck. Kneeling Woman. 1911. Museum of Modern Art, New York. (Mus. Mod. Art)

F. Carl Milles. Orpheus. Fountain. Stockholm, Sweden. (U. of Ill.)

G. Raymond Duchamp-Villon. Baudelaire. 1911. Louvre, Paris. (U. of Ill.)

## ZORACH · EPSTEIN · ARCHIPENKO · BRANCUSI · LACHAISE

A. William Zorach. Child and Cat. 1926. Museum of Modern Art, New York. (Mus. Mod. Art)

B. Jacob Epstein. Night. 1929. London Underground Railway Offices, London. (U. of Ill.)

C. Alexander Archipenko. Flat Torso. 1914. Collection Dr. Ruth Morris Bakwin. (R. M. Bakwin)

D. Jacob Epstein. Primavera God. (Met)

E. Constantin Brancusi. Mlle. Pogany. Philadelphia Museum of Art. (Phila. Mus.)

F. Constantin Brancusi. The Bird. c. 1925. Philadelphia Museum of Art. (Phila. Mus.)

G. Alexander Archipenko. Glorification of Beauty. Berlin. (U. of Ill.)

H. Jacob Epstein. John Dewey. 1928. Columbia University. (John Dewey)

I. Jacob Epstein. Madonna and Child. 1927. (Met)

J. Gaston Lachaise. Woman. 1912–27. Albright Art Gallery, Buffalo, N. Y. (U. of Ill.)

# MOORE · LAURENS · STORRS · LIPCHITZ · BOCCIONI · PICASSO · DUCHAMP-VILLON

A. Henry Moore. Reclining Figure. 1935. Albright Art Gallery, Buffalo, N. Y. (Albright Art Gall.)

B. Henry Laurens. Dance. 1915. (U. of Ill.)

C. John Storrs. Ceres. Board of Trade Building, Chicago. (John Storrs)

D. Jacques Lipchitz. Figure. 1926–30. Museum of Modern Art, New York. (Mus. Mod. Art)

E. Umberto Boccioni. Unique Forms of Continuity in Space. 1913. Museum of Modern Art, New York. (Mus. Mod. Art)

F. Umberto Boccioni. Muscles in Action. 1911. Gallery of Modern Art, Milan, Italy. (U. of Ill.)

G. Pablo Picasso. Head. Bronze. 1909. Museum of Modern Art, New York. (Mus. Mod. Art)

H. Raymond Duchamp-Villon. The Horse. 1914. Museum of Modern Art, New York. (Mus. Mod. Art)

A. Naum Gabo. Head of a Woman. Before 1926. Museum of Modern Art, New York. (Mus. Mod. Art)

B. Meret Oppenheim. Still Life: Fur-Lined Tea Cup. 1936. Museum of Modern Art, New York. (Mus. Mod. Art)

C. Max Ernst. Two Children are Menaced by a Nightingale. 1924. Museum of Modern Art, New York. (Mus. Mod. Art)

D. Hans Arp. Individuals. 1931. (U. of Ill.)

E. Rudolph Belling. Head. 1923. Weyhe Collection, New York. (Weyhe Coll.)

F. Jacques Lipchitz. Composition. 1927. (U. of Ill.)

G. Oskar Schlemmer. Rotund Plastic. 1921. (U. of Ill.)

H. Antoine Pevsner. Developable Column. 1942. Museum of Modern Art, New York. (Mus. Mod. Art)

A. Alberto Giacometti. The Palace at 4 A.M., III. 1934. Paris. (U. of Ill.)

B. Ladislaus Moholy-Nagy. Plexiglas and Chromium Construction. 1940. (Sibyl Moholy-Nagy)

C. Naum Gabo. Column. 1923. Collection of the artist. (U. of Ill.)

D. Alberto Giacometti. The Palace at 4 A.M. 1933. Museum of Modern Art, New York. (Mus. Mod. Art)

E. Isamu Noguchi. Kouros. 1945. Collection of the artist. (I. Noguchi)

F. Henry Moore. The Bride. 1940. Museum of Modern Art, New York. (Mus. Mod. Art)

G. Alexander Calder. Mobile: Red Petals. 1942. The Arts Club, Chicago. (Arts Club)

H. Isamu Noguchi. Table. c. 1947. (Herman Miller Furniture Co.)

A. Edouard Manet. Bar at the Folies Bergère. 1882. Courtauld Collection, London. (Gir)

B. Edouard Manet. Berthe Morisot. Collection M. and Mme. Rouart. (Gir)

C. Edouard Manet. Bon Bock. 1873. Collection Carroll S. Tyson, Philadelphia. (Carroll S. Tyson)

D. Edouard Manet. Olympia. 1863. Louvre, Paris. (Louvre)

E. Edouard Manet. Dinner Under the Trees. 1863. Louvre, Paris. (Louvre)

F. Edouard Manet. Boy with a Fife. 1866. Louvre, Paris. (Louvre)

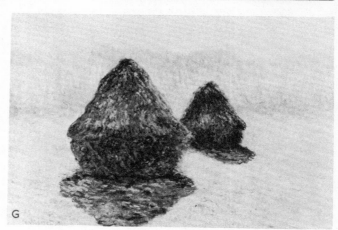

A. Edouard Manet. The Balcony. 1868. Louvre, Paris. (Louvre)

B. Claude Monet. The Japanese Fan. 1876. Collection Lord Duveen. (Duveen Bros.)

C. Edouard Manet. Alabama and Kearsarge. c. 1864. Philadelphia Museum of Art. (Phila. Mus.)

D. Claude Monet. Bridge at Argenteuil. 1874. New Staats Gallery, Munich, Germany.

E. Claude Monet. Detail of D.

F. Claude Monet. Rouen Cathedral. c. 1894. Louvre, Paris. (Louvre)

G. Claude Monet. Haystacks in Snow. 1891. Metropolitan Museum, New York. (Met)

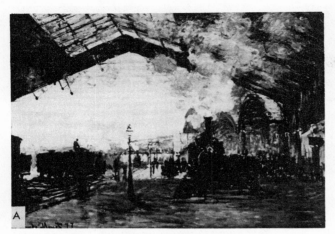

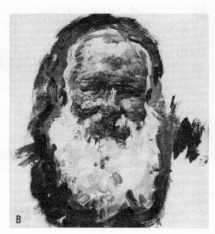

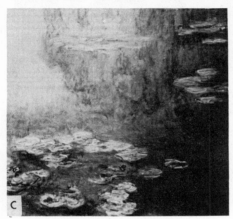

A. Claude Monet. Old St. Lazare Station, Paris. 1877. Ryerson Collection, Art Institute. (Art Inst.)

B. Claude Monet. Self Portrait. Unfinished. Louvre, Paris. (Louvre)

C. Claude Monet. Waterlilies. 1908. Worcester Art Museum. (Worcester Mus.)

D  Edgar Degas. Bather. Lithograph. Fogg Museum, Harvard University. (See 309 E for detail.) (Fogg)

E. Edgar Degas. Absinthe Drinkers. 1876–77. Louvre, Paris. (Gir)

F. Edgar Degas. The Ironers. c. 1884. Louvre, Paris. (Louvre)

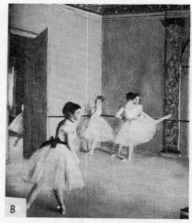

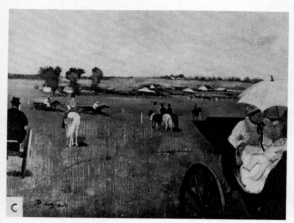

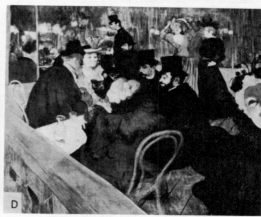

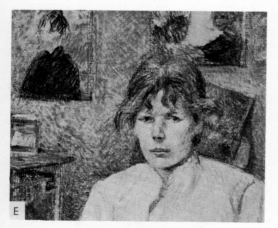

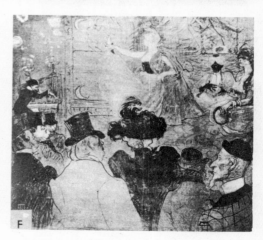

A. Edgar Degas. Le Foyer de la Danse à l'Opéra de la Rue Le Peletier. 1872. Louvre, Paris. (Arch. Photo)

B. Edgar Degas. Detail of A.

C. Edgar Degas. Carriage at the Races. 1873. Museum of Fine Arts. (M.F.A.)

D. Toulouse-Lautrec. The Moulin Rouge. 1892. Art Institute. (Art Inst.)

E. Toulouse-Lautrec. Woman Seated. Detail. Collection John T. Spaulding, Boston. (Fogg)

F. Toulouse-Lautrec. The Moorish Dance. Louvre, Paris. (Louvre)

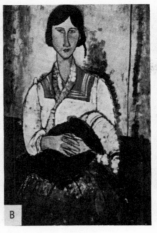

A. Marie Laurencin. Two Girls. Collection O. von V., Dusseldorf, Germany.

B. Amadeo Modigliani. Maternity. Chester Dale Collection. (U. S. Nat. Gall.)

C. Odilon Redon. The Closed Eyes. Luxembourg, Germany. (Gir)

D. Camille Pissarro. Place du Havre. 1893. Art Institute. (Art Inst.)

E. Alfred Sisley. Snow at Louveciennes. Phillips Collection, Washington, D. C. (Phillips Coll.)

F. Pierre Renoir. Luncheon of the Boating Party. 1881. Phillips Collection, Washington, D. C. (Phillips Coll.)

G. Pierre Renoir. Woman with a Parasol. 1877. Collection John T. Spaulding, Boston. (John T. Spaulding)

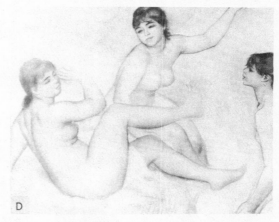

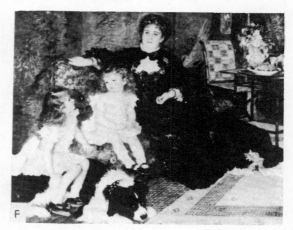

A. Pierre Renoir. A Girl Reading. Städel Art Institute, Frankfort, Germany. (U. of Ill.)

B. Pierre Renoir. Detail of A.

C. Pierre Renoir. Girls at the Piano. Louvre, Paris. (Louvre)

D. Pierre Renoir. Bathers. Drawing. Detail. 1885. Laroche Collection. (Librarie de France)

E. Pierre Renoir. Two Little Circus Girls. 1875–76. Potter Palmer Collection, Art Institute. (Art Inst.)

F. Pierre Renoir. Portrait of Mme. Charpentier and Her Children. 1878. Metropolitan Museum of Art, New York. (Met)

A. Pierre Renoir. The Dancer. 1874. U. S. National Gallery of Art, Washington. (U. S. Nat. Gall.)

B. André de Segonzac. Landscape. Luxembourg. (Gir)

C. Georges Seurat. Models. 1888. Barnes Collection, Merion, Pa. (Barnes Coll.)

D. Pierre Renoir. By the Seashore. 1883. Metropolitan Museum of Art, New York. (Met)

E. Georges Seurat. The Circus. Louvre, Paris. (Louvre)

F. Georges Seurat. Sunday on the Island of La Grand Jatte. 1884–86. Art Institute. (Art Inst.)

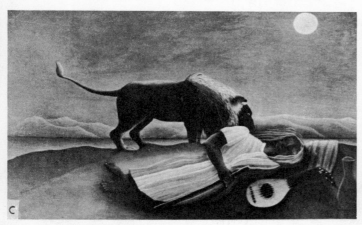

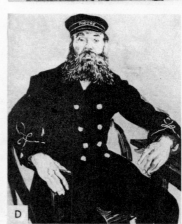

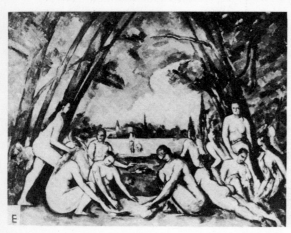

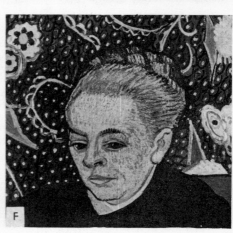

A. Henri Rousseau. The Dream. 1910. Sidney Janis Gallery, N. Y. (Sidney Janis Gall.)

B. Vincent Van Gogh. La Berceuse. 1889. Collection John T. Spaulding, Boston. (Fogg)

C. Henri Rousseau. The Sleeping Gypsy. 1897. Museum of Modern Art, New York. (Mus. Mod. Art)

D. Vincent Van Gogh. The Postman. 1888. Museum of Fine Arts. (M.F.A.)

E. Paul Cézanne. Bathers. 1895–1905. Pellerin Collection, Paris.

F. Van Gogh. Detail of B.

A. Vincent Van Gogh. Pére Tanguy. 1886–88. Edward G. Robinson Collection. (Ed. G. Robinson)

B. Paul Cézanne. Mont Ste. Victoire. c. 1885. Phillips Collection, Washington, D. C. (Phillips Coll.)

C. Vincent Van Gogh. Cypresses. Drawing, 1889. Brooklyn Museum, New York. (Brooklyn Mus.)

D. Paul Cézanne. Card Players. 1892. Barnes Collection, Merion, Pa. (Barnes Coll.)

E. Vincent Van Gogh. Street of Auvers. 1890. Collection John T. Spaulding, Boston. (Fogg)

F. Paul Cézanne. Still Life. Collection John T. Spaulding, Boston. (Fogg)

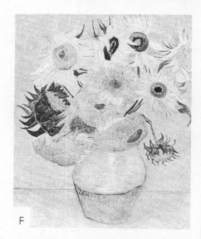

A. Paul Gauguin. Seated Woman (La Faaturuma). 1891. Worcester Art Museum. (Worcester Mus.)

B. Paul Gauguin. The Day of the God (Mahara no Atua). 1894. Art Institute. (Art Inst.)

C. Paul Gauguin. Oh, You're Jealous (No Te Aha Oe Riri). 1896. Art Institute. (Art Inst.)

D. Paul Gauguin. The White Horse. Luxembourg, Paris. (Gir)

E. Paul Gauguin. Tahitian Women. 1891. Luxembourg, Paris. (Gir)

F. Vincent Van Gogh. Sun Flowers. 1888. Carroll S. Tyson Collection, Philadelphia. (Carroll S. Tyson)

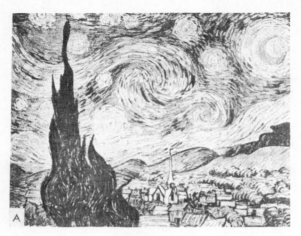

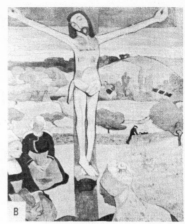

A. Vincent Van Gogh. Starry Night. Museum of Modern Art, New York. (Mus. Mod. Art)

B. Paul Gauguin. The Yellow Calvary. 1889. Albright Art Gallery, Buffalo, N. Y. (Albright Art Gall.)

C. Pablo Picasso. Guitar Player. 1903. Art Institute. (Art Inst.)

D. Pablo Picasso. The Frugal Repast. Etching, second state. 1904. (Univ. of Ill.)

E. Pablo Picasso. Mme. Picasso. 1923. Coll. Mr. and Mrs. Chester Dale. (Mr. and Mrs. Chester Dale)

F. Pablo Picasso. Les Demoiselles d'Avignon. 1907. Museum of Modern Art, New York. (Mus. Mod. Art)

G. Pablo Picasso. Still Life: Vive la . . . 1914–15. Sidney Janis Gallery, New York. (Sidney Janis Gall.)

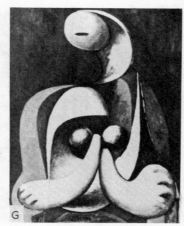

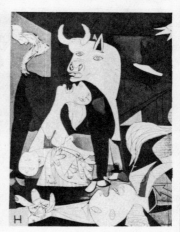

A. Pablo Picasso. Abstraction. 1916. Columbus Gallery of Fine Art, Columbus, Ohio. (Col. Gall.)

B. Pablo Picasso. Harlequin. 1928. Reber Collection, Lugano.

C. Pablo Picasso. Combat of Perseus and Phineus over Andromeda. Etching. 1930. (U. of Ill.)

D. Pablo Picasso. Seated Woman. 1927. James Thrall Soby Collection, Farmington, Conn. (J. T. Soby)

E. Pablo Picasso. The Painter and His Model. 1928. Sidney Janis Gallery, New York. (Sidney Janis Gall.)

F. Pablo Picasso. Girl Before a Mirror. 1932. Museum of Modern Art, New York. (Mus. Mod. Art)

G. Pablo Picasso. Figure in a Red Chair. 1932. Collection of the Artist. (U. of Ill.)

H. Pablo Picasso. Guernica. Detail. 1937. Collection of the Artist. (Mus. Mod. Art)

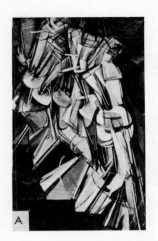

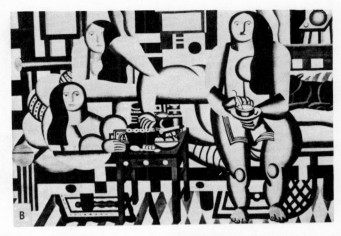

A. Marcel Duchamp-Villon. Nude Descending the Stairs. 1912. Arensberg Collection, Philadelphia Museum of Art. (Phila. Mus.)

B. Fernand Léger. Three Women. 1921. Museum of Modern Art, New York. (Mus. Mod. Art)

C. Andre L'Hote. The Judgment of Paris. 1912. Collection Georges Pauli, Stockholm. (U. of Ill.)

D. Fernand Léger. The City. 1919. Philadelphia Museum of Art. (Phila. Mus.)

E. Georges Braque. Still Life with Grapes. 1927. Phillips Collection, Washington, D. C. (Phillips Coll.)

F. Georges Braque. Woman Combing her Hair. 1936. (U. of Ill.)

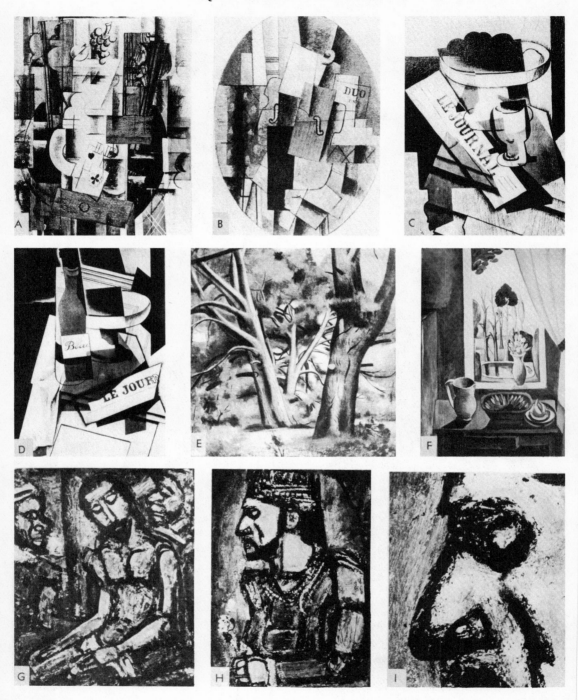

A. Georges Braque. Still Life with Playing Cards. 1914. (U. of Ill.)

B. Georges Braque. Oval Still Life. 1914. Museum of Modern Art, New York. (Mus. Mod. Art)

C. Juan Gris. Fruit Dish, Glass and Newspaper. 1916. Museum of Modern Art, New York. (Mus. Mod. Art)

D. Juan Gris. Bottle and Fruit Dish. 1915. Museum of Modern Art, New York. (Mus. Mod. Art)

E. Andre Derain. Three Trees. Lewisohn Collection, Museum of Modern Art, New York. (U. of Ill.)

F. Andre Derain. Window on a Park. 1912. Collection Mrs. Cornelius J. Sullivan, New York. (Mrs. Cornelius J. Sullivan)

G. Georges Rouault. Christ Mocked by Soldiers. 1932. Museum of Modern Art, New York. (Mus. Mod. Art)

H. Georges Rouault. The Old King. Carnegie Institution, Pittsburgh, Pa. (Carnegie Inst.)

I. Georges Rouault. Detail of H.

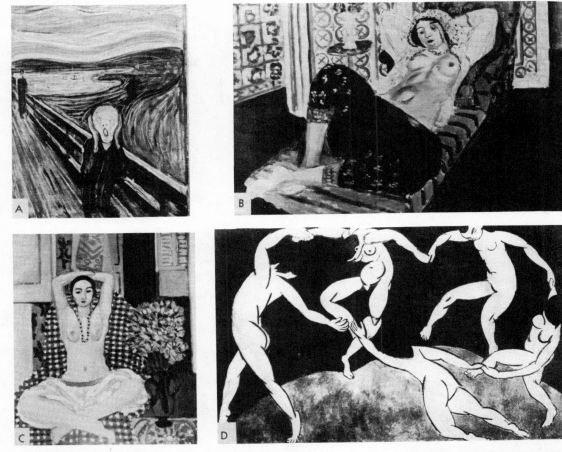

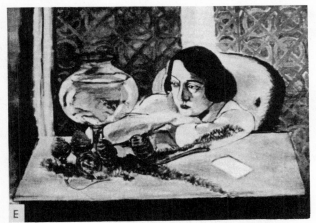

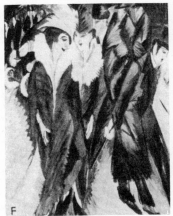

A. Edvard Munch. The Scream. 1893. National Gallery, Oslo. (U. of Ill.)

B. Henri Matisse. Odalisque. Luxembourg, Paris. (Gir)

C. Henri Matisse. Hindu Pose. 1923. Ex. S.C.C. Collection, New York. (U. of Ill.)

D. Henri Matisse. The Dance. 1909. Museum of Western Art, Moscow. (U. of Ill.)

E. Henri Matisse. Girl Looking at a Fishbowl. Art Institute. (Art Inst.)

F. Ernst Kirchner. Street Scene. 1913. National Gallery, Berlin. (U. of Ill.)

A. Max Beckmann. Young Men by the Sea. 1943. St. Louis City Art Museum. (St. Louis C.A.M.)

B. Käthe Kollwitz (Schmidt). Never Again War. Lithograph. 1924. (U. of Ill.)

C. Käthe Kollwitz (Schmidt). Self Portrait. Etching. 1910. (U. of Ill.)

D. Karl Hofer. Girls Throwing Flowers. c. 1926. Art Institute. (Art Inst.)

E. Franz Marc. Red Horses. 1909. Essen Museum. (U. of Ill.)

F. Wassily Kandinsky. Improvisation No. 30. 1913. Art Institute. (Art Inst.)

G. Paul Klee. Jörg. Arensberg Collection, Philadelphia Museum of Art. (Phila. Mus.)

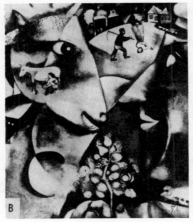

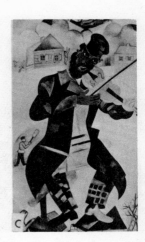

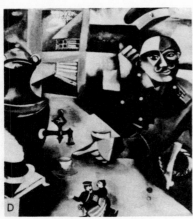

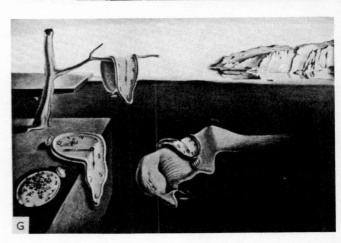

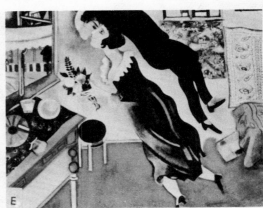

A. Otto Dix. Dr. Meyer-Hermann. 1926. Museum of Modern Art, New York. (Mus. Mod. Art)

B. Marc Chagall. I and the Village. 1911. Museum of Modern Art, New York. (Mus. Mod. Art)

C. Marc Chagall. The Fiddler. 1913–20. Solomon R. Guggenheim Museum, New York. (S. R. Guggenheim Mus.)

D. Marc Chagall. The Soldier Drinks. 1913. Solomon R. Guggenheim Museum, New York. (S. R. Guggenheim Mus.)

E. Marc Chagall. The Birthday. 1915–23. Solomon R. Guggenheim Museum, New York. (S. R. Guggenheim Mus.)

F. George Grosz. Couple. 1934. Whitney Museum of American Art, New York. (Whitney Mus.)

G. Salvador Dali. The Persistence of Memory. 1931. Museum of Modern Art, New York. (Mus. Mod. Art)

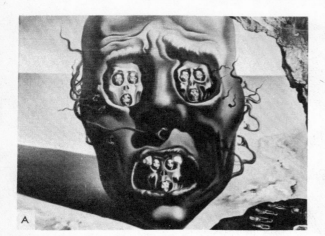

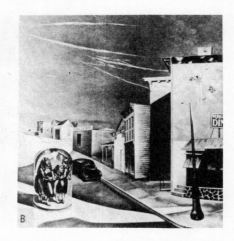

A. Salvador Dali. Visage of War. 1949. Carstairs Gallery, New York. (Carstairs Gall.)

B. Louis Guglielmi. Terror in Brooklyn. 1941. Whitney Museum of American Art, New York. (Whitney Mus.)

C. Giorgio de Chirico. Toys of a Prince. c. 1914. Museum of Modern Art, New York. (Mus. Mod. Art)

D. Detail of A.

E. Peter Blume. Parade. 1930. Museum of Modern Art, New York. (Mus. Mod. Art)

F. Pierre Roy. The Electrification of the Country. c. 1929. Wadsworth Atheneum, Hartford, Conn. (Wadsworth Atheneum)

A. Roberto Matta Echaurren. Three Men Crying. Pierre Matisse Gallery, New York. (Pierre Matisse Gall.)

B. Joan Miro. Dog Barking at the Moon. 1926. Philadelphia Museum of Art. (Phila. Mus.)

C. Joan Miro. Person Throwing a Stone at a Bird. 1926. Museum of Modern Art, New York. (Mus. Mod. Art)

D. Piet Mondrian. Broadway Boogie-Woogie. 1942–43. Museum of Modern Art, New York. (Mus. Mod. Art)

E. Joan Miro. Carnival of Harlequin. 1924–25. Albright Art Gallery, Buffalo, N. Y. (Albright Art Gall.)

F. Pierre Roy. Daylight Saving. 1930. Museum of Modern Art, New York. (Mus. Mod. Art)

A. Diego Rivera. Sugar Workers. Mexico City. (U. of Ill.)

B. Diego Rivera. The Reconstruction. The School Teacher. Mexico City. (Met)

C. David Siqueiros. Ethnography. 1939. Museum of Modern Art, New York. (Mus. Mod. Art)

D. Diego Rivera. Vaccination Panel. 1933. Detroit Institute of Arts. (Detroit Inst.)

E. José Orozco. Migration of the Spirit. 1932–34. Dartmouth College, Hanover, N. H. (Dartmouth Coll.)

F. José Orozco. Golden Age of Aztec Civilization. 1931. Dartmouth College, Hanover, N. H. (Dartmouth Coll.)

G. Diego Rivera. The Flower Vendor. 1935. San Francisco Museum of Art, Cal. (S. F. Mus.)

A. Thomas Benton. The Art of Building. 1930. New School for Social Research, New York. (New School)

B. John Taylor Arms. Mont St. Michel. Aquatint. Collection Frank J. Roos, Jr. (See 309 G for detail.)

C. Bernard Karfiol. Bathers. 1917–18. (Bernard Karfiol)

D. Eugene Speicher. Portrait of a Girl. Whitney Museum of American Art, New York. (Whitney Mus.)

E. John Steuart Curry. The Tornado. Hackley Art Gallery, Muskegon, Mich. (Hackley Gall.)

F. Reginald Marsh. High Yaller. 1934. Collection Mr. and Mrs. Alfred Easton Poor. (Mr. and Mrs. Alfred Easton Poor)

A. Grant Wood. American Gothic. 1930. Art Institute. (Art Inst.)

B. Thomas Benton. The Jealous Lover of Lone Green Valley. 1931. Collection of the artist. (Thomas Benton)

C. Charles Burchfield. Winter Solstice. Columbus Gallery of Fine Arts, Ohio. (Col. Gall.)

D. Preston Dickinson. Industry. Whitney Museum of American Art, New York. (Whitney Mus.)

E. Charles Burchfield. Winter Twilight. Whitney Museum of American Art, New York. (Whitney Mus.)

F. Charles Demuth. My Egypt. 1925. Whitney Museum of American Art, New York. (Whitney Mus.)

A. Lyonel Feininger. Glorious Victory of the Sloop Maria. 1926. City Art Museum, St. Louis (Mus. Mod. Art)

B. Charles Demuth. Modern Conveniences. 1922. Columbus Gallery of Fine Arts, Ohio. (Col. Gall.)

C. John Marin. Maine Islands. 1922. Phillips Collection, Washington, D. C. (Phillips Coll.)

D. Charles Sheeler. Still Life Number One. Columbus Gallery of Fine Arts, Ohio. (Col. Gall.)

E. John Marin. The Cove. 1917. Columbus Gallery of Fine Arts, Ohio. (Col. Gall.)

F. Charles Sheeler. Interior. 1926. Whitney Museum of American Art, New York. (Whitney Mus.)

A. Ben Shahn. Handball. 1939. Museum of Modern Art, New York. (Mus. Mod. Art)

B. Karl Knaths. Cock and Glove. 1927–28. Phillips Collection, Washington, D. C. (Phillips Coll.)

C. Yasuo Kuniyoshi. Self Portrait as a Golf Player. 1927. Museum of Modern Art, New York. (Mus. Mod. Art)

D. Marsden Hartley. Mt. Katahdin, Autumn, No. 1. 1939–40. Hall Collection, University of Nebraska Art Gall. (Hall Coll.)

E. Nahum Tschacbasov. The Clown. Perls Galleries, New York. (Perls Galls.)

F. Stuart Davis. Red Cart. 1932. Addision Gallery, Phillips Academy, Andover, Mass. (Addison Gall.)

A. Karl Zerbe. Melancholia. c. 1946. Art Institute. (Art Inst.)

B. Pavel Tchelitchew. Twilight Head. 1948. Durlacher Brothers, New York. (Durlacher Bros.)

C. Jack Levine. The Feast of Pure Reason. 1937. (W.P.A. Art Program)

D. Karl Priebe. The Fronfroneur. c. 1947. Collection of the artist. (Karl Priebe)

E. Max Weber. Flute Soloist. 1945. Collection Paul Rosenberg and Co., New York. (Paul Rosenberg and Co.)

F. Adolph Gottlieb. Spectre of the Sea. c. 1947. Kootz Gallery, New York. (Kootz Gall.)

A. Max Weber. Detail of 307 E.

B. John Carroll. The White Flower. 1951. Collection of the artist. (John Carroll)

C. William Gropper. Time. Associated American Artists Galleries, New York. (A. A. A. Galls.)

D. Peter Blume. Crucifixion. Detail. c. 1950. Durlacher Bros., New York. (Durlacher Bros.)

E. Philip Guston. Martial Memory. 1941. St. Louis City Art Museum. (St. Louis C.A.M.)

F. Richard Koppe. A Collection of Things. c. 1948. Collection of the artist. (Richard Koppe)

G. I. Rice Pereira. Receding Red. c. 1948. Collection of the artist. (I. R. Pereira)

A. Woodcut. Dürer. (See 167 I)

B. Mezzotint. Prince Rupert. (See 170 C)

C. Engraving. Claude Mellan. (See 203 F)

D. Wood Engraving. Timothy Cole. (See 162 E)

E. Lithograph. Degas. (See 285 D)

F. Etching. Whistler. (See 261 B)

G. Aquatint and Etching. John Taylor Arms. (See 303 B)

# CHART A

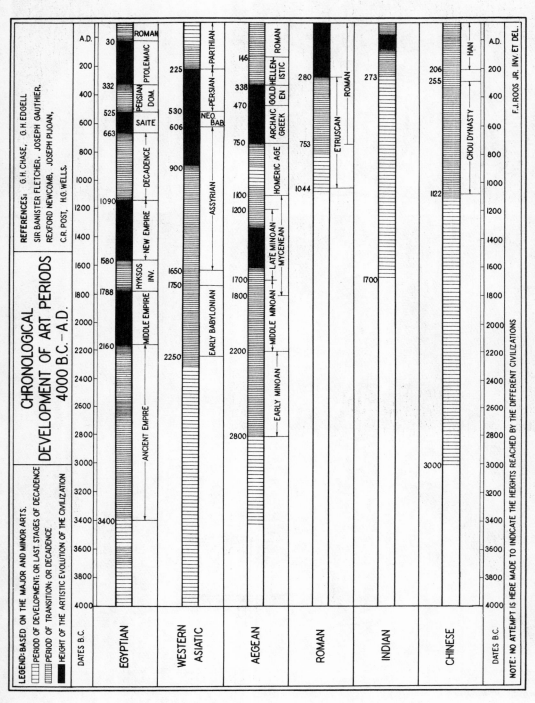

CHRONOLOGICAL
DEVELOPMENT OF ART PERIODS
4000 B.C. — A.D.

REFERENCES: G.H. CHASE, G.H. EDGELL
SIR BANISTER FLETCHER, JOSEPH GAUTHIER,
REXFORD NEWCOMB, JOSEPH PIJOAN,
C.R. POST, H.G. WELLS.

LEGEND: BASED ON THE MAJOR AND MINOR ARTS.
PERIOD OF DEVELOPMENT; OR LAST STAGES OF DECADENCE
PERIOD OF TRANSITION; OR DECADENCE
HEIGHT OF THE ARTISTIC EVOLUTION OF THE CIVILIZATION

EGYPTIAN

WESTERN ASIATIC

AEGEAN

ROMAN

INDIAN

CHINESE

F.J. ROOS JR. INV. ET DEL.

NOTE: NO ATTEMPT IS HERE MADE TO INDICATE THE HEIGHTS REACHED BY THE DIFFERENT CIVILIZATIONS

# CHART B

## CHRONOLOGICAL
## DEVELOPMENT OF ART PERIODS
## I A.D.–DATE

REFERENCES: G.H. CHASE, G.H. EDGELL, SIR BANISTER FLETCHER, JOSEPH GAUTHIER, REXFORD NEWCOMB, JOSEPH PIJOAN, C.R. POST, H.G. WELLS,

LEGEND: BASED ON THE MAJOR AND MINOR ARTS
PERIOD OF DEVELOPMENT, OR LAST STAGES OF DECADENCE
PERIOD OF TRANSITION, OR DECADENCE
HEIGHT OF THE ARTISTIC EVOLUTION OF THE CIVILIZATION

F.J. ROOS, JR. INV. ET DEL.

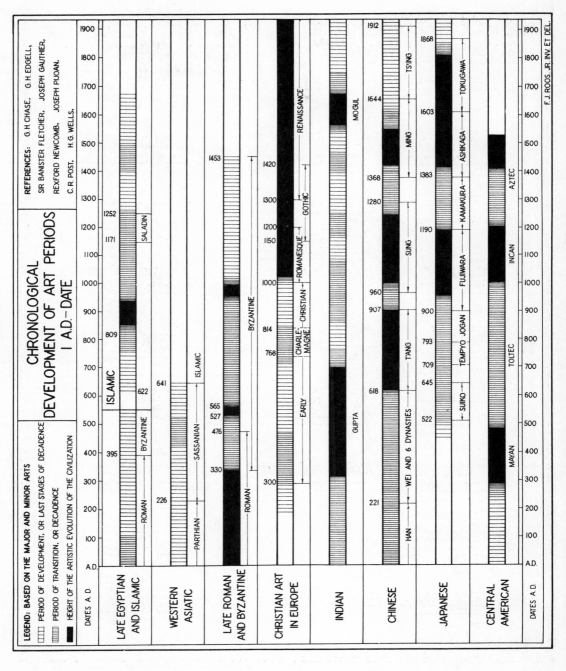

311

# CHART C

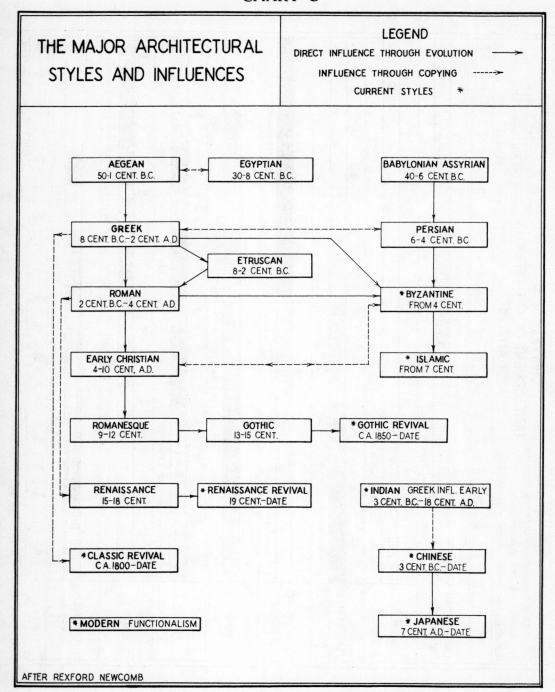

THE MAJOR ARCHITECTURAL STYLES AND INFLUENCES

LEGEND
DIRECT INFLUENCE THROUGH EVOLUTION ⟶
INFLUENCE THROUGH COPYING ⇢
CURRENT STYLES *

AEGEAN
50-1 CENT. B.C.

EGYPTIAN
30-8 CENT. B.C.

BABYLONIAN ASSYRIAN
40-6 CENT. B.C.

GREEK
8 CENT. B.C.–2 CENT. A.D.

PERSIAN
6-4 CENT. B.C.

ETRUSCAN
8-2 CENT. B.C.

ROMAN
2 CENT. B.C.–4 CENT. A.D.

* BYZANTINE
FROM 4 CENT.

EARLY CHRISTIAN
4-10 CENT. A.D.

* ISLAMIC
FROM 7 CENT.

ROMANESQUE
9-12 CENT.

GOTHIC
13-15 CENT.

* GOTHIC REVIVAL
C.A. 1850–DATE

RENAISSANCE
15-18 CENT.

* RENAISSANCE REVIVAL
19 CENT.–DATE

* INDIAN  GREEK INFL. EARLY
3 CENT. B.C.–18 CENT. A.D.

* CLASSIC REVIVAL
C.A. 1800–DATE

* CHINESE
3 CENT. B.C.–DATE

* MODERN  FUNCTIONALISM

* JAPANESE
7 CENT. A.D.–DATE

AFTER REXFORD NEWCOMB

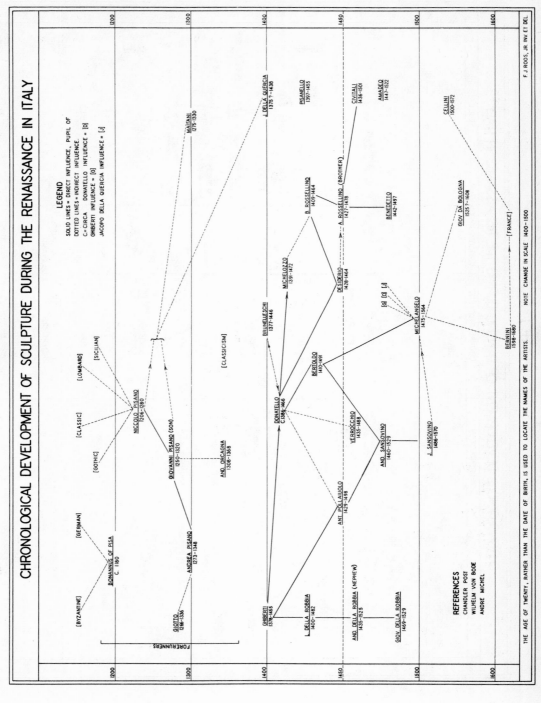

# CHART D

## CHRONOLOGICAL DEVELOPMENT OF SCULPTURE DURING THE RENAISSANCE IN ITALY

**LEGEND**
SOLID LINES = DIRECT INFLUENCE, PUPIL OF
DOTTED LINES = INDIRECT INFLUENCE.
C = CIRCA   DONATELLO INFLUENCE = [D]
GHIBERTI INFLUENCE = [G]
JACOPO DELLA QUERCIA INFLUENCE = [J]

[BYZANTINE]   [GERMAN]

BONANNUS OF PISA
C. 1180

GIOTTO
1266-1336

ANDREA PISANO
1273-1348

[GOTHIC]   [CLASSIC]   [LOMBARD]   [SICILIAN]

NICCOLO PISANO
1206-1280

GIOVANNI PISANO (SON)
1250-1320

MAITANI
1275-1330

AND. ORCAGNA
1308-1368

[CLASSICISM]

J. DELLA QUERCIA
1375 ?-1438

PISANELLO
1397-1455

BRUNELLESCHI
1377-1446

MICHELOZZO
1391-1472

B. ROSSELLINO
1409-1464

A. ROSSELLINO (BROTHER)
1427-1478

CIVITALI
1436-1501

GHIBERTI
1378-1455

DONATELLO
C.1386-1466

BERTOLDO
1410-1491

DESIDERIO
1428-1464

BENEDETTO
1442-1497

AMADEO
1447-1522

L. DELLA ROBBIA
1400-1482

VERROCCHIO
1435-1488

AND. SANSOVINO
1460-1529

[G] [D] [J]

MICHELANGELO
1475-1564

GIOV. DA BOLOGNA
1525 ?-1608

CELLINI
1500-1572

AND. DELLA ROBBIA (NEPHEW)
1435-1525

ANT. POLLAIUOLO
1429-1498

J. SANSOVINO
1486-1570

GIOV. DELLA ROBBIA
1469-1529

BERNINI
1598-1680

[FRANCE]

FORERUNNERS

**REFERENCES**
CHANDLER POST
WILHELM VON BODE
ANDRE MICHEL

1200   1300   1400   1450   1500   1600

THE AGE OF TWENTY, RATHER THAN THE DATE OF BIRTH, IS USED TO LOCATE THE NAMES OF THE ARTISTS.        NOTE CHANGE IN SCALE 1400-1500

F. J. ROOS, JR. INV ET DEL.

# CHART E

## CHRONOLOGICAL DEVELOPMENT OF PAINTING DURING THE RENAISSANCE IN ITALY

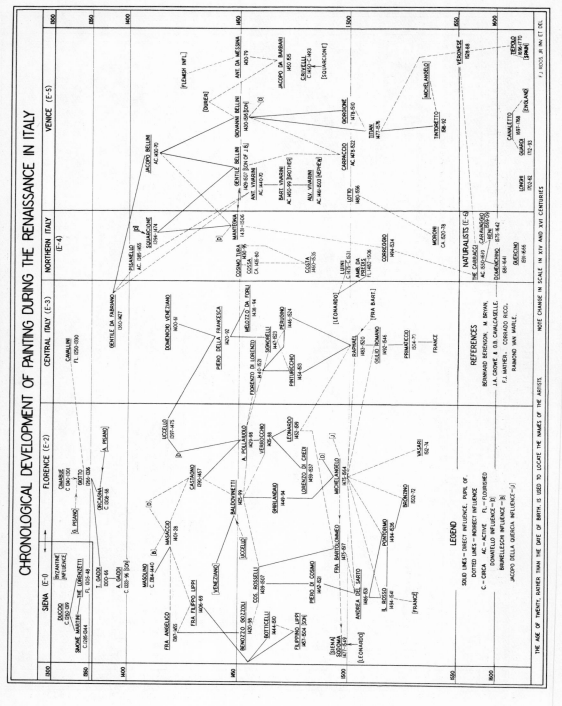

# CHART F

## CHRONOLOGICAL DEVELOPMENT OF PAINTING IN EUROPE
### 1350 - 1700

REFERENCES A DE BÉRUETTE Y MORET, W. BODE, M. BRYAN, W.M. CONWAY, H. FIERENS-GEVAERT, E. FROMENTIN, L. HOURTICQ, M. ROOSES, W.R. VATENINER, W.H.J. WEALE.

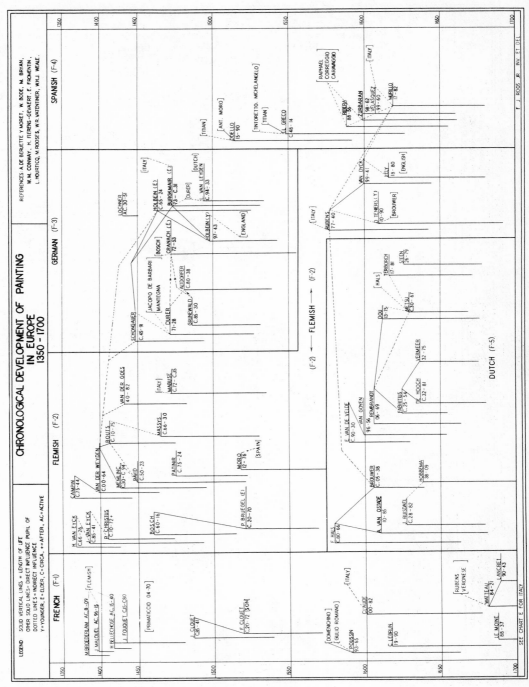

LEGEND  SOLID VERTICAL LINES = LENGTH OF LIFE
OTHER SOLID LINES = DIRECT INFLUENCE PUPIL OF
DOTTED LINES = INDIRECT INFLUENCE
Y = YOUNGER, E = ELDER, C = CIRCA, A = AFTER, AC = ACTIVE

F. J. ROOS, JR. INV. ET DEL.

315

# CHART G

## CHRONOLOGICAL DEVELOPMENT OF PAINTING IN EUROPE
### 1700 – DATE

LEGEND: SOLID VERTICAL LINES = LENGTH OF LIFE,
OTHER SOLID LINES = DIRECT INFLUENCE.
DOTTED LINES = INDIRECT INFLUENCE.
Y = YOUNGER, E = ELDER, C = CIRCA, + = AFTER, AC = ACTIVE

REFERENCES: W. ARMSTRONG, M. BRYAN, C.J. HOLMES,
S. ISHAM, AND R. CORTISSOZ,
R. MUTHER, W. H. WRIGHT.

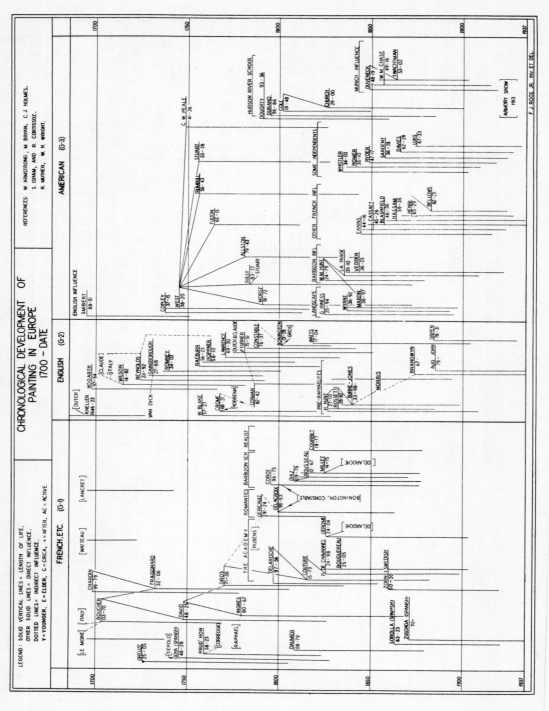

F. J. ROOS, JR. INV. ET DEL.

316

# BASIC EUROPEAN FURNITURE STYLES

**DATES:** 1500 — 1600 — 1700 — 1800

## FRANCE

| PERIOD | GOTHIC | RENAISSANCE | | | | ROCOCO | | CLASSIC | |
|---|---|---|---|---|---|---|---|---|---|
| STYLE | GOTHIC FROM AB. 1150 | FRANCIS I | HENRY II | HENRY IV | LOUIS XIII | LOUIS XIV  TRANSITION | LOUIS XV | LOUIS XVI | EM-PIRE |
| SOVE-REIGN | | FRANCIS I | HENRY II to 1559  FRANCIS II 1560  CHARLES IX 1574  HENRY III | HENRY IV | LOUIS XIII | LOUIS XIV | LOUIS XV | LOUIS XVI | DIRECTOIRE / NAPOLEON |
| DATE | | 1515 | 1547 | 1589 | 1610 | 1643 — 50 — 06 | 1715  1723 | 1774 | 1793  1804  1815 |

(TRANSITION 50; 06; REGENCY 1715–1723)

## ENGLAND

| PERIOD | GOTHIC | RENAISSANCE | | LATE | | | | GEORGIAN / CLASSIC | | |
|---|---|---|---|---|---|---|---|---|---|---|
| STYLE | GOTHIC FROM AB. 1150 | TUDOR | ELIZABETHAN | JACOBEAN | CROMWELL (MID) | [STUART] REST. LATE | WM. & MARY | QUEEN ANNE | CHIPP-ENDALE 1710-79  |  GEORGE III |
| SOVE-REIGN | | HENRY VIII | ELIZABETH FROM 1558 | JAMES I TO 1625  CHARLES I | | CHARLES II TO 1685  JAMES II | WM. & MARY | ANNE | GEORGE I | GEORGE II |
| DATE | | 1509 | 1557 | 1603 | 1649 | 1660 | 1688 | 1702  1714 | 1727  1760 | 1820 |

GEORGIAN classic styles: SHERATON 1751-1806, R. & J. ADAM 1760-92, HEPPLEWHITE 1765-95

## ITALY

| PERIOD | RENAISSANCE | |
|---|---|---|
| | LOW FROM 1400 | HIGH |
| | FLORENCE 1425 | ROME 1557 |

NOTE: ALL EUROPE TOOK ITS INSPIRATION FROM THE RENAISSANCE IN ITALY

## AMERICA

| EARLY COLONIAL | LATE COLONIAL | FEDERAL |
|---|---|---|
| | 1725 | 1790 |
| | | DUNCAN PHYFE  AC. 1795-1818 |

NOTE: AMERICAN COLONIAL STYLES FOLLOW THE ENGLISH ONE TO TWO DECADES LATER

## AGES OF WOODS

| OAK | OAK & WALNUT | WALNUT | COLOR WOODS INLAY | MAHO-GANY |
|---|---|---|---|---|
| 12th 13th 14th CENTS. | 2nd HALF 14-END 15 | 16 & 17 CENTURIES | PEAR  ROSEWOOD  OLIVE  EBONY | |

F. J. ROOS, JR. INV ET DEL

317